A HANDBOOK OF LITERARY FEMINISMS

A HANDBOOK OF
LITERARY FEMINISMS

Shari Benstock
University of Miami

Suzanne Ferriss
Nova Southeastern University

Susanne Woods
Wheaton College

New York Oxford
OXFORD UNIVERSITY PRESS
2002

Oxford University Press

Oxford New York
Athens Auckland Bangkok Bogotá Buenos Aires Cape Town
Chennai Dar es Salaam Delhi Florence Hong Kong Istanbul Karachi
Kolkata Kuala Lumpur Madrid Melbourne Mexico City Mumbai Nairobi
Paris São Paulo Shanghai Singapore Taipei Tokyo Toronto Warsaw

and associated companies in
Berlin Ibadan

Published by Oxford University Press, Inc.
198 Madison Avenue, New York, New York, 10016
http://www.oup-usa.org

Oxford is a registered trademark of Oxford University Press

Library of Congress Cataloging-in-Publication Data

A handbook of literary feminisms / by Shari Benstock, Suzanne Ferriss, Susanne Woods.
 p. cm.
 Includes bibliographical references (p.) and index.
 ISBN 0-19-510206-1 (pbk. : alk. paper)
 1. English literature—Women authors—History and criticism—Handbooks, manuals, etc.
 2. Feminism and literature—Great Britain—Handbooks, manuals, etc. 3. Women and
literature—Great Britain—Handbooks, manuals, etc. 4. Feminist literary
criticism—Handbooks, manuals, etc. I. Benstock, Shari, 1944– II. Ferriss, Suzanne,
1962– III. Woods, Susanne, 1943–

PR111 .H36 2002
820.9'9287—dc21

 2001036415

Printing number: 9 8 7 6 5 4 3 2 1

Printed in the United States of America
on acid-free paper

For our students

CONTENTS

ACKNOWLEDGMENTS

This project could not have been completed without the generous assistance of our colleagues and students. Lee Jacobus first suggested this idea; Elizabeth McGuire, our original editor at Oxford, enthusiastically embraced the idea and expanded our original design. Susie Chang provided support and guidance. Anthony English shepherded the project through a crucial phase and Janet Beatty saw the book to completion. Our institutions, the University of Miami, Nova Southeastern University, and Wheaton College, provided support and assistance.

Several outside readers provided helpful suggestions, corrections, and necessary encouragement of both our proposal and the finished manuscript. They enabled us to see the project as important and contributed to its final design.

Friends and colleagues responded to early versions of individual sections of the manuscript: Melissa Bradshaw, Elizabeth H. Hageman, Margaret Hanney, Jocelyn Harris, Andrea Henderson, Terence Hoagwood, Jaime Hovey, Annemarie Jutel, Barbara K. Lewalski, Dale Rogers Marshall, and Rochelle Simmons.

Students at the University of Miami, Nova Southeastern University, Florida Atlantic University, the University of Bologna, and the University of Otago (Dunedin, New Zealand) graciously allowed us to test our ideas in the classroom.

We could not have done this without the love, support, and *humor* of Steven Alford, Tom Goodmann, and Anne Shaver.

INTRODUCTION

This book emerged from the **feminist** work in literature over the past 40 years, a body of writing that includes contemporary literature written by women who consider themselves feminists and who address in their poetry, prose, and drama issues central to women's identity, creativity, and lived experiences. This statement, however, presumes that we know what "feminist" means and that the connection between the creative act of writing and the political stance of **feminism** is clear both to the writers and to their audiences. The link between feminism and literature is complex and sometimes elusive, and definitions of both terms have changed over time.

Women writers of the second half of the twentieth century were influenced by a consciously constructed feminism that shared its political roots with the civil rights movements of the 1950s and 1960s. But what can we say about women writers who treated women's issues in earlier historical periods when neither the word "feminist" nor organized movements toward women's independence and political rights existed?

We assume that there is not a single definition of "feminism" that can encompass five centuries of women's literary history. In the late eighteenth century, for instance, Mary Wollstonecraft was among the first writers in English to advocate equal rights for women, including equal access to education and the professions. But could we not apply the term "feminism" retroactively to Aphra Behn, who in the seventeenth century defended her sex's ability in writing as equal to men's, including that of the "immortal" Shakespeare? The positions held by both of these women imply women's right to public lives and writing for publication as providing a means of effecting change in culture and society. Contemporary feminists recognize Behn and Wollstonecraft as two of our most important literary and political foremothers. But what about women, such as Hannah More, who published poems against slavery in the late eighteenth century but advocated limiting women's education in other works? Or George Eliot, herself a much published female author of the nineteenth century, who dismissed "silly novels" by lady novelists? For their independence of mind and willingness to speak it, these writers have been claimed by contemporary readers as equally significant contributors to the history of women's literature. Would we then eliminate them from a handbook of "literary feminisms"? Not at all.

One way of identifying a tradition of women's writing is to recognize the contributions of women writers of whatever historical period, whether or not they saw themselves as "feminists" or in their work self-consciously ex-

amined the issues of gender and sexuality, such as women's place in politics and society, access to education, and the right to vote. Another way would be to include only those women writers whose subject matter or literary style could be described as "feminist." Our approach has more in common with the first than the second.

We believe that there is no single tradition of literary feminism, nor is there a litmus test for including some women writers and eliminating others. This book is aimed at asking a broad range of questions about women's literary production without enforcing a divide between "good" feminists and "bad" feminists. Our approach is to ask instead what writing by women means and has meant over the centuries:

- Why do women write?
- What is the range of women writers' subject matter and themes?
- What genres have women chosen to write in and why?
- How are female characters presented in women's texts?
- What innovations in form and style have women contributed to literature?
- How have women's texts been received by readers?
- How have the processes of publication affected women's writing?
- How has the process of canonization shaped the literary history of women?
- How have women writers responded to literature written by women?
- How did women's literature affect history and culture, including feminism?

These questions mean that we would not castigate George Eliot for dismissing her literary sisters. We might, instead, appreciate that she was evaluating their literary production, which was her prerogative as a writer and could be viewed not as a dismissal of women, but rather as an attempt to improve the quality of women's writing.

Contemporary feminism and literary criticism and theory have opened the way to varieties of literary *feminisms*. For example, contemporary feminist critics have not shied away from redefining the work of Edith Wharton as feminist (despite the fact that she refused that label in her lifetime) and have enlarged the interpretation of her works beyond the "novel of manners." Indeed, she is given credit now for having reinvented the form.

A Handbook of Literary Feminisms examines two aspects of literary feminism: (1) the history of women's contributions to Anglo-American literature over the past 500 years, charting the social, cultural, and historical conditions that shaped women's work and (often) guaranteed that women's writing would be devalued by literary history or disregarded altogether, and (2) the emergence in the early 1960s of feminist criticism and theory in the academy. Seeking initially to rediscover lost women's texts and encourage

their acceptance into the canons of Anglo-American literature, feminist criticism developed critiques of Western patriarchy's power structures (including racism, colonialism, and capitalism), examining the philosophical, political, economic, and linguistic systems that supported these structures.

The literary history section begins with early women's writing in English, providing a broad historical sweep intended to offset the recent emphasis on women's writing from the nineteenth and twentieth centuries. We believe that the writing from earlier periods and the perspectives offered by women authors is crucial to understanding the differences among historical periods, especially their social and religious mores, and provides us the opportunity to discuss literature in danger of loss from the literary canon. These texts offer some of the earliest examples of women's contributions to genres that previously had belonged to men, including devotional texts and philosophical treatises. Women revised these, as they did **belles lettres**, and made them their own. This writing, particularly from the earlier periods, can be difficult in ways that challenge contemporary readers, but to ignore or eliminate it altogether is to erase hundreds of years of women's work and effectively to erase the existence of the women themselves.

The large body of women's writing in the nineteenth and twentieth centuries presents a challenge of another sort. The enormous literary production of women in these periods has made it impossible to include every woman writer in all genres of women's literary contributions. We have tried to highlight works that are exemplary in their innovation in literary form and subject matter and their influence on changing cultural norms and values. The **novel** came to dominate all other **genres** during these two centuries, and women were the major practitioners of this form. But women also produced **poetry**, **drama**, **memoirs**, philosophical treatises, and political tracts, and our literary history reflects these aspects of women's literature and criticism.

Our divisions in the history section are organized into the traditional literary periods. We recognize that such boundaries are arbitrary and not without controversy, particularly from a feminist standpoint. But for ease of use we have retained these divisions, noting wherever possible how women's writing challenges not only the division of literature into such neat historical units but also the grouping of works according to literary movements, such as Romanticism and Modernism.

The history of women's literature in the nineteenth and twentieth centuries is inseparable from the development of feminist literary criticism and theory that emerged as a separate form of literary analysis beginning in the 1960s and was influenced by the contemporary women's movement. We provide a brief summary of this development from the 1960s through the 1990s and discuss its relation to other important theories and schools of criticism. The final sections covering the most recent developments in feminist theory and criticism are organized conceptually rather than chronologically, emphasizing that feminist approaches to texts have incorporated theoretical investigations of sexuality, subjectivity, and ideology.

A HANDBOOK HOW TO

This handbook is intended for classroom use at the advanced high school, undergraduate, and graduate levels. It was created with the idea that instructors may want to supplement the handbook with primary texts and additional secondary materials. Organization of the handbook is intended to allow teachers and students maximum flexibility.

The volume is organized into four sections—a history of women's literature, an overview of feminist theory and criticism with particular attention to its applications, a glossary of key terms, and bibliographies of primary and secondary sources. These can be used in a variety of ways:

• The literary history section is arranged chronologically into six chapters: Early Modern Traditions (1500–1700), Eighteenth-Century Triumphs (1700–1780), Romantic Revolutions (1780–1832), Victorian Contradictions (1832–1895), Modern Experiments (1895–1945), and Late Twentieth-Century Directions (1945–2000). Together they trace the sweep of literary feminism in English across five centuries. As a result, the history section could serve as the foundation for a course on women's literature. The individual chapters can also stand alone and may be used with other materials for courses specializing in a particular period.

• The criticism and theory section is intended to be used in conjunction with the literary history section by offering approaches to reading women's literature. But it could also be used on its own as part of a course on feminist literary criticism and theory. Instructors may also choose to begin here, referring students back to the history section for discussion of the texts in question. The Critical Intersections chapter focuses on the most promising engagements of feminist theories with emerging work in studies of gender and sexuality, race and ethnicity, and ideology and culture. These discussion also stand alone and can be used in courses investigating these theoretical issues, as well as in relation to the literary history section.

• The Glossary provides brief definitions of the key terms invoked in the text. Terms contained in the glossary are identified in boldface in the text.

• Bibliographies guide readers to works mentioned in the text itself and also to the many other primary and secondary resources available. The bibliographies are divided into sections, corresponding to the chapters in the text.

In addition, we have provided a time line that traces the historical and cultural events shaping literary feminism, including major publications by author. Birth and death dates for each author are included in the history section of the text.

Part 1

History

1

Early Modern Traditions: 1500–1700

Literary feminism, broadly conceived as a visible tradition of women's voices asserting a woman's position within the culture, is a product of the printing press. Until the late fifteenth century all publication was by manuscripts, whose circulation was often confined to a small coterie. In the late 1400s, as Johannes Gutenberg and others developed movable type, books were still mostly handwritten, sometimes by one person copying another's book, sometimes by an assembly of monks or nuns in a "scriptorium." Despite the obvious limits of manuscript production, some women in earlier European society found voices and a wide readership through manuscript publication going back as far as ancient Greece, where the poet Sappho (sixth century B.C.E.) achieved lasting fame for her extraordinary love poems, mostly to other women. Plato called her "the tenth muse," and her influence on European **lyric poetry** extends to the present day. In Rome several patrician ladies also became recognized writers, including another famous lyricist, Sulpicia (first century B.C.E.).

In medieval Europe, too, a few women sustained reputations as writers and intellectuals, notably nuns such as Heloise in France (ca. 1100–63), Hildegard of Bingen in Germany (1098–1179), Catherine of Siena in Italy (1347–80), and the anchorite Dame Julian of Norwich in England (1342–after 1416). Both Julian and the other great medieval English woman writer, Margery Kempe (ca. 1373–1439), may have been illiterate or semiliterate, although it is difficult to know for sure since standards for literacy were more complex in their time. Literacy usually meant the ability to read and write Latin, so it was no particular shame to dictate one's vernacular voice and have it preserved by more learned clerics, but the resulting text does involve mediation by a hand belonging to someone else, usually male. Margery certainly dictated her book, the first autobiography in English, and Julian may have dictated the visions that comprise the two versions of her "Showings."

While literacy rates were low in the middle ages, clerics and other religious scholars could generally read and write Latin and their own vernaculars, and others might well be able to read but not write (Finke 64–72; Clanchy). The nobility could often read (though not necessarily write) English and French. Both men and women of the gentry and mercantile classes might well be able to read their vernacular language but would hire scribes to write as the demands of their estates or business required. One of our richest troves of information about fifteenth-century England comes from a series of letters from the Paston family, whose matriarch, Margaret Paston,

wrote (or dictated) with lively immediacy. Even earlier, in the fourteenth century, the popular Lollard religious movement encouraged both men and women to copy and circulate books. John Wycliff's translation of the Bible into English in the 1390s was forcefully suppressed by church authorities but managed to reach a wide audience anyway (Aston). By the later middle ages "literacy was no longer the sole preserve of the aristocratic class," and women of the middle classes increasingly owned books (Finke 71).

Women could also become familiar with literature through the common experience of hearing books read out loud. From the earlier monastic practice of reading aloud during mealtimes through the late sixteenth-century report of Edmund Spenser reading his *Faerie Queene* to Queen Elizabeth's court, women and men in reading communities were in this sense "literate" whether or not they could read by themselves. By the late middle ages continental writers, such as Christine de Pisan (1365–ca. 1430), whose *City of Ladies* is perhaps the first popular feminist text, were read widely in England alongside Chaucer and other English court poets. Christine's influence, including her arguments for women's education, continued into the print era as she became one of the earliest continental vernacular writers translated and published in England (in 1521).

At the dawn of the print era many women owned books, many could read, and others who could not read had communities in which books were read to them, and the international literature included texts by as well as for women. Print, however, had a subversive effect on the control of literary production, making it somewhat easier for more women to publish.

The printing press allowed for a largely uncontrolled proliferation of reading opportunity, even though it took two centuries after the press's first appearance for it to dominate manuscript circulation fully. Until nearly 1700 members of the ruling class still considered it brash and inappropriate to have their work printed (Eisenstein, Marrotti). Manuscript circulation allowed an elite to control culture in a way print did not, since usually a reader would need access to the privileged group to get a copy of the manuscript. By contrast, in the early days of printing almost anyone with a few shillings could arrange for multiple copies to be printed, advertised in the common bookstall area of St. Paul's Cathedral yard, and sold to anyone with a few pennies. This relatively uncontrolled circulation of texts posed a threat to cultural hegemony and quickly led to a variety of libel and censorship laws, along with some clear anxieties about women as readers and writers (Wall 279–83). A similar situation exists today, at the dawn of another new technology, as print has itself become a kind of coterie publication largely controlled by a wealthy few through business conglomerates. Anyone with access to a computer, however, can post and read (and see and hear) the unregulated publications of the Internet and Web.

While aristocrats resisted having their writing put into print during the first 200 years of the new print technology, the situation was fluid. The Countess of Pembroke permitted a wide manuscript circulation of her poems based on the Psalms, for example, although they did not reach print

until the nineteenth century, 200 years after her death (ed. Hannay et al.). On the other hand, she carefully edited and supervised the posthumous publication of her brother's work and had no compunction about publishing works that she translated from French to English. When her niece, Lady Mary Wroth, published the *Urania* in 1621, she provoked a scandal, and as Margaret Cavendish, Duchess of Newcastle, began in the 1650s to publish and distribute volume after volume of her essays, poems, and plays, critics such as Dorothy Osborne and Samuel Pepys reacted with shocked fascination. Yet the Countess of Pembroke used print to enshrine her brother and to promote the Huguenot (French Protestant) ideas they both favored, and Cavendish certainly knew, as did at least a few of her predecessors, that if she were to speak to both present and future audiences and achieve the fame and visibility she desired, she would need printed books to do it. Despite the rich tradition of manuscript circulation, the assertive female community that we associate with literary feminism developed only (and slowly) with the beginning of print.

Among the earliest printed works in English were a few pages from the manuscript *Book of Margery Kempe*, offered as a short pamphlet in 1501 by Wynkyn de Worde and titled *A Short Treatise of Contemplation*. The excerpted pamphlet was reprinted in 1521 by Henry Pepwell, the same year that he printed Bryan Anslay's translation of Christine de Pizan's *City of Ladies*. It would be interesting to know who read Christine's provocative book, and whether it inspired any Englishwomen to assert themselves. As far as we can tell, however, no living Englishwoman brought her own words to the printing press within the first 50 years of its life in English.

Finally, sometime between 1524 and 1526 there appeared in print *A Devout Treatise upon the Pater Noster* (Lord's Prayer), whose subtitle tells us that it was "made first in Latin by the most famous doctor Erasmus Roterdamus, and turned into English by a young, virtuous and well-learned gentlewoman of 19 year[s] of age." The translator was Margaret More Roper, one of the famously learned daughters of Sir Thomas More, the great humanist scholar and author of *Utopia*. More was a Lord Chancellor of England (chief minister to the king) who became a Roman Catholic martyr for his refusal to swear the oath of succession that made Henry VIII the head of the Christian church in England. His daughter Margaret tended him in the Tower of London during his last weeks, and their letters to each other (published in a biography of More by Margaret's husband, William Roper) are an early and moving example of a father-daughter relationship based on intellectual respect as well as familial affection.

That Margaret More Roper's translation should be the first printed English work by a living woman suggests a great deal about cultural values and gender roles. In the sixteenth century, women were legally and socially defined in relation to men and in terms of their sexuality. They were daughters (and virgins) before marriage, wives (and expected to be faithful and fruitful) after marriage, and widows (and expected to remarry or remain chaste) should they survive their husbands. It was the man's role to speak

and work in the public sphere. A woman who went beyond the bounds of the home, who appeared and spoke in public, became an accessible sexual temptation. Men so deeply feared female sexuality and self-assertion, often associated with unauthorized speaking, that they defined the virtuous woman as "chaste, silent, and obedient" (Hull).

Margaret More Roper's translation of Erasmus both enacts and challenges that definition. On the one hand a translation hides the translator behind the authority of the original, in this case (as in all but a few cases in the early modern period) a man. In that sense Roper maintains her silence. On the other hand the "new learning," what we have since come to call Renaissance humanism, advocated translation of classical texts as both homage to the civilizing power of the original and a serious exercise of one's own rhetorical skill. Roper's translation of a text in Latin by a contemporary and family friend, an important voice for religious reform within the Catholic church, may have been a volley in the rhetorical wars of religion set off by Martin Luther in 1517. Roper feigns anonymity; her name appears nowhere in the book. Her authorship was no secret, however, and both her contemporaries and her father's biographers refer to this and other manuscript works, most of them unfortunately lost, as evidence of her "elegant and graceful" work in English, Latin, and Greek (Verbrugge in Hannay, *Silent* 30). Roper's silence, then, is a vexed issue, although as daughter and wife of learned men who encouraged her intellect, her chastity and obedience were never in question.

The Reformation and counter-Reformation, along with the printing press, were the principal motivating forces of change in the sixteenth century. Their effect was almost universal, touching gender roles and responses along with everything else. Starting around 1540 (toward the end of the reign of Henry VIII), intellectual women and the Protestant movement encouraged and reinforced each other so that the radical appeal of reform Protestantism recurs like a refrain in the history of early literary feminism.

FEMINISM AND RELIGION IN EARLY MODERN ENGLAND

The word "feminism" usually signifies a range of recent ideas, most of them less than 100 years old. The term should be used carefully in relation to early modern women (that is, women writing between about 1500 and 1700), since the effort to find present-day meanings often leads to serious distortions of early modern experience. There are some analogies we can use, however, to begin to understand the terms in which early modern women perceived and sometimes challenged their social, political, and economic situation— challenges that we may call in retrospect a form of feminism. One useful analogy is between twentieth-century psychology and sixteenth-century religion.

Modern feminists have had to grapple with the ideas, beliefs, and language of twentieth-century psychology, from Sigmund Freud's assertion that "biology is destiny" and his analysis of the mind, through Carl Jung's gendered archetypes with their "anima" and "animus," to later renderings of human relationships and sexuality.

In sixteenth-century Europe it was religion, not psychology, that determined the principal ideas, beliefs, and language from which discussion of gender developed. Like twentieth-century psychology, sixteenth-century European Christianity defined the healthy individual and the healthy community, and just as Freudian and post-Freudian psychology posited the driving force of desire, never to be fully satisfied, so Reformation and counter-Reformation religion talked about the longing for a perfect God by creatures forever separated from Him by sin. If the psychologically healthy twentieth-century person was one who knew how to relax into discovering who he or she is, the sixteenth-century Christian was one who had to learn to abandon all pretense of self-creation in order to receive God's revealing grace.

Also like twentieth-century psychology, religion in the sixteenth century was a battleground of disputed terms and ideas, but with the stakes not present happiness but eternal joy or damnation, the life or death of the soul. The language of sin and salvation, damnation and grace, not only ordered and controlled social and personal behavior but also became the vocabulary for defining and expressing the premodern self. We do not find modern feminism in this period, but we do find ideas that could and did empower some women to question gender roles and risk the opprobrium of appearing in print.

The **Reformation** and **counter-Reformation** both assumed an all-powerful, personal God. Everyone agreed, following Genesis 1–3, that God created humankind and had given men and women free will, but they had chosen to disobey God and follow their own desires. Not everyone agreed exactly how this happened and who was to blame, however. The two versions of the creation story in Genesis present quite different views of the relation of male to female, with the second version also providing the theological foundation for distrust of women generally. In the first Genesis story, male and female were created together in the image of God (Gen. 1:27; all citations are from the King James translation, 1611), while in the second God makes Adam first, gives him dominion over the world, and then forms Eve from one of Adam's ribs to be his companion (Gen. 2:21–23). In the first version God sees that everything he has made is "very good" (Gen. 1:31), while in the second he warns Adam (before Eve is formed) to stay away from the "tree of knowledge of good and evil" (2:17). Eve, however, is tempted by a serpent: "and when the woman saw that the tree was good for food, and that it was pleasant to the eyes, and a tree to be desired to make one wise, she took of the fruit thereof, and did eat, and gave also unto her husband with her; and he did eat" (Gen. 3:6). The result of this "original sin" was separation from God and therefore all that was good, which meant pain and death. The object of life was to get back to God, which meant happiness and eternal life.

Both Catholics and Protestants agreed that the sacrificial death of Jesus Christ on the cross had provided the means of salvation, but they differed substantially on how that means applied to the salvation of individuals, and their theological arguments often carried class and gender implications. One trigger of the Reformation, for example, was the longstanding Catholic prac-

tice of granting "indulgences," or mitigation of a person's individual sins, through a variety of "works." Catholic theology posited a temporary hell, purgatory, which virtually all saved sinners must endure before their translation to heaven (saints were an exception). Good works, whether your own or ones you paid to have done for you, could cut down your time in purgatory. In practice, wealthy people could give money to monasteries to say prayers on their behalf, both before and after their deaths, effectively buying their way out of responsibility for their actions, and unscrupulous wandering preachers and "pardoners" (such as Chaucer's most wicked pilgrim) could scare the poorer folk and con them out of their money.

Protestants also dismissed the Catholic tradition of saints, charging it with encouraging idolatry and the practice of indulgences. One consequence was to eliminate the longstanding worship of Mary as a co-redeemer with her son, Jesus, and so eliminate the only widespread female symbol of divinity. While Mary represented the apotheosis of female obedience, virginity, and motherhood, she was also embued with enormous power and with values assumed to mitigate the harsher judgments of a patriarchal God.

Honorable churchmen had long attacked abuses such as the sale of indulgences, but Martin Luther questioned many of their very premises. In 1517 he put 95 topics for debate on the church door at Wittenberg, the usual method for inviting theological discussion, but his questions were volatile and included a denial of many standard Catholic practices, such as the Catholic sacrament of penance, or confession. Luther's core belief was that faith alone in Jesus Christ saved the sinner, and not works, whether performed by the sinner or his surrogate. If faith alone made a person righteous, then why have a special sacrament of priesthood to mediate between a person and God?

Luther also questioned the Catholic doctrine that celibacy was a holier calling than marriage, which was to have mixed results for women. One result was considerable attention to the idea of Christian marriage, and ultimately the development of a patriarchal family structure alongside, and often in place of, the authority of religious hierarchy. At the same time, by disparaging celibate life, glorification of marriage led to the decline of monasteries and convents, eliminating a socially approved and productive environment for single women.

The Reformation did have two unquestionably positive effects for women. Its emphasis on scripture and on the centrality of the Bible promoted vernacular literacy for everyone, including women. And its assertion of the salvific power of faith, with Christ (not priests or saints) the only mediator between a person and God, placed great emphasis on the integrity of the individual conscience. As a result, if a woman of faith firmly believed that Christ was calling her to do something (including write and publish), no one could tell her with authority that she could not.

Further, the Catholic counter-Reformation saw girls as a powerful resource for challenging the progress of the Reformation, since, as mothers, they would become their children's first teachers. An important result was

an effort to catechize (that is, teach the doctrine of the church) and make literate as many Catholic girls as possible, not just those from the upper classes. This effort in turn spawned educational movements throughout Catholic Europe, including the teaching nuns of the Ursuline Order and St. Vincent De Paul's Daughters of Charity.

Both Protestants and Catholics in the sixteenth and seventeenth centuries saw merit in vernacular female literacy, if not in the more extensive education usually confined to men. It seems reasonable to suggest that literary feminism begins in the turmoil of religious change in early modern England, and often in the language of religion.

WOMEN AND THE BEGINNINGS OF THE ENGLISH REFORMATION (1533–60)

Some years ago rumor had it that a serious young graduate student in history had submitted an M.A. thesis with the unfortunate title "The Position of Women under Henry VIII." In the popular imagination Henry is the king with many wives who did not like the Pope telling him he could not divorce them, so he broke with Rome and founded the Church of England. The full truth is considerably more complicated, but it is true that religion and wives were central to the last half of Henry's long reign, with far-reaching consequences both for English political history and for the history of English-women as thinkers and writers.

The story of Henry VIII and his time is worth a pause, since it shows some of the issues women confronted in a culture very different from our own. Women's power, with rare exceptions, came through their relationship to men, primarily through marriage. In marriage women remained subject to the authority of their husbands, the law, and the church. Henry embodied all three.

The popular perception of Henry's divorces and brutality misses the larger point. Women's bodies were tools of the realm. Yet dangerous as their positions could be, high-born women still had the greatest potential to achieve the education and visibility that might allow them to challenge patriarchal assumptions. During its first century, Protestantism was a principal avenue for that challenge, limited though it was by tradition and by the social and political realities of the time.

Henry was just 19 when he came to the throne in 1509. One of his first acts was to marry the wealthy Spanish princess Catherine of Aragon, who had originally come to England in 1501 to marry Henry's older brother, Arthur. Arthur died only a few months after the wedding, and their father, Henry VII, whose victory over Richard III in 1485 had finally ended the Wars of the Roses, was reluctant either to send Catherine and her wealth back home or to marry her to his younger son. Freed by his father's death, the younger Henry proceeded with the marriage. Since church law forbade a man to marry his brother's widow, the young king first asked for and received papal dispensation to marry Catherine (Scarisbrick 7–13). By all accounts it was a love match, and if Henry and Catherine had produced a male

heir, English history would have been very different. Instead, a daughter, Mary, became the only issue who lived beyond a few weeks, and by the mid 1520s Catherine was beyond her childbearing years. England had never had a successful queen. The king's fear that a royal succession dependent on a woman, his daughter Mary, would be fragile illustrates the patriarchal assumptions of the day.

Henry had numerous affairs, widely considered acceptable indulgences of his royal and masculine authority. When he became enamored of Anne Boleyn in the late 1520s Henry had already enjoyed a liaison with her sister, Mary, but Anne was smart enough to hold him off as he became increasingly convinced that God had frowned on his hasty liaison with his brother's widow. The good Catholic Henry again sought a papal injunction, this time one that would render the original dispensation null and void, making his marriage to Catherine illegal and their daughter a bastard. Despite Henry's efforts on behalf of papal Catholicism, the Pope was at the time dependent on the Holy Roman Emperor, who was Catherine's nephew, and so he was in no position to grant Henry's divorce from Catherine.

Anne picked this time to succumb to Henry's advances and by early 1533 she was pregnant. Henry's English bishops granted him the divorce he wanted, and thus the English church broke from Rome. Despite the popular imagination, which has historically credited (or blamed) Henry for the English Reformation, England did not make a full transition to becoming a Protestant nation until well into the reign of that daughter, Elizabeth, whose birth in 1533 had so disappointed Henry and Anne's hope for a son. In any case, the issues roiling during the early days of the Reformation were to have continuing consequences until at least the eighteenth century.

Despite Henry's insistence on masculine power and traditional religion, women played important roles in the early days of the English Reformation. Anne Boleyn had Protestant sympathies and encouraged Protestant-minded clerics during her brief reign. With the birth of Elizabeth and then a subsequent miscarriage, however, Anne was doomed. Henry allowed Anne's enemies to accuse her of infidelity, which was legally defined as treason since her husband was the king, and he had her beheaded. By then Henry had become infatuated with another young woman, Jane Seymour, who gave him his long-desired son, Edward. Jane died shortly thereafter, but her family members were Protestant sympathizers, and their continuing presence at court, and influence on the young prince, affected the direction of English religion.

Henry's next two wives had little impact on the course of English history, but his last queen, Katherine Parr, became a central figure of the English Reformation and the core of a group of women whose influence extended over several generations. This group may well have included but certainly influenced Anne Askew (ca. 1521–46) and Anne Vaughan Lock (ca. 1532–90). These important Protestant writers inaugurated what we might call the first wave of literary feminism in modern English.

Anne Askew's outspoken Protestant beliefs were in direct opposition to the English church laws passed in 1539, the "Six Articles of Religion" that

largely supported Henry's theological orthodoxy. Askew's report of her *Examinations* by the bishops of London and Winchester, conservative members of Henry's council, made clear her opposition to her expected role as silent and obedient wife. Among things about Askew that scandalized the bishops were her use of her maiden name, despite her marriage to "Mr. Kime," and her insistence on reading the newly translated copy of the Bible kept in the church.

Askew was convicted for not believing in transubstantiation, the doctrine that insisted that bread and wine become the literal body and blood of Christ in the communion service of the mass. She held, instead, the Calvinist view that communion was a memorial of Christ's sacrifice, not its reenactment. This view threatened the special status of priests, who alone, according to the church, had the power to effect transubstantiation. In her *Examinations*, published on the continent shortly after her death, she records her examiners' efforts to have her admit her heresy and displays a keen wit:

> Fourthly he asked me, if the host [i.e., consecrated bread] should fall, and a beast did eat it, whether the beast did receive God or no? I answered, seeing ye have taken the pains to ask this question, I desire you also to take so much pain more, as to assoyle [resolve] it yourself, for I will not do it, because I perceive ye come to tempt me. And he said that it was against the order of schools [i.e., against the scholarly form of asking questions] that he which asked the question should answer it. I told him, I was but a woman, and knew not the course of schools.

In the last years of Henry's reign many others were examined and condemned for outspoken Protestant beliefs, but Askew, a woman of respectable birth but no national importance or influence, seems on the surface an odd target. The bishops most likely pursued her prosecution in order to find evidence against Queen Katherine Parr and the other high-born ladies of Katherine's immediate court circle. That they interrogated Askew about such women strongly suggests that the circle of Protestant women extended across traditional class boundaries. When Askew refused to implicate them she was tortured on the rack, and when she refused to recant her Protestant beliefs she was burnt as a heretic. Before her death she arranged to have her record of her examinations, which construct a godly martyr (and reveal a clever and principled woman), given to John Bale, who assured they would be printed. Bale could not resist an interpolated commentary, running to more prose than Askew's own, in which he seeks to define and enclose the portrait of Askew for the Protestant cause. A reader who ignores Bale and just reads Askew's own text will get a more authentic sense of her experience and self-definition. Reading Bale afterwards makes it easy to see the difference between Askew's voice, with its sly construction of a God-empowered female, and the effort by the emerging Protestant patriarchy to reconstruct her into a humble martyr.

A few years after Askew's execution another strong-minded young woman, Anne Vaughan, born into an influential merchant family sympa-

thetic to the Protestant cause, married Henry Lock, another Protestant merchant. Anne Vaughan Lock (later Dering, then Prowse, as she married successively) was the most important woman writer to emerge during the first years of Queen Elizabeth's reign. Her translation of four sermons by John Calvin, published in 1560, is prefaced by a rhetorically sophisticated dedication to the legendary Protestant Duchess of Suffolk and followed by an original **sonnet sequence** based on Psalm 51, the first sonnet sequence published in English. As Anne Prowse she would frame one more translation in a similar way, *On the Marks of the Children of God* by Jean Taffin, in 1590, but it is the earlier work that is most original and remarkable as a precursor of literary feminism.

The sonnet sequence, the first in English, consists of five introductory sonnets followed by 20 sonnets based on verses from Psalm 51, the most penitential psalm of the Hebrew sequence. The poems are characterized by a passionate denunciation of sin and desire for purification. Interestingly, although the poem denies sin, it never denies the body; Lock would cleanse both body and soul rather than eliminate either. Bodily sickness becomes the metaphor for the soul's sinfulness:

> Wash me, O Lord, and do away the stain
> Of ugly sins that in my soul appear.
> Let flow thy plenteous streams of cleansing grace,
> Wash me again, yea wash me everywhere,
> Both leprous body and defiled face.
> Yea wash me all, for I am all unclean,
> And from my sin, Lord, cleanse me once again.

Lock's dedicatee, the duchess of Suffolk, was Catherine Willoughby Brandon Bertie, an interesting pivotal person in the history of sixteenth-century court and church. The duchess had known Queen Mary from her childhood—her own mother, Lady Willoughby, had come from Spain as lady-in-waiting to Catherine of Aragon and remained deeply loyal to the deposed queen. The daughter, however, early developed Protestant sympathies and became Katherine Parr's closest friend, and therefore one of the people Henry VIII's bishops hoped Anne Askew would implicate. The duchess's secret escape to the continent with her infant daughter, Susan Bertie, during Queen Mary's reign inspired Protestant women. The poet Aemilia Lanyer, who grew up in the household of the duchess's daughter, Susan Bertie, centers the story in a poem dedicated to Susan. According to Lanyer, the daughter endured as an infant "all dangerous travels by devouring sea" in order "to fly to Christ from vain idolatry" (that is, from the Catholicism Queen Mary was seeking to reimpose on England). Lanyer explains that Susan's mother, "That noble duchess, who lived unsubjected," fled

> From Rome's ridiculous prior and tyranny,
> That mighty monarchs kept in awful fear,

Leaving here her lands, her state, [her] dignity.
Nay, more, vouchsafed disguised weeds [i.e., clothes] to wear,
　　When with Christ Jesus she did mean to go,
　　From sweet delights to taste part of his woe.

Printed sources, therefore, allow us to identify one continuing tradition of strong Englishwomen who shared beliefs and influenced each other across class lines and over several generations: Anne Askew knew the duchess of Suffolk, who knew Anne Lock, who knew Aemilia Lanyer's parents (Lock's brother was their close friend), who knew the duchess's daughter Susan Bertie, in whose household Lanyer received her education. Lanyer creates the exile story in terms of a mother and daughter who would not be made subject to a rule that went against individual conscience. Literary feminism in England might be said to begin, then, with three generations of inter-connected Protestant women.

LITERARY FEMINISM IN THE AGE OF ELIZABETH I

Queen Mary's death in 1558 brought Queen Elizabeth I (1558–1603) peace-fully to the throne. Despite Catholic and Protestant wrangling over the le-gitimacy of King Henry's two daughters (if he was never truly married to Catherine, Mary must be illegitimate, and if he was married to Catherine, then Elizabeth must be illegitimate), the succession followed Henry's own wishes and the traditional order of the day: First the son inherited, then the older daughter, then the younger. As Anne Boleyn's daughter, often in real danger during Mary's reign, Elizabeth was assumed to be Protestant. She remained cautious, however, and it took the Pope a full 10 years to be cer-tain that Elizabeth would not be brought to Rome. In 1568 Elizabeth was ex-communicated and England was formally and, as it turned out, permanently Protestant.

Elizabeth's 45-year reign finally disproved the prevailing belief that En-gland could not have a successful queen. Historians have assumed that a reigning queen had little impact on the status of women more generally in the later sixteenth century, and that seems largely true. For one thing, Eliz-abeth and her advisors portrayed her reign as a God-given exception to the natural order of things. Anne Lock's good friend, John Knox, put himself in trouble with Elizabeth when he published *The First Blast of the Trumpet against This Monstrous Regiment of Women* in 1558. In it he argued that it was a vio-lation of nature and an offense against God for women to rule. His targets were Catherine de Médicis (the Queen Mother of France), Mary Tudor of England, and Mary Stuart of Scotland, all Catholics, but his timing was ter-rible; the book appeared in print right after Elizabeth succeeded her sister on the throne (Davis and Farge 168; Neale). In response to Knox, Bishop John Aylmer quickly produced *A Harbor of True and Faithful Subjects*, in which he carefully showed that God could (and did) raise up some women to rule. Part of Aylmer's argument was based on English law: Women were allowed

to inherit property in England, which was not true throughout Europe. If women can inherit, argued Aylmer, and rule is hereditary, then a woman can inherit her father's rule. In any case, John Knox was quick to respond that his attack against women rulers did *not* include Elizabeth, for whom God had obviously made an exception from the general order of His plan. Elizabeth, in turn, was happy to accept herself as God's exception; she made no changes in English law that would have particularly benefited women, and her influential counselors, as far as we know, were all men.

Nonetheless, Elizabeth's reputation as a scholar and the very fact of her rule affected women's imaginations. Mary Sidney Herbert, the Countess of Pembroke (1561–1621), ruled her own domain with the pomp and assurance of a queen, in large part, her biographer argues, on the model of Elizabeth (Hannay, *Philip's Phoenix*). Aemilia Lanyer remembered vividly her youth spent around Elizabeth's court, images that fired her literary imagination. Further, the two principal means by which Elizabeth ruled, through the ritualized courtesies of love conventions and through religious authority, took their subsequent direction in women's writing from the Elizabethan model. Isabella Whitney (fl. 1565–75) and Lady Mary Wroth (1587–ca. 1653), from very different social positions, explored the love conventions from a woman's point of view, while the Countess of Pembroke and Aemilia Lanyer dealt with issues of religion, authority, and power.

Courtly love, which first appears as a literary system in the twelfth-century poetry of Italy and southern France, was a game in which the lover treated his lady as if she were his feudal lord, swearing faithfulness to her and performing brave deeds on her behalf. His honor was to serve her and protect her reputation; her honor was her chastity and its inspirational value to the knight who served her. In a world in which women, as daughters and wives, were ever subordinate to men, this game allowed women to enact a superior role, however far from the general circumstance of women. Elizabeth, who used her marriageability as her principal diplomatic card for the first 20 years of her reign, used her image as the Virgin Queen throughout her reign. She formed this image in iconic progresses around the country and it was encoded by the art, poetry, and music of her court. For Elizabeth the courtly love game became literal; she *was* the ruler of her vassal-lovers, inspiring (sometimes ordering) their good deeds. But by enshrining her rule in the language of courtly love, she managed to keep and use her culture's construction of the feminine. Her own poetry responds to her courtly lovers, notably Sir Walter Ralegh and her last serious suitor, Francis, Duc D'Alencon, and keeps the game going. In her poetry, as in her more famous speeches, Elizabeth walks a fine line between womanly coquettishness and the ruler's power.

"On Monsier's Departure," for example, is filled with the **Petrarchan** oxymorons typical of the genre:

> I am and not, I freeze and yet am burned,
> Since from myself, another self I turned,

My care is like my shadow in the sun,
Follows me flying, flies when I pursue it,
Stands and lies by me, doth what I have done.
. . .
Some gentler passion slide into my mind,
For I am soft and made of melting snow;
Or be more cruel, love, and so be kind,
Let me or float or sink, be high or low,
Or let me live with some more sweet content,
Or die, and so forget what love ere meant.

The passion is so deeply encoded in the Petrarchan material that it is impossible to say whether the poem is meant to imitate a real expression or a ceremonial one. It is a skillful poem, in any case, in which the speaker never loses the force of her own authority.

The situation is quite different for the powerless. Isabella Whitney was a young woman of the minor gentry who came to London from Cheshire in the 1560s. Her family valued learning enough to provide a university education to her oldest brother, Geoffrey Whitney, who became famous as a writer and translator of emblem books (books of small pictures accompanied by a short explanatory verse, usually with moralizing intent). Isabella Whitney published the first secular book of verse on a theme of love and marriage, *The Copy of a Letter by a Young Gentlewoman to Her Unconstant Lover* (1567), engaging from a more realistic and middle-class perspective the topic that helped secure the Queen's power. Marriage is a central theme of her *Letter*, which admonishes her lover for deceiving her and planning to marry someone else and recounts briefly the stories of various unfaithful lovers (Jason, Troilus). She moves throughout the poem between modestly accepting a situation she cannot change and asserting her own value:

It shall suffice me, simple soul,
of thee to be forsaken:
And it may chance, although not yet,
you wish you had me taken.

Whitney follows with a second poem, described on the book's title page as "an admonition to all young gentlewomen, and to all other maids in general, to beware of men's flattery," and the book concludes with a poem by a male writer, "a loveletter sent by a bachelor (a most faithful lover) to an unconstant and faithless maiden." In all three cases the theme is the pain of love when the lover does not play by the courtly rules. Whitney had entered service in London (presumably as a lady's maid or governess), a position she lost around 1573, prompting her second book of verse, *A Sweet Nosegay*. The book consists of 110 short moral verses, an exchange with family and friends in which she complains of her loss of position, and a poem she describes as a "Last Will and Testament," but which amounts to a review of

London places and life. She is careful to situate her literary work as a form of housework and a compensation for not having "a husband or a house."

Two generations later, a woman of much higher social class, Lady Mary Wroth, describes a love very different from Whitney's affair on the surface but surprisingly similar at the core. Ostensibly a series of sonnets written by the heroine to the hero of her long prose romance, *The Countess of Montgomery's Urania* (1621), they have thinly disguised biographical relevance. The eldest daughter of Sir Robert Sidney, Mary was the niece of the famous author Sir Philip Sidney (d. 1586) and his literary sister, the Countess of Pembroke, after whom she was named. Unhappily married to Sir Robert Wroth in 1604, she had long been infatuated with her cousin, the countess's son William Herbert, who became Earl of Pembroke after 1601. At some point after her husband's death she began an affair with Herbert and in the second decade of the seventeenth century had two children by him. She apparently hoped that the otherwise childless Pembroke would designate their son his heir, but that did not happen. The *Urania*, dedicated to Susan, Countess of Montgomery, the wife of her other Herbert cousin, Philip, is filled with lost children, unknown and complicated parentage, faithful women, and faithless men. The sonnet sequence, *Pamphilia to Amphilanthus*, praises love and the beloved man but bemoans the situation of a woman in love:

> My pain, still smothered in my grieved breast,
>> Seeks for some ease, yet cannot passage find
>> To be discharged of this unwelcome guest;
> When most I strive, more fast his burdens bind.
> Like to a ship, on Goodwins [Sands] cast by wind
>> The more she strives, more deep in sand is pressed
>> Till she be lost; so am I, in this kind
> Sunk, and devoured, and swallowed by unrest,
> Lost, shipwrecked, spoiled, debarred of smallest hope
>> Nothing of pleasure left; save thoughts have scope
>> Which wander may. Go then, my thoughts, and cry:
> Hope's perished, Love tempest-beaten, Joy lost.
>> Killing Despair hath all these blessings crossed;
>> Yet Faith still cries, Love will not falsify.

Although courtly and sophisticated in form and metaphor, the sentiments are remarkably similar to those in the cruder verse of Isabella Whitney: beloved and faithless men remain beloved and infuriatingly faithless, and the faithful lady suffers.

The Countess of Pembroke engages in the Renaissance fascination with love games only indirectly, through her translation of Robert Garnier's French version of the story of Antony and Cleopatra. Her version, *Antonius*, printed in 1592, is, like Garnier's original, a closet drama (that is, a dramatic work meant to be read rather than staged). It very probably influenced Shakespeare's choice of the topic for his *Antony and Cleopatra* (1606), but the

earlier work's attention is to character rather than action, and its principal concern is whether "fortune" or free will governs the course of a life. Pembroke's Cleopatra is remarkably sympathetic, presented as someone who loves truly and takes responsibility for her failures, while Antony rails at fortune and blames Cleopatra. Critics have speculated why the aristocratic Protestant countess would translate and print this work, with the most likely explanation that she saw it as part of the French Huguenot (that is, Protestant) intellectual life that she and her brother Philip had actively supported. The work does raise important moral issues, and was published secondarily along with her translation of Phillipe de Mornay's *Discourse of Life and Death*, an important French Protestant treatise by a personal friend of the countess and her brother.

The countess's greatest achievement is as a lyric poet. She wrote occasional verse, including a very substantial pastoral elegy on the death of her brother, "The Doleful Lay of Clorinda," which the great Elizabethan poet Edmund Spenser included when he published his own tribute to Sidney, *Astrophel* (1595). She joined the fashion of celebrating Queen Elizabeth with "A Dialogue between two shepherds, Thenot and Piers, in praise of Astrea," a classical name that equates the queen with the goddess of justice. In 10 clever dialogue verses Thenot praises "Astrea," and Piers accuses him of lying:

> THEN: Astrea sees with Wisdom's sight,
>
> Astrea works by Virtue's might,
>
> And jointly both do stay in her.
>
> PIERS: Nay take from them her hand, her mind,
>
> The one is lame, the other blind,
>
> Shall still your lying stain her?

At the end all is made clear, as Thenot queries and Piers responds with the queen's incomparability:

> THEN: Then Piers, of friendship tell me why,
>
> My meaning true, my words should lie,
>
> And strive in vain to raise her.
>
> PIERS: Words from conceit [metaphor, imagination] do only
> rise,
>
> Above conceit her honor flies;
>
> But silence, nought can praise her.

Although her secular poems were as good as any in Elizabeth's court, her poems based on the Psalms remain the Countess of Pembroke's principal legacy. Philip Sidney began the project, producing 43 poems before his death fighting for the Protestant cause in the low countries in 1586, and the countess

completed the sequence with poems based on Psalms 44–150. These lyrics are elegant, graceful, and assured and contain a breathtaking variety of verse forms. Taking into account forms that vary so-called masculine and feminine rhymes (lines that end with stressed or unstressed syllables, respectively), no two of her lyric verse structures are exactly the same throughout the sequence. She brings an assured grace to her translations, moderating, for example, the passion that Anne Lock brought to her version of Psalm 51. In the countess's version of the first stanza, for example, the balance and parallelism of the verse restrain the more impassioned sense of sin Lock conveys:

> O Lord, whose grace no limits comprehend [i.e., has no limits]
> Sweet Lord, whose mercies stand from measure free,
> To me that grace, to me that mercy send,
> And wipe, O Lord, my sins from sinful me.
> O cleanse, o wash my foul iniquity.
>> Cleanse still my spots, still wash away my stainings,
>> Till stains and spots in me leave no remainings.

Despite their circulation in manuscript only, the Sidney-Pembroke psalms were known and admired by many poets, including Lanyer, Ben Jonson, John Donne, and George Herbert. The countess herself apparently hoped to be remembered particularly for this achievement: In 1618 when she allowed what was probably the last portrait of her lifetime, an engraving by Simon van de Passe, she portrayed herself holding a clearly marked volume of "David's Psalms." This is perhaps the earliest and certainly one of the most direct published images of a woman choosing to base her fame in her identity as a writer. She could do this without impunity in part because her subject matter is biblical (they are "David's Psalms," after all) and in part because of her position as a countess and as a Sidney.

Whatever the limits on a woman as a writer in the Elizabethan period, the countess of Pembroke found ways to maneuver around them. As patron, editor, translator, and, ultimately, great lyric poet in the reform Protestant tradition, she established an unmistakable place for women who wanted to write. When Lord Denny, offended by references to his own family scandals in Lady Mary Wroth's *Urania*, told Wroth she should go back to needlework, he also conceded that he would not find her literary activities inappropriate if she would stick to her aunt's piety and write religious verse. In some ways, therefore, by so visibly negotiating acceptable paths for women to write, the countess also may have appeared to exclude others. But nothing can take away from the vitality of her presence in the history of women writers in English. She is unquestionably the founding mother of the English literary tradition.

Aemilia Bassano Lanyer (1569–1645) was perhaps the first woman to respond explicitly to the countess's model. The daughter of an Italian court musician and his English wife, Lanyer grew up around Elizabeth's court and within the influence of the English Reformation.

Lanyer's volume of poetry, *Salve Deus Rex Judaeorum* (Hail God, King of the Jews, 1611), has some claim as the first feminist literature. It consists of 11 dedicatory pieces, all to women (including a particularly notable one to the Countess of Pembroke), followed by a long poem on the story of Christ's death and the events surrounding it told entirely from women's points of view. The volume uses religious themes to encompass poetic ambition and to speak directly on behalf of women. The long poem includes, for example, a speech in defense of Eve, spoken in the voice of Pilate's wife, which concludes that the male-ordered crucifixion far outweighs any guilt for original sin attributable to Eve:

> Then let us have our liberty again,
> And challenge to yourselves no sovereignty;
> You came not in the world without our pain,
> Make that a bar against your cruelty.
> Your fault being greater, why should you disdain
> Our being your equals, free from tyranny?
>> If one weak woman simply did offend,
>> This sin of yours hath no excuse, nor end.

Similarly, her prose dedication "To the Virtuous Reader" condemns women who join with men in attacking other women:

> Often have I heard that it is the property of some women not only to emulate [i.e., disparage] the virtues and perfections of the rest, but also by all their powers of ill speaking to eclipse the brightness of their deserved fame. Now contrary to this custom . . . I have written this small volume, or little book, for the general use of all virtuous ladies. . . . And this I have done, to make known to the world that all women deserve not to be blamed though some, forgetting they are women themselves, and in danger to be condemned by the words of their own mouths, fall into so great an error as to speak unadvisedly against the rest of their sex.

The verse is often witty and sometimes quite moving, particularly as she focuses a female gaze on the beautiful body of Christ on the cross. In terms taken from the Bible's Song of Solomon, for example, she praises his outward as well as inward beauty. His hair is

> Black as a raven in her blackest hew;
> His lips like scarlet threads, yet much more sweet
> Than is the sweetest honey-dropping dew
> Or honeycombs, where all the bees do meet.
> Yea, he is constant, and his words are true,
> His cheeks are beds of spices, flowers sweet.
>> His lips, like lillies, dropping down pure myrh,
>> Whose love before all worlds we do prefer.

CONTROVERSY AND DEFIANCE IN THE REIGN OF JAMES I (1603–25)

Lanyer's work is in part a response to the longstanding *querelle des femmes*, or debate about the nature, virtues, and (especially) vices of women. At the turn of the fifteenth century, for example, Christine de Pisan participated in a round of this debate that included the chancellor of the University of Paris. Jokes about women have long been a staple of masculine bonding, and the learned wits of the English Renaissance were happy to use their rhetorical skills to excoriate the other sex. In 1589 the pseudonymous "Jane Anger," most probably a woman, reacted with a spirited attack against this practice. But the "woman controversy" continued well into the seventeenth century, when James I (1603–25) came to power following Elizabeth's death. The controversy was fueled in part by King James's preference for the company of men and his dislike and distrust of female transgression. When women took to adding masculine feathers to their hats or wearing small daggers as accessories, James reacted by ordering the practice attacked from English church pulpits. In James's world, it was not male homosexuality that was "effeminate" (James's own strongest attachments with men may have included sex) but, rather, too much attention to women. In this atmosphere Joseph Swetnam's 1615 attack against women, *The Arraignment of Lewd, Froward, and Idle Women*, was immediately popular, but it also sparked a series of responses. The first of these marks the first polemic on behalf of women by a known woman author.

Rachel Speght's *A Muzzle for Melastomous* (or "black-mouth," 1617) relegates direct response to Swetnam to an appendix with a separate title page, but uses the opportunity of his fairly typical diatribe to compose something considerably more serious as the main body of her work: a treatise that challenges the most negative biblical interpretations of woman's nature and role. Daughter of the Rev. James Speght, a Puritan Protestant clergyman, Rachel Speght (ca. 1597–?) apparently wrote and published with her father's permission and shows considerable evidence of a very good education, presumably under her father's supervision.

While Speght accepts the biblical texts on which the arguments against women are based, she uses the *Muzzle* to liberalize their interpretation. Like Lanyer and others before her, Speght argues that Eve did not know she was sinning when the serpent tempted her to eat from the tree of knowledge of good and evil, but, when she offered the fruit to Adam, he did know, and his sin completed the fatal act. Men are not therefore exempt from blame, as much of the anti-woman rhetoric implied, but men and women are together both in their responsibility for sin and in the promise of human redemption (Aughterson 272). Speght can be quite clever, as well as earnest and logical, sometimes turning arguments about women's expected inferior role to her advantage. If woman was made secondarily in order to be man's companion and helper, she argues, "then are those husbands to be blamed who lay the whole burden of domestical affairs and maintenance on the shoulders of their wives?" (Lewalski 20). This may be the earliest published suggestion that men should share in housework.

Speght's second work, *Mortality's Memorandum* (1621), is a long poem on mortality sparked by the loss of her own mother. She precedes it with an introductory dream allegory expressing the speaker's love of learning and prefaces both poems with an introductory defense of her previous effort against Swetnam. She insists particularly that the *Muzzle* was indeed her own work, and not her father's (as rumor apparently had it). Speght's modern editor notes that publication of these more personal poems was "in part an excuse to reassert her authorship" of the *Muzzle* (Lewalski 157). While the poetry is not elegant, it is skillful enough to make her case. In support of her own love of knowledge, for example, is this stanza:

> True knowledge is the window of the soul,
> Through which her objects she doth speculate.
> It is the mother of faith, hope and love;
> Without it, who can virtue estimate?
> By it, in grace thou shalt desire to grow;
> 'Tis life eternal God and Christ to know.

Rachel Speght's work continues the line of Protestant women interested in the enterprise of reinterpreting church tradition to include women more fully. Nearly a century after Queen Katherine Parr's circle challenged English Catholicism, England had become securely Protestant and a few women risked being more vocal and visible than they had been in the past, but the state of women generally was hardly better than in earlier times. *The Law's Resolution of Women's Rights* (1632, but probably written at the end of Elizabeth's reign) notes that God's punishment of Eve in Genesis 3 (that she will thenceforth be subject to her husband) is "the reason . . . that women have no voice in parliament. They make no laws, consent to none, they abrogate none. All of them are understood either married or to be married, and their desires are subject to their husband. I know no remedy, though some women can shift it well enough" (Aughterson 153). The Protestant patriarchy remained suspicious of women's speech, while a defiant wife was a sinner. Still, some women apparently did "shift it well enough."

Elizabeth Tanfield Cary, Lady Falkland (1585–1639), became a defiant wife. As early Protestant women risked their lives for what they perceived to be the true faith (and an expanded role for their personal conscience), so English Catholic families risked their property and perhaps more as they continued in secret the traditions of the Catholic mass through Elizabeth's reign and beyond. Elizabeth Cary was in an even more precarious position: She converted to Catholicism against the wishes of her Protestant husband and raised her younger children in the Catholic faith. In so doing, she challenged directly the patriarchal system that English Protestantism had newly codified and raised again the issue of what women had lost, as well as what they might have won, with the Reformation.

Arranged marriages were nothing new, but Protestant patriarchy emphasized the obedience of children to their fathers, making it sinful as well as disrespectful to resist a parental arrangement. According to a *Life* written

by one of her daughters, Elizabeth Tanfield was a precocious and scholarly heiress who early developed a reputation for her translations from Latin. Skilled in Latin, she was able to read not only the classics but also the Catholic church fathers and contemporary religious controversies. She was married to Sir Henry Cary in 1602 and, when her husband went to fight for the Protestant cause in the Netherlands, lived first with her own parents and then with her mother-in-law. When the latter found Elizabeth resistent to authority and too inclined toward her own scholarly independence, she denied her the use of her books. As a result, Cary began to write her own.

Probably around 1603, when her husband was in the low countries and many years before Cary made her formal conversion to Catholicism, Cary wrote the closet drama *Mariam, Fair Queen of Jewry*, which was printed some 10 years later, in 1613. It is the first published original drama by a woman writing in English. The mode follows the Latin author Seneca, the Countess of Pembroke's *Antonius* (a translation that Cary apparently much admired), and other Senecan closet dramas of her own time (most notably, Fulke Greville's *Mustapha*, which, like *Mariam*, is interested in the concept of tyranny). The story comes from the Jewish historian Josephus and tells of the jealousy and brutality of the Judaean tyrant, Herod, toward his wife Mariam and her family. The play is skillful and subtle, with particular attention to Mariam's conflict as she tries to balance her wifely obedience with her personal convictions. Both Mariam and her nemesis, Herod's sister Salome, are complex and defiant characters, with the other principal female, the dutiful and virtuous Graphina, a soft foil for their hard intelligence. While Salome uses sex and subversion to accomplish her ends, however, Mariam's defiance is entirely verbal, and she remains chaste and honest. Her chastity does not save her, but, in the terms of the time, it confirms her martyrdom, even as she recognizes that her determination to speak back to her tyrannous husband, a lack of proper "humility," has contributed to her fall:

> . . . I thought, and yet but truly thought,
> That Herod's love could not from me be drawn.
> But now, though out of time, I plainly see
> It could be drawn; though never drawn from me
> Had I but with humility been graced,
> As well as fair, I might have proved me wise.
> But I did think because I knew me chaste,
> One virtue for a woman might suffice.
> . . . but 'tis my joy
> That I was ever innocent, though sour,
> And therefore can they but my life destroy;
> My soul is free from adversary's power.

By the 1620s Cary's conversion and defiance went against the tone of the country and its new patriarchal social structure, although it comported, to some extent, with the fashionable Catholicism of Queen Henrietta Maria's

court. Those tensions, between court and popular Protestant culture, form part of the backdrop of the English civil wars.

WOMEN IN PRINT 1650–88

The seventeenth century was a tumultuous time in England, centered by civil wars (1642–49) that were occasioned by disputes between the monarch, Charles I, and his contentious parliament. While there were many reasons for the conflict, Protestant suspicion of Charles's Catholic Queen, Henrietta Maria, was one of them. The frequent court **masques** that celebrated royal love and virtue often included the queen dressed as a heroic or Amazon figure, adding to the fear engendered by her religion. Whatever the causes, by 1646 Charles was completely defeated and parliament had negotiated a larger role for itself in a revised monarchy. His intransigence and parliament's zeal led to the king's execution in 1649, introducing a Commonwealth government, soon controlled by the successful parliamentary general, Oliver Cromwell.

During this difficult period, families were often divided between royalists and followers of the parliamentary cause. Women faced new choices and responsibilities, as they played active roles on both sides of the conflict. Elizabeth Lilburne petitioned publicly for the freedom of her radical Protestant husband, John, for example, while Margaret Cavendish, then Countess of Newcastle, traveled back to England to look after her exiled royalist husband's interests. Other women on both sides of the war ran husbandless households and built barricades to protect their property. Everything was dangerous, but anything seemed possible to a resourceful woman.

Two years after Cromwell's death in 1658, Charles II was crowned king, beginning in 1660 a period known as the Restoration (i.e., of the monarchy). Charles II's reign marked a new era of intellectual and moral tolerance and magnificent display. As much as his grandfather had preferred the presence of men, Charles II enjoyed women and had a distinguished list of mistresses, some of them influential at court. Women appeared on stage for the first time (the famous actress, Nell Gwyn, became one of Charles's mistresses). The more dour aspects of evangelical Reformation Protestantism were at bay.

The watershed events of the civil wars, Commonwealth, and Restoration were accompanied by the developing presence of women in print. Certainly print, in general, played a large part in later seventeenth-century history. The civil wars were fought with words as well as weapons; pamphleteering reached new heights, as loyalists and parliamentarians jockeyed for public opinion.

Katherine Philips (1632–64), a poet and playwright, developed and carried on a coterie audience despite the tensions of the time, producing work radical for its gender dynamics. Puritan poet Anne Bradstreet (1612–72) and her family left Charles I's England in 1630, taking their convictions across the Atlantic to help found a new society, from which she sent her poems to

be published in London in 1650. Margaret Cavendish, Duchess of Newcastle (1623–73), autobiographer and biographer of her royalist husband, autodidact intellectual of philosophy and science, poet, and playwright, lived the drama of royalist exile and return and sought public fame in the classical mode. Aphra Behn (ca. 1640–89), playwright, novelist, and poet, took advantage of the new license offered during the relaxed morals of the Restoration to become, famously, the first woman to earn her living as a writer. By their willingness to seek print and their visibility as writers, these women made literary feminism a fact of English-speaking culture. Their accomplishments were periodically degraded or ignored by subsequent generations, but they were never fully lost. Their visibility became the foundation on which later women writers fought the social and cultural battles that yet remained.

Katherine Philips brought coterie publication into print and became the first great poet of female friendship. Her poetic name for herself was "Orinda," and she became to her admiring contemporaries "the matchless Orinda." Her earliest known poetry, written at the age of 15, consists of verses addressed to a female friend concerning the dangers of marriage. Although only a few poems were published with her formal consent during her lifetime, Philips was well known for her manuscript poems, based on the Aristotelian ideals of friendship as love derived from equally shared virtues. These ideas were often associated with the royalist "cavalier poets," followers of Charles I who espoused tranditional masculine values. Her poems on friendship, by contrast, were addressed mostly to women (and a few men), and their terms suggest a deep affection.

Philips's first serious "Platonic friend" was her schoolmate, Mary Aubrey, "Rosania" in Philips' poetic world, to whom she exclaimed in "L'Amitie" 1651:

> Soul of my soul! My joy, my crown, my friend!
> A name which all the rest doth comprehend.
> How happy are we now, whose souls are grown,
> By an incomparable mixture, One!

Aubrey was followed by Anne Owen, "Lucasia," to whom Philips wrote "upon receiving the name of Lucasia, and adoption into our society, 29 Decemb 1651":

> We are complete; and fate hath now
> No greater blessing to bestow:
> Nay, the dull World must now confess
> We have all worth, all happiness.

Poems such as these both acknowledge and help to create a network of female friendship bound by common values and strong affection. In language and forms borrowed from seventeenth-century love poetry, particularly John Donne's *Songs and Sonnets* (1633), Philips celebrates chaste love that reflects divine mysteries and extends beyond death.

Her principal male friend was Charles Cotterell, master of ceremonies to the court of Charles II, who, as "Poliarchus," became part of her coterie of friendship and her literary advisor. With his and others' encouragement, Philips translated "The Death of Pompey" by the French playwright Corneille, which was presented at Dublin's Smock Alley Theatre in February 1663. She thus became the first women to have her words performed on a British stage. Also in 1663 she became the first named woman poet to appear in an anthology, *Poems, by Several Persons*. She claimed these poems had been "stolen," but she did not seem to mind their appearance in print. Philips had nearly completed a second Corneille translation, *Horace*, when she died in June 1664. In 1667 the publisher Henry Herringman brought out a folio of her works, probably edited by Charles Cotterell, which includes corrected and additional poems from the 1664 volume as well as both plays.

Katherine Philips was the first English woman writer to establish a widespread literary reputation during her lifetime, one that has been sustained, virtually without interruption, by subsequent generations. She was admired by her male contemporaries, Henry Vaughan and John Dryden, and featured in eighteenth- and nineteenth-century anthologies of women poets. She made the successful transition from a poet writing in manuscript for and to a coterie audience to a poet publishing first a few poems, then planning her own correction and expansion of an unauthorized edition. Although she expressed public dismay at the publication of her poems in early 1664, it is just possible that she conspired with the publisher to have them printed. Even if she did not, she finally accepted and embraced the move to print. Her 1667 folio, featuring as it does so many poems on female friendship as well as poems that address events of her time, remains one of the most important volumes in the history of literary feminism.

Anne Bradstreet, from the remote and difficult world of early New England, parallels Philips's accomplishment and even precedes her publication. She was born Anne Dudley in Northampton, England, around 1612, the daughter of Thomas Dudley, Steward to the Earl of Lincoln and reportedly a voracious reader, and Dorothy Yorke. Anne reaped the benefit of her father's love of books, since he apparently taught her Latin at an early age and gave her access to the standard classical writers in the Earl's famous library (including Virgil, Livy, Pliny, Ovid, and Seneca) as well as popular English writers such as Sidney, Spenser, Sir Walter Ralegh (whose *History of the World*, 1614, was admired by radical thinkers), and Joshua Sylvester's translation of Guillaume du Bartas's *Divine Weeks and Works*. These last two provided clear models for Bradstreet's serious verse, as they did for Milton's *Paradise Lost*.

The Tenth Muse Lately Sprung Up in America (1650) was published in London through the agency of Bradstreet's brother-in-law, John Woodbridge, who tells its readers that the "gentlewoman" author is "honored and esteemed where she lives," and her poems "are the fruit but of some few hours curtailed from sleep and other refreshments." He thus assures readers that the author is a chaste housewife who would not take time from her household duties for so unusual a task as writing poetry. The book was immedi-

ately popular, with William London listing it among *The Most Vendible Books in England* (1658). Its second edition, *Several Poems Compiled with Great Variety of Wit and Learning* (1678), made it one of the earliest works of poetry published in America. Her poems have remained a staple of American anthologies since the eighteenth century, although until recently her poems to her husband and children received the most attention, probably because they satisfied the general expectation of where a woman's concerns should lie. Among these are some poignant expressions of a woman's sense of mortality, as in "Before the Birth of One of Her Children," addressed to her husband:

> All things within this fading world hath end,
> Adversity doth still our joys attend;
> No ties so strong, no friends so clear and sweet,
> But with death's parting blow is sure to meet.
>
> . . .
>
> How soon, my dear, death may my steps attend,
> How soon may't be thy lot to lose thy friend,
> We both are ignorant, yet love bids me
> These farewell lines to recommend to thee,
> That when that knot's untied that made us one,
> I may seem thine, who in effect am none.

Her "quaternion" poems, with which she chose to begin *The Tenth Muse*, however, are something quite different. These are four long poems on "The Four Elements" (earth, air, water, and fire), "The Four Humors of Man" (sanguine, choleric, melancholic, and phlegmatic), "The Four Ages of Man," and "The Four Seasons." Poems on "The Four Monarchies" (Assyrian, Persian, Greek, and Roman) follow the quaternions, taking her interest in the structure of the world into the structure of history. Written in heroic couplets, these five sets of poems have epic scope and suggest comparisons with Milton as well as with Bradstreet's English female contemporaries Lucy Hutchinson, who wrote a long poem on the creation, and Margaret Cavendish. All four poets shared the mid-seventeenth-century desire to rethink the relation of humanity to the universe, as the Copernican revolution and Francis Bacon's popularizing of the scientific method finally took hold. Bradstreet's cosmographies and anatomies are largely medieval, however, which may reflect her remoteness from England during the development of the new science.

Bradstreet is America's first literary feminist as she deals with her role as a woman author. She appears to accede to masculine superiority in "The Prologue," but her tone is playful and even ironic as she asks for a "thyme or parsley wreath," cooking herbs replacing the traditional crown of (male) poets, the laurel wreath. In what is now among her most famous poems, "In

Honor of that High and Mighty Princess Queen Elizabeth of Happy Memory," she attacks the common assumption of female intellectual inferiority with a witty reminder of Elizabeth's power:

> Nay, masculines, you have thus taxed us long,
> But she, though dead, will vindicate our wrong.
> Let such as say our sex is void of reason
> Know 'tis a slander now, but once was treason.

Later in the same poem she claims that Elizabeth "has wiped off the aspersion to her sex/That women wisdom lack to play the rex [king]." Bradstreet's radical temperment, combined with her domestic life, make her a compelling icon of New England's gradual drift away from the old, an experience that she codifies in her "Dialogue between Old England and New." Mostly a lament for the religious disagreements and civil wars that have plagued Old England, the poem provides a sympathetic perspective on mid-century England from someone who is learning to let go of her native land.

Very different was Margaret Cavendish, who, as Countess and then Duchess of Newcastle, rose through marriage to the highest social position next to royalty itself. She endured years of life away from England in Europe, but was able to return, at last, and help reestablish her husband's wealth and reputation, in part through her writings. Her prolific publication set new standards (and new targets) for women's writings, yet she always regretted her lack of a formal education.

More than any woman writer before her, Cavendish openly and actively sought fame. Between 1653, when she published her first volume of poetry during a visit to England, and her death in 1673, she published 14 separate works in a total of 22 editions. Most of these publications were folios, the largest and most expensive books of the time. They are accompanied by her own prefaces (usually more than one) and poems or comments from others, especially her husband, William, who had been made a duke during the Restoration. Without question, the Duke's authorization and his high rank gave Cavendish permission for self-display that other woman writers could not command. Whatever the cultural expectations about proper gender behavior, Margaret believed that her honesty and virtue, which she often asserted, were sufficient to legitimize her work. "Honesty," like virtue, carried a traditional meaning of chastity, but also the more modern meaning of sincere pursuit of truth. In that pursuit she published poems, plays, essays, philosophical treatises, an autobiography, a biography of her husband (until recently, her only work to receive consistent praise), fictionalized "Sociable Letters" from one lady to another on a series of topics large and small, and the first science fiction **novella** in English, *Blazing World*.

The "Letters" include intelligent commentary on Shakespeare's plays as well as more traditional female concerns, such as fashion and the dangers of marriage. This last is a major topic in her plays as well. In *Convent of Pleasure*, for example, Lady Happy decides to reject marriage in favor of creat-

ing a female convent of intellectual and social pleasure. Here the lady and her women friends watch entertainments that underscore the dangers of marriage, and Lady Happy finds herself passionately drawn to a visiting "Princess." The princess turns out to be a prince, and the play ends ambiguously with his declaration and capture of Lady Happy's hand in marriage and her silence.

Blazing World is the story of a beautiful young woman who is kidnapped by pirates, endures passage through an icy polar region (which kills off her captors), and emerges into another world. There she enchants the admiring inhabitants (including such creatures as bear-men and bird-men, along with the more usual sort) and totally charms the emperor. He not only marries her instantly but also gives her absolute rule over his realm. This allows her to enact policies, create a religion, and debate science with the wisest in the Blazing World. The (now) empress and a character named the Duchess of Newcastle also join to save the empress's lands and enjoy a Platonic sharing of a single body where they have excellent conversations until it is time for the duchess to return home to her duke.

The Duchess of Newcastle was a fascination and a scandal in her own time. Dorothy Osborne, in a letter to her future husband, William Temple, proclaimed herself shocked that Cavendish would publish her poems: "sure, the poor woman is a little distracted [crazy], she could never be so ridiculous else as to venture at writing books, and in verse, too." There may have been some envy in Osborne's conventional stance; she was a prolific writer herself but was determined to keep her writing within the private world of letters. The diarist Samuel Pepys was equally fascinated by the duchess of Newcastle, known for her unique fashion displays and eccentric interests in, for example, the new scientific investigations that developed into the Royal Academy, chartered in 1662. Like others in Cavendish's London, Pepys enjoyed pursuing her coach when it appeared on the streets, since the fashion and feathers and colorful display of duchess, attendents, coach, and horses made a great show.

The Duchess of Newcastle is a major figure, describing in her own prefaces the complexity of her position. She bemoans women's lack of education, to which she usually attributes their inferior position. She wants the applause of the scholarly community (she sent copies of her books to the Oxford and Cambridge colleges) but she does not expect to get it (she didn't, except in the suspect praise of sycophants hoping for the duke's **patronage**). She claims, then, to speak to the future, not the present. But even Virginia Woolf was to describe her writing as "a vision of loneliness and riot . . . as if some giant cucumber had spread itself over all the roses and carnations in the garden and choked them to death." Only recently have critics stepped back from this scornful history and begun to read what she wrote. The result is surprised admiration for the enormous range, wit, and inventiveness of a vast and questioning mind. Her writing is not formally neat, but it is richly imaginative.

Blazing World has now become a staple of seventeenth-century English literature. *The Convent of Pleasure* has now had its first of several—and re-

markably successful—performances. Her "Sociable Letters" have recently received a wide audience, although Charles Lamb, the essayist, was a fan of the "Letters" as far back as the early nineteenth century. Her exploration of gender, her fascination with "singularity" and originality, her shameless self-promotion, and the variety and complexity of her work make her a rich and fascinating precursor of a more modern literary feminism.

Aphra Behn knew and admired the work of Katherine Philips and Margaret Cavendish, and from this developing tradition produced a body of work that ranks as high as or higher than that of any other English Restoration writer, with the exceptions of Milton and Dryden. She was not only the first woman to make her living as a writer but also the first to be acknowledged as a professional playwright in virtually the same terms as her male contemporaries. In addition, she is one of the most important founders of the novel, with her sensitive portrayal of new world slavery, *Oroonoko*, preceding Daniel Defoe's travel adventure, *Robinson Crusoe*, by two generations, and her story of an elopement between a man and his sister-in-law, *Loveletters between a Nobleman and His Sister*, preceding the eighteenth-century epistolary novel by three generations. *Oroonoko* is the story of an African prince betrayed by a jealous relative into slavery and his beautiful wife whom he rediscovers, also enslaved, in the new world. Oroonoko's rebellion and tragic death brought a fully human dimension to the scandal of slavery.

We know almost nothing about Behn's early years, although tradition has it that she was the "Eaffrey" Johnson born in Canterbury in 1640 to a tradesman who became an innkeeper. This birth would not explain what seems to have been a good education, in English and French if not in Latin. She almost certainly spent some time in Surinam, the setting for *Oroonoko*, since the novel describes people and details that would be difficult to include without firsthand knowledge. If the novel includes biographical fact, then she and her mother and brother accompanied her father to the West Indies around 1663, and, when he died on the way, stopped over in Surinam to await passage home. Presumably she married Mr. Behn, possibly a Dutch merchant who died in the plague of 1665, around 1663. In 1666 she appears on the public record as a spy for Charles II in the low countries, where she was particularly to keep track of William Scot, a republican sympathizer in Antwerp. Letters in which she sought payment from the crown for these services survive, although she seems not to have received it; by 1668 she was in serious enough debt to be arrested, although there is no evidence that she actually served time in debtor's prison.

Her public career as a writer began with the production of *The Forced Marriage* at Duke's Theatre in September 1670. The play was successful enough to provide Behn with some income and to encourage her to publish the play in early 1671. She followed it with *The Amorous Prince*, also a success, and *The Dutch Lover*, a failure. She nonetheless continued writing plays, some of them very successful (such as *The Rover*, 1677, based on a longer play by her friend Thomas Killigrew). She shifted to publishing primarily fiction and poetry after 1682, when the king's illegitimate son, the Duke of Monmouth, objected to an epilogue she had written for someone else's play. She pub-

lished *Love Letters between a Nobleman and His Sister*, which was based on the actual elopement of Ford Lord Grey and his sister-in-law, Henrietta Berkeley, in three installments in the mid-1680s, and at the same time she put together a collection of her poems, published with a loose translation from a French author: *Poems on Several Occasions with a Voyage to the Island of Love.* In 1685 she also joined many fellow writers in producing elegies on the death of Charles II and celebrations of the accession of James II. In 1688 she published *Oroonoko* and another novel, *The Fair Jilt*, and continued to work and publish until her death a year later.

Aphra Behn did not make a very good living as a writer. As late as 1685 she complained to one of her publishers, Jacob Tonson, that "I have been without getting for so long that I am just on the point of breaking," and in her last years she wrote a number of celebratory poems to the great, undoubtedly in hopes of finding a patron. But she did make a living using the same techniques, venues, and publishers as her male counterparts (although she apparently offended Tonson, who was to become one of the most influential publishers of the early eighteenth century; he published nothing of hers after *Poems on Several Occasions*).

Behn not only wrote for the stage but was also able to write for actresses as well as actors, since women were allowed to perform for the first time only after the Restoration. The boy actors who played women in earlier times allowed for much of the wit about gender and the fascination with cross-dressing that we find, for example, in Shakespeare's characters in *As You Like It* and *Twelfth Night*. Yet that fascination with gender continued, even with women actors, producing in Behn and some of her contemporaries a witty examination of such things as the double standard and the morality of Puritan patriarchy. Behn's popular work expresses the tension between parliament and crown, and her career embodies it. She would shortly be reviled as obscene and unladylike as the eighteenth century sought to recover from the excesses of the Restoration, but she would remain the first enduring female professional writer.

However we define it, literary feminism in England had no steady progress. From the outspoken communities of women in the early Reformation to the scandalous popularity of Behn is not a single line but a series of publishing events in the face of open hostility and sometimes very real danger. Anne Askew was destined to be burned at the stake, yet she wrote her own account of her examinations and made sure they were smuggled out of England to be published. Anne Lock went into exile, then came back and wrote in support of radical Protestantism. The reign of Queen Elizabeth empowered the Countess of Pembroke and Aemilia Lanyer, but gave way to the misogyny of James I. Elizabeth Cary defied her husband and sons in order to assert her Catholicism. Lady Mary Wroth had her brilliant and ambitious long prose romance suppressed. Katherine Philips and Anne Bradstreet made poetry respectable for women, even as the Duchess of Newcastle and Aphra Behn, each more prolific and arguably more successful, made it scandalous again. What emerges, through it all, is the desire to be heard, and heard as women, despite the man's world.

2

Eighteenth-Century Triumphs: 1700–80

T
he eighteenth century saw both triumphs and setbacks for literary feminism. By the end of the century, it appeared that women writers, especially women poets, had become and would remain successful members of the English literary establishment. While in the first decade only two women published collections of their verse, more than 30 did so in the 1790s (Lonsdale xxi). In addition, women wrote and published plays, histories, and essays. The novel emerged during this century, and women exploited the genre's reliance on domestic realism and feminine literary forms, such as the personal letter and memoir. By the 1750s, Samuel Johnson noted "the revolution of the years has now produced a generation of Amazons of the pen, who . . . have set masculine tyranny at defiance" (*Adventurer*, 11 December 1753).

Conditions during the period were right for producing successful and productive literary women. The eighteenth century brought commercial growth, the rise of the middle class, and the professionalism of writing. Transformations in politics and culture led to increased emphasis on equality and tolerance by century's end as European ideals of the Enlightenment prevailed. In the "age of reason," England developed a secularized parliamentary government and witnessed the emergence of two distinct political parties, the Whigs and the Tories. Puritan dissenters emphasized individual conscience over the dictates of the church and, as the earliest settlers in America, sought to establish a morally regulated community that would serve as a model for the rest of the world.

Challenges to religious orthodoxy by secular thought begun in the late seventeenth century culminated in the eighteenth. The Royal Society of London for the Improving of Natural Knowledge, founded in 1662, endorsed the scientific movement initiated by Sir Francis Bacon and supported additional advances in the physical sciences. Sir Isaac Newton advanced a new model of the universe in his *Principia Mathematica* (1687), envisioning it as a mechanism operating by a rational formula. Deists similarly argued that the natural world itself provided evidence of a creator, that the Book of Nature was God's true revelation.

Philosophical skepticism and materialism rationalized morality. John Locke wrote "morality is capable of demonstration, as well as mathematics." In *Treatises of Civil Government* (1690), he contended that governments are not divinely ordained but creations of men. His ideas were echoed by

American thinkers later in the following century during America's fight for independence from Britain in 1775 to 1781.

The period's emphasis on reason directly influenced literature. Writers reacted against what they perceived as the intricacy and obscurity of Renaissance in favor of greater simplicity, clarity, restraint, regularity, good sense, and "mathematical plainness" in writing.

The literature of the period was also designed, in part, to appeal to an enlarged reading public. The move from a rural to an industrial economy led to the growth of populations in cities in Britain and in North America. In 1700, approximately 250,000 settlers resided in British North America; by 1800, the number had increased to 5 million. Large urban centers on both sides of the Atlantic led to the creation of first daily newspapers, *The Daily Courant* (1702) in England and the *News-Letter* (1704) in Boston, as well as periodicals such as *The Spectator* and *The Gentleman's Magazine*.

As a result, publishing became for the first time a successful economic enterprise. The rise of publishing houses eroded the patronage system and opened the profession of writing to previously marginalized groups, including women. Writing became a respectable means of earning an income, and many women wrote to supplement or substitute for the earnings of husbands and fathers. The rise of the novel further benefited women, who, as readers and writers, popularized the form. Not until the end of the century, however, were women able in sizable numbers to challenge persistent notions of the incompatibility of femininity and writing. Periodicals were not only vehicles for women writers but also a forum for masculine opinion, sometimes used to challenge and thus shape women's literary production. In fact, much of the complexity accompanying the rise of women's writing in the eighteenth century stems from old fears of assertive, nondomestic women combined with renewed charges of immorality among women writers.

EDUCATION FOR WOMEN

At the end of the seventeenth century the situation looked promising. Bathsua Makin advocated women's education in her *Essay to Revive the Ancient Education of Gentlewomen* (1673), dedicated to the future Queen Mary II. Her essay argues that educating women produces wives who are less interested in trivialities and more useful to their husbands, standard arguments that were later adopted by Mary Wollstonecraft in *A Vindication of the Rights of Women* (1792) and that would recur for the next 200 years. Makin further asserts women's innate intellectual equality with men: "Seeing nature produces women of such excellent parts, that they do often equalize, sometimes excel, men, in whatever they attempt, what reason can be given why they should not be improved?"

In 1697 appeared the first two works advocating women's political and social equality, Mary Astell's *A Serious Proposal to the Ladies* and the anonymous *Essay in Defense of the Female Sex*. Astell proposed creating an institution, a retreat from worldly temptations where women would be free to pur-

sue good works while establishing a "great and dear affection to each other" and educating themselves: "One great end of this institution shall be, to expel that cloud of ignorance which custom has involved us in, to furnish our minds with a stock of solid and useful knowledge, that the souls of women may no longer be the only unadorned and neglected things." Astell, in keeping with the temper of the new age, offers a reasoned, utilitarian argument. Women shall "busy themselves in a serious inquiry after necessary and perfective truths, something which it concerns them to know, and which tends to their real interest and perfection." Women will learn not merely "words but things," eschewing study of languages in favor of understanding and digesting a few well chosen and good books. As a result, education will render women "more agreeable and useful in company." In defense of her "startling" and "unfashionable" suggestion, Astell bolsters her reasoned claims with religious argument, asking "since God has given women as well as men intelligent souls, why should they be forbidden to improve them? Since he has not denied in us the faculty of thinking, why should we not (at least in gratitude to him) employ our thoughts on himself their noblest object, and not unworthily bestow them on trifles and gaieties and secular affairs?" Anticipating a negative reaction from men, Astell assures them that women will not "usurp authority where it is not allowed them" but use their education to "understand [their] own duty."

THE "FEMALE WITS"

Women writers, including Katherine Philips, were recommended by Astell to "excite the emulation of English ladies." At the turn of the century, women were writing and publishing at an increased pace. Several women, including Catharine Trotter, Mary Pix, and Delarivière Manley, had their plays produced in London. Trotter, who began writing for publication at the age of 14, published five successful plays, including *Agnes de Castro* (1696), based on a French short story translated by Aphra Behn. She also wrote on religion and philosophy, publishing *A Defence of Mr. Locke's Essay on Human Understanding* in 1702. Her contemporary Mary Pix produced six comedies and seven tragedies between 1696 and 1706. In the prologues to her most popular tragedy, *Ibrahim, the Thirteenth Emperour of the Turks* (1696), Pix entreated ladies to "produce one harmless, modest play." Delarivière Manley's wrote her first play, *The Lost Lover; or, the Jealous Husband*, in the same year, and produced three more before turning her attention to prose fiction.

In 1700, the three women contributed to *The Nine Muses*, an anthology of poems by women published on the death of John Dryden, the Poet Laureate. During the final years of the Stuart monarchs (1688–1709) and the first years of the Hanoverian kings (George I, 1709–27, and his grandson George II, 1727–60), it seemed that literary women were becoming part of the cultural establishment.

Yet Trotter, Manley, and Pix were objects of satire in *The Female Wits* performed at Drury Lane in 1696, suggesting that their remarkable debut year

caused some anxiety about female authorship. Manley, in particular, became the focus of negative attention, and in the preface to her second play rather disingenuously admitted, "Writing for the Stage is no proper Way for a Woman, to whom all Advantages but mere Nature are refused." Clearly, she had no real desire to abandon her pen. She turned to journalism, creating *The Female Tatler*, and is credited with two scandalous chronicles, *The Secret History of Queen Zarah* (1705) and *Secret Memoirs and Manners of Several Persons of Quality, of Both Sexes from the New Atalantis, an Island in the Mediterranean* (1709), thinly veiled attacks on Whig politicians and supporters.

The *New Atalantis* was a popular success (seven editions appeared by 1736) and established both Manley's notoriety and influence. In Alexander Pope's *The Rape of the Lock* (1714), one character boasts that his fame will endure "as long as Atalantis shall be read." Manley's satire anticipated the novel in its attention to familiar details of life. While purportedly based on the works of unknown Italian and French authors, the *New Atalantis* was in fact based on gossip and rumors about well-known members of the Whig party. Hiding behind a thin veneer of "history" and allegory, Manley savages her contemporaries. The goddess Intelligence, leads Astrea, the goddess of Justice, on a tour of Atalantis to provide her with knowledge of earthly corruption so that she may return to the moon to educate the prince about proper behavior. Manley casts Whig corruption as sexual violation in repeated scenes of seduction and rape. The most salacious (and hence sensational) sections feature orgies, incest, and homosexual encounters.

Critics credit Manley's influence on both male and female authors of the period. Daniel Defoe, who published his famous novels *Robinson Crusoe* (1719) and *Moll Flanders* (1722) a decade later, first experimented with his own "secret histories," including the *Atalantis Major* (1710). More successful imitators included Eliza Haywood, who mocked the Hanoverian court in two satires of her own. Manley's emphasis on the threats to female innocence became a staple of the novel developed in the 1740s, from the works of Samuel Richardson to those of Tobias Smollett. Even Henry Fielding grudgingly acknowledged the "modern Novel and Atalantis Writers" in *Joseph Andrews* (1742).

As there were precedents and successes, so were there setbacks. The history of literary feminism is by no means a story of relentless progress, but of accomplishments followed by denial or obscurity. Aphra Behn's great achievements were scorned and shunned in the eighteenth century, her effective catering to the lewd taste of Restoration theater interpreted as personal immorality. A similar fate befell Manley. Following her death, her works were reviled as sensationally erotic and her reputation as a writer plummeted.

VIRTUE, FEMININITY, AND FEMALE AUTHORSHIP

As a result, many women writers sought to establish themselves as virtuous women and allied themselves more with predecessors such as Katherine Philips than with Behn. Poet Anne Finch, Countess of Winchelsea

(1661–1720) was the most famous in her own time and the most influential after it (poets as diverse as Alexander Pope and Percy Bysshe Shelley admired her work). Her poems had appeared in anthologies and had circulated in manuscript at the court of James II, where she had served as a lady-in-waiting to his second wife, Queen Mary of Modena, prior to the "bloodless revolution" of 1688. In 1713, however, she published her *Miscellany Poems, On Several Occasions*, which showed her debt to Philips (she used one of the minor names from Philips's friendship circle, "Ardelia," as her own poetic sobriquet) and asserted her own poetic power. She does so, however, at times while acknowledging the "presumptuousness" of such an act. In "The Introduction," she anticipates the public's censure:

> Alas! a woman that attempts the pen
> Such an intruder on the rights of men,
> Such a presumptuous creature is esteemed,
> The fault can by no virtue be redeemed.

Finch counters, "Sure 'twas not ever thus," but still warns her Muse to be "retired" and—"aiming to be admired"—to sing with "contracted wing." In her response to Pope's infamous suggestion in the *Rape of the Lock* that women's spleen or discontent causes them to "scribble plays" and succumb to "poetic fits[s]," Finch is far from constrained. She claims that women "rule the world our life's whole race,/Men but assume that right" and offers Orpheus as an example of how men's "scoffing rhymes" lead to their own punishment.

Two of the most successful early eighteenth-century writers, Lady Mary Wortley Montagu (1689–1762) and Eliza Haywood (ca. 1690–1756), were not as skilled as Finch in walking the fine line between candor and decorum. Montagu started with many privileges and great promise of becoming the first women fully embraced by the establishment press. Not only was she born to the nobility, but she also married (for love) a husband who was to have a largely successful career as a member of parliament, diplomat, and businessman. He was a friend of the two most influential early periodicalists, Joseph Addison and Richard Steele, and in 1713 Montagu contributed an essay to their *Spectator*. She knew and corresponded with Alexander Pope, wrote poems with John Gay, traveled through Europe to Turkey for her husband's embassage there, suffered from smallpox and became an early advocate of the new and still daring process of inoculation, conversed with Mary Astell and Voltaire, advised the poet Edward Young, and acted as a patron to her second cousin, Henry Fielding, as he began his literary career. Although she pretended to resist publication (the aristocratic scorn of print took a long time to die), her poems and essays found their way to periodicals and anthologies, and she allowed Horace Walpole to publish a collection of her poems in 1747.

In Montagu's "The Lover: A Ballad" (1747) a female speaker boldly lists the qualities she is seeking in a man, from his appearance to his social behavior to his intelligence. Repeatedly the poem asserts equality within rela-

tionships. The lover "would value his pleasure, contribute to mine." The speaker asserts her high standards and vows to remain chaste until she finds the "astonishing creature" who can measure up to them, a prospect that seems far from likely. A far more assertive female speaker can be found in "Epistle from Mrs. Yonge to Her Husband," composed in 1724 but not published until the 1970s. Montagu imagines the response of Mary Yonge to her adulterous husband, William, who having discovered that she had also committed adultery sued her lover for damages and petitioned for divorce. In Montagu's poem, the outraged Mrs. Yonge castigates her husband for his hypocrisy and lambasts the institution of marriage, which enslaves women. Arguing that "too, too severely laws of honor bind/The weak submissive sex of womankind," she justifies her affair on the basis of women's equality to men:

> Are we not formed with passions like your own?
> Nature with equal fire our souls endued,
> Our minds as haughty, and as warm our blood;
> O'er the wide world your pleasures you pursue,
> The change is justified by something new;
> But we must sigh in silence—and be true.

Defiant to the end, she claims that by his own "mean conduct, infamously loose," he is at once her "accuser and excuse." The poem's vitriolic female speaker and its contentious assertions of women's independence and equality would no doubt have raised questions during the early eighteenth century about the author's virtue and femininity.

Montagu's social standing, connections, and unquestionable skill made her an important figure in the literary world of the first half of the eighteenth century. At the same time, literary quarrels, aristocratic arrogance, and personal passion all devoured her ability to stand as the model for the new woman writer. She was admired and scorned in equal measure. By mid-century, she was long estranged from her husband and from Pope, who attacked her in the *Dunciad* (1729) and cast her in *Epistle II: To a Lady* (1735) as a "dirty" and "greasy" Sappho.

Haywood had none of Montagu's advantages and therefore is, in many ways, a more substantial representative of early eighteenth-century literary feminism. Like Aphra Behn, Haywood earned her living (somewhat precariously) by her pen, writing plays, poems, essays, and novels. Also like Behn, her life is a mystery. As a professional woman writer, she was apparently so much of a target in the notorious literary battles of the period that she conspired to keep the details of her life from becoming known (Spacks ix–x). Pope attacked her several times, accusing her of promiscuity, even depicting her children as illegitimate in his *Dunciad* (II.158), and Swift called her a "stupid, infamous woman."

Haywood was a successful and much-reprinted novelist from the first of her many fanciful romances, *Love in Excess* (1719), to the domestic novels

that followed the popularity of Samuel Richardson's *Pamela* (1740), such as *Betsy Thoughtless* (1751). She produced more than 60 works of fiction during a career that lasted over three decades. So popular were her novels that Henry Fielding dubbed her "Mrs. Novel." All her stories are concerned with the dangers and limitations of female experience, topics that receive their fullest expression in her remarkable periodical, *The Female Spectator* (1744–46). Her title quotes that of Addison and Steele's earlier periodical and takes advantage of the fashion for chattiness and literary variety offered by the format. She advertises her own vast range of experience and acquaintance to establish her authority as a dispenser of advice for women and adds three other fictive voices to the construction of her own: a happily married woman, a wise widow, and a virtuous maid—the three official roles for women in early modern and eighteenth-century society. While the essays show enormous concern for the situation of women in society, the advice they dispense is practical rather than theoretical. Given the limitation on women's education and position, how does one deal with arranged marriages, unfaithful husbands, and the demands of family and society? The original female advice columnists, Haywood's four voices are often called upon to reply to letters from the readership, ladies who preface their questions and comments with such appreciations as: "permit me to thank you for the kind and generous task you have undertaken in endeavoring to improve the minds and manners of our unthinking sex."

Haywood, although popular and devoted to the plight of women, was no lady. Although a lady, Montagu was no more a model for the increasingly severe morality of the eighteenth century than was Haywood. Women who were able to negotiate the eighteenth-century literary scene felt increasingly the need to assert their personal virtue, which both allowed their entry into the culture of intellectual men and women and also limited what they could write and approve. Poets such as Elizabeth Singer Rowe (1674–1737), for instance, established reputations based on devotional literature, participating in the conservative tradition of Christian verse. The members of what became known as the "bluestocking circle," however, were intent on establishing the respectability of women writers working outside such traditional confines.

THE BLUESTOCKING CIRCLE

The term "**bluestocking**," which came to be synonymous with women scholars and writers, originally referred to men. Elizabeth Montagu (1720–1800) first used the term in 1756 to refer to Benjamin Stillingfleet, a scholar and botanist who wore blue, not white, stockings to gatherings at a time when blue hose were associated with the working class. It was later used by Montagu and her friends in the 1760s to refer to male intellectuals who supported women in developing their own abilities (Myers 7). The men and women who belonged to the bluestocking circle engaged in conversation and correspondence, developing a supportive network that granted respectability

to women's efforts to write, study, and publish. Eventually the term acquired a derogatory connotation and was used only in reference to women to ridicule those who defied traditional expectations by taking a public role in intellectual life. Such a transformation is another reminder of the complex and shifting response to women writers during the eighteenth century.

The original female members of the "bluestocking circle"–Elizabeth Carter (1717–1806), Catherine Talbot, Hester Mulso Chapone (1727–1801), and Elizabeth Montagu—sought to combine learning and feminine virtue. As such they considered Lady Mary Wortley Montagu a negative model and, apart from the works of Katherine Philips, eschewed the study of their female precursors and sought their models in texts by famous male authors, from classical philosophers to Shakespeare. Elizabeth Carter is a good example of the success of this strategy.

A famous intellectual in her time, Carter began contributing to *Gentleman's Magazine* when she was only 17. She published translations from ancient and modern texts, became a good friend of Samuel Johnson, and enjoyed a network of writers of both sexes, the wealthier of whom became her patrons, the younger of whom (Hannah More, Joanna Baillie) she encouraged. Most notably, she was able to survive comfortably as a single woman, partly through inheritance but also through her publications and the patronage of wealthy friends. She produced elegant verse and, priding herself on her virtue and delicacy, offered an alternative, if constrained, model of the professional woman writer.

Carter's mastery of Greek and Latin classics won her the admiration of her contemporaries. One described her as "not only the most learned Woman of any age but one of the most learned Persons of that in which she lives." Samuel Richardson called her "our British Minerva." As a result, much of her verse celebrates the powers of the mind. In fact, Richardson incorporated her poem "Ode to Wisdom" in *Clarissa* (1747–48), unaware that the author was a woman. In it, the speaker asks Pallas Athena for gifts of the mind: "Each moral Beauty of the Heart/By studious Thought refin'd." Carter's translation, *Epictetus* (1758), caused a sensation. Audiences were stunned by the mere fact that a woman knew Greek. No wonder that her friend and fellow bluestocking, Hester Mulso Chapone, considered her the "nearest to perfection" of all human creatures.

Chapone had, in fact, contributed a prefatory ode to *Epictetus*. Like Carter, Chapone was skilled in languages, having taught herself French, Latin, and Italian. She, too, was acquainted with Johnson and contributed to his *Rambler*. A gifted poet—her poem "To Stella" appeared in Johnson's dictionary to illustrate the quatrain—Chapone is better known for having produced *Letters on the Improvement of the Mind: Addressed to a Young Lady* (1773), the most popular work of the first generation of bluestockings (Myers 231). Addressed to her niece and dedicated to fellow bluestocking Elizabeth Montagu, the book offers a program of self-education for young women. Its bold premise, however, is tempered by Chapone's piety and social conservatism. While women are advised to learn philosophy, science, and history, they are

also expected to display traditional feminine mastery of dancing and etiquette. A bestseller, the book went through 60 editions in Britain, America, and France by 1851. Like the other members of the bluestocking circle, Chapone managed to offer traditional images of women while advocating their intellectual independence. Women should not, for instance, succumb to vanity and sentimentality: "Remember, my dear, that our feelings were not given us for our ornament, but to spur us on to right actions." She also publicly disagreed with Richardson on the issue of a marriage. While Richardson contended that a daughter must marry her parents' choice of a husband, Chapone contended that she was free to refuse. She nonetheless emphasizes the daughter's duty to her parents, arguing that she must have her parents' consent to marry a man of her choosing.

Chapone had been encouraged to publish her letters by Elizabeth Montagu. Crowned the "Queen of the Bluestockings" by Samuel Johnson, Montagu acted as the center of bluestocking society, opening her house to Carter, Chapone, and other women as well as influential men such as Johnson, Richardson, Horace Walpole, and Sir Joshua Reynolds, who painted her portrait. While less prolific, perhaps, than some of her contemporaries, Montagu did firmly establish her intellectual reputation with the publication of *An Essay on the Writings and Genius of Shakespeare* (1769), in which she defended Shakespeare against Voltaire's criticism of the poet in his *Dictionnaire philosophe*. Originally published anonymously, the work was almost immediately revealed as hers, and she became recognized as a Shakespearean critic, with her work translated into French and Italian. A tireless correspondent, she valued female friendship and community above all. She was in favor of establishing a woman's college and made plans with her sister to open a home for unmarried women. She also supported women through patronage, assisting members of the "second generation" of the circle, such as Hannah More, as well as those outside it, including Anna Laetitia Barbauld. More's "The Bas Bleu, or Conversation" (1786) offered an insider's view of the social life of the famous circle.

WOMEN WRITERS AND THE RISE OF THE NOVEL

By that time, however, the term "bluestocking" was being applied derisively to women with intellectual and literary pretensions, especially those publishing in established genres of poetry and philosophical translation. The new novel form, however, provided women with a relatively untried genre, one that stressed the realities of domestic and social life and appealed to a growing audience of readers, which included women in larger numbers. In fact, women writers came to dominate the form. It has been estimated that women wrote between two-thirds and three-quarters of epistolary novels between 1760 and 1790 (Spencer 4). This may have been the case because the novel drew on the familiar letter, the diary, and the domestic conduct book—all forms of personal writing associated with women. With its emphasis on social realism, novel writing also was not predicated on a classi-

cal education. As a result, women, who had traditionally been denied such training in classical literature and philosophy, were no longer disadvantaged (Turner 15). The novel also drew on the mid-century's cult of **sentiment**, which valued emotional responsiveness and conspicuous displays of intense feeling, such as tears of pity at displays of suffering or expressions of awe at majestic works of art or nature. Since emotion had long been considered the province of women, female writers now had the opportunity to exploit what had once been taken as a sign of weakness.

Women's contributions to the rise of the novel can be traced to the beginning of the century, and even before. Manley's "secret histories," for example, provided the same glimpse into love and sexual relations that became the staple of the **novel of manners**, which offered detailed portraits of social life and conventions, often focused on richly drawn female characters. Autobiographies, memoirs, and diaries gave entrée to the lives of extraordinary as well as ordinary women. For instance, Sarah Kemble Knight's journal, published posthumously in 1825, recounted her travel by horseback from Boston to New York (1704–10). Composed midway between the arrival of the Pilgrims on the Mayflower (1620) and the outbreak of Revolutionary War (1775), Kemble's text gives readers great insight into colonial America. Her text borrowed from the picaresque to satirize the "primitive" practices of backwoodsmen and women. Like the Indian captivity narratives of Mary Rowlandson and others, Knight's journal served a dual function: It provided a firsthand description of a unfamiliar culture but also "domesticated" that culture by making it real for readers. Later in the century, British author Hester Salusbury Thrale Piozzi (1740–1821) would publish her own experiences and encounters with other literary figures, such as Johnson, from her journal, *Thraliana* (1778). Such texts gave insight into the human mind and the nuances of the self, an investigation that assumed fictional form in the novel.

While the indefatigable Eliza Haywood capitalized on the form in the 1720s, it was not until after 1740 that women produced novels in significant numbers (Turner 38). By that time, novels had become the staple of circulating or lending **libraries**. The first circulating library, founded in the 1740s in the corner of a London bookstore, enabled middle-class individuals, for whom book prices were still beyond reach, to borrow books for a small fee. At mid-century, novels in book form were expensive, roughly the equivalent of a whole pig or a pair of women's shoes (Turner 145). Reprint and secondhand editions lowered the cost, but the libraries offered a cheaper alternative and further popularized the novel by basing their trade on them. Novels also reached a wider audience through serial publication and the reviews and summaries that were featured in popular periodicals.

Female novelists, like women poets, faced the challenge of balancing perceptions of their role as producers of literature against conventional expectations of feminine behavior. They often succeeded by appealing to the predominantly female literary audience with sentimental stories about virtuous women brought down by either male oppressors or their own weaknesses.

Such tales had the advantage of making female virtue the contested terrain in accord with traditional views of female propriety while at the same time offering opportunities to present positive images of female independence and action. The most popular and respected novelists writing at mid-century—Sarah Fielding, Sarah Scott, Charlotte Lennox, and Frances Brooke—produced didactic novels stressing feminine morality while exploring women's potential for education, philanthropy, and love.

The novels of Sarah Fielding (1710–68) chart the changes in the form. Her first novel, *The Adventures of David Simple in Search of a Faithful Friend* (1744), published in two volumes, as was the habit of the day, presents a classic conflict between good and evil: The honest and trusting David Simple is pitted against his treacherous brother Daniel in a dispute over the family fortune. Once secure in the possession of his fortune, David travels in search of a friend, only to encounter a series of swindlers and cheats. Finally, David finds friendship with Valentine, Cynthia, and Camilla, whom he eventually marries. Her sequel, *The Adventures of David Simple. Volume the Last* (1753), presents a far more complex portrait, as David and his friends endure a series of tests. David concludes on this deathbed that happiness cannot be found "from an Attachment to Objects subject to Infirmities, Diseases, and to certain Death." Fielding thus moved away from abstract embodiments of good and evil to present more psychologically aware portraits of human capacities for deception and benevolence. As a result, Richardson would later claim that Fielding's "knowledge of the human heart" exceeded her brother's: "His was but the knowledge of the outside of a clockwork machine, while your's [*sic*] was that of all the finer springs and movements of the inside."

In her later novels, Fielding transferred her focus to the interior lives of women. *The Lives of Cleopatra and Octavia* (1757) offers fictionalized autobiographies of two contrasting models of female virtue, and *The History of the Countess of Dellwyn* (1759) traces the corruption of Lady Dellwyn, as she succumbs to greed and vanity. Fielding's final novel, *Ophelia* (1760), draws on the tradition of "secret histories" perfected by Manley, employing the device of the found manuscript to recount the endurance and triumph of a virtuous and resilient woman. This emphasis on feminine virtue also characterizes *The Governess* (1749), the first educational novella written specifically for girls.

The same penchant for moralizing about female behavior characterizes the novels of Sarah Scott (1723–95). As the narrator of her most famous novel, *Millennium Hall* (1762), claims, a writer should "inculcate the best principles into youthful minds, the only probable means of mending mankind." Sister to Elizabeth Montagu, Scott apparently married the wrong man, and eventually separated from him. With her friend Lady Barbara Montagu, she moved to Bath, where they established a home dedicated to employing and educating the poor. *Millennium Hall* draws on their experiences to offer a model for virtuous female behavior and education. Five women of means purchase a country home together to educate young women, who sell the

art and goods they produce to support the community they have established. On the grounds, indigent older women are housed in cottages in exchange for caring for poor children. The community also serves as a haven for deformed and disabled, for all those, in short, ostracized from an oppressive society. Despite its didactic tone, the novel proved popular for its portrait of female friendship as an alternative to the often unstable relationships between women and men. In her *Progress of Romance*, critic and novelist Clara Reeve described *Millennium Hall* as a work "calculated to inspire the heart with true benevolence and the love of virtue."

A middling poet and failed actress, Charlotte Lennox (ca. 1729–1804) happily turned to novel writing as a means of earning an income. Encouraged by her friends Johnson and Richardson, Lennox produced *The Female Quixote* (1752), modeled, as the title announces, on Quixote's classic picaresque but featuring a virtuous and intelligent heroine, Arabella. Influenced by fantastic tales of chivalry, the naïve Arabella perceives the world through the distorted lenses of love and romance. She is pursued by two suitors: her cousin Glanville, who is sophisticated and knowing, and George Bellamour, who shares her passion for reading romances and is similarly misguided. Arabella eventually recognizes her error and chooses the rational Glanville. Reason triumphs over romance. Thus, like other eighteenth-century novels by women, *The Female Quixote* stresses the moral dangers facing women in society and outlines a course of right action. The novel was a popular and critical success. While Lennox subsequently produced several novels and a play, none had the impact of *The Female Quixote* and she sunk into obscurity and poverty. Subsequent novelists, most notably Fanny Burney and Jane Austen, did find inspiration in her comic treatment of women's susceptibility to romantic notions and their need for moral guidance.

Women's role in society is also the repeated theme in the novels of Frances Brooke (1724–89), best known as the author of the first Canadian novel. The British-born Brooke, like Sarah Fielding, used the recurrent device of contrasting female characters—one independent, the other traditional—to explore and challenge feminine decorum and sensibility. Like many women writers of the time, Brooke first established her reputation by writing for magazines and the theater. Under the pseudonym of "Mary Singleton, Spinster," she contributed to the *Old Maid* (1755–56), a periodical she established modeled on Addison and Steele's *Spectator*. Fictionalized letters to the editor and reports of discussions among invented characters enabled her to hone her skills as a novelist. Her theater reviews drew on her own, largely unsuccessful, efforts as a dramatist. While her husband, an army chaplain, was assigned to America and then Canada, Brooke turned to novel writing. Her first effort, an epistolary romance, the *History of Julia Mandeville* (1763), with its conventionally virtuous heroine, was a popular success, going through three editions in its first year of publication.

In 1763, when France ceded Canada to Britain, Brooke joined her husband in Quebec. There she wrote *The History of Emily Montague* (1769), the first novel written in and about Canada. Its conventional plot about the com-

plications of courtship and marriage is, in fact, overshadowed by the information it supplies about Canadian landscape, politics, and culture. Brooke does, however, present female characters whose attraction lies in their intellect and independence: "Women are most charming when they join the attraction of the mind to those of the person," claims one male character. Both male and female characters further espouse equality in marriage and the right of individuals to choose a mate over their parents' objections. Brooke's most outspoken heroine, however, appears in *The Excursion* (1777), published after she returned to England with her husband. The novel's protagonist, Maria Villiers, is intelligent and ambitious. Brooke focuses less on Maria's success in upholding her reputation and more on the corrupt society that threatened it. Thus, she implies that the danger to feminine virtue is not women's weakness but men's actions.

Arguably the most influential female novelist of the eighteenth century, Frances (Fanny) Burney (1752–1840) is generally credited with enhancing the status of women writers. She herself bemoaned the low reputation of novelists, noting that "in the republic of letters, there is no member of such inferior rank, or who is so much disdained by his brethren of the quill, as the humble Novelist." And among novelists, women were still measured against their male counterparts: the famous trio of Defoe, Richardson, and Fielding, as well as Laurence Sterne, whose inventive *Tristram Shandy* appeared in 1760–67. Burney's first novel, *Evelina* (1778), however, earned critical and popular acclaim for uniting the sentimentalism of Richardson with the comic wit of Fielding. As a result, a women novelist became for the first time a standard of comparison (Spencer 97). In recognition of her contribution, Virginia Woolf later claimed that women writers should lay a wreath on Burney's grave in gratitude for her being the first respectable, middle-class woman to earn money by writing.

Like her precursors, Burney managed to achieve a balance between propriety and independence in her works. *Evelina* established a standard pattern for her works: A young, intelligent woman is introduced to fashionable society where, through a series of temptations and struggles, she learns lessons about the possibilities for feminine action and achievement. This work and her subsequent publications, *Cecilia* (1782), *Camilla* (1796), and *The Wanderer* (1814), have been identified as novels in the didactic tradition, dramatized **conduct books** instructing women in proper feminine behavior. They are more properly defined as novels of manners, for their depiction of individualized female characters who change, grow, and develop in relation to the values of their society as they are embodied in outward conventions (Bowers and Brothers 4). Contemporary critics, however, have recognized in the works an implicit questioning and challenge to narrow cultural definitions of female achievement. While not openly critical, Burney nonetheless points out the frustrations facing women at the turn of the century.

Burney's example had direct effects on new women novelists. Sarah Emma Spenser's novel, *The Memoirs of the Miss Holmsbys* (1788), is so beholden to *Evelina* that its story parallels the plot of Burney's masterpiece.

The more successful novelists of the early nineteenth century, including Maria Edgeworth and Jane Austen, would credit Burney's influence as well.

The 1780s witnessed a precipitous increase in the numbers of women novelists (Turner 35–37). This has been traced to significant shifts in politics and culture at century's end. America began its fight for independence from Britain in 1775, introducing new ideas about individual rights and equality that were to shape future events in Europe and the world. By the time hostilities between Britain and America ended in 1783, the literary marketplace had been transformed both economically and culturally. Readership continued to increase and women, for the first time, formed the majority of the reading public. In addition, changing conceptions of femininity were beginning to emerge partly as a product of the political emphasis on equality. Female literary professionalism was now a respectable alternative to traditional women's work as teachers, governesses, actresses, and domestic servants. Writing was still a precarious alternative, however, dependent on market forces. To earn a decent middle-class income, a novelist would have to write and publish 10 novels a year (Turner 116). As a result, most women writers also wrote for the periodical press and the stage or turned their hands to children's books, translation, and travelogues. The women writing at the end of the eighteenth century thus established the conditions for the flourishing of women's literary production in the nineteenth century.

AFRICAN AMERICAN FIRSTS: POETRY

The changing cultural and political landscape in the final decades of the eighteenth century also produced the first writing by black women. Lucy Terry (1730–1821) composed the first African American poem, "Bars Fight," in 1746. Brought to New England as a slave at age five, Terry learned to read and write from a Congregationalist minister in Deerfield, Massachusetts. She used her skills to write a 26-line ballad memorializing an Indian raid on the town in August 1746. Designed to be recited or sung, the poem was not originally published. Its popularity, however, led to its eventual publication in 1855.

While Terry may have earned the distinction of writing the earliest known poem by a black American, Phillis Wheatley's achievement—in letters and influence—is far more significant. Wheatley (ca. 1754–84), like Terry, was brought to America as a slave, seized from her home in West Africa when she was about seven years old. Employed as a domestic servant by the Wheatley family in Boston, young Phillis benefited from her employers' recognition of her intelligence. The family taught her to read and write, introducing her not only to the Bible but also to the sciences, history, and literature, including works by Homer, Ovid, Virgil, Milton, and Pope. Her training led her to compose her first poems in the classic mode of the elegy. "An Elegaic Poem, on the Death of that Celebrated Divine, and Eminent Servant of Jesus Christ, the Reverend and Learned George Whitefield . . . " was published as a pamphlet in America in 1770 and London in 1771, bringing Wheatley international attention.

Despite the success of her elegy, however, Wheatley could not gather enough **subscribers** to publish a collection of her poems. Colonial reluctance to support the publication of Wheatley's work points to the realities of racism in America. At the time that Wheatley published her first poems, 70,000 slaves were arriving in America annually. The Wheatleys thus sought a publisher for her work in London, happily finding a champion in Selina Hastings, a wealthy supporter of evangelical and abolitionist causes. With her assistance, *Poems on Various Subjects, Religious and Moral* was published in 1773. As the slave trade faced growing criticism from abolitionists in America and Britain, Wheatley's achievements were often cited as arguments that blacks were as intelligent as whites and were capable of great artistry.

Wheatley's most famous poem, "On Being Brought from Africa to America" (1773), makes slavery its subject. She chides readers, "Remember, Christians, Negroes, black as Cain,/May be refined, and join the angelic train." At the same time, Wheatley defended the American movement for independence. In "To His Excellency General Washington" (1776), she glorifies the new nation as Columbia, "the land of freedom":

> Fixed are the eyes of nations on the scales,
> For in their hopes Columbia's arm prevails.
> Anon Britannia droops the pensive head,
> While round increase the rising hills of dead.
> Ah! cruel blindness to Columbia's state!
> Lament thy thirst of boundless power too late.

Ironically, it was Britannia, not Columbia, who fostered Wheatley's art. As late as 1779, she still could not find enough American subscribers to underwrite a new collection of poems.

As Wheatley's example clearly indicates, the principles of equality and freedom were imperfectly applied in the new America. The revolutionary discourse of individual rights and liberty awaited its more radical application in France at century's end. The French Revolution in 1789 shook the foundations of aristocratic privilege and tradition in Europe, challenging oppression based not simply on distinctions of class but on differences in race and sex as well. Movements against slavery and in favor of women's equality made possible the extraordinary literary production of women in the nineteenth century.

Romantic Revolutions: 1780–1832

The democratic revolutions in America and France at the end of the eighteenth century introduced significant political and cultural changes that profoundly affected women's literary production in the nineteenth century. The **Romantic** period (1780–1832) in literature captured the "spirit of the age," stressing freedom of imaginative expression and transforming the theory and practice of literature. The Romantic revolution in literature translated the ideals and principles of political revolutions, particularly the radical French Revolution, into poetic terms, altering the language and subject of literature as well as our conception of the literary artist. Reflecting the period's emphasis on equality and class leveling, writers shifted their focus to representing daily life and avoiding elevated diction. As playwright Joanna Baillie described, her object was to "choose incidents and situations from common life, and to relate or describe them throughout, as far as was possible, in a selection of language really used by men." Stressing the power of the imagination, writers experimented with new forms and exploited new forms of publishing, such as literary magazines and annuals, to reach an expanding popular audience.

Women writers benefited from such changes. By 1832, women writers emerged as significant contributors to political, cultural, and literary changes. The period boasted hundreds, perhaps thousands, of women writers, at least 20 of whom may be considered among the most influential of the period. Joanna Baillie, for instance, dominated the neglected field of drama, while poet/novelist Felicia Hemans was second in popularity only to Byron and Jane Austen was recognized for her enduring contributions to the novel. For the first time, women's literary production and reputation rivaled—and sometimes exceeded—men's. They participated in revolutionary politics, the abolition movement, as well as the "revolution in female manners," or feminism. Female authors contributed significantly to all literary genres and came to dominate prose fiction.

Attention to women's literature of the period challenges traditional definitions of Romanticism itself, traditionally conceived of as the province of male poets whose works stressed concepts of the self, imaginative transcendence, and nature as a sublime and inspiring force. Women's writing of the era does not always conform to this definition. Their texts often accentuate familial relationships in place of radical individualism, quotidian and domestic concerns rather than the supernatural, and nature as nurturing and comforting, as opposed to awesome and potentially threatening.

Without question, the inclusion of texts written by women changes how we conceive of the period.

LITERATURE OF PROTEST

The revolutions of the late eighteenth century introduced the concepts of individual rights and equality that preoccupied intellectuals on both sides of the Atlantic. Women were better prepared to participate in such ideological debates since they were beginning to benefit from educational reform. While the majority of women were still educated at home, the stigma against female intellectualism was diminishing. Gathering in intellectual circles in London, women participated in political and cultural debates and assumed the role of political commentator in essays and in literature. Mary Hays (1760–1843), Elizabeth Inchbald (1753–1821), and Helen Maria Williams (1762–1827) were part of a circle of intellectuals associated with the radical philosopher William Godwin, who later married Mary Wollstonecraft (1759–97). When Williams moved from England to France in 1790 to explore the "sublimer delights of the French Revolution," her home became the gathering place of politicians, writers, actresses, and artists of various nationalities and generations. Her Parisian salon fused two spheres conventionally regarded as opposites: the masculine arena of public action and debate and the domestic space associated with the feminine.

This fusion found expression in women's works written in the new discourse of rights, independence, and liberty to express moral outrage at oppression and tyranny. Williams's first publication, *Edwin and Eltruda* (1782), is a long antiwar poem inspired by England's struggle with the American colonies. Written in celebration of the American Revolution's end, *Ode on the Peace* (1783) encouraged readers to consider the potential value of revolutionary principles for transforming British culture. Williams envisions the spirit of the age reviving its arts, literature among them: "And poesy!/thy deep-ton'd shell/The heart shall sooth, the spirit fire,/And all the passions sink, or swell,/In true accordance to the lyre." Poet Anna Seward won instant fame with her *Monody on the Death of Major André* (1781), which criticized George Washington for the hanging of Major John André, wrongly accused of conspiring with Benedict Arnold. The poem presents Britain moved by "cries of horror wafted from afar," not simply from the war itself but from America's miscarriage of justice: "Justice drops her scales!/And radiant Liberty averts her sail!"

Focused attention on human rights inevitably led to transformed visions of imperialism and slavery. While Phillis Wheatley had failed to find sufficient numbers of American colonists willing to support publication of her works in the 1770s, the post-revolutionary period in Britain brought attention to injustices based on race. Between the seventeenth and nineteenth centuries, Britain controlled half of the Atlantic slave trade, forcibly transporting over 2 million African natives (Ferguson). The abolition movement launched in 1788 gave female writers access to the traditionally male world

of politics through poetic responses that exploited emotional appeals, conventionally associated with the feminine. While male anti-slavery writers did employ fiction and poetry, most of their work took the form of pamphlets, parliamentary speeches, histories, reports, and scriptural treatises (Ferguson). Women, by contrast, relied on poetry, as well as direct participation in petition drives and boycotts of goods such as West Indian sugar, as the basis for political engagement. Poems by Williams and Hannah More (1745–1833), for instance, written in the same year that William Pitt introduced legislation to regulate the slave trade, endeavored to inspire pity and compassion through horrific descriptions of the abuse suffered by slaves. At the invitation of the Abolition Committee, More wrote *The Black Slave Trade: A Poem* (1788) to boost support for the abolition bill to be introduced in the House of Commons in May 1788. In the poem, More criticizes British hypocrisy: "Shall Britain, where the soul of Freedom reigns,/Forge chains for others she herself disdains?" (ll. 295–96). Authorized to speak by the demands of truth, More launches a vituperative assault on slave traders, termed "murderers" (l. 127) and "white savages" (l. 249), excoriated for their greed:

> Insulted Reason loathes th' inverted trade—
> Loathes, as she views the human purchase made;
> The outrag'd Goddess, with abhorrent eyes,
> Sees MAN the traffic, SOULS the merchandise!

The slave trade is at once an affront to reason and to feeling. More's poem seeks to humanize the slaves, dehumanized by the slave trade, claiming that "they have heads to think, and hearts to feel" (l. 83). In contrast to the unfeeling and indifferent traders, she offers an emotionally moving portrait of a black mother separated from her child: "See the scar'd infant, hear the shrieking wife!/She, wretch forlorn! is dragg'd by hostile hands,/To distant tyrants sold, in distant lands" (ll. 116–18). She reminds readers that slaves are human, too, possessed of reason, feeling, and souls, that in "all the love of Home and Freedom reign" (l. 148). While slaves may be "dark and savage, ignorant and blind,/They claim the common privilege of kind" (l. 166–67). Such statements clearly reveal a Eurocentric bias, but it may well be that this strategy reveals More's awareness of her audience: She appeals to their pity for persuasive ends. She casts slavery as unnatural, as a perversion of creation—at once God's and Nature's. More cannily exploits typically feminine appeals to sentiment, to the family, and to piety to make a statement in defense of new political ideals of equality and freedom.

With the publication of her anti-slavery poem, "A Poem on the Bill Lately Passed for Regulating the Slave Trade" (1788), Williams joined More, Anna Laetitia Barbauld, Ann Yearsley, and other female poets in persistent questioning of British policy. Williams writes on the passage of the Dolben Act of 1788, which regulated the slave trade, stipulating more humane conditions on slave ships. She focuses on the fate of the slaves, shackled and

"bound in hopeless chains," and bitterly mocks efforts at regulation as offering the "captive band" simply more spacious quarters in the holds of slave ships and "a lengthen'd plank, on which to throw / Their shackled limbs." Williams, like More, capitalizes on emotionally wrought images of mothers separated from children:

> . . . woman, she, too weak to bear
> The galling chain, the tainted air,—
> Of mind too feeble to sustain
> The vast, accumulated pain,—
> No more, in desperation wild,
> Shall madly strain her grasping child;
> With all the mother at her soul,
> With eyes where tears have ceas'd to roll,
> Shall catch the livid infant's breath,
> Then sink in agonizing death!

At the same time, Williams makes a political argument, entreating England to be the first among Europe's nations to eradicate slavery.

Despite mass propaganda campaigns in support of abolition, William Wilberforce's bill for abolition was defeated 163 to 88 in parliament in 1791, and would not succeed until nearly a half century later, with the enactment of the bill for "Immediate Abolition" in 1838. Wilberforce's defeat provoked Anna Laetitia Barbauld (1743–1824) to pen "Epistle to William Wilberforce Esq. on the Rejection of the Bill for Abolishing the Slave Trade, 1791." The poem deplores the continuance of "the human traffic," and, as in More's and Williams's works, the blame falls on the avarice of the slave traders. Barbauld pictures slavery as a plague, spreading from "injured Afric" to the "gay East." She envisions, however, the revenge of the slaves themselves: "Afric's sons, and India's, smile avenged." The poem acknowledges the slave rebellions occurring intermittently between 1787 and 1792 in the Caribbean (Ferguson).

Williams's friend, Mary Robinson (1758–1800), made attention to disenfranchised peoples a signature of her work. Poems such as "The Negro Girl" (1800) and "The Lascar" (1800) criticize slavery and racism. While More and Williams engaged in a direct assault on the slave trade and its political protectors, Robinson's critique is indirect and subtle, yet like More and Williams, Robinson capitalizes on the feminine association with the emotional. Each poem dramatizes the situation of oppressed innocence to engage the reader's sympathy. Zelma, the "negro girl," watches from shore as her lover, Draco, perishes as the waves churned up by a storm submerge the slave ship bearing him away. She curses Fate for decreeing "that some should sleep on beds of state—/Some in the roaring Sea," that "Some nurs'd in splendour deal Oppression's blow,/While worth and Draco pine—in Slavery and woe!" The lascar, separated from his native India, weeps at the "taunting Scorn" heaped upon his "wretched race" and, impoverished and alone, prays for death.

Only in death does the lascar, like Draco, escape his enslavement and realize his freedom.

Barbauld and Robinson composed their works following the French Revolution, which, more radical than its American precursor, raised the stakes in debates about rights. While introducing principles of equality and freedom, the colonies' separation from Britain left the monarchical system intact. The storming of the Bastille on July 14, 1789, precipitated events leading to the imprisonment and execution of the king and queen of France. Liberal sympathizers in England established corresponding societies with French radicals and published pamphlets defending the French example. Detractors such as Edmund Burke criticized the movement's radicalism and violence. In *Reflections on the Revolution in France* (1790), Burke portrays the revolutionaries as a "swinish multitude" and the king and queen as victims of unspeakable crimes, as their palace is "left swimming in blood, polluted by massacre, and strewed with scattered limbs and mutilated carcases."

Wollstonecraft achieved fame by being the first—man or woman—to respond to Burke's emotionally wrought *Reflections*. Her *Vindication of the Rights of Man* (1790) defended human rights and liberty while savaging Burke for his defense of tradition, including primogeniture and patronage. She tersely dismissed his "wild declamation" and reminded him: "there are rights which men inherit at their birth, as rational creatures, who were raised above the brute creation by their improvable faculties; and that, in receiving these, not from their forefathers but, from God, prescription can never undermine natural rights." She fuses defense of revolution with defense of abolition, claiming that "the slave trade ought never be abolished if Burke's ideas hold sway." In her measured and rational argument, Wollstonecraft boldly challenged Burke's conservatism, initiating her own revolution in writing, a "revolution in female manners" that was to have a lasting effect on women's political project to gain equal rights and, more subtly and pervasively, on women's literary production.

While Wollstonecraft appealed to readers through reasoned argument, Williams's *Letters Written in France in the Summer of 1790, to a Friend in England* (1790) and subsequent works presented firsthand accounts of events in France that capitalized on the emotional immediacy of her experiences. In her letters, published between 1792 and 1816, Williams reported on events following the fall of the Bastille, supporting French radicalism against the criticism of conservatives such as Edmund Burke. Despite being briefly imprisoned in 1793, along with other British subjects living in Paris, and escaping for a time to Switzerland during the height of the Terror, Williams steadfastly defended revolutionary principles and alienated many readers disturbed by the violence of Robespierre and later Napoleon. (Her decision to live with a divorced man, John Hurford Stone, may also have influenced reception of her work. Detractors were reported to have called her a "scribbling trollope" as well as a Jacobin prophetess.)

In *Letters Containing a Sketch of the Politics of France* (1795), particularly its moving account of Madame Roland's execution, Williams does, however, critique the revolution's turn toward violence and renewed authoritarian-

ism as a betrayal of revolutionary ideals. Nonetheless, Williams never wavers in her commitment to the principles of liberty and equality, claiming "it must be allowed, notwithstanding a few shocking instances of public vengeance, that the liberty of twenty-four millions of people will have been purchased at a far cheaper rate than could ever have been expected from the former experience of the world." She justifies the revolution as "an experiment in politics" destined to advance the human mind to "greater perfection." Like Wollstonecraft, Williams fuses anti-slavery and pro-revolutionary causes, believing that revolutionary ideals will transform the nation and the world: "The Africans have not long to suffer, nor their oppressors to triumph. Europe is hastening towards a period too enlightened for the perpetuation of such monstrous abuses. The mists of ignorance and error are rolling fast away, and the benign beams of philosophy are spreading their lustre over the nations."

In her defense of the French Revolution itself, Williams employed the same emotional appeals evident in her anti-slavery poetry, exploiting her position as "spectatrice" to arouse pity in her readers. She describes a visit to the Bastille, recalling the situation of its chained prisoners before their liberation at the start of the revolution. The dungeons are "regions of horror [where] human creatures [were] dragged at the caprice of despotic power." Yet, she employs similar tactics to argue against the revolution's disastrous descent into the Reign of Terror in her description of Mme. Roland interned before her execution in the prison of St. Pelagie. Her passionate excoriation of Robespierre and others as "fanatics of liberty" makes clear that she rejects not the revolution itself but those who have profaned liberty: "the enchanting spell is broken, and the fair scenes of beauty and order, through which the imagination wandered, are transformed into the desolation of the wilderness, and clouded by the darkness of the tempest." She thus fuses emotional and rational appeals in defense of rights and against the poverty and suffering of those among the lower classes.

The class leveling at the core of the French Revolution can also be seen in working-class poetry of the era, from the works of John Clare to the poetry of Ann Yearsley (1752–1806), "the Bristol Milk Woman and Poetess." Poets Hannah More and Elizabeth Montagu, who recognized the uneducated woman's genius and sought to help her sustain her family, secured subscribers for *Poems, on Various Subjects* (1785). After breaking with More and Montagu over the distribution of profits, Yearsley later published essays and verse that exhibited consciousness of the oppressed condition of African and Caribbean slaves, as in *A Poem on the Inhumanity of the Slave Trade* (1788), and the devalued status of women's domestic labor. She fuses class and race in her poem on slavery in the character of Luco. Rather than employing generalized references to unnamed slaves, as Williams and More do, Yearsley, like Robinson, presents a concrete portrait of slave labor, describing Luco at work under the command of a cruel master. Luco, whipped for pausing in his work, retaliates by striking the "rude Christian" overseer with his hoe and is burned alive as punishment for his retaliation.

Women writers' participation in the movements in defense of rights at the end of the eighteenth century provided the foundation for feminism. Denied access to education and to legal protection, women of all classes referred loosely to themselves as slaves (Ferguson). Writing in defense of those disenfranchised and subjugated by race or class, women set a precedent for political agitation in defense of their own rights.

A REVOLUTION IN FEMALE MANNERS

For many, a natural consequence of securing rights of citizenship for men was to extend such rights to women—American and British. Abigail Adams wrote to her husband, John, anticipating American independence:

> in the new code of laws which I suppose it will be necessary for you to make, I desire you would remember the ladies and be more generous and favorable to them than your ancestors. Do not put such unlimited power into the hands of the husbands. Remember, all men would be tyrants if they could. If particular care and attention is not paid to the ladies, we are determined to foment a rebellion, and will not hold ourselves bound by any laws in which we have no voice or representation.

Women's rebellion later found its voice with the publication of Wollstonecraft's *Vindication of the Rights of Women* in 1792. In it, Wollstonecraft criticized the social system which limited women by encouraging them to nurture vanities and frivolities, thus preventing them from developing either their minds or their moral capacities. Marriage, she noted, cast women as property and doomed them to a childlike status. Essentially, she attempted to apply the broad strokes and ideals of the French Revolution to women and argued vehemently for their civil rights, most particularly their right to an equal education. She claims that "all writers who have written on the subject of female education and manners from Rousseau to Dr. Gregory, have contributed to render women more artificial, weak characters, than they otherwise have been; and, consequently, more useless members of society." Women, like men, are "rational creatures," according to Wollstonecraft, and should be treated as such. If women are perceived of in terms of **sentiment** alone, they are "degraded by mistaken notions of female excellence" and rendered subordinate in "a system of slavery." It was "tyrannic," she writes, "to attempt to educate moral beings by any other rules than those deduced from pure reason, which apply to the whole species."

Wollstonecraft, in writing her feminist manifesto, simultaneously embodied the revolutionary principles she espoused by presenting herself as a model of female rationalism. She self-consciously highlighted her position as a woman addressing women: "My own sex, I hope, will excuse me if I treat them like rational creatures instead of flattering their *fascinating* graces, and viewing them as if they were in a state of perpetual childhood, unable to stand alone." Instead, she entreated women

to endeavor to acquire strength, both of mind and body, and to convince them that the soft phrases, susceptibility of heart, delicacy of sentiment, and refinement of taste, are almost synonymous with epithets of weakness, and that those beings who are only the objects of pity and that kind of love, which has been termed its sister, will soon become objects of contempt.

Her style reflected her purpose. As she claimed, she wished "rather to persuade by the force of my arguments, dazzle by the elegance of my language."

As a professional writer, Wollstonecraft challenged sociocultural expectations, as is evident in critical reaction to her texts. Horace Walpole deemed her a "hyena in petticoats," dismissing both her revolutionary stance and her femaleness. This doubling of feminist radicalism—in word and in deed— set the writers of the 1790s apart from earlier generations. Many influential writers of the mid-eighteenth century, such as Elizabeth Carter, Elizabeth Montagu, Hester Mulso Chapone, and Hannah More, had also supported educating women, but in their literary productions they sought to uphold an image of female chastity, respectability, and morality. By contrast, Wollstonecraft, influenced by the radicalism of the revolutionary period, directly challenged the prevailing ideology of femininity.

Both Wollstonecraft and her friend, Mary Hays (1760–1843), wrote frankly about female sexuality. In the *Memoirs of Emma Courtney* (1796), Hays presents a woman torn between her sexual passion and social restrictions against its expression. She later wrote *The Victim of Prejudice* (1799) "to delineate the mischiefs that have ensued from the too great stress laid on the reputation for chastity in woman." Wollstonecraft's unfinished novel, *Maria: Or the Wrongs of Woman* (1798), published posthumously by Godwin, similarly explores a woman's sexual desire while arguing against the potentially imprisoning bonds of marriage (Maria is "bastilled" by marriage) and in favor of woman's right to seek happiness outside its confines. The novel further demonstrates the oppressive effects of poverty on women through portraits of domestic labor, prostitution, and imprisonment.

This is not to say that all women writers during this period openly espoused feminist principles. To some, their sex was no mark of shared concerns or creative approach. When, in 1804, Maria Edgeworth (1768–1849) proposed creating a literary magazine for women called the *Feminead*, her colleague Barbauld wrote: "there is no bond of union among literary women, any more than among literary men; different sentiments and different connections separate them much more than the joint interest of their sex would unite them." In fact, many women writers criticized Wollstonecraft, Hays, Williams, and others for venturing into the realm of politics. Sydney Owenson (Lady Morgan) (ca. 1776–1859) stressed conventional understandings of women as feeling, rather than rational, creatures when she argued that "Politics can never be a woman's science; but patriotism must naturally be a woman's sentiment." Despite her anti-slavery activism, More actively lobbied against revolutionary influences and advocated limits on women's education. In *Strictures on the Modern System of Female Education* (1799), she

writes, "the study, my dear madam, which I place in the climax of unfitness, is that of *politics*."

These two competing visions of femininity emerge in *A Vindication of the Rights of Woman* and other texts. Equal education for women is advanced not simply to enable women to compete with men—as writers and intellectuals—but for the benefit of the family and, by extension, society as a whole. Assuming that the mother, as center of the domestic circle, is responsible for early education of children, enhanced education for women means better education for children—male and female—and hence a better educated, more rational society. Thus, "**woman**" emerged during the period as simultaneously a figure of political and cultural revolution *and* a figure of domesticity.

REVOLUTIONS IN THE NOVEL

Much has been written about the novel's relation to the emergence of the domestic sphere and the rise of the reading public in the eighteenth century. As we have seen, the novel, in its attention to the particulars of daily existence, emerged out of private modes of writing typically associated with women: letters, memoirs, devotional verse, children's literature, and conduct books. The novel's popularity also coincided with changes in publication and distribution. Circulating libraries made books available to a growing middle-class audience, composed in large part of women with the time and leisure to read. Indisputably, women dominated the production and consumption of prose fiction during the late eighteenth and early nineteenth century. One estimate sets the number of female novelists at 200 or more (Mellor 2).

Their canny exploitation of the literary marketplace produced the first American best-seller. Actress and writer Susanna Rowson (1762–1824) originally published *Charlotte: A Tale of Truth* in London in 1791, but it did not achieve its success until Rowson found a publisher in Philadelphia, the center of a new popular literature in America. In her preface, Rowson appeals directly to a female readership: "For the perusal of the young and thoughtless of the fair sex, this Tale of Truth is designed; and I could wish my fair readers to consider it as not merely the effusion of Fancy, but as a reality." Under the guise of offering a slightly fictionalized account of a real woman, Rowson offers an imagined portrait of a woman for a moral purpose, much like her eighteenth-century precursors. The 15-year-old Charlotte Temple is seduced by a British soldier conscripted to fight in the American Revolution. After she elopes with him to New York, he abandons her and she dies in childbirth. By its third edition in 1797, the novel's title had changed to *Charlotte Temple*, capitalizing on the audience's enduring affection for its heroine. By the end of the nineteenth century, over 200 editions had been published and a "Charlotte cult" sprang up, with devotees making pilgrimages to Charlotte's supposed tombstone in New York's Trinity Churchyard.

The second American best-seller was also produced by a woman. Hannah Webster Foster (1758–1840) published *The Coquette* in Boston in 1797. Like Rowson's novel, it is a sentimental tale that capitalizes on the popular vogue for stories "founded on fact." While Rowson used the device disingenuously in her fictional portrait of Charlotte Temple, Foster based her story on an actual and much-publicized case. *The Coquette* sympathetically portrays the life of Elizabeth Whitman, a poet who, like Charlotte, elopes with her lover, only to die giving birth to his illegitimate child. Unlike the sentimental heroines of the mid-eighteenth century, Foster's heroine is less the victim of unscrupulous men than the restricted options offered her as a woman. Neither of her possible choices of husband—a womanizer or a pompous pedant—is worthy of her as a woman of intellect, so she succumbs to the advances of another.

Tabitha Tenney (1762–1837) offers a far more biting critique of sentimental fiction in *Female Quixotism* (1801). Roughly modeled on Charlotte Lennox's *Female Quixote*, Tenney's comic tale spoofs the vogue for sentimental novels and their negative influence on female readers. But while in Lennox's novel the heroine is schooled to reject fantasy and value reason, Tenney's Dorcasina Sheldon arrives at a different conclusion. She similarly recognizes the deceptive potential of romantic fantasy. The source of error is not herself as a reader, as in Lennox's novel, but the culture that restricts women's education and realm of action, making them prefer fantasy to the reality of their limited opportunities.

In England, Maria Edgeworth (1768–1849) established herself as the (if not *the*) preeminent novelist of the period with similarly complex literary heroines. Her fame rivaled that of Byron: "I had been the lion of 1812: Miss Edgeworth and Madame de Stael . . . were the exhibitions of the succeeding year." Her novels, including *Belinda* (1801), *Leonora* (1806), and *Helen* (1834), critique fashionable society and sentimentality. Like Fanny Burney, Edgeworth highlights male restrictions on female behavior. However, her heroines are generally thought to exhibit greater independence of mind and spirit than Burney's. The social consciousness developed in her **regional fiction** as well as her *Essay on Irish Bulls* (coauthored with her father in 1802) and *Tales of Fashionable Life* (1809) infuses her works, as she makes extensive references to the political and cultural concerns of the post-revolutionary period.

Both Burney and Edgeworth were identified by Jane Austen (1775–1817) as exemplary writers in her own novel, *Northanger Abbey* (1818), where *Belinda*, *Cecilia*, and *Camilla* are defended as positive examples of the novel's influence on women. Her narrator defends them as works "in which the greatest powers of the mind are displayed, in which the most thorough knowledge of human nature, the happiest delineation of its varieties, the liveliest effusions of wit and humor are conveyed to the world in the best chosen language." More than either of her predecessors, however, Austen is credited with transforming the **novel of manners**. In novels such as *Sense and Sensibility* (1811), *Pride and Prejudice* (1813), and *Emma* (1816), Austen

gave unprecedented access to the interior states of her female characters: strong, competent women who forge egalitarian relationships with men. *Emma*, for example, traces a classic comic arc: A misguided matchmaker, overconfident in her abilities, learns the error of her perceptions and discovers love in the process. The text takes up key themes relating to the role of women (the fallibility of match-making and flirtation, the danger of a girl "having too much her own way" and thinking "too well of herself"). The achievement of the novel comes in its use of point of view: While written in the third person, the novel is told from Emma's perspective. The reader perceives events as Emma does, and thus is deliberately misguided. The chief delight of the novel comes through revelation, through the comic recognition of Emma's lack of insight.

This access to the interior states of her characters has been lauded as Austen's singular contribution to the novel. Sir Walter Scott praised Austen's "new style" of novel for its characterization, its depiction of the life and speech of ordinary people, and its avoidance—even parody—of the stylized conventions of the romance and heroic fiction. More than Burney or Edgeworth, Austen mocks the conventions of courtship and marriage that were the staples of sentimental novel.

Austen turned her playful humor on the **Gothic** novel as well, spoofing its conventions in *Northanger Abbey*. The Gothic novel was introduced by Horace Walpole in *The Castle of Otranto* (1764) but was transformed and popularized by Ann Radcliffe (1764–1823). Radcliffe's *The Mysteries of Udolpho, A Romance* (1794) achieved spectacular success in Britain and abroad. Influenced by Walpole, but also by Clara Reeve's *Old English Baron* (1777) and Sophia Lee's *Recess* (1783–85), *The Mysteries of Udolpho* exploited the typical Gothic conventions: forbidding castles, victimized females, menacing villains, supernatural forces, and sexual longing. But Radcliffe injected added suspense by focusing on her longings and fears, on the psyche of the female victim. The heroines in *The Mysteries of Udolpho* and *The Italian, or the Confessional of the Black Penitents: A Romance* (1797) triumph over their male aggressors as seemingly supernatural forces receive rational explanation.

In *Frankenstein* (1818), Mary Shelley (1797–1851) draws on the supernatural to offer a critique of man's Promethean daring and overreaching. Her popular tale of Victor Frankenstein's creation of his monster presents us with an irreducible paradox, for it is an image of human creation and scientific mastery, and the origin of disaster. Feminist critics have recognized the tale as a critique of attempts to manipulate and usurp natural processes, including the feminine power of reproduction. Victor Frankenstein's creation is a distortion of natural, female reproductive capabilities, and the monster's isolated existence and education are counterpoised to the "ethics of care" exhibited by the Lacey family. Frankenstein's abandonment of the monster also demonstrates the male's failure to care for and nurture offspring, and this failure to offer compassion leads directly to the monster's violence. Thus, domestic affection is contrasted to the male creator's egotistical self-assertion through science.

This critique is reflected in the novel's form. An epistolary novel, *Franken-stein* draws on the personal letter, a private mode of writing associated with the domestic. The story is framed by Robert Walton's letters to his sister. The story is narrated by three men—the monster, Frankenstein, and Walton—but directed to an absent female reader. Walton, unlike the monster and Frankenstein, sustains the connection to the domestic sphere, and his decision to abandon his Arctic explorations and return home underscores this fact.

While Shelley's novel does reflect on "feminine" issues such as reproduction, family, and education, it also reveals its author's immersion in the emerging science of evolution as well as her engagement with politics. Frankenstein's ambitions equate him not only with classic literary over-reachers such as Milton's Satan and Marlowe's Dr. Faustus, but also with the political Prometheus, Napoleon. Daughter of radicals Godwin and Wollstonecraft and wife of their disciple, Percy Bysshe Shelley, Mary demonstrates her own ferocious intellect and contributions to the preoccupations of the age.

In her introduction to the 1831 edition, Shelley nonetheless felt compelled to explain, "How, I, then a young girl, came to think of, and to dilate upon, so very hideous an idea?" She defends her ability to have created her remarkable novel not simply at the age of 19, but also as a woman. This suggests that even while women dominated the form, expectations regarding appropriate subject matter persisted. In addition, since the novel directly addresses the potential and danger of human creative powers, it has also been taken as a self-conscious reflection on writing, particularly the question of female authorship itself. The ambivalent position of the female author can be glimpsed in Shelley's reference to her novel as a "hideous progeny," her own monster. As a result, the novel may also be a critique of imaginative self-indulgence and Romantic individualism.

REVOLUTIONS IN DRAMA AND POETRY

While the novel has been deemed the women's genre of the period, women also featured prominently in drama and poetry. Joanna Baillie (1762–1851) was without question the leading playwright of the era. Author of 26 plays, Baillie secured the admiration of audiences and critics, including Sir Walter Scott, who called Baillie "the best dramatic writer" in Britain "since the days of Shakespeare and Massinger." *Plays on the Passions* (3 vols., 1798–1812) established her reputation for delineating human emotion, from love and hope to hatred, ambition, jealousy, and fear. Like Shelley, Baillie demonstrates a typically Romantic preoccupation with the mind and the imagination. Baillie's intent, outlined in her "Introductory Discourse" to the 1798 edition, was to unveil "the human mind under the dominion of those strong and fixed passions, which, seemingly unprovoked by outward circumstances, will from small beginnings brood within the breast." Each play focused on "exhibiting a particular passion." More properly, Baillie experimented with how

to reveal human feeling in print and on stage, how to interest audiences in the spectacle of emotion. In a departure from tradition, her plays were published before being produced for the stage. Eventually, her works were produced in all of the leading theaters in the United Kingdom and the United States between 1800 and 1826. Her first staged play, *De Monfort* (29 April 1800 at Drury Lane), became enormously popular, due in part to its near-Gothic portrait of hatred, murder, and madness.

Baillie's success aside, drama itself was a marginalized form during the period as poetry predominated. In this era literary success came from achievement in verse, a critical prejudice perpetuated in later assessments of the period. An impressive collection of female poets, including Anna Laetitia Barbauld, Felicia Hemans, Letitia Elizabeth Landon, Hannah More, Mary Robinson, Anna Seward, Charlotte Smith, and Mary Tighe, to name only a few, introduced innovations in major forms, including the sonnet. Many multitalented female authors achieved fame in more than one genre.

While Williams's letters from France secured her reputation, her early political engagement came through verse. Wordsworth liked her "Sonnet to Twilight" and admired her work to such a degree that his earliest published poem was "Sonnet, on Seeing Miss Helen Maria Williams Weep at a Tale of Distress" (1787). Hannah More's six volumes of poetry earned her the respect of Samuel Johnson, who called her "the most powerful versificatrix" in the English language.

Anna Seward (1742–1809), the "Swan of Lichfield," distinguished herself as a remarkable innovator in verse. Friend of Helen Maria Williams and William Hayley, she was first encouraged to publish by Erasmus Darwin, who asked Seward to write a poem about the Linnaean system. (It has been argued that his own *Botanic Garden* includes her lines without acknowledgment.) She later invented a form she called "monody" (or "epic elegy" in Darwin's terms), which she used to great effect in her *Monody on the Death of Major André*. She further experimented in narrative verse in *Louisa, a Poetical Novel, in Four Epistles* (1784), presenting the domestic romance typical of the novel in verse. Seward adopts the conventions of the novel, such as the epistolary form, as well as those of pastoral and epic verse, to offer a detailed narrative of frustrated love spanning nations and cultures. Told as an exchange of four letters, *Louisa* transforms the personal story of the domestic novel into a poem of epic scope set against a backdrop of mercantilism and colonialism.

Experimenting with traditional verse forms, Charlotte Smith (1749–1806) joined Seward in receiving attention for her poetry. A successful novelist–author of *Emmeline, the Orphan of the Castle* (1788), *Desmond* (1792), and *The Old Manor House* (1793)—Smith was known as much for her poetry as for her fiction. *Elegaic Sonnets, and Other Essays* was published in 1784 at her own expense and went through nine editions in her lifetime. She has been credited with reviving the sonnet form in English, employing the traditional Shakespearean and Petrarchan sonnet forms, but also creating structures of her own. Her use of original structures influenced the form's development,

as did her choice of subject matter. As she stated in her preface, she found the sonnet "no improper vehicle for a single sentiment." Each poem captured moments of emotional intensity (Curran, *Poetic Form*), from solitude to sorrow, often employing dramatic exclamations to convey the fervor of feeling.

Her best work, *Beachy Head: With Other Poems* (1807), published posthumously, exhibits a characteristic Romantic fascination with nature, as well as an engagement with contemporary sociopolitical concerns. For this reason, she has been called the first Romantic poet (Curran, *Poems* xix). The title poem, which is unfinished, opens with the speaker meditating on the shore and seascape from a promontory overlooking the English channel, reflecting on trade, including trade in slaves, the toil of fishermen, and the Norman invasion. In Wordsworthian fashion, the speaker claims to have been an "early worshipper at Nature's shrine" and wistfully recalls a simple, direct relation to a natural world unspoiled by "human crimes." The poem closes with an idealized image of natural affinity: A hermit, "feelingly alive to all that breathed" and cognizant of human misery, devotes himself to the rescue of mariners imperiled by the waves, an act of "charity" that secures him spiritual transcendence after death.

The poem mixes forms and voices, oscillating between the personal and the political, poetry and prose. The speaker's abstract meditations on the nature of labor, for instance, are interrupted by the question, "Ah! who *is* happy?" and the speaker's melancholy response, "*I* once was happy." Copious notes to the poem foreground Smith's knowledge of history, geography, natural history, and geology and force the reader to move back and forth between the two texts. The notes themselves are a mix of forms, from the impersonal language of history and science to personal voice of the autobiographical. In several notes, Smith recounts her own experiences, such as when she first came across fossilized shells in the chalk while exploring the landscape as a child. The poem itself incorporates the songs and love poems of a poor youth "cross'd in love." Smith's work thus embodies the revolutionary urgency of the era in its amorphous form as well as its subject matter.

Like Smith, Barbauld engaged in poetic reflection on Britain's turbulent political situation and its consequences for art. Both were writing during the period of Britain's war with France (1793–1815). British women's participation in pro-war activities, such as clothing and subscription drives, allowed them to assume public roles, as during the abolition movement (Colley). And again writers such as Barbauld took the opportunity to voice their political views.

Barbauld's controversial "Eighteen Hundred and Eleven, a Poem" (1812) has as its foundation not simply the "storm of war," but political and social unrest. That year George III was deemed insane and power was transferred to the Prince of Wales. In Luddite uprisings, weavers destroyed machinery in rebellion against the mechanization of textile production, and, fearing a revolution, the British government made damaging property a crime. Bar-

bauld's poem offers a prophetic image of the British Empire in decline, vexed by war and abandoned by commerce, with its literary preeminence transferred to America. The poem warns that

> . . . fairest flowers expand but to decay;
> The worm is in thy core, thy glories pass away;
> Arts, arms and wealth destroy the fruits they bring;
> Commerce, like beauty, knows no second spring.
> Crime walks thy streets, Fraud earns her unblest bread,
> O'er want and woe thy gorgeous robe is spread,
> And angel charities in vain oppose:
> With grandeur's growth the mass of misery grows.

Instead, Barbauld envisions "Genius" flourishing in the new world: "Thy world, Columbus, shall be free." For bold statements such as this, as well as for poems with more of a traditionally feminine domestic focus, Barbauld exerted a powerful influence—perhaps the most powerful influence—over subsequent female poets, who often cited her texts or otherwise acknowledged her contributions to their own works.

In "Grave of a Poetess," Felicia Hemans recognizes the achievement of Mary Tighe (1772–1810). While most of Tighe's work was unpublished, a small number of copies of *Psyche; or the Legend of Love* were privately printed in 1805, and then posthumously in 1811. Tighe's poem, composed in Spenserian stanzas, recounts the story of Cupid and Psyche, taken from Apuleius. It earned ecstatic reviews, with contemporary reviewers comparing Tighe's poem favorably to works of Ariosto, Tasso, and Spenser. In her original poem, Tighe transforms the myth to emphasize the female Psyche's desire. In her opening stanza, the speaker defends the "lighter labours of the muse," who prefers to tell not of "cruel battles" but "goodly bowers and gardens rare,/Of gentle blandishments and amorous play,/And all the lore of love, in courtly verse essay."

Women writers during the period not only participated in its self-proclaimed revolution in poetry but also influenced its direction. The period's defining literary manifesto, Wordsworth's preface to the second edition of *Lyrical Ballads* (1800), was clearly influenced by Baillie's "Introductory Discourse" to a *Series of Plays*, published anonymously in 1798. In her preface, Baillie anticipated Wordsworth in defining the object of literary creation as the faithful delineation of "passion genuine and true to nature." Wordsworth argues:

> The principal object . . . which I proposed to myself in these poems, was to choose incidents and situations from common life, and to relate or describe them throughout, as far as was possible, in a selection of language really used by men. . . . And further, and above all, to make these incidents and situations interesting by tracing in them (truly, though not ostentatiously) the primary laws of our nature, chiefly as regards the manner in which we associate ideas in a state of excitement.

Two years earlier, Baillie had argued that the dramatist must relate "every circumstance however trifling or minute," for "those circumstances of ordinary and familiar life [are] most favourable for the discovery of the human heart." Before Wordsworth she argued that "the characters must speak directly for themselves," not in "feigned or adopted" language, and that "Drama improves us by the knowledge we acquire of our own minds, from the general desire we have to look into the thoughts, and observe the behaviour of others." In her conviction that readers are moved by "the sympathetick interest we all take in beings like ourselves" and that such sympathy is the basis for moral improvement, she further anticipated Percy Bysshe Shelley's contention, in *A Defence of Poetry* (1821), that "a man to be greatly good . . . must put himself in the place of another and of many others; the pains and pleasures of his species must become his own."

REVOLUTIONS IN PUBLISHING

Changes in the system of publication enabled a second generation of female poets to achieve fame and influence the direction of literature and popular culture. Women embraced new means of publishing and distributing their works, writing for literary magazines, editing and contributing to gift books and annuals, and capitalizing on the vogue for travel writing. At the same time, they exploited the popularity of forms conventionally associated with women, such as children's literature and songs, often subverting traditional expectations in the process.

In creating the popular **gift books** (also called album books or annuals), women writers informally shaped the contemporary reception of literature. Letitia Elizabeth Landon (1802–38) and Felicia Hemans (1793–1835), two of the most popular writers in the 1820s and 1830s, contributed regularly to collections such as *Heath's Book of Beauty* and *Friendship's Garland*. Sumptuously designed, the literary albums had leather or silk bindings, gilt-edged paper, and elegant steel-plate engravings of landscapes, fashionable women, and travel scenes by popular artists, such as J. M. W. Turner, John Martin, and Thomas Gainsborough. The books' titles often reflected their status as beautiful objects: *The Amulet, The Gem, The Amethyst, The Keepsake*. They were purchased primarily by middle-class women—on both sides of the Atlantic—to be given on special occasions, especially Christmas and New Year's Day, to friends and family. The poetry and short fiction the albums contained sometimes conformed to the beautiful wrapping, with poems commissioned to accompany the engravings contained within. But often the literary texts explored the dark sides of apparent domestic tranquillity, featuring tales of unhappy marriages, orphans and single women, and the mental and emotional abuse of women. Such themes were clearly directed at the targeted audience of middle-class housewives and may suggest much about women's perceptions of their roles in Romantic culture and society.

Hemans's works are a good example. A frequent contributor to the gift books, Hemans owed her popularity in part to them. She was one of the

most read and admired poets of the nineteenth century, achieving fame in America as well as Britain. Hemans's work was admired by Percy Bysshe Shelley, William Wordsworth, Lady Morgan, Matthew Arnold, William Michael Rossetti, Mary Ann Evans (George Eliot), Elizabeth Barrett, and "countless other writers and literary critics of discerning taste" (Feldman 275). Obviously unsettled by his competition, Byron called her "Mrs. Hewoman" in a letter to John Murray date 12 August 1820. She was a prolific contributor to periodicals such as *Blackwoods* and *New Monthly Magazine*, as well as the annuals. She published her first book at the age of 15, *Poems, by Felicia Dorothea Brown*. Her best mature work is collected in *The Forest Sanctuary* (1825). Several of her poems from that volume, including "The Homes of England," "The Better Land," "The Graves of a Household" (1825), "The Treasures of the Deep," and "Casabianca" (1826), became standards in the nineteenth century as representing reigning cultural ideals and values. "Casabianca," her most anthologized piece, memorializes a young son's fidelity to his father, standing by his corpse only to perish himself. Implicit in the poem's concluding conviction that "the noblest thing that perish'd there,/Was that young faithful heart" is an indictment of war. This same subversiveness can be seen in other works. Contemporary feminist scholars have noted that while the appeal of several of Hemans's poems stemmed from their apparent adherence to the traditional view of women's role, supporting the "**cult of domesticity**," they in fact subtly critique the self-sacrifice and self-effacement necessitated by the domestic ideal. The mother in "Indian Woman's Death-Song" (1828), for instance, vows to spare her infant daughter from "women's weary lot" and "that wasting of the heart" (ll. 36–37).

Like Hemans, Landon achieved her fame through publication in the popular mediums, the literary magazines and annuals. She first published her poetry in the *Literary Gazette*, eventually contributing over 300 poems to the popular weekly magazine, and later edited (and in fact wrote most of the poems for) *Fisher's Drawing Room Scrap Book* in the years 1832 to 1839. Her poems were so popular with readers that the "Original Poetry" section of the *Literary Gazette* expanded during the years she contributed to it, often featuring readers' responses to her poetry in the same section—or more accurately to her persona, for readers were fascinated by the mysterious "L. E. L." When it was eventually revealed that the popular L. E. L. was a woman, her reputation as a writer was enhanced. As one admirer remembers, "we soon learned [the author] was a female, and our admiration was doubled, and our conjectures tripled. Was she young? Was she pretty?"

Landon capitalized on the public's imagined perceptions of her youth and femininity. Critics agree that she cannily targeted her audience, tailoring her work for specific groups of readers. It is tempting to take later works such as "Lady, Thy Face Is Very Beautiful" and "Lines of Life" (1829) as a commentary on the fleeting nature of physical beauty and the costs of literary fame and social acceptance based on such mutable ground:

I live among the cold, the false,
And I must seem like them;
And such I am, for I am false
As those I most condemn.

I teach my lip its sweetest smile,
My tongue its softest tone;
I borrow others' likeness, till
Almost I lose my own.

The poem's ending affirms the endurance of spirit in contrast to the vagaries of literary reputation. Repeatedly, Landon self-referentially meditates on the high price of fame, on the gap between the much-loved public persona and the "real," unloved self of the woman writer, as in her tribute to Hemans. In "Stanzas on the Death of Mrs Hemans," she intimates that Hemans's fame as a poet was purchased at a price:

Ah, dearly purchased is the gift,
The gift of song like thine;
A fated doom is hers who stands
The princess of the shrine.
The crowd—they only see the crown,
They only hear the hymn—

Hemans's literary fame is presented as separating her from true human affection, not mediated by her works.

Many Romantic poems were first performed as songs, and annuals and gift books often included musical scores in recognition of popularity of musical performance. During the period, women were expected to excel musically, performing for guests by playing an instrument or singing. For that reason, many of the most enduring songs were composed by women. Jane Taylor (1783–1824) has the distinction of being the only female poet whose works were anthologized through the twentieth century. "Twinkle, Twinkle Little Star," one of the first songs children learn to this day, has immortalized her contribution, although not her name. The most popular ballad of the era, Lady Anne Lindsay's "Auld Robin Gray" (1772), was sung not only in her native Scotland but also in England and, in translation, in France. It made its way into literary works, too: A character in Wollstonecraft's *Maria* sings the song. It even influenced fashion: One season women wore Robin Gray hats!

Women's connection to children made writing books for them an obvious—and culturally acceptable—choice. For many female authors, including Wollstonecraft and Barbauld, children's literature offered economic and moral advantages. Barbauld composed *Hymns in Prose for Children* (1781) and the *Lessons for Children* (1787–88) before turning her attention to political concerns. Influenced by Barbauld's work, Edgeworth coauthored *Practi-*

cal Education with her father in 1798 before completing *Early Lessons* (1801–25) and *Moral Tales for Young People* (1801) on her own. Smith wrote *Rural Walks* (1795) and *Rambles Farther* (1796) to "repress discontent, to inculcate the necessity of submitting cheerfully to such situations as fortune may throw them into . . . and to correct the errors that young people often fall into in conversation, as well as to give them a taste for the pure pleasures of retirement, and the sublime beauties of Nature." Educational writing was perceived of as an extension of women's roles as caregiver and first educator of children. While the genre was considered "sub-literary," it nonetheless provided women with an occasion to explore philosophical and social issues. In fact, Wollstonecraft's argument for enhanced rights to education for women hinges on their fundamental role in educating children in their formative years. She thus cannily transforms a traditional expectation for women into the origins of their intellectual emancipation.

Women writers, from Wollstonecraft to Shelley, also profited from the nineteenth-century vogue in travel writing. Writing before the turn of the century, female writers faced the stigma associated with women travelers: As a journey away from home, travel was the antithesis of domesticity and hence perceived of as a masculine activity. In its association with exotic climes and cultural practices—from eastern seraglios to Italian adultery—travel also carried suggestions of sexual license. In the 1790s, for instance, Williams was dismissed as a "scribbling trollope" for her defense of revolutionary France, its liberal tendencies associated with sexual freedom and depravity in the English popular press. Wollstonecraft's *Letters Written during a Short Residence in Sweden, Norway, and Denmark*, published posthumously in 1796, carries forward her views about equality for women, noting that Scandinavian women are relegated to menial work.

Later women writers benefited from the groundbreaking work of Williams, Wollstonecraft, and others. Lady Morgan's *France* (1817) was openly pro-revolutionary and, as a result, was singled out by Lafayette as the best contemporary work on the nation. *Italy* (1821) was judged "fearless and excellent" by Byron and "singularly free from the usual British prejudice against the Italians" by her contemporary, Mary Shelley; its influence can be seen in Shelley's own *Rambles in Germany and Italy in 1840, 1842, and 1843* (1844). Accounts of travel and exploration exerted a pull on the imaginations of those remaining at home, as well, and can be seen in works as varied as Seward's *Elegy on Captain Cook* (1780) and Williams's *Peru: A Poem, In Six Cantos* (1784), which imagines the impact of war on conquered, indigenous peoples. Dorothy Wordsworth's *Grasmere Journal*, begun in 1800, documents travels closer to home, making the familiar appear as unfamiliar in its fascinating descriptions of vagrants, abandoned wives, itinerant soldiers, and local laborers in rural England.

As editors, established women writers also shaped literary history. As the poetry editor of the *Morning Post*, beginning in 1799, Mary Robinson directed popular appreciation for contemporary poetry, simultaneously refashioning her own reputation as a serious literary figure. Women's achievements—in

literature and other fields—became a distinct focus in their own right. Mary Hays's *Female Biography; or, Memoirs of Illustrious and Celebrated Women of All Ages and Countries* (1803) documented women's achievements in Western culture in six volumes and influenced generations of readers in England and America throughout the nineteenth century. Hemans's *Records of Women*, published a quarter of a century later, testifies to the importance of female models in its dedication to Joanna Baillie. Barbauld's series, *The British Novelists* (1810, 50 vols.), with its preface on the "Origin and Progress of Novel Writing," enabled her to document and perpetuate accomplishments in a genre itself dominated by women. Elizabeth Inchbald's 25-volume series on British playwrights, *Modern Theatre* (1811), similarly highlighted women's achievements in drama, a form dominated by women in the 1790s (Curran, "Romantic" 186).

Attention to gender offers an altered vision of Romanticism: By 1832, women writers emerge as significant contributors to political, cultural, and literary changes. They participated in revolutionary politics, the abolition movement, as well as the "revolution in female manners," or feminism. Female authors contributed significantly to all literary genres and came to dominate prose fiction. In the process, they revised traditional forms in innovative and imaginative ways that won them popular, as well as critical, respect. As readers and editors, women shaped the publication and reception of literature, influencing the course of women's literary production during the remainder of the nineteenth century.

4

Victorian Contradictions: 1832–95

By the early decades of the nineteenth century, women's literature had achieved great visibility and influence. Female authors were generally viewed as dominating both poetry and prose fiction. George Henry Lewes lamented in 1850 that "the group of female authors is becoming every year more multitudinous and more successful. Women write the best novels, the best travels, the best reviews, the best leaders, and the best cookery books. . . . Wherever we carry our skilful pens, we find the place preoccupied by a woman" (Buck 22). The nineteenth century was indelibly marked by the poetry of Elizabeth Barrett Browning, Christina Rossetti, Emily Dickinson, and Frances Harper and the fiction of the Brontë sisters, George Eliot, Harriet Beecher Stowe, and more. Unfortunately, the history of the production and reception of women's writing documents that such gains were consolidated in the mid-nineteenth century but gradually diminished by the turn of the century.

Women's notable achievements in literature must be considered against the contradictory nature of the mid- to late nineteenth century in Britain and America. In England, Queen Victoria presided for 63 years (1837–1901) over a period of unprecedented change and transition in industry, colonial expansion, and societal expectations, including conceptions of gender roles. London was the undisputed center of industrial development and urbanization. Railways, steamships, and mechanized production increased the pace of work and life. While at the beginning of the nineteenth century one-fifth of the population lived in cites, by the end more than three-quarters did. By 1890, one-quarter of the world's population was part of England's empire (including Canada, Australia, New Zealand, Rhodesia, Kenya, Nigeria, Uganda, South Africa, India, Ceylon, Malaya, Hong Kong, Singapore, Burma, Jamaica, the Bahamas, and Bermuda). In America, the new colonists pressed West, similarly expanding their territories and markets for goods. Inventions such as the cotton gin, sewing machine, telegraph, and assembly line transformed commercial enterprise and communication. By 1800, New York had supplanted the colonial centers of Boston and Philadelphia as America's economic and cultural capital.

Such rapid changes, however, produced profound anxiety and had real social costs on both continents. America's expansion, for instance, resulted in the extermination and subordination of Native American populations and was accomplished through slave labor. While slave trading was officially abolished in 1808 on both continents, it continued unchecked. Only in 1833 did England finally abolish slavery, but rebellions in colonial possessions

from India to the Caribbean in subsequent years proved that repressive prac-
tices persisted. Not until the Civil War of 1861–65 did slavery finally end in
America.

Resistance and challenges to unequal power relations continued until the
end of the century. Women in Britain and America lobbied for their rights
to own property and to vote. While Queen Victoria dismissed "this mad,
wicked folly of Women's Rights," feminists and their supporters prevailed.
In his *Subjection of Women* (1869), for instance, Mill argued that "Marriage is
the only actual bondage known to our law. There remain no legal slaves,
except the mistress of every house." Divorce was introduced in England in
1857, and the Married Women's Property Acts of 1870 and 1882 gave women
the right to possess their wages and property. In America, Susan B. Anthony
and Elizabeth Cady Stanton organized initiatives in New York beginning in
1854. Stanton appealed to revolutionary principles, arguing to the judiciary,
"Yes, gentlemen, in republican America, in the nineteenth century, we, the
daughters of the revolutionary heroes of '76, demand at your hands the re-
dress of our grievances—a revision of your State Constitution—a new code
of laws." Almost 70 years after Abigail Adams had prodded her husband
to extend rights to women, the authors of the Seneca Falls Declaration (1848),
the manifesto of the modern American feminist movement, borrowed the
language of the Declaration of Independence to extend its "inalienable
rights" to women. Agitation for women's **suffrage** and education continued
throughout the century. In 1837, Mary Lyon founded Mount Holyoke Fe-
male Seminary to educate young women in New England, and in 1848,
Queen's College, the first institution for the higher education of women in
Britain, opened in London in 1848.

Women's literary production during this period benefited from their en-
hanced opportunities for education as well as changing attitudes toward
their participation in culture. It was further supported by advances in pub-
lishing and literacy. New print technologies—steam-powered presses,
cheaper wood-pulp paper, mechanized typesetting—enabled the mass pro-
duction of books, magazines, and newspapers at lower costs, opening up
audiences of middle- and lower-class readers. Railways and steamships fur-
ther enhanced distribution systems. As a result, literacy rates increased and
audiences grew. Over 90 percent of both sexes in Britain were able to read
by 1900. The emerging middle class became the largest consumers of prose
and poetry in England and America. Both countries experienced an explo-
sive growth of weekly and monthly magazines, tailored for increasingly spe-
cialized audiences. In America, for instance, only five magazines existed in
1794; by 1860 readers could choose among more than 500. By that time, most
novels were serialized in such periodicals, giving them an enormous popu-
lar reach. Circulating libraries provided growing urban audiences with ad-
ditional low-cost access to literature. The mass distribution and consump-
tion of literature created the conditions for popular genres and best-sellers.

The novel as a genre dominated the mid- to late nineteenth century, and
women predominated as writers and as readers. By one estimate, over 50,000

novels were published in Britain by 3,500 novelists, the majority of whom were women. In keeping with the age, novels emphasized the practical, the details of what Elizabeth Barrett Browning called "this live throbbing age." In their attachment to realism, the novels of the period frequently reflected and commented on the issues of the day.

LABOR AND REFORM: NOVELS OF SOCIAL PROTEST

The **realistic novels** of the early Victorian period in Britain focused on the upheavals produced by rapid industrialization. The so-called condition-of-England novels documented the disastrous social conditions of the "Hungry '40s," the food shortages and poverty resulting from the transition from agrarian to mechanized production. In London and in American urban centers such as Boston and New York, conditions for workers in factories and textile mills sparked agitation for reforms. The century saw the growth of unions from Robert Owen's Grand National Consolidated Trades Union (1834) to the First Trades Union Congress (1868). The oppression of the working classes was not only the subject of Karl Marx and Friedrich Engel's *Communist Manifesto* (1848). In *Principles of Political Economy* (1848), John Stuart Mill sympathized with the plight of the laboring classes, as did novelists of the period.

Harriet Martineau's *Manchester Strike* (1832) and Elizabeth Gaskell's *Mary Barton* (1848) drew attention to the grim plight of factory workers in Manchester, presenting detailed portraits of depressed living standards and brutal working conditions. Gaskell's evident sympathy for the workers shocked many of her middle-class readers, as did her modified use of the Lancashire dialect to evoke her characters' real speech patterns. In *Shirley* (1849), Charlotte Brontë, like Gaskell, emphasized the effects of repressive labor practices on female characters. While women made up one-third of all workers, work was still sex segregated. Mary Taylor wrote to Brontë: "there are no means for a woman to live in England, but by teaching, sewing, or washing. The last is the best, the best paid, the least unhealthy and the most free."

Women novelists thus attended to gender differences under industrial **capitalism**, distinguishing their works from the social protest novels of their male counterparts, such as Benjamin Disraeli (*Sybil, or the Two Nations*, 1845), Charles Kingsley (*Alton Locke, Tailor and Poet*, 1850), and Charles Dickens (*Hard Times*, 1845). Some women did, like their male counterparts, focus on the brutality directed indiscriminately at men, women, and children. Frances Trollope's *Michael Armstrong, the Factory Boy* (1840) tells how overseer Joseph Parsons and factory owner Elgood Sharpton victimize their apprentices. American Rebecca Harding Davis (1831–1910) published "Life in the Iron Mills" (1861) to chronicle the inhumane conditions for male and female laborers. In her story, Hugh Wolfe, who longs to be an artist, toils instead in the iron mill, while his hunchbacked cousin Deb works in a cotton mill for wages so low that she resorts to stealing to support them.

The most famous novels of George Eliot (Mary Ann Evans, 1819–80) evoke movements of social change. *Adam Bede* (1859), *The Mill on the Floss* (1860),

and *Silas Marner* (1861) are set in the period of transition from an agrarian to an industrialized society; *Felix Holt* (1866) and *Middlemarch* (1872) take place during the period when the Reform Bill extended the vote to members of the lower classes. A voracious reader, Eliot's works are **novels of ideas**, based on her knowledge of Greek classics and philosophy, astronomy, law, and mathematics. The *Mill on the Floss* features a young woman who distinguishes herself based on her intellect, and Eliot's most famous work, *Middlemarch*, has been described as fixated on intelligence itself.

Epic in scope, *Middlemarch* takes up issues facing Victorian society: the conflict between science and religion, marriage and sexuality. Eliot engages these ideas not abstractly but in richly detailed portraits of the inhabitants of Middlemarch, focusing on two unhappy marriages, that of Dorothea Brooke and her husband Edward Casaubon, and of Lydgate and his wife Rosamond Vincy. The narrator's claim, "We do not expect people to be deeply moved by what is not unusual," is a key to understanding Eliot's works. Like her favorite poet, Wordsworth, she makes the familiar appear as unfamiliar, or, as her narrator further explains:

> That element of tragedy which lies in the very fact of frequency, has not yet wrought itself into the coarse emotion of mankind; and perhaps our frames could hardly bear much of it. If we had a keen vision and feeling for all ordinary human life, it would be like hearing the grass grow and the squirrel's heart beat, and we should die of that roar which lies on the other side of silence. As it is, the quickest of us walk about well wadded with stupidity.

Turning the force of her own "keen vision and feeling" and powerful intellect on the past, Eliot engages readers simultaneously with events and ideas of the present. In Henry James's estimation, Eliot succeeds in endowing otherwise trivial domestic matters with intelligence, sensing "the constant presence of thought, of generalizing instinct, of *brain*, in a word, behind her observation."

"THE WOMAN QUESTION"

By far the most popular novels of the period, however, focused not on women's participation in labor but on the "womanly woman," the figure of domesticity who provided comfort and refuge from the competitive world of work. Coincident with the rise of capitalism during the mid-nineteenth century was the creation of "**separate spheres**" for men and women. The private sphere of the family was opposed to the public sphere of work: The private sphere was conceptualized as a realm of love and intimacy, in opposition to the more "impersonal" norms that dominated the modern economy and politics. Each sphere was gendered: The private sphere, conceived of as domestic, emotional, nuturing, was the province of women, while the public sphere, governed by reason, business, professions, political life (from voting to government), and war, was the province of men. John Ruskin summed up the distinction in *Sesames and Lilies* (1865):

> He is eminently the doer, the creator, the discoverer, the defender. His intellect is for speculation and invention; his energy for adventure, for war, and for conquest whenever war is just, whenever conquest necessary. But the woman's power is for rule, not for battle,—and her intellect is not for invention or creation, but for sweet ordering, arrangement, and decision. She sees the qualities of things, their claims and their places. Her great function is Praise. . . . The man, in his rough work in open world must encounter all peril and trial:— to him, therefore, the failure, the offence, the inevitable error: often he must be wounded, or subdued; often misled; and *always* hardened. But he guards the women from all this; within his house, as ruled by her, unless she herself has sought it, need enter no danger, no temptation, no cause of error or offence.

While Ruskin presents men and women as each possessing power, although differently defined, in reality, separation of spheres restricted women's participation by narrowly configuring their realm of influence. Women were banned from the masculine realm of intellect and commerce. Those of the female sex, and in particular the women of the middle class, were sentenced to the domestic sphere where "the fair sex" was expected to cultivate "feminine" skills and moral virtues only. She became the "angel in the house," a phantasmic, unattainable ideal of womanhood as ageless, eternally lovely, incorruptibly virtuous, self-sacrificing, and infallibly wise. Coventry Patmore's best-selling poem *The Angel in the House* (1856) gave her literary form: "all the wisdom that she has/Is to love him for being wise."

The contradictions of her position in literature are readily evident: Women writers predominated yet middle-class perceptions still emphasized the ideology of femininity against the reality of women's participation. Some popular novelists, such as Charlotte Young and Mrs. Craik, catered to popular morality with their impossibly virtuous heroines. The most famous novels by women of the nineteenth century offer a more complex recognition of the strictures imposed by the **"cult of true womanhood"** and often subvert its divisive portrait of women as either the angel of the house or her demonized opposite: the "fallen woman," the madwoman, or the whore.

The novels of Charlotte Brontë, for instance, delve into the feminine psyche to present the effects of emotional repression and restricted action. Drawing on her own experiences as a governess, Brontë wrote *Jane Eyre*, published under a male pseudonym, Currer Bell, in 1847. To this day, the novel appeals to female readers owing to its bold portrait of the orphaned Jane, who triumphs over conventional barriers of class, appearance, and religion on the basis of her will and intellect. Using first-person narration, Brontë allows readers to experience events from Jane's point of view, as she is demeaned by her aunt and cousins for being "plain" and as she eventually rebels against their tyranny, as she endures the repressive education of the Lowood Institution and enters into "a new servitude" as governess at Thornfield Hall. We empathize with Jane's resistance to her submission and her emotional turmoil as she falls in love with the gruff Rochester. She reminds readers that "Women are supposed to be very calm generally; but women feel just as men feel; they need exercise for their faculties, and a field for

their efforts as much as their brothers do; they suffer from too rigid a restraint, too absolute a stagnation, precisely as men would suffer." While Jane's eventual marriage to Rochester suggests Brontë's conformity with Victorian conventions, the two are nonetheless united as equals in their willfulness and intelligence.

Brontë's novel does, however, allude to the inverse of domestic tranquillity in its portrait of the mad Bertha Mason, the wife Rochester imprisoned in the attic at Thornfield. Her unbridled sexuality and irrational emotion embody the dark, repressed force in the novel, the projection of extreme passion that Jane must not succumb to herself. Brontë's novel implies Jane must still contain her passions to some degree. Not until the late twentieth century do we witness events from Bertha's perspective, in Jean Rhys's *Wide Sargasso Sea* (1966). In its **modernist** exploration of Bertha's psyche, Rhys presents her as an effect of colonial oppression and sexual repression. Brontë hints at Jane's desire for Rochester, but her sexuality is not fully realized, reminding us that Brontë balances her heroine's independence against conventional expectations for women.

In *Villette* (1853), Brontë represents the psychic consequences of internalizing such contradictions. Lucy Snowe is consumed by emotion but fears displaying her emotions. She represses her desire for Dr. John but still harbors romantic illusions that find expression in altered form as dreams and visions. Even after she switches her attachment to M. Paul Emmanuel, who teases out her feelings, Lucy is haunted by the recurrent image of a ghostly nun. Brontë employs this **Gothic** device as the projection of Lucy's tormented desire. The novel's pessimistic ending only reinforces Lucy's frustration and hints at Brontë's dim view of the possibility for women's fulfillment.

Charlotte's sister Emily's novel *Wuthering Heights* (1847) similarly focuses on frustrated desire. Her Romantic tale of Cathy and Heathcliff presents lovers divided by class division and social convention. Denying her own feelings, Cathy rejects Heathcliff owing to his lowly status. The novel is interested less in the consequences for Cathy than in those for Heathcliff, who seeks his revenge by earning an income and marrying another. Still, Heathcliff finds no solace, tormented by visions of his lost love, even after her death. While the novel's ending is ambiguous, it nonetheless emphasizes the costs of social conformity.

The consequences were, of course, greatest for those without the good fortune of Jane Eyre, Lucy Snowe, and Cathy Earnshaw, who secured protection and approbrium through marriage. In *Ruth* (1853), Gaskell criticizes the social conventions that condemned the "fallen woman." Abandoned and pregnant, Ruth faces ostracism from the community where she has taken refuge, passing herself off as a widow, but redeems herself on the basis of her work as a nurse.

Despite Gaskell's example, other women novelists traded on conventional condemnation and vilification of such women. The 1860s witnessed a vogue for **sensation novels**, with their lurid descriptions of crimes. "Crimes of morality," that is, women's sexual license, featured prominently in these

popular novels catering to the Victorian audience's appetite for stories of bigamy, adultery, incest, illegitimacy, assault, and murder. While Wilkie Collins's *The Woman in White* (1860) may have started the trend, women such as Rhoda Broughton (1840–1920), "Ouida" (Marie Louise de la Ramée, ca. 1839–1908), Mrs. Henry Wood (1814–87) and Mary Braddon (1835–1915) dominated the genre. Mrs. Wood sold over 2.5 million copies of *East Lynne* (1861) to readers, including the Prince of Wales, who was transfixed by its melodramatic story of desertion, adultery, and divorce. Braddon's *Lady Audley's Secret* (1862) was more sensational still, and served as the prototype for the genre. Her story features a seemingly innocent woman with golden hair who, as is eventually discovered, has committed bigamy, murder, and arson. Denounced by serious critics as "one of the most noxious books of modern times," it nonetheless was popular with readers and became one of the best-selling novels of the century. Such novels domesticated crime, making it the business of otherwise "respectable" Victorian women and men. Contemporary critics have noted that, especially in Braddon's novels, criminals often get away with their crimes and thus the novels subvert moral conventions. Since the criminals are often aristocrats, the novels can further be taken as class critiques. Others, however, have noted that the novels actually enforced middle-class conceptions of femininity by demonizing the independence of action, sexuality, and feeling of women.

The popular Margaret Oliphant (1828–97) objected to such stories in an article in *Blackwood's Magazine* in 1867, claiming, in a review of Rhoda Broughton's *Cometh Up as a Flower*, that they inspired too much openness about feelings in women. She also criticized Jane Eyre's " 'protest' against the conventionalities in which the world clothes itself." Oliphant's own novels presented moral and virtuous female figures and were read and admired by the queen and Henry James. In her 50-year career, she produced almost 100 novels, using the proceeds to support her family after her husband died of tuberculosis. While her novels were praised for their simplicity and reverence of hearth and home, contemporary critics have discerned some skepticism in her works. She evokes the religious quarrels of her day, as well, through her portrait of the English Dissenters in her Carlingford novels (1863–76), which bear comparison to Francis Trollope's in their rich evocation of community.

Like Oliphant, George Eliot was critical of her contemporaries. She dismissed "silly novels" by lady novelists, the "mind-and-millinery" type of fiction that was pious in instructing women using highly charged but ultimately empty language.

"WOMAN'S FICTION"

As in Britain, America developed a popular taste for domestic or "woman's fiction," featuring a heroine who, deprived of the protection of her family, triumphs over adversity using her own skills and wits (Baym). Although she asserts her independence and will, she is typically rewarded with mar-

riage. The absent family (more specifically, husband/father) is restored and she assumes the traditional feminine role of wife and mother. Thus they are "woman's" novels in that they not only feature female protagonists but also uphold societal definitions of woman's role. Their appeal was enormous: Woman's novels by Catharine Sedgwick, Maria Cummins, Caroline Chesebro', E. D. E. N. Southworth, Susan Warner, Sara Parton (Fanny Fern), and others dominated American literature from 1820 to 1870.

Like British novels of the same period, the woman's novels were realistic, not in only their portraits of family life but also in their engagement with the issues facing the young country, from the displacement of Native Americans to agitation for workers' rights to national conflicts over slavery, which culminated in the Civil War. Thus while they retain vestiges of the eighteenth-century appeal to sentiment, they add a typically Victorian attention to detail of place, time, and character.

Understandably, the first novels emphasized the frontier experience. The young American nation prized individualism—for men, at least. The role of women on the frontier was to promote the opposite of individualism—connection to others and self-sacrifice—and thus balance the competitive independence of self-reliant men. Catharine Maria Sedgwick's *New England Tale* (1822) was first among the many novels written by American women upholding the image of women as the moral and spiritual center of their families and communities. Sedgwick (1789–1867) is credited, along with Washington Irving, James Fenimore Cooper, and William Cullen Bryant, as founding the American literary tradition. While the male writers focused on pioneer adventures, battles with Native Americans, and men in action, women extolled the virtues of hearth and home as civilizing forces. Sedgwick's best-known novel, *Hope Leslie* (1827), describes home life in colonial New England in rich detail. For her common sense and lack of sentimentality, Sedgwick earned praise from Margaret Fuller and Ralph Waldo Emerson.

Sedgwick's influence can been seen in other works by women about frontier life, from Caroline Kirkland's *A New Home—Who'll Follow?* (1839) to Alice Cary's *Clovernook* (1852, 1853). Susanna Moodie, the first Canadian novelist, offered a fictionalized account of her emigration from England to Upper Canada (Ontario) in *Roughing It in the Bush; or, Life in Canada* (1852). The novel takes the form of an episodic memoir, with Moodie speaking in her own voice to detail the hardships she and her husband encountered, including a cholera epidemic in Quebec and their failed attempts at farming. Ann Stephens's *Malaeska: The Indian Wife of the White Hunter* (1860) draws on the history of conflict between Native Americans and white settlers and has the distinction of being the first **dime novel**. While Beadle's Dime Novels, a series of inexpensive adventure novels, became a domain of male authors, Stephens contributed six more novels to the series.

If Sedgwick established the "woman's novel," Susan Warner (1819–85) was its most popular practitioner. *The Wide, Wide World* (1851) was surpassed in sales only by *Uncle Tom's Cabin*. Infused with Warner's evangelical Protes-

tantism and experience of New England farm life, the novel traces the development of adolescent Ellen Montgomery. Abandoned after the deaths of her parents, Ellen learns to submit herself to her aunt and to God, becoming self-sufficient through farm work and household labor. The enduring influence of the novel can be glimpsed in Louisa May Alcott's *Little Women* (1868, 1869) published nearly two decades later: Jo March is pictured reading *The Wide, Wide World*. Alcott's Jo, like Ellen, learns to control her temper and ambition.

The *Lamplighter* (1854) by Maria Susanna Cummins (1827–66) tells a story strikingly similar to Warner's, and the novel was equally successful. Eight-year-old orphan Gerty endures abuse and neglect. She learns that only those who have learned submission will find happiness: only "those who, in the severest difficulties, see the hand of a loving Father and, obedient to his will, kiss the chastening rod." Gerty learns her lesson and engages in great acts of charity.

The success of such novels, and the women who dominated the form until 1870, is clearly expressed by Nathaniel Hawthorne in a letter to his publisher:

> America is now wholly given over to a d—d mob of scribbling women, and I should have no chance of success while the public taste is occupied with their trash—and should be ashamed of myself if I did succeed. What is the mystery of these innumerable editions of the 'Lamplighter,' and other books neither better nor worse?—Worse they could not be, and better they need not be, when they sell by the 100,000.

While Hawthorne later credited Cummins with more talent than her contemporaries, his comments point out that the popular, largely female readership was attracted to these works despite their literary shortcomings. They succeeded owing to their realism. Elizabeth Gaskell explained, "These American novels unconsciously reveal all the little household secrets. . . . [We] enter into their home struggles, and we rejoice when they gain the victory."

The attention to place that characterizes such works led to the development of **regional fiction** as a distinct genre, one often associated with women writers. Sarah Orne Jewett (1849–1909) is considered among the most talented practitioners of the form. In short stories and novels, Jewett evoked the realities of country and town life in New England, especially her native Maine. She called her works "sketches," a term that aptly describes their lyric descriptions of the natural landscape found in story collections such as *A White Heron* (1866) and *The Country of the Pointed Firs* (1896). Her attention to realism is not limited to nature, for her stories and novels contain richly drawn characters, particularly women. The autobiographical *A Country Doctor* (1884), for instance, centers on the struggle of Nan Prince to become a doctor, foregoing the traditional path of marriage.

As the example of Jewett suggests, while many women's novels were didactic, enforcing social conventions, some stressed feminine resistance and

the dark side of domesticity. The novels of Julia Dorr (1825–1913)—*Farmingdale* (1854), *Lanmere* (1856), and *Sibyl Huntington* (1869)—depict the endless work of women on New England farms, from laundry to milking to rug making, offering literature and education as women's sole escape. Others, such as Caroline Chesebro' (1825–73) and E. D. E. N. Southworth (1819–99), pictured angelic women oppressed by merciless men. Chesebro's *Victoria, or The World Overcome* (1856) criticizes hierarchical, male-dominated Puritan society. In *Peter Carradine* (1863), the heroine learns "to conceal herself, to circumvent, connive, contrive, to have her own way to conquer herself, to choose the will of another, to prefer another's pleasure to her own." Southworth's *The Hidden Hand* (1859) centers on a virtuous woman forced to make it on her own. She laments, "While all the ragged boys I knew could get little jobs to earn bread, I, because I was a girl, was not allowed to carry a gentleman's parcel . . . or do *anything* that *I* could do just as well as *they*." The first female American journalist, Fanny Fern (Sara Payson Willis Parton, 1811–72), drew criticism for *Ruth Hall* (1855), which featured a widow who emerges as a canny businesswoman and competitor with men. The novel was, nonetheless, a success with readers.

St. Elmo (1866), by Augusta Evans (1835–1909) sold more copies than any other novel written by a woman in the nineteenth century. While it retains the conventional form, it also features an assertive heroine who acknowledges her own sexual attractiveness. The best-seller *A Family Secret* (1876) by Eliza Andrews (1840–1931) similarly exploited literary convention—here the mystery—to make a point about women's position. One character exclaims, "Oh, the slavery it is to be a woman and not a fool!"

ABOLITION AND WOMEN'S RIGHTS

This equation of women's oppression with slavery can be traced to the 1840s, with the simultaneous emergence of the anti-slavery movement and the movement for women's rights. The American emphasis on equality and individual rights ties the women's movement to the abolitionist movement. As Frederick Douglass argued, "right is of no sex." Pre–Civil War feminists Margaret Fuller, Lucretia Mott, Lucy Stone, Elizabeth Cady Stanton, and others first established a voice politically by speaking out against slavery. Douglass wrote in his autobiography, "When the true history of the antislavery cause shall be written, women will occupy a large space in its pages, for the cause of the slave has been peculiarly woman's cause." Stanton and Mott met at the World's Anti-Slavery Convention in 1840, for instance, and their exclusion from the meeting on the basis of their sex was an impetus for the Seneca Falls Declaration.

As women supported the cause of abolitionists, abolitionists lent their support to the women's movement. William Lloyd Garrison, who refused to take his seat in solidarity with women barred from the 1840 Convention, later publicly argued that both slaves and women had been victims of men's tyranny: "Does not this nation know how great its guilt is in enslaving one-

sixth of its people? Do not the men of this nation know ever since the landing of the pilgrims, that they are wrong in making subject one-half of the people?"

Other abolitionists, including Thomas Wentworth Higginson, Wendell Phillips, Theodore Parker, Parker Pillsbury, and Frederick Douglass, expressed their solidarity. Douglass, "Observing woman's agency, devotion, and efficiency in pleading the cause of the slave," explains that "gratitude for this high service early moved me to give favorable attention to the subject of what is called 'woman's rights' and caused me to be denominated a woman's-rights man. I am glad to say that I have never been ashamed to be thus designated" (Schneir 83). He spoke from the floor of the Seneca Falls Women's Rights Convention in favor of a resolution extending the vote to women. Later noting that "Many who have at last made the discovery that the negroes have some rights as well as other members of the human family, have yet to be convinced that women are entitled to any," Douglass used his influential abolitionist weekly, *The North Star*, to announce his solidarity with the women's movement:

> We are free to say that in respect to political rights, we hold women to be justly entitled to all that we claim for man. We go farther, and express our conviction that all political rights which it is expedient for man to exercise, it is equally so for woman. . . . [I]f that government is only just which governs by the free consent of the governed, there can be no reason in the world for denying to woman the exercise of the elective franchise, or a hand in making and administering the laws of the land. (Schneir 84)

Still, despite these alliances between the causes of anti-slavery and women's rights, the role of black women was limited. As many were later to argue, the emerging women's movement was not without class or racial tensions. Sojourner Truth (ca. 1799–1883), a freed slave who could neither read nor write, was the only black woman to attend the First National Woman's Rights Convention in Worcester, Massachusetts, in 1850, and when she appeared at a later convention in Akron, Ohio, some women were hesitant to allow her to speak for fear that "every newspaper in the land will have our cause mixed with abolition," as Francis Gage argued. When she did speak, her comments revealed the biases underscoring the debate. As both a woman and a former slave, Truth was at least doubly oppressed. In her short speech, she revealed the tyranny of slavery and poverty that she endured without any of the "privileges" accorded white, middle-class women, asking repeatedly "Ain't I a woman?" All the more remarkable, then, was her determination to speak in front of hostile audiences, composed of both men and women, to remind them that equality for women meant equality for all women. In 1853, to a particularly unruly crowd at the Broadway Tabernacle, she met their resistance head on: "I know that it feels a kind o' hissin' and ticklin' like to see a colored woman get up and tell you about

things, and Woman's Rights. We have all been thrown down so low that nobody thought we'd ever get up again; but we have been long enough trodden now; we all come up again, and now I am here." Illiterate, Truth relied on others to transcribe her speeches and her autobiography, *The Narrative of Sojourner Truth* (1850).

Truth appealed to Harriet Beecher Stowe for assistance in publicizing her work after *Uncle Tom's Cabin* appeared in book form in 1852 and drew national and international attention to slavery in America. In Cincinnati Stowe had witnessed and heard direct testimony of the atrocities of slavery, but the passage of the Fugitive Slave Law in 1850, which empowered federal agents to return escaped slaves to their owners, sparked the creation of her "epic of Negro bondage." The novel traces the path of two slaves, Eliza, who eventually escapes with the assistance of the Underground Railroad, and Tom, who remains a slave, eventually beaten to death by his evil master, Simon Legree. Stowe depicts slavery as antithetical to Christian ethics, represented in the text by the virtuous and loving little Eva. Like the "woman's novels" of the period, *Uncle Tom's Cabin* is clearly didactic: Stowe wrote the novel to make "the whole nation feel what an accursed thing slavery is."

Although contemporary critics have faulted the novel for its predictable plot and racial stereotyping, in its day it drew praise from leading intellectuals as well as its legions of readers. Douglass called it "the *master book* of the nineteenth century" and Ralph Waldo Emerson wrote in "Success":

> We have seen an American woman write a novel of which a million copies were sold in all languages, and which had one merit, of speaking to the universal heart, and was read with equal interest to three audiences, namely, in the parlor, in the kitchen, and in the nursery of every house.

Emerson's delineation of the "three audiences"—men, women, and children—not so subtly reminds us of the divisions in American society based on sex as well as race. His praise of Stowe's involvement in such a highly volatile political issue shows how American women at mid-century succeeded in circumventing the doctrine of the spheres. Women's involvement in reform movements, not only against slavery but also against prostitution and for temperance, was not seen as rebellion against feminine role but as an extension of their presumed superior virtue and civilizing influence to the public world.

Ironically, the first novel written by a black woman received virtually no attention until the 1980s. Harriet E. Wilson (ca. 1808–70) published *Our Nig* in 1859, thus becoming the first black woman to publish a novel in English. The text is assumed to be autobiographical, based on Wilson's own experiences as an indentured servant. It tells the story of Frado, daughter of a white mother and black father. She is eventually abandoned by her mother and left with a white family, who make her their indentured servant when she is only seven. She gains her freedom at 18 but continues to work in the de-

graded role of servant until she establishes a new career in needlework. She marries, but her husband repeatedly deserts the family and eventually leaves Frado alone with her son. In her concluding appeal to the reader, Wilson reveals that she wrote the novel in hopes of earning enough money to retrieve her son, whom she had entrusted to a white foster family after her own husband abandoned them. Her son died six months after the book's publication. Her achievement is also noteworthy in that the novel synthesizes two separate traditions: the **sentimental novel**, a staple of white female authors, and the **slave narrative**, until then a black, masculine preserve.

With the publication of *Incidents in the Life of a Slave Girl* (1861), Harriet Jacobs (ca. 1813–97) became one of the first women to contribute to the genre. The text speaks openly of Jacobs's sexual exploitation at the hands of white men. Determined to escape the sexual advances of Dr. Norcum, her owner's father, Jacobs entered into a relationship with a white attorney, bearing him two children. Norcum's wife, who knew of her husband's pursuit of Jacobs, abused her. Discovering that Norcum planned to sell her children, Jacobs escaped, hiding first in a swamp and later in an attic for seven years. With the support of abolitionists, she eventually fled to the north and was reunited with her children. Norcum's daughter tried to have her recaptured until abolitionist Cornelia Grinnell Willis finally arranged her emancipation. Jacobs rejected Stowe's offer to fictionalize her story in *Uncle Tom's Cabin* and, instead, assisted by abolitionist Lydia Child, published her account under the pseudonym Linda Brent, fearing criticism as a single mother for writing about sexual exploitation. While her narrative resembles those written by men, in its emphasis on the suffering of slaves and the corruption of their white owners, it differs in that Jacobs finds freedom not on the basis of physical strength, education, and self-reliance as in the *The Narrative of Frederick Douglass* (1845) but owing to her connection to the slave and abolitionist communities. She also emphasizes her commitment to her children. Jacobs contends that men and women experienced slavery differently as well: "Slavery is terrible for men, but it is far more terrible for women."

As an African American and a woman, poet Frances Harper (1825–1911) wrote movingly in opposition to slavery and, following the Civil War, in favor of women's rights. An abolitionist who regularly lectured throughout the North, Harper incorporated readings from her own poetry in her speeches. *Poems on Miscellaneous Subjects* (1854) was published with a preface by William Lloyd Garrison. Harper uses the vogue for sentiment and simplistic style and rhyme to engage readers in the charged subject of slavery, as in "Eliza Harris," based on a character in *Uncle Tom's Cabin*:

> The bloodhounds have miss'd the scent of her way;
> The hunter is rifled and foil'd of his prey;
> Fierce jargon and cursing, with clanking of chains,
> Make sounds of strange discord on Liberty's plains.

Later works, such as the famous "Bury Me in a Free Land," speak with the immediacy of slave narratives:

> Make me a grave where'er you will,
> In a lowly plain, or a lofty hill;
> Make it among earth's humblest graves,
> But not in a land where men are slaves.

In her use of dialect in the poems in *Sketches of Southern Life* (1872), she preceded later poets, such as Paul Laurence Dunbar, in capturing the rich oral tradition of African American culture.

In her stories, Rebecca Harding Davis drew on her firsthand experience of the Civil War, exploring its effects on individuals rather than its battles. Living in West Virginia she had been able to "see the great question from both sides." "John Lamar" (1862) presents events from the perspective of a slave, while "David Gaunt" (1862) focuses on the moral transformation of a Union soldier. Davis critiques not only the "general wretchedness" and "squalid misery" of the war but also its uncertain impact on race relations in America.

America's unjust treatment of Native Americans also emerged as a subject in the works of women writers following the Civil War. Sarah Winnemucca Hopkins (1844–91) was encouraged to publish her autobiography, *Life among the Piutes* (1883), by the Peabody sisters, two Boston activists trying to influence federal policy and legislation. Each chapter of the narrative recounts events as Winnemucca would have experienced them given her age. The six-year-old narrator of the first chapter, for instance, describes the invasion of Paiute lands "when the white people came." Fearing that her daughter would be eaten by these white cannibals, Winnemucca's mother buried her in the sand. The 21-year-old who has become an interpreter describes the massacre of her family and mocks the reservationists. Her final chapters recount in impeccable detail the hostilities between the Paiute warriors and those who had exiled them from their land. Her text has not only served as an accurate history of their battles but also memorializes the traditions of the Paiutes.

In her novel *Romana: A Story* (1884), Helen Hunt Jackson (1830–85) endeavored to do for Native Americans what Stowe had done for African Americans in *Uncle Tom's Cabin*. Although not nearly as successful as Stowe's, Jackson's novel did effectively draw attention to the mistreatment of Native Americans in California missions. The half-Indian, half-Scots Ramona falls in love with a Native American laborer, Alessandro. Her cruel stepmother forbids her marriage to an Indian, so the two elope, traveling west to live in the Indian communities of Alessandro's family. They discover, however, that the villages have been destroyed by white invaders and the villagers dispersed in the hills. Sentimental and melodramatic, the novel nonetheless dramatizes the real violations of justice and international law

Jackson had previously outlined in her nonfiction study, *A Century of Dishonor: A Sketch of the United States Government's Dealings with Some of the Indian Tribes* (1881).

The writings of American and British women share a common commitment to realism and to minority concerns. They reflect the tensions and conflicts preoccupying the Victorian era: the impact of rapid industrialization on workers and the family and the unequal treatment of slaves and native peoples. As women, authors on both sides of the Atlantic could not escape the "woman question" and, regardless of whether they supported or resisted arguments for women's equality, gendered themes emerged in their domestic focus and impulse for reform.

THE "POETESS"

In the face of the overwhelming critical attention given to women novelists, it is worth remembering that the "poetess," as she was then called, was a respected figure during the Victorian period. Annuals and gift books remained popular in the mid- to late nineteenth century, and popular periodicals and anthologies supported the work of women poets, essayists, and short story writers. In America, anti-slavery journals, such as William Lloyd Garrison's *The Liberator*, as well as *The Genius of Universal Emancipation* and the *National Anti-Slavery Standard*, published the work of women. Magazines specifically targeting a female audience, including *Godey's Lady's Book* (established in 1830), *The Lily*, and *Peterson's Magazine*, not only featured the latest fashions and household advice but also engaged readers in debates over women's education and suffrage. Anthologies, such as Frederic Rowton's *The Female Poets of Great Britain, Chronologically Arranged with Copious Selections and Critical Remarks* (1848), George Bethune's *The British Female Poets* (1848), Caroline May's *The American Female Poets* (1848), and Eric Robertson's *English Poetesses* (1883), attested to the popularity of the poetesses and established two distinct national traditions of women's poetry. They were linked, however, in upholding a particular aesthetic of women's poetry, associating it with sentiment and emotion, presumed to be feminine qualities. In her introduction May explained: "poetry, which is the language of the affections, has been freely employed among us to express the emotions of a woman's heart." As a consequence, many during the period noted a "feminization" of poetry as well as the novel.

The British poets of the nineteenth century considered themselves as working within a tradition of women's poetry (Armstrong 323). The "poetesses" of the early Victorian period consciously and deliberately invoked their female precursors. Just as their male contemporaries turned to the Romantics for inspiration—Robert Browning to Percy Bysshe Shelley, Lord Alfred Tennyson to John Keats, Matthew Arnold to William Wordsworth—the women turned to the female Romantics, particularly Felicia Hemans and Letitia Elizabeth Landon, not only for the form but also for the subject of their works. Often, their works continued the self-conscious awareness that

pervaded the works of Landon and others. Gendered issues—definitions of womanhood, femininity, as well as love and marriage—predominate as themes.

In her preface to *Venetian Bracelet* (1829), L. E. L. wrote, "I can only say, that for a woman, whose influence and whose sphere must be in the affections, what subject can be more fitting than one which it is her peculiar province to refine, to spiritualise, and exalt?" Poetry represented its female author: "as she is in art, so she is 'in actual life.'" A generation later, Dora Greenwell wrote in "Our Single Women" (1860):

> It is surely singular that woman, bound, as she is, no less by the laws of society than by the immutable instincts of her nature, to a certain suppression of all that relates to personal feeling, should attain, in print, to the fearless, uncompromising sincerity she misses in real life; so that in the poem, above all in the novel— . . . a living soul, a living voice, should seem to greet us; a voice so sad, so truthful, so earnest, that we have felt as if some intimate secret were at once communicated and withheld,—an Open Secret, free to all who could find its key—the secret of a woman's heart, with all its needs, its struggles, and its aspirations.

Exploiting the female voice, Lydia Sigourney (1791–1865) achieved celebrity as the "sweet singer of Hartford" for her sentimental and religious poems, children's books, and travel writing. For catering to the common tastes of her reader, Edgar Allen Poe dismissed her as a Hemans imitator, only to later seek her work for *Graham's Magazine*. She was also listed as editor of *Godey's Lady's Book* from 1839 to 1842, as the magazine attempted to cash in on her enormous popularity with American audiences. Like Hemans and her British contemporaries, her work upholds feminine virtues. "Death of an Infant" (1827), for example, mixes motherly sympathy with sentiment:

> Death found strange beauty on that cherub brow,
> And dashed it out.—There was a tint of rose
> On cheek and lip;—he touched the veins with ice,
> And the rose faded.—Forth from those blue eyes
> There spake a wishful tenderness,—a doubt
> Whether to grieve or sleep, which Innocence
> Alone can wear. . . .

But while critics have discerned implied criticism of the limited role of women in Hemans's works, Sigourney's published claims enforce her conventional views. She argued that "woman should keep to her own sphere and not attempt to fill man's place." This did not prevent her, however, from becoming the rival of male poets Henry Wadsworth Longfellow and William Cullen Byrant.

If there does exist a recognizable "poetics of the feminine" as described by L. E. L. and Sigourney, individual poets alternately endorse the ideal of poetry as the gush of feminine emotion or resist and undermine it. Their

works demonstrate a complex negotiation of expectations for feminine literary production.

This can easily be seen in the works of two of the most famous and respected Victorian poets: Elizabeth Barrett Browning (1806–61) and Christina Rossetti (1830–94). In poems written following Landon's salaciously mysterious death in 1838, they self-consciously meditate on female artistry. Landon's death appears almost a literary creation itself: She had traveled to Africa with her husband, George Maclean, who was appointed governor of Cape Coast, Africa, where she had found herself the sole woman in the colony and spent her days in isolation in the gloomy castle. A maid discovered her dead on the floor of her bedroom, a bottle of prussic acid in her hand, apparently the victim of an accidental overdose of medication that she had routinely taken for stomach spasms. Rumors circulated that she had either committed suicide in response to being isolated and neglected by her husband or that he had poisoned her. The image of the dead author, in exotic Africa, bottle of prussic acid in hand, inspired Elizabeth Barrett Browning's poem "L. E. L.'s Last Question" (1844). Barrett Browning's poem perpetuates the image of the secretly insecure, unfulfilled female celebrity.

Barrett Browning's poem, in turn, prompted Christina Rossetti to write her poem "L. E. L." (1863), producing yet another imaginary portrait the solitary poetess. Significantly, Rossetti constructs her image of L. E. L. by consciously echoing the poet's own works. Her opening stanza directly recalls "Lines of Life":

> Downstairs I laugh, I sport and jest with all:
>> But in my solitary room above
> I turn my face in silence to the wall;
>> My heart is breaking for a little love.

In Rossetti's poem, the poet is cut off not only from other humans but also from nature itself, from the birds, flowers, animals, and plants of "living spring." Not real readers but only transcendent beings can accurately perceive her pain: "Perhaps some saints in glory guess the truth,/Perhaps some angels read it as they move." An angel tells her that "true life is born of death." Ironically, the test of fame is that it continues after death. Both Barrett Browning and Rossetti thus perpetuate the image of the doomed female author, thus highlighting the contradictions inherent in the ideal of feminine expressiveness.

FEMININE INNOVATIONS IN POETRY

By 1850, despite the reservations she may have expressed in her own works, Barrett Browning was indisputably famous. During her marriage to Robert Browning, her literary reputation surpassed his. Self-taught in Greek, Latin, French, Italian, and Hebrew, she consumed European history and literature and, at the age of 11 or 12, composed her own epic, *The Battle of Marathon*, privately printed by her father in 1820. *Seraphim and Other Poems* (1838) es-

tablished her reputation, but it was *Poems* (1844) that made her an international celebrity and drew Robert Browning's admiration. His first letter to her begins, "I love your verses with all my heart, dear Miss Barrett." Their courtship served as the basis for her famous *Sonnets from the Portuguese*, which she only dared to show him three years after their marriage. After he read the poems, Browning urged their publication in a new edition of *Poems* (1850).

Barrett Browning's sonnets are the first to present the sequence of love, from its first flowering to its consummation, from the female lover's perspective. While "How do I love thee? Let me count the ways" is surely the most famous and assured of her sonnets, others are noteworthy for so directly expressing the confusions, fears, and raptures of love. In Sonnet 5, for instance, Barrett Browning writes,

> I lift my heavy heart up solemnly,
> As once Electra her sepulchral urn,
> And, looking in thine eyes, I overturn
> The ashes at thy feet. Behold and see
> What a great heap of grief lay hid in me,
> And how the red wild sparkles dimly burn
> Through the ashen greyness.

These lines, with their classical allusion, movingly describe the grief she had felt over the loss of her brother, who drowned while sailing, and the release she has found through Browning's affection. An invalid plagued by a lung disease she first experienced at age 14, Barrett Browning had looked forward only to her own death until he appeared, bringing with him "Not Death, but Love," as she says in the opening sonnet in the cycle. In Sonnet 7, she explains the transforming power of their love:

> The face of all the world is changed, I think,
> Since first I heard the footsteps of thy soul
> Move still, oh, still beside me, as they stole
> Betwixt me and the dreadful outer brink
> Of obvious death, where I, who thought to sink,
> Was caught up into love, and taught the whole
> Of life in a new rhythm.

The "red wild" of desire he aroused is evident in the sensuous imagery of Sonnet 29, as her thoughts wrap around him "as wild vines, about a tree." Better still, she wishes for his presence, asking that he "let these bands of greenery which insphere thee,/Drop heavily down, . . . burst, shattered, everywhere!" Elsewhere she describes her doubts, asking "Beloved, dost thou love?" fearing she has imagined his affections or that she herself cannot love. Taken as a cycle, the sonnets capture the complexities of love and add greater depth and resonance to the assurance she offers in "How do I love thee?": "I shall but love thee better after death."

The sonnets' classical allusions and Italian structure showcase Barrett Browning's learning and literary artistry in her use of traditional forms. At the same time, their simple language and tangible, domestic associations mark the poems as products of their age as well as their female author. Barrett Browning describes herself as a "poor, tired, wandering singer," an "out-of-tune/Worn viol, a good singer would be wroth/To spoil his song with." By contrast, Robert is a "princely Heart," enrobed in royal purple, who lifts the latch to her home and heart. Her "woman-love" is pure and humble, while his divine passion transports her: in "master-hands" her defaced viol produces "perfect strains."

Just as Barrett Browning feminized the sonnet sequence, she transformed the epic, another traditionally male form, in *Aurora Leigh* (1857). Her poem, like Wordsworth's *Prelude*, traces the growth of the mind of a poet—a female poet. In the process, Barrett Browning offers insight into the restrictions of education, marriage, and action imposed on women in the nineteenth century. The orphaned Aurora Leigh chafes under the limited education offered by her aunt: superficial knowledge of religion, history, languages, sewing, and music. Intellectually rebellious, Aurora takes refuge in her own imagination:

> I had relations in the Unseen, and drew
> The elemental nutriment and heat
> From nature . . .
> I kept the life thrust on me, on the outside
> Of the inner life with all its ample room
> For heart and lungs, for will and intellect,
> Inviolable by conventions.

Aurora further challenges convention by rejecting Romney Leigh's marriage proposal, perceiving that she will have no life of her own but subordinate herself instead to supporting him in his philanthropic activities. She flees to London, where she supports herself as a writer and poet. Eventually, however, both Romney and Aurora are changed by their experiences: Romney sees the failure of his abstract socialist project and Aurora accepts the human need for companionship. Their marriage closes the poem. Thus, Barrett Browning's epic captures the contradictions of the age, resolving the tension between women's desire for independence, particularly intellectual freedom, and her expected role as wife and mother.

The same tensions are present in the works of Christina Rossetti. The title poem from *Goblin Market and Other Poems* (1862) embodies the duality in two sisters, one reserved and cautious, the other impulsive and desiring. Goblins tempt the sisters with the luscious fruits they sell. Laura gives into temptation, gorging herself on fruit purchased with a lock of her hair; her sister, Lizzie, resists. Laura, deprived of their fruit the next evening, slips into illness and is revived only when Lizzie brings her the juices of the fruit smeared on her face. Despite the goblins' attempts to make her open her

mouth, Lizzie refuses. Laura is revived by her sister's charity, and, by the poem's end, each has married and borne children. The sexual overtones of Rossetti's poem are evident: The girls know "We must not look at goblin men,/We must not buy their fruits." Laura exchanges a portion of herself for the fruit, which she "sucked and sucked and sucked the more," returning to her sister still longing for more: "I ate and ate my fill,/Yet my mouth waters still." Deprived of the fruit, she endures a "passionate yearning,/And gnashed her teeth for baulked desire." In her resistance, Lizzie is a model of chastity: She stands "like a royal virgin town." They tell their own children the story to teach them "there is no friend like a sister," implying that women embody both desire and restraint and that balance between the two is the solution.

Women's concerns figure prominently in the works of the popular Adelaide Anne Proctor (1825–64). Proctor published *Legends and Lyrics* (1858), a collection of poems containing several that had been previously published in Charles Dickens's *Household Words* under the pseudonym Mary Berwick. Her most famous poem may well be the sentimental "A Lost Chord," but its conventional piety is absent in much of Proctor's other poems, which focus on societal expectations for women. "A Legend of Provence" recounts the redemption of a "fallen woman," and the series "A Woman's Question," "A Woman's Answer," and "A Woman's Last Word" considers woman's position in love and marriage. The speaker in "A Woman's Question" asks her lover to question the sincerity of his love before she trusts her "fate" to him. In "A Woman's Answer," she toys with her lover, listing all the things she loves, before finally admitting "I love you more,/Oh, more a thousand times than all the rest." Facing the dissolution of a romance, the speaker in "A Woman's Last Word" says "I shall try, not vainly,/To be free" but by poem's end, hesitates: "must we part, when loving/As we do?" Proctor's poems, like Barrett Browning's, conform to the expressive conventions of women's poetry but capture the ambivalence of women themselves.

"Miss Proctor I am not afraid of," Rossetti confessed to her publisher, "but Miss Ingelow . . . would be a formidable rival to most men, and to any woman." Rossetti's judgment was prescient, for Jean Ingelow (1820–97) achieved commercial success with her highly descriptive, lyrical works and attracted the admiration of Edward Fitzgerald and Tennyson. Many of her popular works feature broken love affairs, as in "Divided" (1863), in which the natural landscape is described as sympathetically reflecting a woman's grief at her lover's departure.

POETIC RESISTANCES

By the 1860s, women writers were beginning to challenge conventional expectations for women in their nonfiction works as well as their poetry, as agitation for women's right to own property, to be educated, and to vote increased. Poet Dora Greenwell, for instance, defended women's education and suffrage and in "Our Single Women" (1862) rejected the doctrine of sep-

arate spheres, arguing that "the proper sphere of all human beings is the largest and highest which they are able to attain to." Augusta Webster (1837–94) also agitated for women's right to a university education and to vote. In her poetry, most notably *Portraits* (1870), she adopts the dramatic monologue popularized by Robert Browning to represent the real attitudes of women. "By the Looking-Glass" and "Faded" criticize the convention of valuing women for their external appearance alone. The aging spinster of "Faded" bemoans the fate of unmarried women left "to wait and wait, like the flower upon its stalk,/For nothing save to wither." In "A Castaway," a high-class prostitute, by contrast, cannily exploits her beauty:

> Why, 'tis my all,
> Let me make much of it: is it not this,
> This beauty, my own curse at once and tool
> To snare men's souls (I know what the good say
> Of beauty in such creatures) is it not this
> That makes me feel myself a woman still,
> With some little pride . . .

For the sure voice displayed in works such as these, Rossetti deemed Webster one of the "most formidable" poets of the nineteenth century.

The prostitute in "Magadalene," by Jewish poet Amy Levy (1861–89), does not trouble to rationalize her trade, as in Webster's poem. Instead, she concludes "Nothing is known or understood/Save only Pain." Like Webster, Levy employed the monologue to give women a voice. In "Xantippe," Socrates's wife describes her original attraction to the philosopher and how, following their marriage, "the high philosopher,/Pregnant with noble theories and great thoughts,/Deigned not to stoop to touch so slight a thing/As the fine fabric of a woman's brain—/So subtle as a passionate woman's soul." Enraged by his comments regarding women's inferiority, she lashes out and resents having borne such a "weary life." Levy herself, perhaps as a consequence of her inability, given Victorian conventions, to express openly her sexual desire for women, including South African feminist Olive Schreiner, committed suicide at age 27.

Women's poetry written near century's end also challenged accepted conventions regarding women's sexuality. Ella Wheeler Wilcox (1850–84) wrote openly about female desire, causing her *Poems of Passion* (1883) to be rejected for its "immorality" by publishers. The audience for such works did exist nonetheless. After a Chicago publisher eventually accepted the work, it became enormously successful, selling 60,000 copies in two years. In Britain, Katherine Bradley (1846–1914) and Edith Cooper (1862–1913) lived together as poets and lovers, publishing their collaborative works under the pen name Michael Field. Inspired by Henry Wharton's edition of Sappho's works (1885), they wrote *Long Ago* (1889), which collects their own translations of Sappho's lyrics and, for the first time, acknowledges that they were addressed to female as well as male lovers. In one fragment, Sappho addresses a "pure band" of maidens:

What praises would be best
Wherewith to crown my girls?
The rose when she unfurls
Her balmy, lighted buds is not so good,
So fresh as they
When on my breast
They lean and say
All that they would,
Opening their glorious, candid maidenhood.

Their poems from *Sight and Sound* (1892) anticipate the works of the Modernists with their experimental rhymes and imagery. "A Girl" plays deftly with rhyme to paint its sensual portrait of femininity, as in this excerpt:

A Girl,
Her soul a deep-wave pearl
Dim, lucent of all lovely mysteries;
A face flowered for heart's ease,
A brow's grace soft as seas
Seen through faint forest-trees:
A mouth, the lips apart,
Like aspen-leaflets trembling in the breeze
For her tempestuous heart.

The short "Cyclamens" offers an equally striking visual image:

They are terribly white:
There is snow on the ground,
And a moon on the snow at night;
The sky is cut by the winter light;
Yet I, who have all these things in ken,
Am struck to the heart by the chiselled white
Of this handful of cyclamen.

In its simplicity and power, this poem is a precursor to the works of the American Imagists writing in the early twentieth century: Ezra Pound, H. D., and Amy Lowell.

Perhaps the most experimental poet of the period was Emily Dickinson (1830–86). Reclusive and eccentric, Dickinson produced poems of startling passion and stylistic daring. Because of her unconventional style, only eight of her poems were published in her lifetime. Four years following her death, Mable Loomis Todd published a volume containing 1,776 poems she had found among Dickinson's books and tucked away in drawers in her home in Amherst, Massachusetts. While she was "enchanted" with Barrett Browning's poetry, particularly *Aurora Leigh,* and admired the works of Sigourney, Dickinson did not emulate her contemporaries but developed a highly original style of her own. Compact and elliptical, Dickinson's poems violate conventions of rhyme and grammar. Often focused on death, her poems offer

unexpected images. Describing the numbness of grief, she writes, "After a great pain, a formal feeling comes—/The Nerves sit ceremonious, like Tombs—." The often anthologized "Because I could not stop for Death" personifies death as a gracious coachman:

> Because I could not stop for Death—
> He kindly stopped for me—
> The Carriage held but just Ourselves—
> And Immortality.

Others are deliberately self-conscious meditations on solitude and creativity that contain tantalizing autobiographical references—to her penchant for wearing only white, for instance, or her self-imposed isolation from others: "A solemn thing—it was—I said—/A woman—white—to be—/And wear—if God should count me fit—/Her blameless mystery." Epigrammatic statements—"The Soul selects her own Society," "Much Madness is divinest Sense," "I dwell in Possibility—/A fairer House than Prose"—depict the creative process itself, including her now famous dictum to "Tell all the Truth but tell it slant." Critics now interpret much of her poetry as self-reflexive comments on the poems themselves:

> She dealt her pretty words like Blades—
> How glittering they shone—
> And every One unbared a Nerve
> Or wantoned with a Bone—

Her daring works, published in 1900 on the threshold of **Modernism**, would not find an appreciative audience until poetic experimentation became the order of the day in the early twentieth century. Not until the 1950s did Dickinson have a standard edition of her work published.

EDITORS AND CRITICS

As editors and critics, women in the nineteenth century shaped literary creation and reception. Margaret Fuller (1810–50), the "high priestess" of the New England Transcendentalist group that included Ralph Waldo Emerson, Bronson Alcott, and others, began her career as editor of *The Dial*, the group's periodical, from 1840 to 1842. Soon afterwards, she became the literary editor of the New York *Tribune*. Her most famous work, *Woman in the Nineteenth Century* (1845), is alternately a work of literary criticism and a feminist manifesto. Fuller analyzes female characters in fiction as the basis for advocating women's independence of mind and action. She argues that "woman can express publicly the fullness of thought and creation, without losing any of the peculiar beauty of her sex." Aesthetic advancement depends on women's participation in society:

> We would have every path laid open to Woman as freely as to Man. Were this done, and a slight temporary fermentation allowed to subside, we should see

crystallizations more pure and of more various beauty. We believe the divine energy would pervade nature to a degree unknown in the history of former ages, and that no discordant collision, but a ravishing harmony of the spheres, would ensue.

She recommends the works of George Sand and Maria Edgeworth as embodiments of female potential.

Anna Julia Cooper's *A Voice from the South by a Black Woman of the South* (1892) added the voice of African Americans to feminist critique as well. One of the very few women, not to mention African American women, to receive a formal education, earning her bachelor's and master's degrees from Oberlin College, Cooper advocates education for black women as well as men: "Not to make the boys less, but the girls more." Only by learning together would African Americans advance in a culture that favored whites.

By the turn of the century, a "new woman" was emerging, committed to securing her participation in American and British society through the vote, equal education, and equal access to the professions. Women were to be at the forefront of the social, political, and cultural changes that would characterize the new century. Literary feminism was a primary vehicle of women's activism.

5

Modern Experiments: 1895–1945

Modernism (1895–1945) was an international, multidisciplinary movement that challenged realist modes of artistic representation. Prizing artistic innovation, Modernism developed out of a reaction against middle-class conventionality that characterized the second half of the nineteenth century. The "moderns" questioned the founding principles supporting social and cultural institutions, including the belief in social progress. They demonstrated a healthy skepticism of organized religion, patriotism and military pride, capitalist economies, and the work ethic and rebelled against sexual prudery and constraints on free speech. On one hand, they embraced change and looked to the promise of new beginnings, new ways of being and living, new forms of art and expression for a new century. On the other, they looked back to the classical cultures of Greece and Rome as artistic sources of modernity.

Feminist historians and critics of the past 30 years have disproved the assumption that women were merely the handmaidens of Modernism, busy furthering the careers of male geniuses but lacking the education and acumen to make important literary judgments. Women played crucial roles in engendering and shaping the new writing by teaching themselves the editorial, administrative, and marketing skills necessary to launch Modernism and by providing space for discussions of the place of art in society and the role of language in shaping culture. Through their own literary productivity—in editorials and journal articles, as poets and fiction writers—they provided examples of the new art and justification of its aesthetic principles.

The moderns were influenced by scientific and sociological discoveries of the nineteenth century: Charles Darwin's theory of the origin of the species, Gregor Mendel's work on heredity, non-Euclidian physics and advances in technology, the theories of sexologists Havelock Ellis and Edward Carpenter, the emerging work in psychology by Sigmund Freud and Carl Jung, and Henri Bergson's writing on time and subjectivity. Modernist intellectuals questioned what it meant to be human and how to represent the "human" in art. Freud's theory of the **unconscious** radically challenged nineteenth-century beliefs in self-control and masterful destiny, providing a rich terrain for artists whose explorations into sexuality revealed their own insecurities about sex differences, sex roles, and creativity. Writers were intensely interested in language as the primary medium of human communication. The "science" of literary representation—in which literary form evolved from subject matter—reflected a larger cultural interest in artistic forms, as can be

seen in the painting, photography, music, dance, and architecture of the pe-
riod. The notion of literature as a scientific enterprise marked a radical break
with earlier ideas about how literature was made, what cultural purposes it
served, and what audiences it addressed.

Although the birth of the modern age of artistic experimentation is often
said to coincide with the death of Queen Victoria in 1901, the roots of this
movement belong to the **fin-de-siècle** period of the 1890s, characterized by
social and political upheaval and threats to European imperialism, such as
the Boer War, Ireland's desire for home rule and independence from Great
Britain, and the United States's efforts in the Spanish-American War to se-
cure political and economic interests beyond its borders. Class tensions, la-
bor disputes, and increasing pressure for woman's **suffrage** in England and
the United States led to violence. In 1895, harassment of homosexuals and
enforcement of sodomy laws culminated in the trial and incarceration of
playwright Oscar Wilde, the best-known **dandy** of his era, for his affair with
the son of the Marquis of Queensbury. Mistreatment of prostitutes was dra-
matically highlighted in the Jack the Ripper murders of prostitutes in East
London (1888). The final decade of the nineteenth century saw reversals
and inversions of codes of masculinity and femininity—homosexual male
dandies dressing in feminized attire and women cross-dressing as men—
that suggested a collapse in moral values and codes of social conduct.

This decade of decadence was characterized by a feminization of culture
as the Victorian doctrine of "separate spheres" broke down. The new gen-
eration of women born in the 1870s and 1880s refused to enter the "cult of
domesticity" that had entrapped their mothers; they also refused to under-
take unpaid social ministry, a hallmark of the Victorian era, that reinforced
family values and the importance of marriage as a civilizing institution.
These new women demanded educational equality, access to professions,
the right to vote and own property in their own names, and sexual freedom.
Independent, outspoken, and ambitious, they threatened the professional
livelihoods of men by joining the workforce and openly espousing feminist
principles of equality with men. In their effort to gain gender equality, new
women and **suffragists** attacked the privilege of the sex, gender, and class
systems with their inherent paternalism as represented by gentlemen's pri-
vate clubs and old school networks. Those who felt threatened by the new
women referred to them as "a monstrous regiment" (*Fortnightly Review*, 1897)
who took jobs away from men.

Women's desires for education and professional, paid work were en-
couraged by government efforts to increase literacy and by the founding of
professional and learned societies that set standards for intellectual labor.
By 1900 the literacy rate in England had reached 97 percent for women and
men. Education was increasingly viewed as essential to advancing civiliza-
tion, as well as providing a primary vehicle for moving into the middle class.
Women entered colleges and universities in growing numbers, and by 1910
accounted for 40 percent of undergraduates in the United States. Expansion
of educational opportunities for women, including training in medicine, law,

social work, and the teaching professions, opened pathways to public life. For example, Gertrude Stein (1874–1946) took an undergraduate degree in philosophy from Radcliffe College (Harvard University) and later studied medicine at the Johns Hopkins University. Poet Edna St. Vincent Millay, born nearly 20 years after Stein, graduated from Vassar College, having studied Latin and Greek—subjects historically restricted to men.

Women in Great Britain faced greater challenges. Following passage of the Education Act of 1870, women could take university courses and sit for examinations but were prevented from taking degrees. Thus they were denied a pathway to graduate study and entrance into the professions of law, medicine, religion, and university teaching, as Virginia Woolf recounts in *A Room of One's Own* (1929) and *Three Guineas* (1938). The expansion of the professions in Britain during the second half of the nineteenth century to include the social and civil services and imperial and military administration paralleled the growth of the middle class and was accompanied by the establishment of professional associations (e.g., Royal Horticulture Society, College of Physicians) that denied women membership.

NEW WOMAN LITERATURE

Literature as an artistic practice, long considered a vocation or "calling," achieved status as an occupation in the last decades of the nineteenth century, a period of enormous change in the literary marketplace. A burgeoning publishing industry marketed books concerned with contemporary public issues, and women writers found an audience eager for writing on such subjects as sexuality, femininity, celibacy, maternal instincts, and patriarchal entitlements. By the 1890s, this **New Woman** literature was beginning to cut into the market for artistic and "high" literature. South African Olive Schreiner (1855–1920) and English writers Mary Cholmondely (1859–1925) and Mona Caird (1858–1932) paved the way for later feminist writers by inverting the love-marriage plot of the women's novel and exposing the **misogyny** and **xenophobia** inherent in British middle-class values. Portraying women as active agents in politics, culture, and social life, these works privileged **ideological** concerns rather than the literary style and aesthetic purity that defined "serious" literature and that became a hallmark of Modernism.

Versions of the New Woman novel written in the modernist period include works in which relationships between women who prize independence and who are committed to feminism and social reform are often central themes. Irish-born Dame Rebecca West (1892–1983, christened Cicily Fairfield) was an outspoken feminist who lived the life of a "new woman." Trained at the Royal Academy of Dramatic Art in London, she supported herself as a novelist and journalist, writing for the feminist *Freewoman* magazine (1911) and for the socialist weekly the *Clarion* (1912), openly criticizing the capitalist-patriarchal system. Vita Sackville West (1892–1962), rebelling against the conservative politics of the English aristocracy into which

she was born, explored feminist themes in *All Passion Spent* (1931). This novel owed a debt to the feminism of her friend Virginia Woolf, especially to *A Room of One's Own* (1929) in which Woolf wittily decried the history of English class prejudice and misogyny. This subject was central to virtually all of Woolf's fiction but especially to *The Years* (1937), which traced the history of the patriarchal Pargiter family.

American writing in the New Woman genre includes Charlotte Perkins Gilman (1860–1935), best-known for her story "The Yellow Wallpaper" (1892), which tells in diary form of a young mother driven to insanity by her controlling physician husband. Gilman's most important novel, the feminist utopian *Herland* (1915), portrays an all-female community ordered by peace, prosperity, and a well-balanced ecological environment. In "A Jury of Her Peers," Susan Glaspell (1876–1948) tells how women neighbors outwit the local police when their friend is suspected of killing her abusive husband. Ellen Glasgow (1873–1945) was known for her "vein of iron" novels about self-sufficient, independent women. Her most powerful and controversial novel was *Barren Ground* (1925), a story of a woman struggling to be a successful farmer. The heroine of Willa Cather's *The Song of the Lark* (1915) defends her choice of personal independence and a career rather than marriage. Kay Boyle (1902–92) also created strong women characters who assumed responsibility and initiative in the face of male weakness. A particularly powerful example can be found in the semi-autobiographical novel, *Plagued by the Nightingale* (1931).

Among these writers Glasgow and Cather gained popular appeal, but others were marginalized because they refused to mute their anger at the class and gender systems that enforced the dominant system of patriarchy or because, as in the case of Radclyffe Hall (1880–1943), their subject matter challenged traditional gender roles. Her early *The Unlit Lamp* (1924), a story of a young girl emotionally and erotically manipulated by her mother, was rejected ten times before appearing in 1924 to critical controversy because of its underlying themes of lesbianism and emotional incest, themes that Hall also explored in *The Well of Loneliness* (1928), which was banned in England.

NOVELS OF PSYCHOLOGICAL DEVELOPMENT

The **novel of psychological development** came into prominence at the beginning of the century. Whereas the **novel of manners** focused on the social contexts of public and private life, the psychological novel focused on the internal mental and emotional life of the central protagonist. Emergent theories in language and linguistics produced innovations in narrative method that allowed writers to explore the psychology of human behavior from new perspectives. Writers used **stream-of-consciousness**, **free indirect discourse**, and internal monologue to match literary style to subject matter. Their efforts to mirror internal and external perspective and conscious and unconscious states accounts for the nearly scientific rigor with which avant-

garde writers approached their subject matter. Literary success was measured by the degree to which the language of the literary work became one with its subject matter.

Stream-of-consciousness, which directly records thought processes, was the most innovative of these techniques. It first appeared in French novelist Edouard Dujardin's *Les Lauriers sont coupés* (*We'll to the Woods No More*, 1888). The first practitioner of this method in English was Dorothy Richardson (1873–1957). In 1913 at age 40, she began writing a multivolume autobiographical novel, *Pilgrimage*, that traced the development of its heroine between the ages of 17 and 40. In an enthusiastic review in *The Egoist* magazine in 1918, British novelist May Sinclair (1863–1946) coined the term "stream-of-consciousness" to define the novel's narrative method. Richardson's technique proceeds as a commentary on events; for example, Miriam thinks to herself as she hears her parents talking: "Of course they talked in their room. They had talked all their lives; an endless conversation; he laying down the law . . . no end to it . . . the movement of his beard as he spoke, the red lips shining through the fair moustache" (Volume 1, 460).

Richardson's audiences missed (or resisted) the point she had hoped to make—that a woman's life, told honestly and in detail, revealing the fabric of intellect and feeling, could have importance and value, and that men's ways of speaking and women's differ markedly in tone and substance (observations later echoed by Virginia Woolf). Although Richardson did not identify herself as a feminist, *Pilgrimage* represents the first modernist-feminist novel, a work that gives aesthetic shape to a woman's life.

Several women modernists adapted the technique to portray female psychological realism. Virginia Woolf used it in *Mrs. Dalloway* (1925) and *To the Lighthouse* (1927) to reveal human consciousness and in *The Waves* (1931) to endow nature with consciousness. Set in London on a spring day, *Mrs. Dalloway* follows Clarissa Dalloway's preparations for a dinner party, seamlessly incorporating her reminiscences and remembrances of the past:

> What a lark! What a plunge! For so it had always seemed to her, when, with a little squeak of the hinges, which she could hear now, she had burst open the French windows and plunged at Bourton into the open air. How fresh, how calm, stiller than this of course, the air was in the early morning; like the flap of a wave; the kiss of a wave; chill and sharp and yet (for a girl of eighteen as she then was) solemn, feeling as she did, standing there at the open window, that something awful was about to happen.

Jean Rhys (1890–1979) used stream-of-consciousness to capture the loneliness and alienation of her women characters and to reveal unconscious elements of human motivation. *Good Morning Midnight* (1939) closes as Sasha Jansen in her Paris hotel room drifts into a drunken stupor: "A hum of human voices talking, but all you can hear is 'Femmes, femmes, femmes, femmes.'" . . . And the noise of a train saying: 'Paris, Paris, Paris, Paris.' . . . But I know quite well that all this is hallucination, imagination" (187).

Other women modernists turned the method inside-out. Gertrude Stein wrote her best-selling memoir, *The Autobiography of Alice B. Toklas* (1933), from the perspective of her lover. In *Everybody's Autobiography* (1937), she erased individual consciousness by invoking the collective "everybody" in a text that challenges Descartes's famous dictum: "I think, therefore I am." Zora Neale Hurston (1901–60) used stream-of-consciousness and internal monologue to distinguish the shape of women's lives from those of men in *Their Eyes Were Watching God* (1937). The novel is told through a double narration—the thoughts of its central character Janie, who speaks in black dialect, and an impersonal, almost biblical voice that opens the story: "so the beginning of this was a woman and she had come back from burying the dead."

Djuna Barnes voiced interior consciousness by using internal monologue, a dramatic technique drawn from Renaissance theater. The most famous example in Barnes's writing is the long monologue by Dr. Matthew O'Connor, a drunken down-and-out abortionist and transvestite, in *Nightwood* (1936). Barnes inverted the method in the final paragraphs of the book when the psychologically disturbed Robin Vote loses the ability to speak and sinks down before an image of the Madonna in a country chapel. Robin mimics the slavering, trembling, barking dog that had followed her there.

H. D. (Hilda Doolittle) used the method to portray mental breakdown, as Virginia Woolf had done with the Septimus Smith character in *Mrs. Dalloway*. In *HERmione* (1983), an autobiographical novel published after H. D.'s death, the central character, whose nickname is "Her," thinks of herself in the third-person and struggles to speak from the "I" position:

> Her Gart tried to hold on to something; drowning she grasped, she caught at a smooth surface, her fingers slipped, she cried in her dementia, "I am Her, Her, Her." Her Gart had no word for her dementia, it was predictable by star, by star-sign, by year.

Literary experimentalists drew on advances in technology, bringing into their work characteristics of emergent means of travel and communication—cinema, radio, telegraph, telephone, newspaper presses, airplanes, ocean liners, and automobiles. These technologies were imported into narrative and poetry both as subject matter and as stylistic devices to represent modernity. Two creeds governed the modern: "Make it new" (the rallying cry of the Imagists, led by Ezra Pound) and "Form follows function," represented in the United States by the architecture of Louis Sullivan and Frank Lloyd Wright.

Writers who sought a general readership and who did not break with standard narrative forms by employing new narrative techniques were labeled "traditionalists." They were dismissed and sometimes openly ridiculed by the avant-gardists. For example, Edith Wharton, Elizabeth Bowen, Willa Cather, Katherine Anne Porter (1890–1980), and short-story writer Katherine Mansfield (1888–1923, born in New Zealand) were praised

for the clarity of their writing. Yet by modernist standards, they belonged to the nineteenth century; their literary subjects and style were considered to be worn out, or "exhausted," incapable of renewal. They failed the "make it new" test. Moreover, they wrote primarily of women's experiences—adolescence, courtship, marriage, and domestic life—their stories revealing the restrictions on girls' and women's lives and the barriers to personal and professional freedom that the New Woman novels touted. Although their work was read and appreciated by educated, discriminating readers, the audience for this writing was considered "common" by those who were setting the new standards of intellectual literature.

Openly contemptuous of the general reading public (those who had not studied Latin and Greek, who were not multilingual, who read for pleasure rather than edification), Eugene Jolas, editor of *transition*, an important avant-garde magazine, declared in the "Revolution of the Word" manifesto "THE COMMON READER BE DAMNED." Jolas may have been responding to Virginia Woolf, who broke with her avant-garde contemporaries in championing the common reader. She published a volume of essays entitled *The Common Reader* (1925) that a provided a social history of the importance of popular writing, much of it written by and for women, work that elitist literary critics saw as derivative, coterie literature and anti-feminists viewed as either too lyrical or too bitter. Woolf knew from her own experience as a writer, and from the novels that she read and loved, that literary experimentalism need not be brash and flamboyant—indeed, it may be most successful when used sparingly and with subtlety.

To see how changing literary standards for "traditional" literature weighed against women we can look at the careers of several writers who made significant contributions to psychological writing. The power of publishing houses to promote writers and the influence of literary critics in defining the nature and worth of literary work created a complex intersection of economic and aesthetic concerns that determined the market for women's writing in the first decades of the century.

Kate Chopin (1850–1904), author of *The Awakening* (1899), met nationwide condemnation when male critics reviewed this story of a young Louisiana mother in an unhappy marriage who seeks sexual liberation, searches for self-sufficiency, and dies by drowning. Critics deemed the novel "unwholesome." Women readers recognized the courage of Edna Pontellier's sexual and psychological awakening; they wrote letters praising the novel and invited Chopin to give readings. But the powers of the publishing industry decried the book's sinfulness and degeneracy and suggested that Chopin herself was a woman of ill repute. Modernist critics and their successors ignored Chopin, considering her a southern regional writer, and they overlooked her stylistic contributions to psychological realism. The final scene of the novel employs omniscient narration to underscore linguistically the psychic failure of Edna to effect agency by saying the word "I." In the final scene, which is both the most intimate and distanced of the novel, Edna's thoughts as she drowns are voiced by a third-person narrator: "Her

arms and legs were growing tired. . . . Exhaustion was pressing upon and overpowering her . . . but it was too late; the shore was far behind her, her strength was gone."

Reviewers of the novel found her death the only redeeming feature of the novel, assuming that Edna committed suicide. The narrative complexity of Chopin's novel challenges this assumption, but the power of critics and publishers was such that Chopin found it difficult to market her literary work following this negative publicity. Not until the late 1960s was Chopin's literary reputation revived and *The Awakening* taught in college classrooms.

Eight years after the ill-fated publication of Chopin's novel, Edith Wharton (1862-1937) published her first study of New York society, *The House of Mirth* (1907), a story of immorality among the new rich industrialists in the Gilded Age of New York. Lily Bart, a poor daughter of old society, searches desperately for a husband, but dies of an overdose of barbiturates at age 29 after 11 years on the debutante circuit, having lost both her looks and her meager inheritance at the gambling tables. The novel was both a scandal and a best-seller. Herself a descendant of Anglo-Dutch Old New York, Wharton was decried by her peers for portraying a member of their own social class as "fast and loose" like the new rich invaders. Wharton described her reaction to this "loud cry of rejection and reprobation" in a preface to a later edition of the novel:

> What picture did the writer offer to their horrified eyes? That of a young girl of their world who rouged, smoked, ran into debt, borrowed money, gambled—and crowning horror—went home with a bachelor friend to take tea in his flat! And I was asking not only the outer world to believe that such creatures were tolerated in New York society, but actually presenting this unhappy specimen as my heroine!

Wharton's broader, popular readership decried the novel on quite different grounds: They were horrified at what they assumed was Lily Bart's suicide. Letters to Wharton's publishers and to editors of newspapers throughout the country protested the unjust "murder" of Lily Bart, whom most readers saw as a victim of a self-centered and manipulative society: Her punishment did not fit her "crimes." But critics and common readers alike missed the delicacy of the novel's ending. The closing moments of *The House of Mirth* are narrated through an **impressionistic** interior monologue that obscures the intentionality or accident of Lily Bart's act. Revisions of the manuscript show that Wharton purposely left the ending ambiguous.

Wharton was not in her own time credited as a literary innovator either of subject matter or of technique. Labeled a satirist of contemporary life, she was assumed to uphold the values of a lost past. At only one point in her career, however, did she find the present too painful to chronicle. In the years after World War I, Wharton discovered that she could not write about "modern" topics and chose New York city in the 1870s as the setting for her Pulitzer Prize–winning novel *The Age of Innocence* (1920). The narrative per-

spective of the book is innovative in two ways: It is structured as a series of scenes easily adapted both to a stage play and to film, and the narrative perspective is that of a man. The woman with whom he falls in love is revealed to the reader only through the man's experience of her, so that the reader never has direct experience of Madame Olenska. Wharton often used this technique to reveal the power imbalances between men and women.

Wharton's contemporary Willa Cather (1873–1947) wore men's clothes, called herself "Will," and like Gertrude Stein believed in "maleness" as an essential element of artistic genius. She also used a male narrative persona, narrating her autobiographical novel *My Ántonia* (1919) through the memories of an alter ego, Jim Burden. Although the Nebraska farm community setting is far from Wharton's Old New York, both stories are set in the last quarter of the nineteenth century; explore small, provincial worlds; and share complementary literary styles. The difference in the two women's career patterns is striking, however: Wharton became rich as an author, negotiating literary contracts and royalty advances as if she were a professional agent. Moving to France in midlife, she established an international reputation, her work compared not only to that of Henry James but also to French novelist Honoré de Balzac, and thereby eclipsing her reputation as the chronicler of Old New York. Cather, who also lived a cosmopolitan life and won the Pulitzer Prize for literature in 1922 for *One of Ours*, has not yet escaped her early reputation as a regional writer of the midwestern plains and the Southwest.

The closest literary counterpart in style and subject matter to Wharton and Cather is Elizabeth Bowen (1899–1973). Born into a family of the Protestant Anglo-Irish ascendancy, Bowen wrote of children's lives encumbered or destroyed by absent or dead parents, drawing on her own experiences of a lonely childhood following the death of her mother. Her stories and novels explore the tensions between a disappearing powerful aristocratic class and the rise of an ambitious capitalist middle class in the 1920s and 1930s. In her fiction, the psychological trauma to children who are motherless or unloved is represented by architecture—houses, rooms, corridors, and windows. This theme is further reinforced by the devastation of two world wars, especially the bombing of London during World War II. Reviewers praised Bowen as a literary stylist with exceptional ability to render the psychological states of children caught in unhappy domestic situations endemic to modern life—for example, the half-Jewish boy in *The House in Paris* (1935) sent from London to Paris to meet his mother, who never arrives, or the adolescent Portia in *The Death of the Heart* (1938), sent to live with her much older brother and his resentful wife. Because Bowen was considered a stylist, not an experimentalist, and because she examined the psychological effects of social class and family tensions on children, she was regarded as a writer with a small "palette," working within the limits of the domestic novel.

Other women writers recognized as exceptional stylists but whose work was narrowly classified by genre or audience include American Katherine Anne Porter, who was doubly categorized—as a regionalist of her native

southwest plains and as a short story writer—although she wrote novels, including the best-selling *Ship of Fools* (1962). She was awarded the Pulitzer Prize and the National Book Award in 1964 for her *Collected Stories*.

Novelist, journalist, and playwright Zona Gale (1874–1938), a Wisconsin native who achieved success on Broadway, chronicled small-town midwestern life. Her 1928 essay collection, *Portage, Wisconsin and Other Essays*, is particularly evocative of time and place. Gale's works focused on the realities of women's lives, including the limited opportunities for women outside of marriage and motherhood. The heroine of her best-known novel, *Miss Lulu Betts* (1920), rebels at small-town life. When Gale turned the novel into a stage play, which won the Pulitzer Prize in 1921, she altered the story to provide a controversial happy ending for her heroine.

The writing of Meridel Le Sueur (1900–98) focused on the plight of the rural poor and especially on the lonely and invisible struggle of working-class women's lives. Born in Iowa, Le Sueur was the daughter of a militant feminist and a socialist lawyer father. A high-school dropout and self-trained writer, she began publishing in the 1930s in left-wing New York magazines, including *New Masses*, *The Daily Worker* (the newspaper of the Socialist Workers Party), and later in *Partisan Review* and the *Nation*. Le Sueur challenged the myth of American individualism and upward mobility and was influenced by her mother's activism in seeking the right of women to use contraceptives. A reformer, she was influenced by the work of Emma Goldman (1869–1940), Margaret Sanger (1883–?), and Eugene Debs. The beauty of Le Seuer's writing, which was influenced by Hopi beliefs in the natural world and her passionate commitment to the upper Midwest, led to her to be labeled "The Voice of the Prairie." In *North Star Country* (1945) she describes lyrically and poignantly the drought following the banking "crash" of 1929 that occasioned the Depression years.

New Zealander Katherine Mansfield lived among and was influenced by the experimental modernists in London and was considered to be the best short story writer of her time. Virginia Woolf noted in her diary that Mansfield's was "the only writing I have been jealous of." Influenced by the French symbolist movement, Mansfield employed the techniques of psychological realism—**epiphanies**, flashbacks, daydreams, and internal monologues—that characterize experimental writing. Because she worked in a minimalist genre and because she was beautiful and died young, critical commentary on her work was for many years focused on her bohemian, New Woman life and personality rather than on her work.

Even the literary reputation of Virginia Woolf, who for many years was the only woman to hold a secure (although narrowly defined) place among modernist innovators, has been subjected to critical commentary focusing on her life—her mental illness, her lesbianism, her socialist politics, and her suicide. A key figure in the **Bloomsbury** group of English intellectuals and artists, she was noted for her lyrical writing and narrative experiments with authorial perspective as exemplified in such novels as *Mrs. Dalloway* (1925) and *To the Lighthouse* (1927). Her feminist and socialist writing—*A Room of One's Own* (first given as a series of lectures at Girton College, Cambridge

University) and *Three Guineas*—undercut her image as a Lady of Letters, daughter of Sir Leslie Stephen and cousin of the Thackerays. In these treatises on the politics of patriarchy, she wittily and angrily traces the history of misogyny in public institutions in Great Britain—university, church, court, and military. Reviewers took issue with Woolf's claims, especially in *Three Guineas*, which compared Great Britain to Hitler's Germany, arguing that English women had suffered injustice under a prejudicial system that denied them equal education with men, the right to enter the professions, the freedom from insult and abuse within marriage, the right to vote, and the right to own property in their own name. A pacifist, Woolf became more outspokenly feminist and socialist as Europe moved toward war in the 1930s, and her last writings are among her most confrontational.

Woolf's career offers another perspective on the power of publishing houses in the first decades of the century. Unlike many of her colleagues, she did not submit her work to literary editors. She owned and operated the Hogarth Press (established 1917 in her home), which during her lifetime published all of her novels, short fiction, and essays; her letters and diaries were published by the press in the 1970s and 1980s. The Hogarth Press became one of the most important publishing houses of the twentieth century, printing the work of many avant-garde writers and important intellectuals, including Sigmund Freud, as well as work by many of Woolf's friends and literary rivals.

In 1904, the 22-year-old Virginia Stephen began publishing essays and book reviews in the London *Times Literary Supplement* (*TLS*), the most prestigious literary review in England. The editorial practice at *TLS* of unsigned reviews allowed Virginia to write with authority, criticizing the work of her elders, including friends of her father, Sir Leslie Stephen. These early writing assignments constituted a kind of on-the-job training for her life's work as novelist, memoirist, literary critic, editor, and publisher. Virginia Woolf is not usually identified as a journalist, yet this is how she described herself in her 1931 essay "Professions for Women." After her marriage to Leonard Woolf in 1912, Virginia contributed to the monthly household expenses from her earnings as a literary journalist. Despite Woolf's lifelong fear of critical commentary on her work, she had control over the production and public reception of her work to a far greater degree than writers who published with trade presses. There were distinct advantages to self-publication—and in Woolf's case, she and her husband Leonard set the type themselves, determining all aspects of the physical appearance of their books (Virginia's sister, the artist Vanessa Bell, sometimes provided woodcuts or drawings for Virginia's texts), and determined the numbers of volumes produced and distributed.

PROFESSIONS FOR WOMEN: JOURNALISM, PUBLISHING, BOOKSELLING, PROMOTING ART

At the beginning of the twentieth century, the line between political journalism and cultural commentary was narrower than it is today. Women

modernists wrote in both forms and for a variety of periodicals, but by the gender politics of the day their political writing on suffrage or international events leading to World War I, for example, was viewed as flamboyant or lacking impartiality.

For women modernists journalism was a primary means of earning their livings, a profession that brought them into the public eye, gained them a readership, and allowed them to address social and political issues that might otherwise have gone unreported. Djuna Barnes, Willa Cather, Janet Flanner, Rebecca West, Nancy Cunard, Charlotte Perkins Gilman, Katherine Anne Porter, and Kay Boyle invented investigative reporting as we know it today. Djuna Barnes, writing an essay for *The Brooklyn Eagle* about the forced feeding of British suffragists as police tried to break their hunger strikes, voluntarily underwent forced feeding herself. Photographs taken of her document the brutality of a process to which many British women were subjected in their efforts to gain the right to vote and hold public office.

American journalist Janet Flanner (1892–1978), longtime cultural correspondent for *The New Yorker* magazine, resented the prohibition against women war correspondents by the United States military in the 1930s. She transformed her biweekly "Letter from Paris" into a forum for exposing the global threat of rising totalitarianism in Europe. Nancy Cunard (1896–1965) reported on the Spanish Civil War in open letters to the *Times* of London.

Rebecca West, columnist for the British feminist weekly *Time and Tide*, was a political activist deeply committed to issues of women's education and their social and economic equality. She began as a professional journalist writing the "women's page" of a British weekly, *Labour News*, and later worked with Dora Marsden, editor of *Freewoman* (later *New Freewoman*), a paper devoted to broadening the aims of feminism beyond suffragist "votes for women" to address issues of sexuality, motherhood and childrearing, and the economic dependency of women. The fate of the *Freewoman* illustrates the risks in changes of leadership in publishing. Boycotted by the newspaper industry because of its candid discussions of sexuality, *The Freewoman* collapsed and reinvented itself as the *Egoist*, one of the most important magazines of early Modernism. The transformation, however, reduced Marsden's power as editor, her essays on philosophy and economics disappeared, and eventually so did the feminist philosophy that had fueled *The Freewoman*. The key position at the journal was literary editorship, first held by Rebecca West, who was ousted in favor of American poet and translator Ezra Pound. He skillfully used the position to promote the new writing. Marsden complained to her benefactor, Harriet Shaw Weaver, who financed the magazine, that Pound "reduces *our* editorial powers to zero" (Benstock, 365). When Pound left the *Egoist* to become foreign literary editor for the *Little Review*, founded in Chicago in 1914 by Margaret Anderson (1886–1973) and Jane Heap (1887–1964), British poet Richard Aldington held the post briefly but was replaced by his wife, H. D., while he served in World War I. Throughout these transitions, literary rather than social issues dominated the magazine. In 1917, the literary editorship of the *Egoist* went to American poet T. S. Eliot, then 23 years old. Like Pound, Eliot used this editorial

position to further his goal of defining a literary tradition for writing in English. His was to become an important voice in establishing the literary canon of Modernism. Between 1916 and 1923, Pound broke with five powerful women editors—Amy Lowell (1874–1925), Harriet Monroe (1860–1936), Harriet Shaw Weaver, Margaret Anderson, and Jane Heap—because he believed that they lacked literary judgment (Benstock, 363).

Cities that were important publishing centers for avant-garde work included New York, Chicago, London, and Paris. In Chicago in 1912, 50-year-old Harriet Monroe pioneered not-for-profit publishing when she founded *Poetry: A Magazine of Verse*. Publishing eclectic writing from poets in the United States, Great Britain, Europe, and Asia, Monroe sought diversity in publication and refused to privilege any single school of literary thought. The longest running of the modernist magazines, *Poetry* is still published today, sponsored by the Poetry Center at the University of Chicago.

Unlike trade publications, little magazines were supported by subscriptions, supplemented by financial support from the editor or a patron. Concerned that poetry flourish, Monroe established literary prizes for new writers that carried financial awards. She shared her experiences with other would-be magazine editors, for example, Margaret Anderson, who founded *Little Review* in Chicago; this magazine later moved to New York City and in the 1920s was published in Paris.

Novelist Kay Boyle began her literary career in 1922 working in the New York office of the journal *Broom* (its name referring to the axiom, "a new broom sweeps clean"). This was a short-lived but important magazine. Poet Lola Ridge (1873–1941), a writer on the political left and associate editor of the magazine, organized Thursday afternoon teas in the editorial offices of *Broom*, where Boyle made important literary contacts with such writers as poets Elinor Wylie (1885–1928) and Marianne Moore (1887–1972). Moore, who had just published her first book of poems, would become editor of the prestigious *Dial* magazine, founded by writers Ralph Waldo Emerson and Margaret Fuller in 1840. Moore edited the journal in its last four years of publication (1925–29). This period was one of the most brilliant in the *Dial*'s history and included some of the most important writers and artists of the twentieth century. In Switzerland in 1927, Bryher (born Winnifred Ellerman, 1894–1983) founded *Close Up*, an international review of cinema that she coedited with Scottish film director Kenneth Macpherson until 1933. They made two films in their first year, *Wing Beat* and *Foothills* (1927). In 1930 they made a full-length avant-garde feature film, *Borderline* (1930), starring African American singer and social activist Paul Robeson and poet H. D., who appeared under the name "Helga Doorn." This was the first screen appearance for both Robeson and H. D. Highly influenced by Freudian psychoanalysis, the film is about racism in the postwar "lost generation" world that produced alienation and "borderline" psychic conditions and stress between the sexes, generations, and races.

Even when women were not the founders of magazines or publishing houses, they were often central to the work of these enterprises, providing

editorial assistance and serving as translators. Robert McAlmon's Contact editions, which published Gertrude Stein's *The Making of Americans* (1925) and parts of James Joyce's *Finnegans Wake* (1941), was financially underwritten by the English family of Bryher (his former wife), who wrote children's fiction. The money came from her father, director of the White Star Shipping Line, the English company that built the ill-fated Titanic. His wealth, dispensed by his daughter, supported a number of avant-garde publishing ventures in Paris and London. More than any other publisher in Paris, Robert McAlmon (perhaps under Bryher's influence) supported women's writing; he published Americans Kay Boyle, Mina Loy (1882–1966), H. D., and Djuna Barnes and British writers Mary Butts (1890–1937), Dorothy Richardson, May Sinclair, and Edith Sitwell.

Harry and Caresse Crosby (1892–1970) established the Black Sun Press in 1924, which produced exquisitely designed and illustrated avant-garde texts. When Harry died in a suicide pact with his mistress in 1929, Caresse directed the press for the next 30 years, turning it into a successful business venture and creating a market for modern literature.

In 1931, Alice B. Toklas established Plain Edition to market Gertrude Stein's unpublished work—in Stein's words, "to shove the unshoveable." Alice typed the manuscripts, oversaw the typesetting process, negotiated sales with bookstore owners in Europe and the United States, wrapped the books (in plain brown paper), and handled the details of postage, shipping, and customs duties. Six works had appeared under the Plain Edition imprint when the success of *The Autobiography of Alice B. Toklas* (1933) eliminated the need for self-publication.

Anais Nin established two publishing imprints. The first, Siana Editions, was set up in 1935 in the barn next to her farmhouse north of Paris. Control of the press was wrested from her by her friend the novelist Henry Miller and some of his friends, who used it to publish their own work. They did agree, however, to set the type for her **surrealist** poem "The House of Incest" (1958), which examines a female-centered world of sexuality and violence. This work was not well marketed by her male colleagues and received no reviews. When the approaching war forced Nin to close her press and flee France in 1939, she settled in New York City's Greenwich Village. Nin set up a small hand press in 1941 with money from Frances Steloff (1887–1941), who marketed Nin's writing through her bookshop, the Gotham Book Mart. As the United States went to war against Germany and Japan, Nin was producing limited editions of her own writings, engraved texts set in unusual typefaces that received high praise even from reviewers who disliked her woman-centered subject matter and described her as a "manhater."

Like small presses, bookstores also played crucial roles in "manifesting" and marketing Modernism. Ground zero of this movement was the Paris Left Bank, in particular the rue de l'Odéon, where an international artistic and intellectual community frequented two bookshops and lending libraries presided over by the two "muses" of Modernism. The English-language

bookshop was Shakespeare and Company, founded by Sylvia Beach (1887–1962), and the French-language bookstore, La Maison des Amis des Livres (The House of the Friends of Books), was located directly across the street and was owned by Beach's companion, Adrienne Monnier (1892–1955). These were the settings for public readings, theatricals, and musical performances. For example, at Shakespeare and Company on an evening in the 1930s, one could listen to T. S. Eliot read his poetry to an audience that included James Joyce. Another time one could hear English poet Edith Sitwell read her work at an evening in honor of Gertrude Stein. On yet another evening, a patron might hear at the shop across the street Valéry Larbaud read from his French translation of Joyce's *Ulysses*, which was first published in English by Sylvia Beach under the imprint "Shakespeare and Company" in 1922. While waiting for the reading to begin, one could browse through the literary review founded and edited by Monnier, *Le Navire d'Argent* (The Silver Ship). The New York City counterpart to Shakespeare and Company was the Gotham Book Mart, still in operation after nearly 70 years.

LITERARY SALONS AND POLITICAL ACTIVISM

Bookstores provided welcoming environments for the modernist literary and artistic "revolution," but the movement's goals were also furthered through **salon** culture, especially in Paris, where meetings in private homes to play music, read poetry, and discuss philosophy and politics had a centuries-old tradition in which women played prominent roles. Of the important European cities of modernism, Paris was most attractive to Americans because of its long intellectual history, its respect for artists and writers, and—from the nineteenth century on—its low cost of living. As Gertrude Stein famously proclaimed in her tribute to the city in *Paris France* (1940), "Paris was where the twentieth century was."

Stein was among the first to arrive; in 1903, she took up residence on the Left Bank, sharing a home with her brother Leo at 27, rue de Fleurus. Soon, they instituted a Saturday evening open house for friends who wanted to see their collection of avant-garde art, which included works by Cezanne, Manet, Renoir, Matisse, and Picasso, and to meet the younger artists who were sometimes present at these evenings. As Stein recalled in *The Autobiography of Alice B. Toklas* (1933), "everybody brought somebody" to these occasions, which lasted well into the night.

When guests departed, she went to her room and wrote until dawn, the darkness and quiet ensuring that she would not be interrupted as she created literary portraits of friends, acquaintances, and people she observed on her long walks in Paris. Literature was the vehicle of this experiment, which was in fact a philosophic and psychological investigation into the essential or "bottom nature" of her subjects. Examples of this work include her 1909 book *Three Lives* and her later *The Making of Americans*, a thousand-page manuscript printed by Robert McAlmon's Contact Editions and underwritten by Bryer's inheritance.

Poet and memoirist Natalie Clifford Barney (1876–1972) preceded Stein to Paris by one year, establishing residence at 20, rue Jacob. She too opened her home to friends and strangers. Barney had two salons, one open to both French and American artists and writers—her effort to create a bilingual, international camaraderie. A second salon, open only to women, was dedicated to Barney's effort in re-creating the gatherings of young women who were students of the ancient poet Sappho of Lesbos. These gatherings, which in good weather took place in the garden near a Greek temple on the property, were attended primarily by women of the lesbian community. Entertainments included dramatic performances, dancing, recitation of poetry, singing, and skits.

As patron of the arts, Barney used her fortune to create a lifestyle dedicated to beauty and proportion, values she admired in ancient Greek civilization; to support publishing ventures; and to help writers and artists in need. Her famous salons continued from 1902 until 1970, two years before she died at age 96. Among those who attended her "afternoons" were French novelist Sidonie Gabrielle Colette (1873–1954), Bryher and H. D., Gertrude Stein and Alice Toklas, Janet Flanner, Mina Loy, Peggy Guggenheim, and painter Romaine Books. Djuna Barnes spoofed these entertainments and also paid homage to Barney as Dame Evangeline Musset, the saint of Sapphic love, in *Ladies Almanac*, a calendar (illustrated with drawings by Barnes) of events starring the participants in Barney's salon. The book was published privately in 1928 by Robert McAlmon in his Contact Editions.

Other salons, less formal and less public, also existed in Paris. Edith Wharton, who lived in Paris from 1907 until 1920, invited French writers, philosophers, academicians, and artists to her apartment on the rue de Varenne and welcomed friends from the United States who were interested in French culture. Henry James, Wharton's close friend and most famous guest, was the centerpiece of her salon. He belonged to an older generation of writers considered passé by the avant-gardists, who saw his work as stuffy and over-stylized. James's "fluency" in Parisian culture, however, based on his long familiarity with France and his friendships with influential people, made him the "Lion" in Wharton's literary evenings.

A quite different group of writers and intellectuals surrounded Virginia and Leonard Woolf. Rebels against the mores of class hierarchy that privileged the landed aristocracy, the intellectuals who were friends of Virginia and Leonard Woolf dressed and acted rather like hippies from the 1960s. They smoked, experimented with forms of sexuality, argued politics, performed skits, and played pranks. In general they lived counterculture lives, rejecting the hidebound mores of middle-class English culture. The group included Virginia's sister, painter Vanessa Bell; art historians Clive Bell and Roger Fry; biographer and historian Lytton Strachey; economist Maynard Keynes; novelist E. M. Forster; and painter Duncan Grant (Vanessa's bisexual partner). The men had been educated at Cambridge; the women were tutored or self-taught. The early years of these gatherings, when Vanessa and Virginia were in their twenties, were particularly important in creating a forum for debate that formed their intellectual, political, and artistic ideas.

In later years, Virginia's and Vanessa's accomplishments made them central to gatherings that included the most important intellectuals in England.

When war broke out in August 1914, the leisure conditions that supported small gatherings such as these were destroyed and men were called up for battle. Salons then became structures through which women organized the "home front" war effort, responses differing depending on the politics of the membership. The Bloomsbury group was pacifist, and the men eligible for active duty applied for conscientious objector status. Natalie Barney, a feminist-pacifist, used her salon to enlist women against the war. Gertrude Stein and Alice B. Toklas worked for the Fund for French Wounded (organized by American Walter Berry, longtime companion of Edith Wharton) and delivered medical supplies in Gertrude's Ford car—a vehicle she christened "Auntie." Edith Wharton organized the largest independent wartime refugee effort of the war. Raising money from her society friends in New York, she established hostels, schools, sanatoria, and workrooms for women and children fleeing the war in Belgium and northern France. Wharton visited the western front several times and published essays that were collected in *Fighting France from Dunkerque to Belfort* (1915), a book that served to raise American awareness of the devastation of the stalemated war. For these efforts she was made a member of the French Legion of Honor.

Sylvia Beach left her home in Princeton, New Jersey, to volunteer as a farm worker in Yugoslavia. British novelist Vera Brittain (1893–1970), a university student at Oxford, served as a Voluntary Aid Detachment nurse in Malta and France. Her brother and fiancé were both killed in the war, events that turned her into a pacifist. In 1933, she published *Testament of Youth*, a memoir of the war years that became a best-seller and is still considered one of the most poignant and powerful accounts of the war and the postwar generation.

The separation of art from history and politics that characterizes Modernism was, in part, a by-product of political disengagement and cynicism following the enormous losses of World War I, a conflict that killed 18 million people, including civilians and soldiers. Many male modernists had seen active duty in the war or served in the ambulance corps, most famously Ernest Hemingway and American poet e. e. cummings, who served time in a prisoner of war camp (*The Enormous Room*, 1922). The 1917 Bolshevik Revolution in Russia inspired artists on the political left, and the collapse of postwar European economies made it possible for artists to live cheaply in Paris, Berlin, and London. Leaving political and economic problems for world leaders to solve, many moderns caught the heady freedom of postwar life through artistic innovation.

WOMEN POETS AND LITERARY EXPERIMENTATION

Literary experimentation began first in poetry in the years prior to World War I. Modernists rejected the heavy rhythms and formal rhyme schemes of nineteenth-century poetry as well as the patriotic, often sentimental

subjects that characterized both popular and academic verse in English. They also rejected the lyric emotionalism of Romantic poetry as represented by Percy Bysshe Shelley and William Wordsworth, as well as the abstractions of French **Symbolism**. Instead, they were inspired by **free verse** (*vers libre*), which had developed in France and drew on Provençal **troubador** songs. The best-known women free verse poets of this period were H. D., Gertrude Stein, and Mina Loy (none of whom, despite their inventiveness, was included in the modernist canon).

One form of the "new poetry" was **Imagism**, a movement that included American poets H. D., Amy Lowell (1874–1925), Ezra Pound, and D. H. Lawrence. Imagist poetry was spare, capturing feeling in a clear-cut, hard images filled with energy. A stanza from H. D.'s poem "Garden" illustrates the technique of creating an image by cutting away all excess, as if the poet were a sculptor:

You are clear
O rose, cut in rock,
Hard as the descent of hail.

Imagism was influenced by Chinese and Japanese forms of writing; poets practiced translating forms such as **haiku** into English, seeking to retain elements of Japanese internal rhythms while also retaining emphasis on the image. The Imagists burst on the poetry scene in 1912. In 1914, they published the first Imagist anthology, edited by Pound. Amy Lowell edited three subsequent anthologies between 1915 and 1917, and she promoted the cause of new poetry both in the United States and England. Although poetry of this period underwent vibrant and various changes, such as expanding into long narrative poems in the tradition of Walt Whitman, the emphasis on clarity of visual imagery remained a central concern of modernist writing. For example, Lorine Niedecker (1903–70) was influenced by the Imagists Lowell, Ezra Pound, and Louis Zukovsky. Her spare, elliptical poetry is arguably more complex and difficult than that of any other modernist and accounts for her relative obscurity.

Another important influence on poetry in these years, one often overlooked by literary historians, was the 1914 publication of newly discovered poems by Emily Dickinson (1830–86), found in her home in Amherst, Massachusetts. This was the first of five volumes of Dickinson's work published in the twentieth century (her collected poems were not published until 1955), and it brought renewed interest in her spare, elliptical forms and the dry irony that underwrote her poetry, even when she turned to the subjects of grief, loneliness, religious doubt, and emotional pain. Her readiness to "tell all the Truth but tell it slant" (1868) fit well with the modernist distrust of sentimentality and their desire to "make it new."

Women's poetry explored the thematic concerns of Modernism—the psychology of the self, the mediating role of language in creativity, sexuality, and relations between the sexes—and demonstrated the close observation

of objects, human behavior, and routines of daily life that became a hall-mark of the modern. But women's writing was not limited to exploration of the psychological or aesthetic themes so prominently displayed in men's writing in the first years of the century. To a greater degree than their male counterparts, women wrote of social and political issues and of the gender politics of marriage, motherhood, and domestic realities. The subject matter of women's poetry, whether written in traditional forms or in free verse, is highly diverse. It includes not only the traditional subjects of love, fidelity, loss, death, nature, and beauty, but also sexuality (including bisexuality and lesbianism), the politics of social protest, feminist polemic, and meditations on women's roles as artists.

Djuna Barnes, Mina Loy, and Gertrude Stein offer three highly original responses to the subject of female sexuality. Barnes's Gothic lyrics in *The Book of Repulsive Women* (1915), a text illustrated by her drawings, explore the relation between women's physical and psychological states. In these po-ems, Barnes seems to be trying to destroy traditional images of women as beautiful, passive, and adaptive in order for the "new woman" to emerge. Women's aging bodies are associated with "degenerate" same-sex love-making. In "Seen from the L," she writes:

> Still her clothing is less risky
> Than her body in its prime,
> They are chair-stitched and so is she
> Chair-stitched to her soul for time.
> Ravelling grandly into vice
> Dropping crooked into rhyme.
> Slipping through the stitch of virtue,
> Into crime.

Gertrude Stein sets same-sex love in domesticated settings in her poetry and prose and playfully explores the interrelation of sexuality and creativ-ity. In "Lifting Belly" (1915), a poem in praise of her partner, Alice B. Tok-las, she asks:

> Can you swim.
> Lifting belly can perform aquatics.
> Lifting belly is astonishing.
> Lifting belly for me.
> Come together.

The poetry of British-born Mina Loy examines relations between the sexes from a feminist perspective. In her 1914 "Feminist Manifesto," Loy declared her resistance to the suffragist feminist rhetoric that women were equal with men:

> Women, if you want to realize yourselves (for you are on the brink of a dev-astating psychological upheaval) all your pet illusions must be unmasked. The

lies of centuries have got to be discarded. . . . Professional and commercial careers are opening up for you. *Is that all you want?* If you honestly desire to find your level without prejudice, be brave and deny at the outset that pathetic clap-trap warcry, "Woman is the equal of man." She is *not*. . . . Leave off looking to men to find out what you are *not*. Seek within yourselves to find out what you *are*.

The emphasis on experimentation in poetry had the effect, as with fiction, of shadowing the contributions of women who worked in standard poetic forms. But these writers took up an arguably more difficult challenge—that of creative expression within the strictures of conventional modes. Women revised the subject matter of traditional forms (love lyrics, elegy, the pastoral) by shifting perspective and modes of address from masculine to feminine, heterosexual to lesbian, and by rewriting the ancient myths of womanhood from a feminist perspective.

Four highly skilled poets who revised subject matter within the bounds of traditional form were British writers Charlotte Mew (1869–1928) and Anna Wickham (1884–1947, born in Australia) and Americans Elinor Wylie (1885–1928) and Poet Laureate Leonie Fuller Adams (1899–?). These women were influential as "poets' poets" in their own time but are virtually forgotten today. Wickham wrote 1,400 poems in 20 years and by the 1930s had an international reputation. Both women were feminists, the formal conventionality of their work belying its pointed politics and ironic humor. Wickham, like Mina Loy, wrote a feminist manifesto, entitling it *The League for the Protection of the Imagination of Women. Slogan: World's Management by Entertainment* (1938). She translated the manifesto into poetry, dedicating it to:

> . . . all the pretty women who marry dull men,
> go into the suburbs and never come out again,
> Who lose their pretty faces and dim their pretty eyes,
> Because no one has the skill or courage or organize.

Charlotte Mew, who preferred forms of dramatic poetry (voiced monologues or conversations between characters), was published in important literary journals—*The Egoist*, *The Yellow Book*—and admired by well-respected writers. Virginia Woolf described Mew as "the greatest living poetess." In her use of repeated rhyme, Mew is a precursor of American poet Marianne Moore. She wrote delicately but explicitly of sexual matters, including feminine homoeroticism, as in the "Absence":

> In sheltered beds, the heart of every rose
> Serenely sleeps to-night. As shut as those
> Your guarded heart; as safe as they from the beat, beat
> Of hooves that dread dropped roses in the street.

Mew's own love for women was a source of psychic pain as well as an inspiration for her poetry.

Elinor Wylie—beautiful, articulate, and an important figure in the New York literary world—was a lyricist with an austere and pessimistic perspective on life. A stanza from her poem "Let No Charitable Hope" examines the conditions that shape women's consciousness:

> I was, being human, born alone;
> I am, being woman, hard beset;
> I live by squeezing from a stone
> The little nourishment I get.

Wylie's younger friend Leonie Adams, also a member of the lively New York cultural scene in the late 1910s and 1920s, developed a recognizably austere voice, as we hear in the opening stanza of "Quiet":

> Since I took quiet to my breast
> My heart lies in me, heavier
> Than stone sunk fast in sluggish sand,
> That the sea's self may never stir,
> When she sweeps hungrily to land,
> Since I took quiet to my breast.

As Wylie's and Adam's texts indicate, the poetry that emerged from the catastrophic events of World War I was dark, often cynical and despairing in tone. Throughout the stalemated war, women voiced their reactions in poems of loss, resistance, and regret, work that revised the traditional forms and perspective of war poetry.

World War I produced thousands of poems by soldiers, some of whom, such as Robert Graves, Siegfried Sassoon, and e. e. cummings, are regarded as major figures of literary Modernism. Weighted by the reality of battlefield experience, men's writing held a "truth" value assumed to be greater than that of the women who worked for the relief forces or tended the home front. But women drew equally on their wartime experiences in poetry. Often, they tried to make sense of the irrationality of war by drawing on religious imagery and structuring their poems within strict forms. In these cases, form circumscribed meaning. May Sinclair (1863–1946) compared a "Field Ambulance Retreat" in Belgium to the *Via dolorosa, Via Sacra* of Christ's journey to the Mount of Golgotha and his crucifixion. In her elegy, "To My Brother Killed: Haumont Wood: October 1918," Louise Bogan (1897–1970) stated her political pacifism and her Christian beliefs:

> You masked and obscure,
> I can tell you, all things endure:
> The wine and the bread;
>
> The marble quarried for the arch;
> The iron become steel;
> The spoke broken from the wheel;
> The sweat of the long march . . .

During World War I and again as Europe moved again toward war in the late 1930s, the **sonnet**, a form long associated with the thematics of love, became a vehicle for political and social commentary. Amy Lowell chose this form to describe her native Boston on an afternoon in September 1918, a month that saw some of the most brutal fighting of the entire war, battles in which American forces battled in the Argonne and Ypres. The only direct reference to the war is the poem's title, "September, 1918," but the contrast between war-torn Europe and New England is captured in autumn images of the boys gathering berries:

> Under a tree in the park,
> Two little boys, lying flat on their faces,
> Were carefully gathering red berries
> To put in a pasteboard box.

Irish-born Lola Ridge, who had contributed to Emma Goldman's (1869–1940) radical magazine *Mother Earth*, served as associate editor of the little magazine *Others* and as editor of *Broom*. In 1926, she became a contributing editor of the magazine *New Masses*, the most important left-wing journal of the early twentieth century. Like Edna St. Vincent Millay, she had protested the executions of Nicola Sacco and Bartolomeo Vanzetti in 1927. She wrote "Stone Face," one of her most important poems, on the false conviction, imprisonment, and death sentence of Irish immigrant labor leader Tom Mooney, accused of throwing a bomb in a 1916 San Francisco parade that killed 10 people. President Woodrow Wilson pleaded for mercy and Mooney's death sentence was commuted to life imprisonment. The first stanza of the poem portrays Mooney as a labor hero and martyr:

> They have carved you into a stone face, Tom Mooney,
> You, there lifted high in California
> Over the salt wash of the Pacific,
> With your eyes . . . crying in many tongues,
> Goading, innumerable eyes of the multitudes,
> Holding in them all hopes, fears, persecutions,
> Forever straining one way.

Other female leftists of this period include Genevieve Taggard (1894–1948), an important educator and feminist writer and editor of *Measure: A Magazine of Verse* published in New York City. She edited a poetry collection of writing from *The Masses* and *The Liberator* entitled *May Days* (a reference to the international workers' day, May 1) and an excellent intellectual biography of Emily Dickinson (*The Life and Mind of Emily Dickinson*, 1930). Her poem "Everyday Alchemy" illustrates the powerful combination of her feminist-leftist politics:

> Men go to women mutely for their peace;
> And they, who lack it most, create it when
> they make, because they must, loving their men,

A solace for sad bosom-bended heads. There
Is all the meager peace men get—no otherwhere;
No mountain space, no tree with placid leaves,
Or heavy gloom beneath a young girl's hair.
No sound of valley bell on autumn air
Or room made home with doves along the eaves,
Ever holds peace, like this, poured by poor women
Out of their heart's poverty, for worn men.

Edna St. Vincent Millay (1892–1950), perhaps the twentieth-century poet most associated with the sonnet, used this form to write of subjects both comic and serious. The poems in *Make Bright the Arrows* (1940) were written against the atrocities of World War II. In "Czecho-Slovakia," she drew on biblical lore to construct an image of the country under Nazi occupation:

If there were balm in Gilead, I would go
To Gilead for your wounds, unhappy land,
Gather you balsam there, and with this hand,
Made deft by pity, cleanse and bind and sew
And drench with healing, that your strength might grow. . . .

REVISING FORMS, ANCIENT AND MODERN

Women writers sought refuge in the past and in myth. Ancient poetic forms and subject matter, especially the fragments of Sappho (sixth century B.C.E.), inspired women poets and challenged their translation skills. Natalie Clifford Barney, British poet Renee Vivien (1877–1909), and H. D., among others, read and translated fragments of Sappho's writing preserved by Latin poets and discovered by archaeologists in the late nineteenth century. Women also were drawn to long episodic poetic forms drawn from the ancient bard poets. In taking up this subject matter, they entered a terrain that historically was the province of male poets from Homer to Milton and claimed these forms and subjects as their own.

H. D. devoted the better part of her long career to revising ancient forms, rewriting the myths, and giving a twentieth-century voice to Greek and Roman gods and goddesses. Her *Trilogy* (1944–46), three long poems set in London during World War II, are excellent examples of revisionist epics. H. D. was drawn to the myth of Helen, whose abduction by the Trojan Prince Paris presumably caused the Trojan War (see Homer's *Iliad*). *Helen in Egypt* (1961), a long poem that employs the film technique of **voice-over** and the figure of a **palimpsest**, renders a complex psychological portrait of Helen. In an earlier poem, "Helen" (1924), H. D. had captured Helen from the perspective of the Greeks who fought for 10 years to bring her home, and in the process came to hate her:

All Greece hates
the still eyes in the white face,

the luster as of olives
where she stands,
And the white hands.

The purpose and place of art served as both the form and subject matter for women writers who explored intellectual, philosophical, and aesthetic questions in their work. Among the most intellectual of modernist poets were Gertrude Stein and Marianne Moore. Their poetry questions cultural values and beliefs and often focuses on everyday events. Although distinctly different in form from that of Emily Dickinson, their work bears a marked resemblance to the questioning posture that Dickinson assumed in her writing.

A stanza from Stein's *Stanzas in Meditation* (written in 1932, published in 1956) reveals Stein's interest in the laws of grammar, the concept of **teleology** (beginnings and endings), and laws of the universe:

What I wish to say is this
There is no beginning to an end
But there is a beginning and an end
To beginning.
Why yes of course.

Marianne Moore's "What Are Years?" (1941)—a poem that grapples with essential issues of mortality, struggle, doubt, and the enigma of immortality—yields an interesting comparison with Stein's meditation:

What is our innocence,
what is our guilt? All are
naked, none is safe. And whence
is courage: the unanswered question,
the resolute doubt,—
dumbly calling, deafly listening—that
in misfortune, even death,
encourages others
and in its defeat, stirs
the soul to be strong? . . .

Modernist women poets turned their poetic talents to other artistic mediums. Edith Sitwell's collaboration with composer William Walton on *Façade* (1922) marks a moment of surrealist drama. Edna St. Vincent Millay was a well-known pianist and librettist. Her opera, *The King's Henchmen* (1926), based on medieval themes, was staged by the New York City Metropolitan Opera and received excellent reviews. Gertrude Stein's *Four Saints in Three Acts* played on Broadway in 1934, when Stein made a six-month lecture tour in the United States. She wrote the libretto and her friend Virgil Thomson composed the music. Djuna Barnes's autobiographical drama, *The Antiphon* (1958), had its premier performance in Stockholm, Sweden, in 1962, under

the auspices of Dag Hammarkjold, then Secretary General of the United Nations.

THE HARLEM RENAISSANCE

The social and economic politics of black artists differed markedly from the widely held modernist emphasis on aesthetics as the single standard of great art and the belief that art occupied a separate sphere from politics. The **Harlem Renaissance** was a movement named for the middle-class area in New York City where the culture of a growing population of urban African Americans flourished in the 1910s and 1920s. Poet and novelist James Weldon Johnson, an important figure in the Renaissance, chronicled in his book *Black Manhattan* the influx of African Americans, many of them new arrivals from the southern states, into the city at the turn of the century. They settled in the lower Bronx, an area in which colonial Dutch settlers had established dairy farms. During the nineteenth century this area had been increasingly developed as a middle-class community of stately houses and prosperous businesses.

Drawing on African images, rhythms, languages, and folk traditions, the Renaissance reached well beyond Harlem to Paris, London, Amsterdam, Berlin, and Rome and brought African American writers, painters, dancers, and musicians into international prominence. This artistic flowering was neither accidental nor naïve. It was linked to a social and political agenda to bring public awareness to African American arts and culture, and it was furthered by the creation of new avenues of publication. Little magazines dedicated to black culture sprung up, edited by college students in their twenties. The short-lived avant-garde magazine *FIRE!! A Quarterly Devoted to the Younger Negro Artists*, founded by Wallace Thurmon, and college students Zora Neale Hurston and Langston Hughes, produced only one issue (November 1926). Yet its contributors included some of the leading figures of the Renaissance. Hurston contributed a play and a short story, Thurman provided a Harlem sketch entitled "Cordelia the Crude," and Langston Hughes was one of seven poets who contributed work. The volume also included drawings, editorial commentary, and an essay. *Opportunity: A Journal of Negro Life*, was produced by the Urban League and was founded to help new writers find an audience. The powerful and long-lived journal *Crisis* was published by the National Association for the Advancement of Colored People (NAACP, founded 1909 by W. E. B. Du Bois). As editor of *Crisis* Du Bois published work that furthered the social and political agendas of the NAACP.

Although women's contributions to the "New Negro Movement" have been noted by cultural historians, until recently their work has been overshadowed by the men of the movement. The situation of women of the Harlem Renaissance mirrors that of women modernists.

For example, poet, short-story writer, and journalist Alice Dunbar Nelson (1875–1935) was a teacher and political activist for women's suffrage.

Born of middle-class Creole parentage in the Reconstruction period following the Civil War, she graduated from Straight University in New Orleans, later earned an M.A. at the Pennsylvania School of Industrial Arts, and studied psychology and educational testing at the University of Pennsylvania. She believed that education was a tool against racism and bigotry. She wrote in several literary traditions—as a book reviewer, journalist, poet, and fiction writer. As an art and literary reviewer, Dunbar Nelson contributed to the Harlem Renaissance by supporting the work of younger artists by commenting on the historical and artistic contexts of their work, including local and daily situations. In these ways, Dunbar Nelson was an artistic enabler. Although her own writing was not formally experimental, she skillfully captured New Orleans Creole culture in the same Louisiana settings and of the same time period as Kate Chopin's *The Awakening*. Dunbar Nelson published poetry in all the major journals—*Crisis, Opportunity, Ebony, Lippincott's* and *Leslie's*. Her social activism included organizing black women in state politics and serving as executive secretary to the American Friends Interracial Peace Committee from 1928 to 1931.

Harlem Renaissance intellectuals and artists were social activists. They expressed their political beliefs in a variety of ways, including support of the international workers movements, including Marxist Communism. In 1926, the influential leftist journal *New Masses* was founded; black writers contributed poems and short fiction. After the economic collapse in Europe and the United states in 1929, black intellectuals joined with their working-class brothers and sisters to support left-wing radicalism and protested against the rise of totalitarianism during the 1930s. The hierarchical relation of race, social class, and gender was a central subject for these artists, many of whom felt they had to rank their allegiances—race coming at the top of the list; black women felt that their sexual identities, their desires as women, were oppressed by race and class pressures. Many women writers of the Renaissance express these conflicts in their writing. Georgia Douglas Johnson (1877–1966) treats the subject obliquely but powerful in her poem "The Heart of a Woman":

> The heart of a woman goes forth with the dawn,
> As a lone bird, soft winging, so restlessly on,
> Afar o'er life's turrets and vales does it roam
> In the wake of those echoes the heart calls home.

In his anthology of African American writing, *The New Negro* (1925), Alain Locke defined a new kind of art and literature that no longer mimicked genteel Anglo-American traditions, but reclaimed African and Caribbean traditions and "dug deep into the racy peasant undersoil of the race life" (North 168). Locke and W. E. B. Du Bois wanted to see racial perspectives in black writing, and this emphasis created tensions with those writers of the Renaissance who believed in the tenets of "art for art's sake"—that is, writing that privileged aesthetic principles above political causes. The leaders of the

various movements to advance the cause of black people were aware of the dangers of American education, which denied its racist roots, but they also believed in the power of education to overcome class restrictions and racial stereotyping. Black women were particularly committed to education as a means of advancement, of maintaining economic independence, and of overcoming gender discrimination that, coupled with race and class prejudice, kept them in menial jobs.

W. E. B. Du Bois reported that some 250 African American women had received their baccalaureate degrees in 1900, 65 of them earning degrees at Oberlin College in Ohio. The majority of these women became teachers, thus carrying on a tradition of educational values. Most women writers of the Renaissance completed undergraduate degrees and several held advanced degrees from some of the most prestigious institutions in the United States. Women of the Renaissance also traveled widely and established reading groups and artistic salons wherever they resided.

During the **prohibition** era of the 1920s, fashionable, wealthy whites patronized Harlem's jazz clubs and speakeasies. Cross-racial identification, referred to as **Negrophilia**, was in vogue. Industrial giants collected African art and jewelry and some became patrons to struggling black artists. The representation of African primitivism in avant-garde visual arts, music, dance, and literature drew, for the most part, on racial stereotypes—facial and body types, dialect, songs, and dress. Such forms in the hands of white artists might be viewed as proprietary, even racist, producing a kind of racial masquerade (and in some cases they were). But the New Negro took the standard genres of literature and art—novel and poem, sculpture and painting—transforming them in both subject matter and artistic medium. For example, Zora Neale Hurston's novel *Their Eyes Were Watching God* (1937), a book that draws on Hurston's folklore studies, reframes the **novel of psychological development** (*Bildüngsroman*) in four ways: It tells a black woman's story rather than a white man's story; it employs a circular narrative of a young woman's three dreams, each of which is killed by the experience of living; these events turn the ending of the novel back on its beginning; and the novel uses various dialects of the American South.

Hurston contributed a list of "Characteristics of Negro Expression" to Nancy Cunard's anthology *Negro* (1934). She catalogued linguistic forms and identified the aesthetics principles inherent in blues, jazz, spirituals, verbal improvisation, folktales, and sermons. Hurston noted that "the Negro's universal mimicry is not so much a thing in itself as evidence of something that permeates his entire self. And that thing is drama." Hurston is perhaps the best-known woman writer of the Renaissance. Although she achieved success as a short story writer and folklorist in the post–World War I years, she did not publish novels and collections of short stories until the 1930s and 1940s, after the heyday of the Renaissance.

Hurston's prominence today as a writer and ethnographer of African American experience in the United States is due almost entirely to the black consciousness and feminist movements of the 1960s and 1970s, and espe-

cially to the efforts of writer Alice Walker (b. 1944), who discovered Hurston's unmarked grave in a segregated cemetery in Fort Pierce, Florida. The gravestone Walker erected describes Hurston as a "novelist, folklorist, anthropologist." Born in Eatonville, Florida, the black town that provides the setting for *Their Eyes Were Watching God* (1937), Hurston was educated at Howard University, where she worked as a manicurist and maid to support her studies in English. Hurston later attended Barnard on a scholarship as its first black student. At Barnard, she studied anthropology with three of the most renowned anthropologists of the twentieth century—Franz Boas, Margaret Mead, and Ruth Benedict. She worked as Boas's assistant, recording songs, jokes, games, and stories. Desiring to reclaim and preserve her cultural heritage, she conducted anthropological fieldwork throughout the South and the Caribbean. *Of Mules and Men* (1935) provides a version of her experiences, and *Voodoo Gods: An Inquiry into Native Myths and Magic in Jamaica and Haiti* (1939) presents her research discoveries.

Hurston was unusual among notable women of the Harlem Renaissance in that she was born and raised in the South, her writings drawing almost exclusively on her experiences there. Playwright and poet Georgia Douglas Johnson was born in Atlanta but moved north to attend the Oberlin Conservatory and Cleveland College of Music. Her writing treated feminist and racial themes, and her home in Washington, DC, became a center of literary and artistic activity. Among the members of her salon, the "Saturday Nighters," was New Yorker Marita Bonner Occomy (1899–1971), whose avant-garde play, *The Purple Flower*, treated the subject of race relations in an impressionist allegory. Angelina Weld Grimke, born in Boston and daughter of a black activist, was educated at Carleton Academy in Minnesota and later the Boston Normal School, graduating in 1902. She became a teacher in Washington, DC. Her play *Rachel* (1916) was written in response to D. W. Griffith's racist film *The Birth of a Nation*. Performances of the work in New York, Boston, and Washington, DC, were sponsored by the NAACP. Grimke is best known as a poet whose late-nineteenth-century work was sentimental and adhered to traditional forms. In the early years of the new century, Grimke's writing became more experimental, anticipating avant-garde writing of the Renaissance.

Nancy Cunard (1896–1965) was an Anglo-American woman whose anthology *Negro* (1934) contributed importantly to our understanding of the African American experience. A poet, publisher, and political activist, she turned against her upper-class London upbringing in the 1920s, devoting her energies to fighting racism and preserving African art. Tall and thin with red bobbed hair and eyes outlined in kohl, her arms covered in ivory bracelets, she was photographed by Cecil Beaton and Berenice Abbot, painted by American artist Romaine Brooks, and became an icon for exotic bohemianism. In 1934, at her own expense she published *Negro*, an 855-page anthology that purported to trace the entire history of blacks around the world. The book took five years to produce, was lavishly illustrated and bound in an oversized format, and included 155 contributors, two-thirds of

them black. Cunard's own contributions included a summary of legal interpretations of the "**colour bar**"—the discretionary rights held by innkeepers and publicans in Great Britain concerning those to whom they gave patronage. She wrote a long essay on the 1931 Scotsboro case of nine young black men accused of raping two white prostitutes in Alabama. Although found innocent in two separate Supreme Court trials, they were held on death row. She also provided an engaging "tour" of Harlem in the late 1920s, describing its streets, people, and quality of life. The *Negro* anthology gave prominence to black women of the past, including a long essay entitled "Three Great Negro Women" by Gladys Berry Robinson. The essay traces the careers of Phillis Wheatley (1753?–1784), Harriet Tubman, and Sojourner Truth.

The publication of *Negro* and Cunard's very public romance with black jazz musician Henry Crowder, who first introduced her to the rich cultural scene of Harlem, scandalized Nancy's mother, Lady Emerald Cunard, and her London society friends. Nancy exposed her mother's bigotry in a pamphlet entitled *Black Man and White Ladyship* (1931), a work that condemned racism, capitalism, class privilege, and imperialism—the four cornerstones of the British Empire in Cunard's thinking. In 1928 Cunard set up a hand press at her farm in north central France. Henry Crowder played at jazz clubs in Paris and assisted her at The Hours Press. She published work by Samuel Beckett, Laura Riding, Ezra Pound, and an essay by sexologist Havelock Ellis entitled *The Revaluation of Obscenity*. As Europe moved toward war, Cunard produced political broadsides and appeals for support of refugees fleeing Francisco Franco's totalitarianism in Spain. The press closed when the Nazis overran France in 1940.

One of two women of the Renaissance to reside in Harlem, Jessie Redmon Fauset (1882–1961), born in Philadelphia and the daughter of a Methodist minister, was for most of her life a teacher. When she moved to New York City, she established an artistic salon of black artists and writers in her home. She was over 40 years old before she began publishing novels, and is primarily seen as a "midwife" to cultural events in her roles as literary editor, journalist, and translator for *Crisis*, the journal of the NAACP. Founded in 1910, by 1919 *Crisis* had reached a circulation of 100,000 readers. In her position as literary editor, Fauset encouraged young writers like poets Arna Bontemps, Jean Toomer, Langston Hughes, and Claude McKay. She also promoted black women writers and illustrators, including poets Georgia Douglas Johnson and Anne Spencer. With W. E. B. Du Bois, Fauset edited *Brownies' Book*, a magazine for black children. She also contributed articles on education, culture, and politics, highlighting the work of black women activists. Fauset reviewed and translated literature from Africa and the Caribbean, and as a world traveler she visited and wrote about life in Algiers and Egypt. In 1921, she reported for *Crisis* on the meetings of the Pan-African Congress in Europe, analyzing women's roles in the movement.

Her four novels—*There is Confusion* (1924), *Plum Bun* (1929), *The Chinaberry Tree* (1931), and *Comedy American Style* (1933)—treat the circumstances

of middle-class black women. Although the dominant themes of these works include issues of class, race, gender, the economics of marriage, male sexual privilege, and the rivalries that inhibit or break bonds between women, they were read as novels of manners reflective of an outdated culture. Recent work by feminist critics and cultural historians has revised the notion that Fauset's work was "old guard" rather than avant-garde and revealed a complex contemporaneity.

Nella Larsen (1891–1964), a major novelist of the Harlem Renaissance, is widely regarded by contemporary African American women writers as an important "foremother" whose work explores the difficulties for black women in patriarchal and racist society. For many years, however, Larson was, like Zora Neale Hurston, lost to the reading public. She had disappeared from the lively cultural scene she helped create and apparently stopped writing. Born of a Danish mother and a West Indian father, Larsen grew up in New York, graduated from Lincoln Hospital School of Nursing in 1915, and after her marriage to Elmer Imes (a prominent physicist) settled in Harlem and established friendships with powerful figures in African American society—W.E.B. Du Bois, Jessie and Arthur Fauset, James Weldon Johnson, and writers and artists who would become important figures in the flowering of African American art, music, and literature.

Larsen's first two novels treat difficult emotional and cultural issues surrounding the place of the mulatto in black society and biracial identity. *Quicksand* (1928), which won the Harmon Foundation Award for Literature, and *Passing* (1929), are considered her best-known works. In 1930–31, Larsen was awarded a Guggenheim Fellowship, the first African American woman to receive this prestigious award. Her marriage in ruins, she moved to Europe, living in Portugal and Spain, and worked on a novel entitled *Mirage*, which was rejected by publishers. She had been charged with plagiarism for a story entitled "Sanctuary," and none of the other literary works she wrote subsequently were published. She returned to nursing, appointed to supervisory positions in New York City hospitals.

In the 1920s writer Julia Peterkin (1880–1935), who was white, began publishing novels set in her native South Carolina that featured black protagonists. The first of these, *Green Thursday*, was published in 1924; *Black April* appeared in 1927; *Bright Skin* was published in 1932. Her most famous novel, *Scarlet Sister Mary* (1928), won the Pulitzer Prize for literature and was dramatized and staged in 1930 by Daniel Reed, with Ethel Barrymore playing the lead character in blackface. Peterkin's knowledge of her characters and familiarity with the local surroundings convinced many readers that she was African American.

By the late 1930s, the innovative movements in literature, theater, and art began to lose energy and were overshadowed by the social concerns arising from the Depression and the threat of global warfare stemming from the rise of totalitarianism in Europe and Asia, in particular the militarization of Hitler's Germany. The work of black artists, so prominent in the between-war years, was eclipsed by renewed poverty and racism caused by the De-

pression, African Americans among the first to suffer from the economic collapse. American expatriate writers in Europe, who had benefited from the inexpensive economic conditions abroad, were forced by international inflation to return to home. New York City would replace Paris and London as the center of artistic energy in the postwar years, and during the war the city served as the epicenter of anti-fascist political activism. Women writers in Europe turned their energies to political and social causes in these years, in particular aiding Jews escaping Nazism. The forced austerity of the war years in England and the horrors of occupation in France effectively brought an end to the cultural experiment that had dominated Europe for the previous 30 years. From 1939 to 1945 Europe was effectively under a "blackout," the destruction and loss of life so enormous that it would take several decades before Paris and London regained their status as intellectual and cultural meccas.

Late Twentieth-Century Directions: 1945–2000

F eminist writing of the second half of the twentieth century reflects the changing roles of women in society and the challenges women faced in achieving the goals of equality, social justice, and self-determination. Much of this writing, whether poetry, drama, narrative, or scholarly analysis of the place of women in society and culture, enacts a form of political activism through the representation of female characters who mirror the struggles around gender and sexuality facing real girls and women. This writing is inflected by personal experience in a critique of patriarchy, and some of this literature imagines a better future for women and men. All of this writing is rooted in history and culture, informed by activist movements of earlier periods of the century—including left-wing and populist activism during the economic collapse of the 1930s in Europe and the United States. The traditional division between responsibility to self and to society is erased in these texts. The rallying cry of American feminism in the 1960s—"the personal is the political"— informs all literary feminism in this 55-year period.

WAR AND ITS CONSEQUENCES

The end of World War II in 1945 brought enormous changes in public and private life in Great Britain and the United States. During the war years women built on the hard-won successes of the first half of the century and also suffered setbacks as they readjusted to traditional roles in domestic life following the Allied military victories over Germany and Japan. Women had contributed to the war effort through military service, intelligence and code-breaking operations, working the "line" in armament and aircraft industries, and through volunteer efforts in relief agencies.

As with the Armistice in 1918, the end of military hostilities in 1945 meant that women who had volunteered for the armed services, worked in munitions factories, or took over family businesses now returned to domestic life. Although the governments of Great Britain and the United States recognized the crucial supporting roles that women played in the Allied victories, combat veterans were given first priority in job training and hiring for civilian positions. While couples were encouraged to produce a new generation of children (the "baby boomers"), government-funded childcare programs that had supported women during the war years were either ended altogether or their subsidies were drastically reduced. Great Britain's economy was

nearly destroyed by the war. Despite aid from the United States, the postwar period was one of austerity and slow rebuilding of Britain's industrial and technological infrastructure.

The German bombing of London during the Battle of Britain (1940) and the carpet bombing in the last months of the war destroyed large sections of London and forced evacuations of women and children to hostels and camps in the countryside. In September 1940 Virginia Woolf returned to London from her country home on the Sussex coast to find that the house next to hers on Mecklenburg Square had been destroyed. In the following days damage from a time bomb and later a land mine caused irreparable damage to Woolf's own house, where the Hogarth Press was also located. As Woolf and her husband Leonard retraced their route back across London toward Sussex, she recorded in her diary scenes of devastation: "Heaps of blue green glass in the road at Chancery Lane. Men breaking off fragments left in frames. Glass falling. . . . Faces set and eyes blurred" (10 September 1940). Such scenes were common at the outset of the war and led to the evacuation of women and children to rural areas; in many cases, children were separated from their parents for long periods of time.

Because World War II was not fought on American soil, the postwar experiences of veterans returning to their families in United States differed markedly from efforts to reestablish normalcy in Great Britain and Europe. The death of President Franklin Roosevelt in April 1945 occasioned major changes in social policy in the United States that would affect women and minority populations. As first lady, Eleanor Roosevelt (1884–1962) had given Americans a model of activism in support of a more egalitarian society during the 13 years of her husband's presidency (1932–45). The issues that she championed—civil rights, access to education, preservation of natural resources, environmental safety, and the right of self-determination—would be central to social policy debates over the next 20 years, especially for feminists.

As one of her first acts as First Lady, she negotiated a controversial arrangement with a national newspaper syndicate to write six daily columns a week that would be published throughout the country—and she received a salary for this work. She used the column, entitled "My Day," to promote issues of importance to women and families, such as health care, education, and opportunities for women in the workforce. In her first five years in the White House (1933–38), she published six books and innumerable articles, some of which openly criticized her husband's policies. Her first book, *It's Up to the Women* (1933), addressed a variety of social causes; she urged parents to encourage children to social activism, especially in protecting the environment through conservation of resources: "One does not destroy what nature gives us to love," she wrote (Cook 7). Such engagement with broad social issues would not be seen again until the 1960s during the Kennedy and Johnson presidencies.

Even as the United States helped rebuild war-torn Europe under the Marshall plan (1947, named for General George C. Marshall), many of Roo-

sevelt's New Deal (1933) economic programs intended to improve opportunities for minorities and immigrant groups were left untended or reversed by Dwight Eisenhower's administration (1952–60). This neglect stalled efforts to integrate immigrants who came to the United States to escape totalitarianism prior to the war and a second group that came in the late 1940s. Among writers of the immigrant experience who arrived early in the century, the work of Anzia Yezierska (ca. 1881–1970) is among the best known. She published two volumes of stories and four novels about Polish-Russian-Jewish immigrants in the early years of the century (see *The Bread Givers*, 1925) and an autobiography. Yezierska was rediscovered by a new generation of readers with the publication of *Red Ribbon on a White Horse* (1950) as part of a wider interest in European history and society in the aftermath of the war.

The war occupied a central place in postwar women's writing, from Gertrude Stein's *Wars I Have Known* (1945) to Kay Boyle's *The Smoking Mountain: Stories of Germany during the Occupation* (1947), a book based on her postwar experience in Germany as correspondent for the *New Yorker* magazine. The 1947 publication of *The Diary of Anne Frank* and its translation into English in the early 1950s gave a poignant glimpse into the effects of Nazi anti-Semitism. Born in 1929 of a German-Jewish family, Anne Frank went into hiding in Amsterdam, Holland, for several years until the family was discovered in 1945. She died in the Belsen concentration camp in March 1945, just weeks before the victory in Europe by Allied forces.

German political philosopher Hannah Arendt (1906–75), who emigrated to New York City from Paris after the occupation, wrote for a German émigré paper, *Aufbau* (Construction). In the 1950s she wrote two highly regarded scholarly works that analyzed fascist ideology: *The Origins of Totalitarianism* (1951) and *The Human Condition* (1958). In 1959, she was appointed professor at Princeton University (the first woman to hold this position), and in 1961 she attended the trial in Israel of Nazi officer Adolph Eichmann, who was charged with crimes against humanity. Her book *Eichmann in Jerusalem: A Report on the Banality of Evil* (1963), which argues that Eichmann was a "cog" in a bureaucracy in which everyone was culpable, including the Jews who were imprisoned and murdered, was highly controversial. She later published two books critical of the 1960s activist movements, *On Revolution* (1963) and *On Violence* (1970); a memoir, *The Life of the Mind*, appeared posthumously in 1978.

The 1950s was a rich period of literary production for American women, and it laid the groundwork for the politically engaged and "liberated" writing of the 1960s and 1970s. The range and diversity of this writing suggest writers' openness to subject matter and style, as well as faith in a receptive reading audience. Yet these years were ones in which freedom of expression was at risk. Three events signaled government scrutiny of public discourse and private behavior. First, the House of Representatives opened hearings to investigate supposed Communist infiltration of the media, government, and academia. Second, in 1953 Ethel Rosenberg and her husband

Julius were executed at Sing Sing prison for allegedly selling atomic secrets to the Soviets. Finally, in that same year President Eisenhower issued an Executive Order prohibiting lesbians and gay men from obtaining federal employment. Despite this environment of suspicion and censorship, writers produced imaginative literature that sometimes mimicked the intrigues reported in the daily papers. Patricia Highsmith (1921–95) published *Strangers on a Train* (1950), a suspense-thriller that was made into a highly successful film directed by Alfred Hitchcock in 1951. In that same year, writing under the pseudonym "Claire Morgan," she published *The Price of Salt*, a lesbian novel that was a runaway best-seller.

In 1950, Anaïs Nin (1903–77), who had left Europe for New York during the war, published her memoir, *The Four Chambered Heart*. Over the next two decades she published seven volumes of her private diaries; these intimate writings revealed elements of her creativity and the place of writing in her life. The diaries found an enthusiastic audience among women, and Nin became a media figure, portrayed as sexually liberated yet traditionally "feminine"—a man's woman. Leaders of the emerging women's movement were troubled by this image of womanhood, especially because Nin was portrayed in the media as a feminist and an expert on women's issues.

The decade of the 1950s was also an important period for women's poetry. Marianne Moore's *Collected Poems* (1951) won the "triple crown" of honors—the Pulitzer Prize, the National Book Award, and the Bollingen Prize. Twenty-two-year-old Adrienne Rich won the Yale Younger Poets Award for *A Change in the World* (1951); the choice was made by American poet W. H. Auden. The collected poetry of several important modernist poets appeared in the early 1950s. The *Collected Poems* of Edna St. Vincent Millay were posthumously published in 1952, two years after her death. Best known for her ballads, lyrics, and sonnets, she used formal structures and traditional meter to counterpoint the emotional intensity of her writing. Louise Bogan's *Collected Poems, 1923–1953* appeared in 1954; interested in psychology, she explored the unconscious and the construction of gender.

Fiction of the period included Gwendolyn Brooks's *Maud Martha* (1952), a coming-of-age novel of African American womanhood; Mary McCarthy's satiric novel *The Groves of Academe* (1952); Flannery O'Connor's *Wise Blood* (1952), a story of hypocrisy and necessary redemption; and the autobiography of Catholic activist and journalist Dorothy Day (1897–1980), entitled *The Long Loneliness* (1952).

In 1953, experimental modernist Jane Bowles (1917–73) published *In the Summer House*, a play that shares with Dorothy Parker's *The Ladies of the Corridor* (1953) and Hellman's *The Autumn Garden* (1953) the theme of family relationships. Bowles's play reverses the assumption that mothers guide their daughters into the larger world. In this instance, the daughter "mothers" her mother. This theme of relations between parents and children was central to Gertrude Stein's writing as well (see *The Making of Americans*, 1925). Yale University Press published posthumously Stein's humorous meditation on language, gender, and power, *Patriarchal Poetry*, which, in claiming that

"Patriarchal Poetry is the same as Patriotic Poetry," plays on the systems of language, power, gender, and family relations. Stein reinforces meaning by rhymes and repetitions: "Let her try. Just let her try. Never to be what he said. Never to let her be what he said [she was]."

Alice B. Toklas, Stein's longtime companion, spent the last years of her life overseeing the publication of Stein's unpublished manuscripts. In 1954, facing poverty in Paris, Toklas had a best-seller with *The Alice B. Toklas Cookbook*, a work best described as a memoir with recipes. Content to be the "wife" who cooked, gardened, and entertained the wives of the male artists and writers who came to meet "Miss Stein," Alice B. Toklas made an art of domestic routines.

In 1955, Anne Morrow Lindbergh (1906–2001), wife of aviator Charles Lindbergh and herself a pioneer in aviation, published a small book that captured the challenges for middle-class women in postwar America. Written during a brief summer vacation with her sister on Captiva Island in Florida, *Gift from the Sea* speaks of the fragmentation of women's lives that produces exhaustion and distraction:

> The pattern of our lives is essentially circular. We must be open to all points of the compass; husband, children, friends, home community; stretched out, exposed, sensitive like a spider's web to each breeze that comes. . . . How difficult for us, then, to achieve a balance in the midst of these contradictory tensions.

Despite the growing prosperity of the white middle-class in the 1950s, one-quarter of married women in the United States were part of the workforce, an increase of 7% since 1945. Half of all women college graduates were employed. Women joined men in establishing businesses and working in government and industry and entered the fields of education, health care, publishing, government, politics and public service, entertainment, and the fashion industry. There was a decided sense that the future held great promise.

The housing shortage in the postwar years produced a boom in home construction that created the "suburbanization" of America, a situation that forced men to commute to work and homebound women to raise children in relatively isolated environments. The suburban middle-class experience became a central subject for literary feminists in the 1950s and for their daughters, who became the feminist activists of the 1960s and 1970s. By 1954, three-fifths of American households had televisions. The happy middle-class families portrayed in television sitcoms such as *Ozzie and Harriet*, *Father Knows Best*, and *The Donna Reed Show* belied the frustrations of lonely, bored mothers who struggled to create a beautiful home and "picture perfect" family. When in 1960, *Redbook* magazine ran a cover story, "Why Young Mothers Feel Trapped," 24,000 women replied with their personal stories.

Alfred Kinsey's study of male sexuality (1949) was followed by his best-selling *Sexual Behavior in the Human Female* (1953). Taking heterosexuality as

the norm, Kinsey concluded that women's sexuality was "active" rather than passive, as the Victorians had maintained. The report confirmed that women's libido was the equal of men's, that women engaged in extramarital sexual relationships in nearly the same number as did men, and that they enjoyed sex even beyond their childbearing years. The first of many reports on female sexuality, the Kinsey report argued that half of the female population engaged in premarital sex, 62% masturbated, 26% had had an extramarital affair, and 20% had had some kind of homoerotic experience. Unlikely as it may seem given the climate of **homophobia** in the 1950s, when gays and lesbians were vilified as "perverts," lesbian **pulp fiction** found a wide reading audience in this period. Ann Bannon (b. 1937), a popular writer in this genre, published six highly regarded novels between 1957 (*Odd Girl Out*) and 1962 (*Beebo Brinker*). These stories, which trace the lives of three lesbians from their college days to life in New York City, were reprinted in the 1980s. The literature of alternative sexualities was vulnerable to investigation by anti-pornography groups. For example, *Women Barracks* (1950), a novel with explicit lesbian subject matter by Tereska Torres, attracted the attention of the House Subcommittee on Pornographic Affairs (1952).

FREEDOM OF SPEECH AND THE THREAT OF COMMUNISM IN AMERICA

The atmosphere of suspicion that characterized **Cold War** hostilities of the 1950s cast dark shadows over the return to normalcy in the United States and led to efforts to contain Communism on the Korean peninsula (1950–53) and in Indochina that would engage the United States in a decade-long war (1965–75) to defeat Communism in southeast Asia. The "red scare" of the early 1950s was created by Senator Joseph McCarthy (Wisconsin), who claimed that Communists had infiltrated the government and military and that the entertainment industry, print and broadcast journalism, and higher education were harboring sympathizers who were indoctrinating the public with Communist propaganda. These suspicions led to the **blacklisting** of many artists, writers, scholars, and members of trade unions; Jews, African-Americans, and gays and lesbians were also targeted. Those brought before the House Un-American Activities Committee (HUAC) were asked to give names of colleagues and friends who had presumed links to the Communist Party. Margaret Chase Smith, the first woman to be elected to both houses of Congress, was the first, and one of few, to denounce McCarthy. Other women who spoke out were Mary McCarthy (1912–89), Lillian Hellman (1906–84), and essayist and cultural critic Diana Trilling.

Hellman, a self-described "moralist" who openly displayed her convictions in her work, was blacklisted in 1948 and called before HUAC in 1952. Highly regarded as a playwright, she published over her lifetime eight original plays distinguished for their economical plotting and vivid characterization, works that had strong women characters and provided opportunities for talented actresses. She wrote seven screenplays (all of them produced), directed three Broadway productions of her own work, was a

newspaper and magazine reporter, and in later life published four volumes of memoirs. She also served as the model for Nora Charles in *The Thin Man* series of books and films by her longtime partner, crime writer Dashiell Hammett.

Hellman advocated for social conscience issues and civil liberties, treating these themes in her plays. Her 1934 drama, *The Children's Hour*, was banned in Boston, Chicago, and London for its references to lesbianism. In 1937, she coproduced with Ernest Hemingway *The Spanish Earth*, a documentary in support of anti-fascist Loyalists in Spain. Her play *Watch on the Rhine* (1941), another anti-fascist drama, won the New York Drama Critics Circle Award. When she was subpoenaed by HUAC, Hellman wrote to the committee, agreeing to answer questions about her own actions but refusing to talk about the activities of her friends and colleagues. She framed her written statement with a fashion metaphor: "I cannot and will not cut my conscience to fit this year's fashions" (i.e., to betray friends). During her interrogation, she invoked the Fifth Amendment and only narrowly escaped charges of contempt before being dismissed by the committee. Playwright Arthur Miller and others repeated her testimony nearly verbatim and were also dismissed by the committee. HUAC was not dissolved until 1977; it remained active throughout the period of social activist movements, but its power was diminished. However, when some members of the Women Strike for Peace Movement were subpoenaed by HUAC in 1962, the committee was unable to intimidate them. The opening witness, Blanche Posner, a retired schoolteacher, lectured committee members on ethics as if they were her students. Television and print media treated the hearings as theater of the absurd.

Blacklisted writers of Hellman's generation suffered financially from the years of repression, but in general their literary reputations were not diminished by the events—to the contrary, many were seen as heroes. Hellman was honored with many awards, including the Gold Medal for Drama from the National Institute of Arts and Letters and the National Book Award for her memoir *An Unfinished Woman* (1970), a work that initially found a large readership among feminists. The second volume of her memoirs, *Pentimento: A Book of Portraits* (1973), was made into a successful film (*Julia*, 1977, starring Jane Fonda and Vanessa Redgrave). *Scoundrel Time* (1977), which describes the period of blacklisting and government investigations, and her final memoir, *Maybe* (1980), caused controversy among her friends, who felt she had glorified her past and misrepresented historical events. Mary McCarthy, also under political suspicion in the 1950s, denounced Hellman on television as a "liar" (Hellman filed a slander suit). Journalist Martha Gellhorn, who had covered the 1936–39 Spanish Civil War, alleged that Hellman's memories of the period were fictions.

Mary McCarthy, a Phi Beta Kappa graduate from Vassar College (1933), began writing for liberal journals at age 21 and became the primary voice of intellectual liberalism in the United States for more than 30 years. During her career she served as book review editor for *The Nation*, wrote for *The*

New Republic, and was editor and drama critic of *The Partisan Review*. As a novelist, McCarthy is best known for her satiric, sexually explicit, and autobiographical writing, which paved the way for feminist fiction of the 1960s and 1970s. These comedies include *The Groves of Academe* (1952), *Memories of a Catholic Girlhood* (1957), and *The Group* (1963). The latter work examines the lives of eight Vassar graduates in the late 1930s and early 1940s. Drawing on her own experience, McCarthy focuses on the materialism and belief in progress that tempted the young women that comprise "the group" into believing that they could shape and control their lives. This account of women's lives in the early 1940s reveals a greater freedom and optimism than one might expect; the reality of it was deferred by World War II, the onset of the Cold War, and the return to conventional roles for women in the 1950s.

Ferociously anti-Communist, Alyssa Rosenbaum (1905–82) created a new identity for herself as Ayn Rand when she emigrated from Russia in the 1920s. A playwright, screenwriter, novelist, and philosopher, Rand resisted the left-wing politics embraced by Hellman and McCarthy based on her first-hand experiences of Soviet brutality in her native Russia. Instead, she outlined a philosophy of capitalism and individualism in works of fiction and nonfiction. *The Fountainhead* (1943), a story dedicated to glorifying the skyscraper as the symbol of self-advancement, first introduced her theory of individualism versus collectivism. By 1945, the novel had sold 100,000 copies, based solely on word of mouth. To this day, the novel sells over 100,000 copies *annually*. Her final novel, *Atlas Shrugged* (1957), became the Bible of a new philosophical theory she defined as "objectivism," which placed self-interest at the center of a moral paradigm. In fact, a 1991 survey by the Library of Congress and the Book of the Month Club found *Atlas Shrugged* second only to the Bible in books that most influenced reader's lives. Following the enormous success of *Atlas Shrugged* (which sold 1.2 million copies by 1963), she turned exclusively to nonfiction, in works such as the *The Virtue of Selfishness* (1964), *Capitalism: The Unknown Ideal* (1966), and the *Romantic Manifesto* (1969). In the 1960s and 1970s, she lectured on college campuses and made frequent guest appearances on television talk shows, exploiting the popular media to advance her theories.

CIVIL RIGHTS AND EDUCATIONAL REFORM AND THE BLACK ARTS MOVEMENTS

The postwar years were characterized by a general blindness of the white majority to the terrible racial tensions that divided the United States. In particular, there was a lack of recognition of African American contributions to Allied victories in World War II and to the Korean conflict—a blindness that led to explosive anger in the Vietnam War years of the 1960s and early 1970s. The efforts to guarantee civil rights to African Americans began with the 1954 decision in the *Brown vs. Board of Education* lawsuit in Kansas in which the United States Supreme Court declared school segregation illegal. Two years later, President Eisenhower was forced to call in federal troops to quell

riots during the desegregation of the Little Rock, Arkansas, school system. In 1964 the United States Congress passed the Civil Rights Act as part of President Lyndon Johnson's "Great Society" initiative. This act banned race and sex discrimination in a variety of public arenas, including employment and access to education, and also mandated Affirmative Action programs to mitigate the effects of the long history of discrimination. The apparent American social and political stability of the 1950s gave way to a period of unparalleled violence in the 1960s. The murders of President John F. Kennedy, his brother Robert F. Kennedy, Dr. Martin Luther King Jr., and other leaders of the Civil Rights Movement and the racially motivated murders of African American students at Memphis State University occasioned international debate regarding the role of democratic societies in the fight against Communism and the failure of democracy to create civil and equitable societies.

The Black Arts Movement of the 1960s and 1970s represented themes of the black experience in the post-slavery and post-reconstruction periods. The primary subjects of women's writing were family, community, female identity, relations between mothers and daughters, sexuality, fear of poverty, and the hope for professional advancement. The struggle to gain civil rights, like the struggle to gain freedom from slavery in the nineteenth century, was reflected in poetry and music. African American women writers who were born in the Depression years and came to adulthood in the aftermath of World War II combined in their writing the stylistic innovations of Modernism with music, speech, and dance rhythms.

Among these women, Lorraine Hansberry (1930–65) was the foremother of African American drama. The daughter of middle-class parents in Chicago, she studied at the University of Wisconsin and Roosevelt College in Chicago. She went to New York in 1950, where she worked on the radical African American newspaper *Freedom*, and met artists and intellectuals, including Paul Robeson, W. E. B. Du Bois, and Langston Hughes. She was interested in a variety of social issues, including race, gender, and assimilation. Like her father, she was a civil rights activist. Hansberry's renown rests on *A Raisin in the Sun* (1959). She was the youngest winner of the New York Drama Critics Circle Award, as well as the first woman and first black to receive this honor. The play dramatizes the black struggle for equality and dignity through the reactions of members of the Youngers family to an inheritance from their dead father. Hansberry's work was a guiding light for younger black dramatists, including black nationalist Amiri Baraka (LeRoi Jones) and feminist Ntozake Shange (b. 1948).

Gwendolyn Brooks (b. 1917), the first African American woman to win the Pulitzer Prize (1950), was a model for those who followed, especially in her commitment to teaching and nurturing younger poets. Black writers were joined in a literary movement in the early 1960s to create a black art that would capture the anger, resentment, and rhythms of Malcolm X's speeches. In "Black Art," Amiri Baraka (Leroi Jones) spoke for the group when he said, "We want a black poem. And a/Black World." In a *Capsule Course in Black Poetry Writing* (1975), Brooks outlines the project of the "new

black literature": "black literature is literature BY blacks, ABOUT blacks, directed TO blacks." She looks back to the writers of the years 1966–69, the height of the civil rights era, and remembers that "sometimes the literature seemed to issue from pens dipped in, *stabbed* in, writing blood." Her own principles for poetry, or "hints" as she called them, included using ordinary speech and speaking personally. These qualities are evident in her own poetry, which reflects the distinctiveness of black experience in the years during and after World War II. In "Kitchenette Building" (1945), her description of domestic reality suggests poverty and unfulfilled dreams: "We are things of dry hours and the involuntary plan,/Grayed in, and gray." In "The Mother" (1945), she writes movingly of abortion: "Abortions will not let you forget./You remember the children you got that you did not get."

One hears echoes of Brooks's urban subject matter, her conviction, and the spare concision of her writing in the narrative poetry of Lucille Clifton (b. 1936), poet laureate of Maryland, as in this excerpt from "Good Times" (1969):

> My Daddy has paid the rent
> and the insurance man is gone
> and the lights is back on
> and my uncle Brud has hit
> for one dollar straight
> and they is good times
> good times
> good times

Like Brooks, Clifton focuses on domestic realities and explores how the underside of "good times" is the poverty and potential violence facing the extended African American family. Both women have committed themselves to nurturing young writers through teaching. Brooks began university teaching in the 1960s, when she was in her forties; Clifton writes children's books that will help young blacks understand their world and their history.

The poetry of June Jordan (b. 1936), who is also and educator a contemporary of Lucille Clifton, is both idealistic and deeply marked by feminism and her commitment to social justice. Her writing is a call to action, as in "Okay 'Negroes' " (1970):

> looking for milk
> crying out loud
> in the nursery of freedomland:
> the rides are rough.
> Tell me where you got that image
> of a male white mammy.

The literary inheritors of these urban, socially aware writers were those who were coming into their womanhood in the years of the women's move-

ment. This group includes politically militant women who were, in the words of Alice Walker, "called to life" by the Civil Rights Movement. Militant on behalf of black rights, they were suspicious of—even hostile toward—middle-class white feminism, which had overlooked black women's experiences. Prominent activists of this generation are Sonia Sanchez (b. 1935), Nikki Giovanni (b. 1943), and philosopher, activist, and educator Angela Davis (b. 1944). These women hold anti-capitalist and anti-totalitarian beliefs and are committed to the global struggle for social justice, human rights, and equality. Their work is part of a larger effort to eliminate First World economic oppression, domestic oppression of women and children, the widespread sexual mutilation of girls and boys, and slavery and enforced military service.

In "The True Import of Present Dialogue: Black vs. Negro" (1968), Giovanni describes the situation of young black American men drafted into white wars. The poem is a response to the 1968 escalation of the war in southeast Asia in which poor inner-city black men and farm workers in the Midwest and South were shipped to Vietnam:

> Can you lure them to bed to kill them
> We kill in Viet Nam
> For them
> We kill for UN & NATO & SEATO & US
> And everywhere for an alphabet but
> BLACK

The poem advocates a transformation in the construction of black masculinity—from men's oppressed position as "niggers" to black men in their own right. Giovanni anticipates the appropriation of the term "nigger" by African American males of the hip-hop generation.

Angela Davis joined the Communist Party in 1968 and was nearly fired from her academic position at UCLA in 1969 by Governor Ronald Reagan. Later accused of conspiring in a courtroom uprising in the Soledad Brothers Defense Committee, she was acquitted on charges of murder, kidnapping, and conspiracy, any one of which would have brought the death penalty. These experiences led to her collaboration on an anthology of writings that addressed prisoners' rights, entitled *If They Come in the Morning*. In 1981, Davis published *Women, Race, and Class*, a critique of the race and class bias of the women's movement, which was followed in 1989 by *Women, Culture and Politics*.

While Giovanni, Sanchez, and Davis, as women of the militant social and black consciousness movements, stressed their racial position, other black women writers were influenced by the nonviolent campaign of Dr. Martin Luther King Jr. and the emerging feminist movement. Poet Maya Angelou (b. 1928) received both popular success and critical acclaim with the first of a multivolume autobiography, *I Know Why the Caged Bird Sings* (1970), which tells the story of her youth and adolescence in Stamps, Arkansas. In the early

1960s, at the request of Dr. Martin Luther King Jr., she served as northern coordinator of the Southern Christian Leadership Conference as part of her commitment to the nonviolence movement. She also joined the Harlem Writers Guild, where she developed her literary skills. This group included novelist Paule Marshall (b. 1929), whose best-known work is *Brown Girl, Brownstones* (1959), a story of West Indian immigrants trying to negotiate cultural and material dislocation in New York City.

SEXUAL DIFFERENCE AND POSTWAR FEMINISM

Feminist activism on both sides of the Atlantic brought women into the political process and created agendas for improved working conditions for women and living conditions for their families. In the United States, academic feminism, represented by the founding of women's studies degree programs in 1969 (at San Diego State University), established the intellectual and pedagogical agenda that would transform higher education, broadening its reach to women of all social classes and racial backgrounds. Important political gains in these years included the 1972 Education Amendments to the Civil Rights Act that included Title 7, which prohibited sex discrimination in federally funded education programs, and Title 9, which prohibited sex discrimination in sports programs. These educational reforms included a package of federal loans to support undergraduate and graduate study for those who needed financial assistance and Affirmative Action programs aimed at attracting minority candidates to colleges and universities and facilitating their entrance into the professions. The changing profile of the workforce also led to increased political pressure for maternity leave policies and childcare benefits.

Political gains for women came slowly, despite legislative initiatives and other kinds of activism, which included voter registration, the founding of shelters for abused women and children, and consciousness-raising groups. Powerful forms of activism in these years included books written by women testifying to the experience of being marginalized, discriminated against, or in other ways limited in their efforts to achieve personal and professional goals. The book that exposed the deleterious effects on women of the culture of "femininity" was *The Feminine Mystique* (1963) by journalist and activist Betty Friedan (b. 1921). This work exposed the psychological and social price that middle-class women pay in the search of fulfillment through their husbands and children. The book was an immediate best-seller. Three years later, in 1966, Friedan met with leaders of the National Conference of Commissions on the Status of Women to create a civil rights organization for women that would give them full equality. The National Organization for Women (NOW) was chartered a few months later with 28 members and Friedan its first president; 35 years later NOW has several thousand members.

NOW lobbied energetically for the Equal Rights Amendment (ERA) legislation intended to guarantee women equal pay for equal work with men.

The U.S. Congress approved the ERA in 1972, the year *Ms.* magazine was founded with Gloria Steinem (b. 1934) as its editor. A decade later, ERA legislation failed by three votes to be ratified by all states, a defeat that constituted a major setback for women's rights.

Reacting strongly against the middle-class culture of the postwar period, feminist-activist fiction and theoretical writings of the movement were produced by women scholars and creative writers. These works found a readership among women eager to understand their conflicting desires and ready to redefine the traditional relations between men and women. This writing, whether academic treatises or works of fiction, aimed to raise the consciousness of women and girls to the effects of social, cultural, and political prejudice against them.

Academic feminists advanced the cause of literary feminism through research and scholarly writing that traced the history of patriarchy. They charted new directions for women's literature by exploring the place of women in the postwar world and by making socially conscious issues central subjects of their writing. Australian born Germaine Greer (b. 1939) was a university lecturer and journalist in England when she published *The Female Eunuch* (1970). This founding text of second-wave feminism reveals the sexist representations of women in literature and art. Translated into 12 languages, it found a worldwide audience. Greer used print and electronic media to raise the profile of the women's liberation movement and pioneered the effort to "recover" women writers who had fallen out of, or were never included in, the canons of English and American literature. Her book, *Sex and Destiny: The Politics of Fertility* (1984), is a feminist critique of sexuality in the context of family structures. Greer's journalism focuses on poverty, disease, and women's health issues in Third World countries.

The parallel text in the United States to Greer's *Female Eunuch* was Kate Millet's *Sexual Politics* (1970), her Columbia University doctoral dissertation, which revealed **patriarchal** assumptions underlying the canon of English literature. In 1973, another graduate student at Columbia University, Erica Jong, published *Fear of Flying*, a comic feminist coming-of-age novel. In 1977, Marilyn French (b. 1929) published *The Women's Room*, a semi-autobiographical novel told from the perspective of a young mother and graduate student in the English Department at Harvard who discovers that male elitism and exclusionary practices toward women prevail, despite the women's movement. The novel reveals that the academy disregards the reality that women students often work harder and are more knowledgeable than their male colleagues. Poet Adrienne Rich (b. 1929), French's contemporary, described her years as a young mother and wife of a Harvard professor in similar terms in *Of Woman Born*: "I *knew* I had to remake my life; I did not then understand that we—the women of that academic community—as in so many middle-class communities of the period—were expected to fill both the part of the Victorian Lady of Leisure, the Angel in the House and also of the Victorian cook, scullery maid, laundress, governess, and nurse."

Rich's feminist manifestos, which comprise a powerful critique of patriarchy, include her autobiographical essay, *When We Dead Awaken: Writing as Revision* (1972); her poem *Diving into the Wreck* (1973), written after the breakup of her marriage; and *Of Woman Born* (1976), a treatise on motherhood in the 1950s. When *Diving Into the Wreck* won the National Book Award for Poetry in 1974, Rich refused to accept it for herself. She agreed to share the honor with Audre Lorde (1934–92) and Alice Walker (b. 1944), who were also nominated for the prize. Together, the poets accepted the award in the name of all women.

These writers laid the ground for the next generation of literary activists, who adopted "consciousness raising" as a strategy for representing women in art. Like many of her contemporaries, novelist and short story writer Joyce Carol Oates (b. 1938) believes in the public role of the writer and rejects the myth of the "isolated" artist. A professor at Princeton University, she is both a scholar and critic and one of the most prolific, versatile, and respected fiction writers of the late twentieth century. Her trilogy of novels of American life from the 1960s include variations on literary methods (satire and surrealism) and complicated repositioning of characters among the novels that underscore her central theme—the contradictions and disparities within and between social classes. The first of these works, *A Garden of Earthly Delights* (1967), is a story of the economic and social underclass. The second book, *Expensive People* (1968), is a satire of suburbia. The third novel, *them* (1969), which portrays urban violence, won the National Book Award. Collectively, these three novels provide a broad panorama of American life at a moment of cultural crisis.

During this period in Great Britain, the centrality of theater to British life and culture made it an important vehicle for feminists. Following the "angry young men" theater of the 1950s (the name taken from John Osborne's *Look Back in Anger*, 1956), women playwrights and actors dominated London stages from the mid-1960s through the 1980s. Playwright and television writer Caryl Churchill (b. 1938) has been a pioneer in this field, her work combining documentary and historical material to examine the oppression of individual rights by capitalist-sexist society.

In 1976, at the height of media coverage of the feminist movement in Great Britain, Churchill produced two historical plays—*Light Shining in Buckinghampshire*, about seventeenth-century millennialists, and *Vinegar Tom*, based on seventeenth-century witch hunts, which was produced by a feminist touring company called Monstrous Regiment. Her best-known play, the feminist comedy *Top Girls*, produced in London in 1982 (and later on Broadway), brought together successful women in history. In 1987, she wrote *Serious Money*, a play about greed. Churchill's work encouraged feminist-activist writing by other women playwrights and provided important roles for actresses. British theater in the last quarter of the twentieth century served as a primary vehicle of raising consciousness of the public to issues of sexism, racism, and class prejudice, as well as presenting role models for girls and women seeking ways to speak out, take action, and create themselves as independent people with full lives.

SOCIAL ACTIVISM

Literary feminists of the postwar years participated in activist movements for social justice by speaking out at conferences and in their classrooms— college and university classrooms became important venues for conscious- ness raising across a spectrum of political, cultural, and environmental issues. For example, fiction writer and journalist Kay Boyle, who began teaching at San Francisco State University in 1963, sided with student demonstrators against the war in Vietnam and used her academic position to prod government officials to end the war (see her memoir *The Long Walk at San Francisco State*, 1970). Anti-war activist and civil rights supporter poet Denise Levertov (b. 1923) explores the place of politics in everyday life. Her work discusses the dangers of nuclear power and the foreign policy initia- tives that brought the United States into the Vietnam War and supported the government of El Salvador and the genocide of its people in the 1980s.

The roots of this literature are found in the American populist movements of the 1930s represented by working-class writers and journalists such as Tillie Olsen (b. 1913), as well as by middle-class women on the political left, including journalist and short story writer Martha Gellhorn (b. 1908), Mary McCarthy, and Lillian Hellman. Feminist activists argued that social and economic devaluation of women was central to broader ideological com- mitments, including the future of our planet—feminized as "Mother Earth." A slogan adopted by environmentalists, peace activists, and feminists was "Love Your Mother."

The most prominent environmentalist writer of the period was zoologist Rachel Carson (1907–64), author of lyrical books about oceans, wetlands, and the sea, including *Under the Sea-Wind* (1941) and *The Sea Around Us* (1951). Concerned that future generations appreciate and protect the natural envi- ronment, she wrote several books for children, including *A Sense of Wonder* (1965). Her most important work was *Silent Spring* (1962), which won liter- ary awards for its shocking portrayal of a pesticide-ridden planet. These pes- ticides were developed as part of the war effort and later used as weed- killers on farms, where they drained into streams and aquifers. The book was highly controversial, some reviewers disputing Carson's evidence, oth- ers claiming that she was an agent of the Soviet Union, still others dismiss- ing her as overwrought. Her 1963 testimony before several House and Sen- ate committees in Washington, DC, however, led to a federal ban on the use of DDT.

Very ill as she testified before Congress, Carson died a year later of breast cancer, a condition that had gone untreated because her surgeon lied to her when she asked whether the biopsies he had taken revealed malignancy. Such practices by male physicians treating women were still common in the 1950s and 1960s. Physicians justified these practices by claiming that they were protecting women from emotional trauma.

Journalist Martha Gellhorn, discovering the poverty of African American families in New England and in the rural South, gave her reports of living conditions to President Roosevelt, and thereby influenced welfare policies

of his administration. She then turned these journalistic essays into short stories, publishing them in 1936 under the title *The Trouble I've Seen*.

Novelist and memoirist Tillie Olsen (b. 1913) and poet Muriel Rukeyser (1913–80) were energetic leftist activists. Olsen's activism began in the 1930s, when she was jailed for participating in strikes, including the Bloody Thursday maritime strike in San Francisco. Her fiction concerns working-class women and children, affirming their courage, endurance, and heroism. Her best-known work in the short story genre is *Tell Me a Riddle* (1961), a collection that explores the forces that corrode love. The opening story, "I Stand Here Ironing," concerns the relationship of mother and daughter and has become a classic text for feminists. *Tell Me a Riddle* was awarded the O. Henry Award for best short stories. Actively engaged in the women's movement, Olsen spoke out for women writers in *Silences* (1978), first published in *Harper's* magazine as "Silences: When Writers Don't Write." This meditation on creativity and repression has exerted profound influence on the shape of academic feminism because Olsen catalogs and explains the "unnatural silences" that keep people from writing and speaking out:

> Literary history and the present are dark with silences: some the silences for years by our acknowledged great; some silences hidden; some the ceasing to publish after one work appears; some the never coming to book form at all.
>
> What is it that happens with the creator, to the creative process, in that time? What *are* creation's needs for full functioning? Without intention of or pretension to literary scholarship, I have had special need to learn all I could of this over the years, myself so nearly remaining mute and having to let writing die over and over again in me.

Muriel Rukeyser, poet, biographer, playwright, translator, and literary critic, was Olsen's exact contemporary. Both women were Jewish and left-wing and were profoundly affected by the Great Depression of the 1930s. Rukeyser's commitment to social protest began in 1932 when she was arrested for protesting the second Scottsboro trial of the nine black men accused of raping two white women in Scottsboro, Alabama. In the 1960s, she served time in a Washington, DC, jail for protesting against the Vietnam War on the steps of the U.S. capitol. Later, she later flew to Hanoi, accompanied by her friend poet Denise Levertov, to meet with North Vietnamese leaders. When she became president of the American chapter of P.E.N., the international society dedicated to the rights of writers worldwide, she traveled to South Korea to support dissident Kim Chi-Hai, who was imprisoned under sentence of death. Forbidden to enter the prison, she stood outside its gates and later took this experience as the subject for her last major poem, "The Gates." As Rukeyser wrote in the introduction to her text, *The Life of Poetry* (1949):

> In time of crisis, we summon up our strength. Then, if we are lucky, we are able to call every resource, every forgotten image that can leap to our quick-

ening, every memory that can make us know our power. . . . In time of the crises of the spirit, we are aware of all our need, our need to reach others and our need for our selves. We call up, with all the strength of summoning we have, our fullness. And then we turn: for it is a turning that we have prepared; and act. The time of the turning may be very long. It may hardly exist.

Poet and nonfiction writer Annie Dillard (b. 1945) extended the literary traditions of nineteenth-century writers Henry David Thoreau and English poet William Wordsworth. Dillard shares the concerns of these earlier writers. Her primary contribution to the literature of landscape has been to revive the essay form as a means of evoking the natural world and its power on the imagination. Her best-selling *Pilgrim at Tinker Creek* (1976), described by reviewers as "a *Walden* for the 1970s," won the Pulitzer Prize for nonfiction. This long essay recounts Dillard's existence during her residence in the Blue Ridge Mountains, where she had gone to find solitude and to write. Dillard later became a writer for *Harper's* magazine and editor of *Living Wilderness*.

CONFESSIONAL FORMS: AUTOBIOGRAPHY, MEMOIR, DIARY

According to Virginia Woolf, women think back through their mothers. This mode of emotional connection to both past and present may explain the continued popularity of confessional and autobiographical forms of writing by women since the 1950s. In the confined domestic circumstances for women of the 1950s and early 1960s, women wrote about their anger and unhappiness. Sylvia Plath (1932–63) and Anne Sexton (1928–74) described the destructive effects of family life—loneliness, alcoholism, absence of intellectual stimulation, distanced relations between husbands and wives, the domestic violence and child abuse that suburban living produced, and other issues central to the women's liberation movement. These women were of the generation of writers that rejected the "objectivity" traditionally valued by the modernists; they retained formalist poetic elements but spoke directly of their experiences. They shared common backgrounds—both were New Englanders born into solidly middle-class families. They met in poet Robert Lowell's poetry writing class at Harvard in 1958. Both women suffered from debilitating depression (the birth of their children seemed to increase their psychological fragility). Both women died by suicide—Sexton at age 46, Plath at 31, two weeks after the publication of her autobiographical novel *The Bell Jar* (1963), which recounts her battle with depression during her undergraduate years at Smith College. In its anger and honesty this work was a harbinger of the women's movement. Plath's account influenced Susanna Kaysen (b. 1948). Her memoir, *Girl, Interrupted* (1993) recounts her two years spent in McLean Hospital in Massachusetts in the 1960s, the same psychiatric institution that housed Plath a decade earlier.

Plath's poetry is regarded for its stylistic accomplishment, terseness, tonal variations, and capacity to render highly personal experience within the context of larger cultural and historical settings. Her *Collected Poems*, published

in 1982, was awarded the Pulitzer Prize for literature. Six days before her death, Plath wrote "Edge," a poem that eerily foreshadows events:

> The woman is perfected.
> Her dead
>
> Body wears the smile of accomplishment
> The illusion of a Greek necessity
>
> Flows in the scrolls of her toga,
> Her bare
>
> Feet seem to be saying:
> We have come so far, it is over.

The idea of the female form perfected in death finds its echo in Marge Piercy's (b. 1936) "Barbie Doll" (1973). In this poem, the speaker pictures a girl displayed in a coffin, with "turned-up putty nose": "Doesn't she look pretty? everyone said./Consummation at last./To every woman a happy ending." Irish poet Eavan Boland (b. 1944) takes up the same pressures on young women, describing the pain of self-starvation in "Anorexic": "Flesh is heretic./My body is a witch. I am burning it."

Anne Sexton won the Pulitzer Prize for her third volume of poetry, *Live or Die* (1966), a volume in which she discussed suicidal tendencies, a subject she had also taken up in *To Bedlam and Part Way Back* (1960). Another primary topic of Sexton's work was the destructive effects of social convention. The following poem, "The Room of My Life," was published posthumously in 1975:

> Here,
> in the room of my life
> the objects keep changing.
> Ashtrays to cry into,
> the suffering brother of the wood walls,
> the forty-eight keys of the typewriter
> each an eyeball that is never shut, . . .
> The windows,
> the starving windows
> that drive the trees like nails into my heart.

Reader response to Plath's and Sexton's writing has often focused on the themes of depression and suicidal longing, as if their work were entirely confessional, domestic, and fully autobiographical. Such readings overlook the comic-ironic tonal shifts that are hallmarks of their writing and miss the "craftedness" of their work, especially their sophisticated use of speaking personas. A danger lies, as well, in reading backward from their deaths, so that all their writing seems to foreshadow their suicides.

The poetry of Louise Gluck (b. 1943) follows in the tradition of Plath and Sexton both in theme and confessional tone and in her interest in the pain of loss. Gluck also follows modernist interest in Greek myth. *Meadowlands* (1996) examines a modern-day marriage in crisis by translating it through the personae of Homer's *Odyssey*.

Between 1955 and 1966, the multivolume *Diary of Anaïs Nin*, which described in intimate detail Nin's difficult passage from girlhood to writer to womanhood, was published in the United States. Eagerly read by college students, housewives, and professionals, the diary encouraged women to explore and record their own inner consciousness and develop their own creativity. In the entry dated 25 May, 1932 (Nin was 29 years old), she wrote:

> Man can never know the kind of loneliness a woman knows. Man lies in a woman's womb only to gather strength, he nourishes himself from this fusion, and then he rises and goes into the world, into his work, into battle, into art. He is not lonely. He is busy. The memory of the swim in amniotic fluid gives him energy, completed. The woman may be busy too, but she feels empty.

When the five volumes of Virginia Woolf's *Diary* were published along with her letters beginning in the late 1970s, a second generation of readers followed the internal landscape of a writer many regard as the "foremother" of second-wave feminism. In particular, the 1976 publication of portions of *Moments of Being: Unpublished Autobiographical Writings* (revised and expanded in 1985) revealed aspects of Woolf's life unknown to the reading public. Of particular interest were her early memories of her mother, who died when Virginia was 13 years old; her child sexual abuse by her older stepbrother; and her close relationship to her sister, artist Vanessa Bell. The market for biographies and autobiographies of women writers flourished in these years as women readers sought role models for their creative lives.

Essayist, journalist, and screenwriter Joan Didion (b. 1934) adapted the novel to create the fiction of confessional forms. While not strictly autobiographical, her novels exhibit the same preoccupation with death, suffering, and alienation from the contemporary world evident in Plath's and Sexton's works. The best example is *Play It As It Lays* (1970), which brought her fame for its story of a modern woman caught in crisis. Protagonist Maria Wyeth, an actress, suffers a mental breakdown and undergoes electric shock therapy. Dismissive of psychiatry's ability to heal the mind, Maria finds no comfort outside the institution in relationships, drugs, or religion. Didion's later novels and essays have established her as a perceptive social critic of life in late twentieth-century America.

Lesbian writers of the 1970s and 1980s have also contributed to the social critique of established patterns of gender sexuality in the form of "confessional" novels. The most widely read of these early works was *Ruby Fruit Jungle* (1973) by Rita Mae Brown (b. 1944), a comic autobiographical account of lesbian life that sold 300,000 paperback copies. Two autobiographical novels by British writer Jeannette Winterson (b. 1959) won major literary

prizes—*Oranges Are Not the Only Fruit* (1985), winner of the Whitbread Prize, and *Sexing the Cherry* (1989), which won the E. M. Forster Award—and speak openly of her sexuality.

Lesbian feminist poet, essayist, and activist Audre Lorde used her literary work to transform power relations between men and women, blacks and whites. Diagnosed with breast cancer in 1978, she began writing *The Cancer Journals* (1980), which were followed by her autobiography, *Zami: A New Spelling of My Name* (1982). Like Maya Angelou's autobiographies, *Zami* was central to the resurgence of women's **memoirs** that grew out of the women's movement.

The assumptions that underwrite **autobiography** and memoir—that the writer speaks in the first person and the story is based in fact—have been put into question by changing conceptions of subjectivity and identity. Therefore, the distinction between autobiography as "truth" and fiction as "storytelling" has broken down, in part because writers do not always feel comfortable in telling their stories "straight," but prefer, as Emily Dickinson claimed, to tell it "slant." In their memoirs women are often confessing to the brutalities they experienced in their family life as children and in their marriages. Canadian Janice Williamson in her memoir *CRYBABY!* (1998) addresses a situation unfortunately all too common to girls—incestuous abuse by older male family members or friends of the family. In trying to explain to herself the sense of violation, she examines childhood photographs that were captioned in her father's handwriting. One photo that showed her on a swing, for instance, was described with the phrase, "Push me some more, Daddy." These photos do not help her solve the puzzle. Instead, they cover over the traumatic events that she cannot fully know nor explain to herself. Instead, she turns to science for an explanation, quoting from a *Scientific American* article that claims that children are unable to remember abuse because the hippocampus cannot yet process and store emotional memories. Her memoir becomes a way of processing the events and their meaning for the adult writer.

In the twenty-first century, the memoir is vying with the novel in popularity among female and male readers. It has become a significantly important genre for academic women authors, offering them a way of investigating identity and its relation to language and to the forms that women turned to in earlier periods: confessional works, letters, diaries, novels, and travel narratives. Women have crossed the once sacred boundaries of academic writing that separated nonfiction from fiction, theory from criticism, in order to erase the impersonal "I" that dominated academic writing from the 1930s until the 1980s. Literary feminisms have replaced this "I" with an individual voice that speaks with self-conscious awareness of personal experience of the reality of women's lives.

LITERATURE OF COMMUNITY AND PLACE

The literary tradition that examines place and local mores has a long history in American writing. This genre flourished in the prewar and postwar pe-

riod of the 1940s and 1950s, defining what was uniquely "American" about rural and small-town life. Women writers attentive to the complex workings of gender, class, and race excelled in this genre and influenced writers of later generations. A contemporary "inheritor" of this tradition is Anne Tyler (b. 1941). Raised on communes in Maryland and North Carolina in the 1950s and 1960s, she is a writer who attends carefully to speech patterns and personal idiosyncrasies. In such novels as *Slipping Down Life* (1970) and *Searching for Caleb* (1976), Tyler's writing reflects an interest in capturing the ordinariness and oddity of daily life.

Tyler has been influenced by the work of Mississippi-born writer Eudora Welty (1909-2001). Welty and Georgia native Flannery O'Connor (1925–64) define a southern tradition of creating memorable characters who represent local values and attitudes—a literary method that allows these writers to critique the culture through characterization. Welty and O'Connor offer complementary portraits of white families in regions of Bible-belt fundamentalism marked by the polite gentility of the former plantation culture, the acceptance of dire poverty among tenant farmers, and horrifying racism. Welty's writing takes a gently comic-ironic view of human behavior as she explores the influence of the past on the present. O'Connor's themes explore the Anglo-Catholic traditions in which she was raised in relation to the emotional spontaneity that characterizes southern fundamentalism. The legacy of the Civil War (1861–65) and the traditions of gentility among the landed gentry form the backdrop of this writing. Death and dying are primary subjects of southern fiction, metaphors for a region that seems unable to shed its violent locked past. Welty treats these subjects in her Pulitzer Prize–winning novel, *The Optimist's Daughter* (1972), in which a widow returns to the South for her father's illness, death, and funeral but refuses to play the traditional role of southern lady. Flannery O'Connor's work has a darker side and is more openly didactic than is Welty's writing. In her story "Judgment Day," a young woman defends the situation of her dying father to her husband:

> "He was somebody when he was somebody. He never worked for nobody in his life but himself, and he had people—other people—working for him."
> "Niggers is what he had working for him," the son-in-law said. "That's all. I've worked a nigger or two myself."
> "Those were just nawthun niggers you worked," she said.

Carson McCullers (1917–67) represents another side of southern writing—a version of **Southern Gothic** informed by modernist literary methods and displaying a dark, existential humor. Her first novel, *The Heart Is a Lonely Hunter* (1940), published when she was 23 years old, brought her national prominence. A film version appeared in 1968, starring Alan Arkin and Sondra Locke as McCullers's central character, a deaf mute. McCullers's fiction includes a cast of poor white trash—drifters and down-and-outs alienated from the capitalist system and excluded from the middle-class environment in which the young Lulu Carson Smith grew up in Columbus, Georgia. This

novel is often described as a book about the Great Depression, part of a long history of protest fiction. Other readers see it as a work of psychological rather than sociological fiction. McCullers herself referred to it as a parable of fascism.

The Ballad of the Sad Café (1951), McCullers's most acclaimed novel, is a study in loneliness and spiritual isolation, primary themes in her fiction. This work is also an experiment in folklore forms (ballad and legend) and in sexual and gender identity. Amelia, the protagonist, is a modern Amazon who refuses to let her husband consummate their marriage. The emotional dynamics of the book include a romantic triangle that McCullers and her husband Reeves (both bisexuals) experienced with a third person in this period in their lives. McCullers's primary subject is southern white culture, with African Americans appearing in supporting roles as servants and farmhands.

Farm life in the Midwest is a central subject in the work of Jane Smiley (b. 1949), who invoked Meridel Le Sueur's belief in the relation of landscape to the human body in her Pulitzer Prize–winning novel *A Thousand Acres* (1992): "The body repeats the landscape. They are the source of each other and create each other." Smiley's novel retells Shakespeare's tragedy *King Lear* through the lives of daughters in an Iowa farm family during the 1980s. In these years, local banks encouraged farmers to increase their landholdings, a situation that resulted in massive bankruptcies and loss of family farms, driving hundreds of farmers to suicide. For Midwesterners, this land crisis brought back memories of the Great Depression. Mary Karr's *The Liar's Club* (1998), a memoir about her childhood experiences in East Texas, similarly attests to the powerful influence of place on psychological development.

British literature of this period also contains strong themes of home and family and the emphasis on England as both a geographical place and a nation. This is well represented in the works of Barbara Pym (1913–80), a writer who did not identify herself as a feminist, although she was an independent thinker. A graduate of Oxford University, she began writing in her twenties but did not publish her work until 1950. Her gentle satires of English life drew a wide readership, and she influenced a generation of women writers by focusing on the lives of unmarried middle-class and middle-aged people connected to the Anglican Church or to academic life. Her novels feature the rituals of church teas and village jumble sales—mainstays of sociability in the straightened economic circumstances of the postwar period. In the 1960s and 1970s, her reputation temporarily declined but revived with the publication of her novel *Quartet in Autumn* (1977), a story of old age, loneliness, and community that was nominated for the prestigious Booker Prize.

Pym's influence on the 1960s generation of women writers and readers was more often ironic than straightforward. For example, the early writing of Margaret Drabble (b. 1939) portrays a youthful, less hidebound and respectful middle class than one meets in Pym's stories. Drabble began publishing in the early 1960s, creating educated, urban "liberated" young peo-

ple representative of her own generation. These semi-autobiographical works focus particularly on the multiple roles women were expected to play in middle-class society in a time of cultural change.

Drabble's writing is reminiscent of George Eliot's fiction of a century earlier as it chronicles the social history of middle-class Britain at the mid-twentieth century. Even the titles of her novels recall Eliot (*The Millstone*, 1965; *The Waterfall*, 1969). Primary themes in these works include marriage, motherhood, and the conflicting desires for independence and intimacy. The background of such novels is middle-class comfort among groups of well-educated and successful people in their thirties. A graduate of Cambridge University with a degree in English literature, Drabble creates women who, like herself, are influenced by the characters they meet in novels. Her characters sometimes even define themselves as fictional characters in nineteenth-century works. Although Drabble's work is influenced by the norms of English domestic fiction, she does not ignore the political and social issues of her age. *The Ice Age* (1977) is set against the economic recession that created an urban "underclass" in Great Britain that subsisted on welfare support for more than 20 years.

ON THE MARGINS OF EMPIRE AND BORDERS OF NATIONS

Britain's legacy of imperialism and colonialism inspired works by women writing in English in the former colonies of South Africa, India, Pakistan, and the Caribbean. The postcolonial experience of English-language writers is represented in the work of Doris Lessing (b. 1919), Nadine Gordimer (b. 1923), Anita Desai (b. 1937), Ruth Prawer Jhabvala (b. 1927), and Arundhati Roy (b. 1960). Lessing, born in Persia, spent her childhood on a remote farm in Rhodesia, South Africa (now Zimbabwe). Gordimer, the daughter of a British mother and Jewish father from Latvia, grew up outside Johannesburg, in the former Dutch colony. Ruth Prawer was born in Germany of Jewish Polish parents; educated in London, she married an Indian architect C. S. Jhabvala and from 1951 to 1975 lived in India. Anita Desai and Arundahti Roy both grew up and live in India. Gordimer and Lessing began publishing in the late 1940s, their work informed by their South African experiences, especially the terrible legacy of **apartheid**. Their fiction explores the violence of racism, sexism, and capitalist abuses of this system.

In the late 1940s, while working for the Rhodesian government, Lessing joined a Marxist group fighting for black liberation. The primary theme of her writing—the attempt to represent political issues from a woman's perspective—is sounded with her first book, *The Grass Is Singing* (1950), and carried through the five-volume *Children of Violence* series that began with *Martha Quest* (1952), her feminist novel-as-diary; *The Golden Notebook* (1962); and her most technically complex work, *Briefing for a Descent into Hell* (1972).

A recurrent theme in the works of Nadine Gordimer, who was awarded the Nobel Prize in 1991, is the destruction of family relationships resulting from the exclusionary policies of the white South African government. Her

writing from the 1960s and 1970s (often referred to as her "liberal" phase) critiques master-servant relations in South Africa and the sexual and racial fear inherent under colonialism. Her 1974 novel *The Conservationist* marks the transition in her writing from liberal to "radical" politics, which are evident in *The Burger's Daughter* (1979), *July's People* (1981), and her novella *Something Out There* (1984). These works directly address the politics of revolution and openly critique the system of apartheid, and the method of literary representation moves beyond realism to forms of postmodernism. *The Burgher's Daughter* opens with a call to the reader's imagination. A young schoolgirl stands in front of the prison that holds her mother, incarcerated for inviting a black man to a picnic. This scene of the girl standing at the prison gate will be repeated every day of her life:

> Imagine, a schoolgirl: she must have somebody inside. Who are all those people anyway? . . . A small slotted door within the great double doors opened on eyes under a peaked cap. The blond woman's face was so close against the door that the warder drew back and in an instant, reasserted himself, but as a fair-ground gun meets its pop-up target she had him.—I demand to speak to the Commandant. . . . [W]e were told we could bring clothing for the detainees between three and four.

Indian novelist and short story writer Anita Desai portays middle-class women balancing their needs against the demands of traditional Indian family life. Her novel *Fire on the Mountain* (1977) was awarded India's National Academy of Letters Award, and *Clear Light of Day* (1980) was nominated for the Booker Prize.

Ruth Prawer Jhabvala now lives in the United States, where she is best known in the United States through her work for Merchant-Ivory film productions. Her screenplays include E. M. Forster's *Room with a View* (1986), for which she won an Academy Award; Forster's *A Passage to India* (1984); and the 1983 screenplay of her own novel about postcolonial India, *Heat and Dust* (1975), which won the Booker Prize. Her writing on Indian subjects, such as *Esmond in India* (1958), provides a cross-cultural perspective on Indian life from the viewpoint of an outsider. Her writing questions Western assumptions about the East as well as the mix of resentment and nostalgia that Indians felt in the immediate aftermath of the end of the British Raj. Her novels include *A Backward Place* (1965) and *A New Dominion* (1972). Her short story collections include *An Experience of India* (1971) and *Out of India* (1986).

The writing of Arundhati Roy is equally preoccupied with the power of traditional Indian family and government. The Booker Prize–winning *The God of Small Things* (1997) tells the story of a love affair that crosses class (or caste) boundaries. Her novel not only takes up contemporary issues but employs an innovative, **postmodern** style with elements of **magic realism**. Increasingly involved in politics in India, she voiced her protests against India paternalism and industrialism in the nonfiction *The Cost of Living* (1999).

She argues that under the guise of a benign republic, the Indian state has engaged in activities against the welfare of its largely impoverished citizens. Massive dam and irrigation projects threaten the minority tribes in the Naramada valley, whose lands, if flooded, will force the removal of large populations in rural areas to dismal camps or urban slums.

These authors write in English and are identified primarily with British literary traditions. The colonial experience, however, almost always requires that native people aspiring to social and economic advancement learn the language of the colonizer. This language—whether English, French, or Dutch—becomes the literary language of the country. The language of the native peoples is restricted to the home, and, as occurred in Ireland under British colonial rule, there is a risk that the native language will be lost. In the late nineteenth century, as Ireland pushed for "home rule," a few writers and scholars tried to bring native Gaelic back as a literary language. The "Gaelic Revival" failed, however, partly because so few people could read and write it.

This situation, which is common to virtually all colonial states, complicates definitions of "British" literature or "American" literature. These categories are usually based on where the author was born or the language in which she writes. Postcolonial literature challenges the underlying premises of such categories, however, by making "language" a central theme.

Immigrant experiences have provided a central theme for American fiction and memoir. Maxine Hong Kingston (b. 1940) combined autobiography with fierce feminism from a Chinese-American perspective in *The Woman Warrior* (1976). Like many women, she takes inspiration from her mother, a doctor in China forced to become a domestic servant in America: "Night after night my mother would talk-story until we fell asleep. I could not tell where the stories left off or the dreams began." The same mother-daughter bond, as well the intergenerational conflicts between first-generation immigrants and their Americanized children, is the subject of Amy Tan's novels *The Joy Luck Club* (1989) and *The Bonesetter's Daughter* (2001).

Like Tan, other novelists, such as Leslie Marmon Silko (b. 1948), Louise Erdrich (b. 1954), Sandra Cisneros (b. 1954), Edwige Danticat (b. 1969), and Jamaica Kincaid (b. 1949), have mined their own experiences to present fictionalized accounts that offer cultural history as autobiography. Silko draws on her own Navajo roots in *Ceremony* (1977) to recount the struggle of a half-breed soldier adjusting to life on the reservation following World War II. Erdrich, whose novel *Love Medicine* won the National Book Critics Circle Award in 1984, pulls from her Chippewa heritage to tell the stories of two native families in the years 1934–84 on a North Dakota reservation. Told from alternating perspectives, Erdrich's novel, like Tan's, employs the same first-person directness of women's autobiographical accounts. Poet Joy Harjo (b. 1951) similarly recounts the displacements—psychological and physical—of native peoples, including the forced removal of the Creeks from their homelands. The vignettes in Cisneros's *The House on Mango Street* (1984) are recounted from the perspective of a young child growing up in the Mexi-

can American community of Chicago. The heroine of Danticat's *Breath, Eyes, Memory* (1994), like the author, grows up in Haiti and moves to New York. Kincaid's novels *Annie John* (1985) and *Lucy* (1990) are autobiographical narratives about girls separated from their families and home in Antigua, capturing contemporary postcolonial displacement.

Kincaid's novel *Autobiography of My Mother* (1996) blurs the distinction between autobiography and fiction, as does Eva Hoffman (b. 1945) in *Lost in Translation* (1990). This memoir focuses on her efforts to re-create herself through a change in language when her family left Poland for Canada in the 1950s to escape the Communist takeover of their country.

Ntozake Shange (b. 1948), in giving up her American name (Paulette Williams) and taking her Zulu name, brought attention to the power of naming as a weapon against oppression. When at age 28 her "choreopoem"— *for colored girls who have considered suicide/when the rainbow is enuf* (1976)— opened off Broadway, it broke the barriers of Eurocentric theater. In this piece, seven black women draw on African traditions, improvising music, dance, and storytelling. This was the first of five choreopoems Shange produced; she has also written novels and poetry. Shange describes her profession as a "war correspondent": "I write to fight."

In *Sister Outsider* (1984), poet Audre Lorde wrote: "The oppression of women knows no ethnic nor racial boundaries, true, but that does not mean it is identical within those differences." African American writers set out to mark the boundaries between the races, crafting works that focused intently on the experience of black women as doubly oppressed minorities.

As a feminist, Alice Walker (b. 1944) articulated an African American aesthetic in her collection of essays, *In Search of Our Mothers' Gardens: Womanist Prose* (1983). American poet Mari Evans (b. 1923) said of this work, it is "composed of music, dance and quiltmaking which relies on colour contrasts and every bit of 'stuff' rather than on the abstraction favoured in white Euro-American aesthetics." Walker's four-part definition of the word "**womanist**" is playful:

> A black feminist or feminist of color. From the black folk expression of mothers to female children, "You acting womanish," i.e., like a woman. Usually referring to outrageous, audacious, courageous or *willful* behavior. Wanting to know more and in greater depth than is considered "good" for one. Interested in grown-up doings. Acting grown up. Being grown up. Interchangeable with another black folk expression: "You trying to be grown." Responsible. In charge. *Serious.* . . .

Walker concludes that "Womanist is to feminist as purple to lavender" (141). Walker's womanist project was intended to bring black feminists into a sense of their own history and to raise the consciousnesses of white women to their racism. Walker provided a key link in the history of black women's writing by bringing the work of Zora Neale Hurston, which was in danger of being forgotten, to a new generation of readers. Her own work includes

her Pulitzer Prize–winning novel of incest and interracial violence, *The Color Purple* (1982, produced as a film in 1985).

Toni Morrison (b. 1931), who won the Nobel Prize for Literature in 1993, draws on the tradition of black women's literature since the Harlem Renaissance, giving women's experiences, slavery, African folklore and myth, and jazz her own highly individual perspective. Her prose is visionary and lyrical, drawing on the unconscious and dreams to figure the experiences of African American women. In her short novel *The Bluest Eye* (1970), Morrison presents the world through the dark eyes of Pecola Breedlove, a young black girl tormented by her desire to fit into a white world. *Sula* (1973) tells the story of two women friends, Sula Peace and Nel Wright, as they mature and grow apart. Her best-known work, *Beloved* (1987, film version with Oprah Winfrey, 1999), tells the story of an escaped slave mother who kills her daughter rather than see her taken into bondage by those who are pursuing them. Later novels, such as *Paradise* (1998), return to recurrent themes—the legacy of the past, the nature of evil, and the sense of mystery in human events.

Along with Morrison, the most influential black woman writer of the late twentieth century is poet Rita Dove (b. 1952), who was named Poet Laureate of the United States in 1993, the first African American to hold this position at the Library of Congress. Dove, who has traveled extensively in Europe, has an international perspective in her fiction and poetry. Like many of her contemporaries, she also explores the intersections of the personal and the political in everyday life in "Nigger Song: An Odyssey":

> We six pile in, the engine churning ink:
> We ride into the night.
> Past factories, past graveyards
> And the broken eyes of windows, we ride
> Into the gray-green nigger night . . .

REVISIONIST ROMANCE

The romance genre, a staple of the nineteenth-century novel, became popular among feminist writers and constituted an important field of literary experimentation. Literary feminists were interested in this genre because of its power to define expectations for girls and young women. Revising the traditional "and-they-lived-happily-ever-after" endings of romances became a form of feminist activism, a way of changing the cultural plot. As feminist theorists have often asserted, "failed" love plots create opportunities for literary heroines (and their readers) to make life choices that support independence and self-sufficiency.

Literary playfulness and references to earlier works in the romance tradition are central characteristics of twentieth-century revisionist romances. For example, American writer Gail Godwin (b. 1937) entitled her 1974 revisionist romance novel *The Odd Woman*. Her heroine, a university professor

like herself, refuses to give up her career for her lover. In her decision to rewrite the romance genre, Godwin gave a nod to her mother, who supported the family by writing love stories and teaching college-level courses on romantic literature.

English writer and scholar A. S. Byatt (b. 1936) (the sister of Margaret Drabble), is one of the most skilled revisionists of romance fiction. She studied English literature at Cambridge University and later did research on Renaissance **allegory**. She began publishing fiction in the 1960s, but it was her 1978 novel, *The Virgin in the Garden*, that brought her to literary prominence. This work was the first of four projected works portraying "the new Elizabethan Age," a reference to the coronation of Queen Elizabeth II. The novel simultaneously chronicles rural life in the 1950s and invokes the Renaissance world of Elizabeth Tudor (1533–1603), the so-called Virgin Queen who managed to avoid marriage to one or another European prince. The neo-Elizabethan play in Byatt's novel is performed at a country house in the year Elizabeth II came to the throne. This use of a play to provide historical contexts recalls not only Elizabeth Tudor's love of theater but also Virginia Woolf's novel *Between the Acts* (1941), in which citizens of a provincial village enact "the history of England" as an entertainment for their neighbors.

Like Virginia Woolf, Byatt enjoys writing "between" historical periods, moving back and forth in time and across literary genres. Her most acclaimed work to date is *Possession: A Romance* (1992, a film version to appear in 2001), a feminist comedy set simultaneously in the 1980s and in Victorian England. The double plot involves a young academic researcher and her male colleague, who discover a secret love relationship between two famous Victorian poets. The internal narrative makes reference to two famous love stories: the relationship of novelist George Eliot (Mary Ann Evans, 1819–80) and George Henry Lewes and the courtship and marriage of Elizabeth Barrett (1806–61) and Robert Browning. The contemporary plot revolves not around the romance of the two researchers but rather around the woman's passion for literary research and scholarship.

The writing of Anglo-Irish philosopher and novelist Iris Murdoch (1919–99) found a wide reading audience in the 1960s and 1970s. The primary concerns of her fiction are ethical and moral concerns of everyday life, such as fidelity, the subject of *The Severed Head* (1961). She dramatizes these themes through middle-class, often highly educated, characters in search of love, freedom, and sexual fulfillment. Her works are filled with references to earlier literatures, for example, medieval quest and courtly romance modes and Renaissance theater, as well as to futurist writing. Exemplary works include *The Flight from the Enchanter* (1956), which examines issues of logic. *The Black Prince* (1973), a work that draws on themes of responsibility and destiny in Shakespeare's *Hamlet*, won the James Tait Black Memorial Prize and was later produced as a play (1989). Murdoch's dark comedy, *The Sacred and Profane Love Machine* (1974), won the Whitbread Prize.

Irony was central to postwar writing, and novelists often sent the traditional love-story plot awry, sometimes returning the would-be lovers to their

isolated existences. This is a favorite technique of Anita Brookner (b. 1938). A scholar of eighteenth- and nineteenth-century French painting, Brookner portrays in her fiction intellectual, educated middle-aged women of independent means. Her characters are often novelists, such as Edith Hope, the romance fiction writer who is the central character in *Hotel du Lac* (1984, winner of the Booker Prize). Her heroines struggle to find relationships, or to end them, and are caught in the contradictions between romantic love and marriage.

In *Brief Lives* (1990), Fay Dodworth is caught in a plot of loss and emotional sterility reminiscent of the women in novels by Caribbean writer Jean Rhys (1890–1979). Rhys focused on lonely, single women of the interwar years in London and Paris. Unprepared to create a meaningful life for herself, Dodworth (whose name means "dead-worthy") lives outside the bounds of human community and is aware of the dangers of isolation:

> I dread the weekends. I dread the pretense that drives me to the shops on a Saturday morning, and the shame of buying a solitary chop. . . . I sit by the window, my hands in my lap, looking out and waiting. . . . I watch the light fade with a sort of anguish, an anguish which is not entirely temporal. I perceive the symbolism of the end of day.

English writer Fay Weldon (b. 1931) and Canadian author Margaret Atwood (b. 1939) play with genre conventions of the eighteenth- and nineteenth-century novel to create feminist allegories of modern life. Weldon's 1984 novel, *Life and Loves of a She-Devil*, creates a novel-writing heroine whose romantic triumphs are limited to fiction. Her 1989 novel, *The Cloning of Joanna May*, takes up the Frankenstein theme, familiar from Mary Shelley's Gothic novel, presenting a male genetic engineer as a postmodern monster. Atwood's writing often explores imaginative, interior worlds. Her first novel, *The Edible Woman* (written 1964, published 1969) critiqued consumer culture through the metaphor of food, her anorexic heroine refusing the message to "consume." *Surfacing* (1972) takes the reader on a mythic journey into nature and selfhood. *Lady Oracle* (1976) is a story of metamorphosis and rebirth. *The Handmaid's Tale* (1985), which was made into a film (1990), is perhaps her best-known work. Often described as a "twenty-first-century fantasy" in which men rule, the book elaborates a primary theme—Atwood's belief that that women are complicit in their own victimization. *The Robber Bride* (1993) draws on folktales and conventions of gothic fiction to spoof romance expectations.

Mixing up traditional literary genres is a hallmark of postwar fiction that anticipates **postmodern** satires that turn "reality" into forms of theater and play on cultural assumptions of truth and reality. In *The Infernal Desire Machines of Dr. Hoffman* (1972) and *Nights at the Circus* (1984), English novelist Angela Carter (1940–92) endows an early twentieth-century New Woman with the ability to fly. A practitioner of magic realism, Carter overturned realist expectations, exploiting Gothic horror, fantasy, nightmare, pastiche,

black humor, eroticism, and the macabre as she investigated forms of sexuality and erotic pleasure. Trained in medieval literature, folklore, and myth, she also studied sociology and psychology. Feminism was central to her writing, as in *The Passion of the New Eve* (1977) and *The Sadeian Women* (1979), works that provide feminist perspectives on patriarchy, capitalism, and sexual violence and repression.

In embracing postmodernism, Carter was unusual among British women writers, however. As we have noted, her contemporaries did not venture far beyond realist modes. They instead chose to portray professional women representative of a growing segment of the postwar population who chose independence and freedom from family responsibilities over the promises (and risks) of marriage.

As a number of feminist critics have noted, the portraits of women in these novels raise questions about the possibilities for women to shape of their lives in late-capitalist society. Whereas in earlier periods it was assumed that young women would marry and take on motherhood and housekeeping as their primary life duties, expectations for twentieth-century women varied. Increased opportunities for education, the opening of professions to women, advances in technology that offered leisure time, longer life expectancy, and—perhaps most importantly—a sense of freedom to create distinguished them from women of previous generations. The themes that dominate British literary feminisms suggest, however, that the late twentieth-century New Woman might experience solitude, even isolation, as the price of her independence.

CONCLUSION

We have a greater diversity of women writing now than in any period. They differ in class, ethnicity, race, age, and cultural and linguistic backgrounds. More educated than their precursors, they also have the advantage of drawing on the works of a rich tradition of male and female writers. These women are transforming, reinterpreting, and blending traditional and nontraditional literary forms in highly inventive ways. Unencumbered by restrictions on subject matter and form, women have claimed every genre and every subject as their own. Women no longer expend energy trying to stake a place for themselves in literary traditions because they are already there.

Part 2

Approaches to Women's Texts

Feminist Literary Criticism and Theory

Feminist literary criticism offers strategies for analyzing texts to emphasize issues related to gender and sexuality in works written by both men and women, but is particularly concerned with women's writing. Inherently interdisciplinary, it is not singular but plural, assuming a variety of forms and approaches to texts. Feminist literary analyses may examine:

- Images of women and representations of female experience in texts written by authors of either sex
- Women writers, including the specific qualities and concerns of female authorship and the creation of a female tradition or canon
- Women readers, focusing on the role gender plays in the reception of literary texts and the emergence of a distinct female readership
- Language, attempting to define a distinctly **feminine** mode of writing or *écriture féminine*
- Literary form, particularly the relationship between literary genre and gender
- Publication, noting the impact of the publishing system on the production and consumption of texts by women

In the early 1960s, feminist **criticism** and **theory** established itself as a distinct form of literary and cultural analysis. It emerged as part of the larger political movement for women's rights and was preceded by a long and rich tradition of literary criticism by women dating from the medieval period. The earliest critics, such as Aemilia Lanyer, Margaret Cavendish, and Aphra Behn, expressed the fundamental ambivalence of early female literary critics: faith in their powers of judgment but fear that expressing such conviction may be "unfeminine." Christine de Pisan appealed to the authority granted by her position as a woman: "in that I am indeed a woman, I can better bear witness on this aspect than he who has no experience of it." In the seventeenth and eighteenth centuries, women presiding over literary salons in France and England, such as the bluestocking circle, established themselves as judges of literary excellence and adjudicators of fame. With the rise of criticism as a separate literary establishment in the eighteenth century, women's contributions—like men's—became more formalized.

By the nineteenth century, the **first wave** of feminism—the push for access to equal education, the professions, and political institutions—challenged separate standards of appropriateness for female readers and highlighted the connection between gender and genre, particularly in defense of

the novel as a respectable literary form. In *Northanger Abbey* (1818), Jane Austen used Fanny Burney's novels to justify novels as works "in which the greatest powers of the mind are displayed, in which the most thorough knowledge of human nature, the happiest delineation of its varieties, the liveliest effusions of wit and humour are conveyed to the world in the best chosen language."

A century later Virginia Woolf again justified women's choice of the novel but with a difference, identifying a distinctly female literary tradition. She praised Austen and Emily Brontë for writing "as women write, not as men write." In *A Room of One's Own* (1928), Woolf noted the odd dichotomy between the "woman in fiction," as she is represented in the works of men, and the woman as author: "she pervades poetry from cover to cover; she is all but absent from history."

The **second wave** of feminist criticism that emerged in the early 1960s followed Woolf's lead in focusing on the place of women in literary history, creating a female **canon** and establishing forms of literary criticism that highlighted gender distinctions in writing, culture, and society. As a separate area of investigation, feminist literary criticism emerged in the late 1960s in the context of the contemporary women's movement and increased attention to civil rights in the United States, the intellectual revolutions undertaken by students and workers in France that toppled the government of President de Gaulle, and the Campaign for Nuclear Disarmament and the resurgence of Marxism and trade unionism in Britain. What distinguished contemporary feminist criticism from that of previous eras was the self-consciousness or self-awareness of its enterprise. Feminist literary criticism became institutionalized, conceiving itself as a collective endeavor of female writers and scholars engaged not only in the practice of literary criticism but also in establishing a tradition of women's literature and feminist critique.

FEMINIST CRITICISM 1963–71: IMAGES OF WOMEN IN LITERATURE AND POPULAR CULTURE

The publication of Betty Friedan's *The Feminine Mystique* in 1963 marked the emergence of contemporary feminist consciousness in America. Friedan's enormously popular work had resonance for many white middle-class housewives frustrated by their exclusion from the workforce and public life. The term "mystique" captured their vague feeling of dissatisfaction. Friedan questioned women's complicity in sustaining gender inequity and their passivity in accepting a narrowly defined domestic sphere of influence. She isolated the source for their indoctrination in popular depictions of femininity in women's magazines, advertisements, and popular fiction. She urged women to "raise their consciousness" through education and to recognize the stereotyped images on display in popular culture and literature.

This consciousness-raising activity was transferred to literature with the publication of Mary Ellmann's *Thinking about Women* (1968) and Kate Millett's *Sexual Politics* (1970) in America and Germaine Greer's *The Female Eu-*

nuch (1970) in England. These early critics followed Friedan's lead in focus-
ing on the images of women in texts by male authors. They saw literature
as a manifestation of male power and an instrument of socialization. Femi-
nist criticism exposed patriarchal constructs. Ellmann argued, for instance,
that Western culture is pervaded by "thought by sexual analogy," that we
tend to "comprehend all phenomena, however shifting, in terms of our orig-
inal and simple sexual differences" (6). This sexual analogy reveals itself in
literature in terms of 11 stereotypes of femininity; women are equated with
qualities from passivity and compliance to irrationality and instability. Greer
likewise argued that stereotypes of women in literature and popular culture
derive from historical understandings of sexuality that equate the female
with the "castrate," and found examples in the works of Blake, Strindberg,
Marlowe, Shakespeare, Rabelais, and others. She took on Mailer in a debate
at town hall in New York City over issues of "machoism" and male domi-
nation, as represented in his writing and in society at large.

Kate Millett's text was the most popular of these early works and hence
the most influential for feminist literary criticism in the 1970s. As a result,
Millett has been claimed as the "mother" of American feminist criticism. Be-
gun as a doctoral thesis, *Sexual Politics* offered a vituperative attack on what
she perceived as the misogyny of D. H. Lawrence, Norman Mailer, Henry
Miller, and Jean Genet. Millett assumed that "however muted its present ap-
pearance may be, sexual dominion obtains nevertheless as perhaps the most
pervasive ideology of our culture and provides its most fundamental con-
cepts of power" (25).

These early examples of feminist criticism enhanced our understanding
of both literature and gender, presenting literature as a product of culture
and gender as a **social construction**, not a biological given. At the same time,
however, they offered a reductive view of literature as an unmediated mir-
ror of social reality, ignoring its fictional and imaginative qualities, and
tended to confuse the author of the text with the characters within it. Mil-
lett, for instance, claimed that "Paul Morel is of course Lawrence himself"
(246) and thus held the author accountable for the crimes of his creation.
The attitudes of Lawrence and other male authors were evidence of a gen-
eralized, universal, unchanging patriarchal system of power, in which
women are granted little individual possibility or potential for resistance.
Almost exclusively focused on male texts, Millett, Greer, and Ellmann over-
looked the position of women as authors and critics. As such, their texts
have provided a problematic legacy.

CREATING A FEMALE TRADITION: 1972–80

By the mid-1970s, feminist critics had turned their attention to texts written
by women and shifted their focus to questions of authorship. They began
recovering and creating a female literary tradition. Patricia Meyer Spacks's
The Female Imagination (1976) examined "the ways the life of the imagina-
tion emerges in the work of women writing prose directly as women" (6–7),

tracing the "themes that have absorbed female minds during the past three centuries as recorded in literature written in English." In *Literary Women* (1976), Ellen Moers identified women's writing as a "rapid and powerful" undercurrent beneath the male tradition (63). She noted, in particular, the interrelationship between women's texts—between George Eliot and Harriet Beecher Stowe, Emily Dickinson and Elizabeth Barrett Browning, and Charlotte Brontë and Harriet Martineau, tracing a distinctly female pattern of influence. According to Moers, Jane Austen "achieved the classical perfection of her fiction because there was a mass of women's novels, excellent, fair, and wretched, for her to study and improve upon. . . . The fact is that Austen studied Maria Edgeworth more attentively than Scott, and Fanny Burney more than Richardson; and she came closer to meeting Mme de Staël than she did to meeting any of the literary men of her age" (67). While Moers later claims there is no single female tradition, sensibility, or style in literature, she asserts that literary scholars have an obligation to pay their "humble toll of tribute to the great women of the past who did in fact break ground for literary women" (95). Moers's text is itself an example of the practice she describes, with chapters on "Female Realism," "Female Gothic," and an appended list of the "great" female authors. She defines literary feminism as "heroinism": women's texts featuring female protagonists "create a heroic structure for the female voice in literature" (187).

In *A Literature of Their Own* (1977), Elaine Showalter not only engaged in recovering a buried or suppressed feminine tradition but also sought to give it shape and direction. She organized English women's writing into three periods—Feminine, Feminist, and Female—divided not simply chronologically but in terms of their subject matter and their authors' conscious awareness of women's position in society and culture. During the "Feminine" period (1840–80), "women wrote in an effort to equal the intellectual achievements of the male culture, and internalized its assumptions about female nature" ("Toward," 137). Examples include George Eliot for the "distinguishing sign" of the male pseudonym, signalling women writers' desire to be accepted as the equivalent of men. Authors identified as "Feminist" (1880–1920) "reject the accommodating postures of femininity and . . . use literature to dramatize the ordeals of wronged womanhood" (138). The "purest" examples are the Amazon utopias of the 1890s, "fantasies of perfected female societies set in an England or America of the future" (138). Finally, authors of the "Female" period (1920–present) "reject both imitation and protest—two forms of dependency—and turn instead to female experience as a source of an autonomous art, extending the feminist analysis of culture to the forms and techniques of literature" (139). Showalter examined the work of Dorothy Richardson and, not surprisingly given her title's obvious allusion to *A Room of One's Own*, Virginia Woolf herself as evidence of a distinct and separate female tradition.

These early attempts to develop a history of women's literature highlighted the politics implicit in creating the Western literary canon, arguing that this tradition was essentially a *male* tradition. Woolf, Spacks, Moers, Showalter, and others challenged the view of history as universal, convinc-

ingly demonstrating that literary history itself was influenced by the position and gender of its authors, that it was a sociocultural construction and not an unmediated reflection on the past. By drawing attention to neglected works written by women, they initiated a project that continues to this day, notably in the work of Dale Spender in Britain and Nina Baym in the United States.

The construction of a separate "female" canon has been criticized, however, for its tendency to fall into many of the errors it set out to address. Showalter's influential account of feminist literary history as divided into three historical moments presumes a progressive, linear development originating in the nineteenth century. This excludes women's writing prior to that period as well as texts that may not fit into one of its three categories. Owing to Showalter's emphasis on increasing feminist awareness, her account implicitly holds texts to twentieth-century standards. Creating a separate female canon further risks marginalizing the contributions of women writers who are considered only in relation to or reaction against the male standard. And, like the male tradition it seeks to reject, the female tradition is conceived of as comprehensive when it is in fact and necessarily partial, as is any history of literature. Take, for instance, Moers's claim that "Women poets do not complain of the power of love . . . they rejoice in love and boast of the transformation in themselves resulting from what Kate Chopin called 'The Awakening.' . . . There seems to be more fire than ice in women's love poetry" (256). Here she not only generalizes about women's love poetry but also argues that male poets, by contrast, "draw on the imagery of cold, because their beloved's resistance, denial, and betrayal are the principle occasions dramatized in their poems" (256). Certainly readers would be quick to take issue with such a simplistic distinction between female passion and male rationalism.

By the late 1970s, feminist criticism revealed a self-consciousness about the practice of feminist literary history and the feminist critical enterprise itself. In "Toward a Feminist Poetics" (1979), Showalter identified "two distinct varieties of feminist criticism." The first, "feminist critique," is focused on

> *woman as reader*—with woman as the consumer of male-produced literature, and with the way in which the hypothesis of a female reader changes our apprehension of a given text, awakening us to the significance of its sexual codes. . . . [I]t is a historically grounded inquiry which probes the ideological assumptions of literary phenomena. Its subjects include the images and stereotypes of women in literature, the omissions of and misconceptions about women in criticism, the fissures in male-constructed literary history. It is also concerned with the exploitation and manipulations of the female audience, especially in popular culture and film; and with the analysis of woman-as-sign in semiotic systems. (128)

Representative works of this form of critique included Kate Millett's *Sexual Politics* and Judith Fetterley's *The Resisting Reader* (1978). Fetterley contended that "American literature is male. To read the canon of what is currently

considered classic American literature is perforce to identify as male" (564). She advocated, by contrast, that "the first act of the feminist critic must be to become a resisting rather than assenting reader and, by this refusal to assent, to begin the process of exorcising the male mind that has been implanted in us" (570).

Showalter's second type focused on *"woman as writer*—with woman as the producer of textual meaning, with the history, themes, genres, and structures of literature by women. Its subjects include the psychodynamics of female creativity, linguistics and the problem of a female language; the trajectory of the individual or collective female literary career; literary history; and, of course, studies of particular writers and works" (128). She termed this form "**gynocriticism**," adapted from the French term *la gynocritique.*

Despite Showalter's contention that "both kinds are necessary," the second—"woman as writer"—in fact predominated from the late 1970s and into the 1980s. Feminists emphasized not women's equality with, but their **difference** from, men, noting that such differences are not natural or essential but culturally determined. According to Stephen Heath:

> Difference . . . speedily comes round to an essence of woman and man, male and female, a kind of anthropologico-biological nature. But men and women are not simply given biologically; they are given in history and culture, in a social practice and representation that includes biological determinations, shaping and defining them in its process. The appeal to an "undeniable" biological reality as essential definition is always itself a form of social representation, within a particular structure of assumption and argument. (222)

For literary critics, the social construction of difference could potentially account for issues of female authorship and provide a framework for discussion of texts as distinctly feminine. Their critical claim clearly echoes Virginia Woolf's discussions of sexual difference and androgyny written decades earlier.

Sandra Gilbert and Susan Gubar's *The Madwoman in the Attic* (1979) offered at once a revisionist literary history focused on women authors of the nineteenth century and a theory of female literary creation derived from a feminist reinterpretation of the "anxiety of influence" Harold Bloom had traced in male authors. Bloom had argued that male authors suffer anxiety when confronted by the literary achievements of their predecessors; Gilbert and Gubar argued that the female artist faced a doubled anxiety, cowed not only by her male literary predecessors but also by strictures against feminine authorship. They asserted that the pen is a "metaphorical penis" and that traditional metaphors of authorship focus on the writer as "father" of his text. How can a woman thus pick up the pen? Further, they argued that "for the female artist the essential process of self-definition is complicated by all those patriarchal definitions that intervene between herself and herself" (17). Patriarchal texts have offered two competing visions of woman as the "eternal feminine"—the "angel in the house" who is passive, docile,

and selfless—or as the monstrous creature, the "madwoman," who refuses this submissive role and asserts herself—in action and in writing.

Women writers of the nineteenth century, they argued, resolved this dilemma through duplicity and subversion:

> Women from Jane Austen and Mary Shelley to Emily Brontë and Emily Dickinson produced literary works that are in some sense **palimpsestic**, works whose surface designs conceal or obscure deeper, less accessible (and less socially acceptable) levels of meaning. Thus these authors managed the difficult task of achieving true female literary authority by simultaneously conforming to and subverting patriarchal literary standards. (73)

In Dickinson's words, the woman writer would "Tell all the Truth but tell it slant." By such duplicity, according to Gilbert and Gubar, the female author could appear as an "angel" by ostensibly conforming to patriarchal conventions while in fact subverting them in her texts.

The result is a "female schizophrenia of authorship," the figure for which is the madwoman, such as Bertha Mason in Charlotte Brontë's *Jane Eyre*. She is the "*author's* double, an image of her own anxiety and rage." As such, the female writer's monster is a parody of patriarchal conventions:

> In projecting their anger and dis-ease into dreadful figures, creating dark doubles for themselves and their heroines, women writers are both identifying with and revising the self-definitions patriarchal culture has imposed on them. All the nineteenth- and twentieth-century literary women who evoke the female monster in their novels and poems alter her meaning by virtue of their own identification with her. For it is usually because she is in some sense imbued with inferiority that the witch-monster-madwoman becomes so crucial an avatar of the writer's own self. (79)

Gilbert and Gubar's readings of these texts served as a model of feminist literary criticism in which the reader is attentive to textual strategies, to subversions and parodies of traditional plots, images, and characters as a means of recuperating the female author and her text. This strategy of reading against the grain proved influential for feminist criticism in the 1980s.

Despite the obvious complexity and sophistication of their argument, Gilbert and Gubar's reading of women's literary history shared some of the same weaknesses of earlier models. Like Showalter, Gilbert and Gubar focused on the nineteenth century almost exclusively, although later they were to extend their argument to twentieth-century texts in their three-volume series *No Man's Land* (1988–1994) and, it could be argued, in *The Norton Anthology of Literature by Women*, first published in 1985. Critics of their work have objected to the image of the woman author as victim and her texts as documents of suffering. Others have noted the relatively small number of writers to which they apply their thesis, claiming that while it may well apply to the major writers of the late nineteenth century it cannot serve as a model for all writing by women.

Dialogue among feminist critics took place in the pages of journals, at conferences, and in the classroom, as women's studies programs developed on university campuses. Journals devoted to women's studies—such as *Signs: Journal of Women in Culture and Society, Tulsa Studies in Women's Literature, Women's Studies, Feminist Studies,* and *differences*—were established in the late 1970s and early 1980s. They fueled the conversation among feminist scholars and became an important means of supporting women's studies programs across the country and legitimating feminist scholarship in a wide variety of fields, including sociology, anthropology, biology, medicine, history, art, and literary studies. Teachers created classroom packets—syllabi, reading lists of primary works and secondary materials—which became the basis for establishing a textbook market for feminist studies across various disciplines. University presses at Columbia, Cornell, Indiana, and elsewhere distributed feminist journals and initiated series devoted to publishing individual and collective works of feminist criticism. Feminist literary studies in fact led the way by posing the types of questions that would guide other forms of feminist scholarship: Are women presented differently in texts written by women and men? Does a literary text written by a woman differ significantly from a text written by a man? Do female readers approach texts differently? Is there a link between gender and genre? How have the processes of production and canonization affected views of women's literature? Journals not specifically devoted to feminist scholarship produced special issues on feminist literary criticism and theory: *Diacritics, Critical Inquiry,* and *Modern Fiction Studies,* to name but a few. But as feminist criticism became increasingly institutionalized, it also came under fire—from within.

RESISTANCES: BLACK, LESBIAN, AND MARXIST CRITICISM, 1977–81

Feminist literary critics of the 1970s were taken to task for claiming to speak for all women when in fact they spoke largely for white, Western, heterosexual women of the middle class. Black feminists, such as Alice Walker, Barbara Smith, Deborah McDowell, bell hooks, Audre Lorde, and Susan Willis, argued that black women writers were doubly oppressed, ignored by both white feminists and black literary critics, who were predominantly male. Two important volumes published in the early 1980s collected essays originally published in feminist journals in the late 1970s that were critical of white, mainstream feminism and outlined plans of action for drawing attention to women of color: *This Bridge Called My Back: Writings by Radical Women of Color* (1981), edited by Cherríe Moraga and Gloria Anzaldúa, and *All the Women Are White, All the Blacks Are Men, But Some of Us Are Brave* (1982), edited by Gloria T. Hull, Patricia Bell Scott, and Barbara Smith. Both books gave impetus to creating a separate canon of works by women of color and defining critical approaches that would account for their differences from white women as well as from men.

A collection of essays, poems, and testimonials, *This Bridge Called My Back* gave voice to marginalized women of color:

We are the colored in a white feminist movement.
We are the feminists among the people of our culture.
We are often the lesbians among the straight.

Deliberately heterogeneous and highly personal, the pieces in the volume reflected the contributors' "flesh and blood experiences to concretize a vision that can begin to heal our 'wounded knee.' " As the title suggests, the collection was an effort to "bridge" the emerging divide among feminists. It was a form of consciousness raising for both women of color and white, middle-class women.

While *This Bridge Called My Back* did not explicitly outline a new feminist project, *But Some of Us Are Brave* set out to advance the cause of black women's studies, supplying reading lists and syllabi listing the literary works of black women. The collection also included Smith's influential essay, "Toward a Black Feminist Criticism" (1977). She contended, "Black women's existence, experience, and culture and the brutally complex systems of oppression which shape these are in the 'real world' of white and/or male consciousness beneath consideration, invisible, unknown" (168). Launching a savage attack on Showalter, Moers, and Spacks for overlooking black and Third World women, Smith outlined three principles for a black feminist literary criticism: (1) It would "work from the assumption that Black women writers constitute an identifiable literary tradition"; (2) it would be "highly innovative, embodying the daring spirit of the works themselves"; and (3) it would trace the "lesbian" subtext in black women's novels (174–75). Smith put applied these principles in a highly personal reading of Toni Morrison's *Sula*. She sees Nel and Sula's friendship as "suffused with an erotic romanticism," a bond strengthened by race, as "Morrison depicts in literature the necessary bonding that has always taken place between Black women for the sake of barest survival" (176–77). In Smith's view, Nel falls prey to convention by marrying an unexceptional man, while Sula defies patriarchal values by rejecting heterosexual marriage. As such, "Sula's presence in her community functions much like the presence of lesbians everywhere to expose the contradictions of supposedly 'normal' life" (178). Although Sula has sex with men, she does so, according to Smith, only to delve further into herself. Instead, "the deepest communion and communication in the novel occurs between two women who love each other" (180). Thus, Morrison's novel is an "exceedingly lesbian novel" (180). Smith's own essay, she hoped, would "lead everyone who reads it to examine *everything* that they have ever thought and believed about feminist culture and to ask themselves how their thoughts connect to the reality of Black women's writing and lives" (183).

Smith's essay did provoke a response from Deborah McDowell, who agreed that black women writers were "disenfranchised" by white feminist critics and by black scholars, "most of whom are males." She pointed out, however, that Smith's articulation of a black feminist aesthetic raised difficulties of its own. McDowell noted that some of the key features of black

women's texts could be found in male texts as well and pressed for greater attention to how such elements were used differently by women, a project later taken up by Susan Willis and others in the mid-1980s. She further asked, "Are there noticeable differences between the languages of Black females and Black males?" (189), anticipating the critical turn toward the examination of language that would characterize the 1980s. Finally, McDowell argued that Smith's definition of lesbianism was "vague and imprecise," that Smith had "simultaneously oversimplified and obscured the issue of lesbianism" and in so doing overlooked *Sula's* "density and complexity, its skillful blend of folklore, omens, and dreams, its metaphorical and symbolic richness" (190). Following the example of author Alice Walker, who had begun to trace a tradition of black women writers in *In Search of Our Mother's Gardens* (1974), McDowell advocated a "contextual approach to Black women's literature" that would expose "the conditions under which literature is produced, published, and reviewed" (192).

Despite its limitations, Smith's essay drew attention to two distinctly marginalized groups within feminist literary criticism—women of color and lesbians—and focused on the identity of the female reader and author, not simply on the basis of her sex, but on her race and sexuality. Lesbian feminists argued that they, like black women, experienced a doubled oppression—sexism and homophobia. The neglect of lesbian authors and lesbian themes in literature was a serious oversight by feminists that seemed all the more striking given the role of lesbians in radical feminist politics in the late 1960s and early 1970s. Shulamith Firestone published *The Dialectic of Sex: The Case for a Feminist Revolution* in 1970, which argued that women had been oppressed on the basis of their reproductive capacity and advocated an end to "the tyranny of the biological family" through women's control of their reproductive functions and a return to a polymorphous sexuality. Ti-Grace Atkinson's *Amazon Odyssey* (1974) took Firestone's thesis a step further, contending that "love" was in fact an institution of heterosexual sex and that feminist revolutionary practice could be found in its rejection. Charlotte Bunch argued that true feminism was lesbianism. Poet Adrienne Rich's "Compulsory Heterosexuality and Lesbian Existence" (1980) outlined a lesbian continuum, a range of "woman-identified experience" from friendship to sexual intimacy.

The woman-identified woman should be a focus of feminist literary criticism, according to Bonnie Zimmerman. In "What Has Never Been: An Overview of Lesbian Feminist Criticism" (1981), she noted a profound absence of lesbian material in the anthologies and collections produced by influential American literary critics, including Moers, Spacks, Showalter, and Gilbert and Gubar. She sought to define a lesbian criticism or "world view" based on the assumption "that a woman's identity is not defined only by her relation to a male world and male literary tradition . . . , that powerful bonds between women are a crucial factor in women's lives, and that the sexual and emotional orientation of a woman profoundly affects her consciousness and thus her creativity" (201). The lesbian critic would be atten-

tive to heterosexist assumptions and contribute to the development of a lesbian canon, a project initiated by Jeannette Foster in *Sex Variant Women in Literature* (1956) and extended by Jane Rule in *Lesbian Images* (1975) and Lillian Faderman in *Surpassing the Love of Men: Romantic Friendship and Love between Women from the Renaissance to the Present* (1981). According to Faderman,

> "Lesbianism" describes a relationship in which two women's strongest emotions and affections are directed toward each other. Sexual contact may be part of the relationship to a greater or lesser degree, or it may be entirely absent. By preference the two women spend most of their time together and share most aspects of their lives with each other. (17–18)

Based on this definition, the lesbian literary tradition would extend from Mary Wortley Montagu, Mary Wollstonecraft, Anna Seward, and Sarah Orne Jewett to the women of the "first self-identified lesbian feminist community in Paris" in the early twentieth century (Natalie Barney, Colette, Djuna Barnes, Radclyffe Hall, Renée Vivien, and peripherally Gertrude Stein.) Analysis would focus on "the images, stereotypes, and mythic presence of lesbians in fiction by or about lesbians" as well as a lesbian literary style.

Critics attentive to race and sexuality introduced a necessary corrective by pointing out the dangers of taking gender alone as a lens for critical investigation and reminding feminists to take differences among women into account as they investigated images of women in literary texts and expanded the canon to include works by women. In many respects, however, the projects of black and lesbian critics shared, or perhaps augmented, the weaknesses of the mainstream feminism they criticized. Feminine identity was more firmly grounded in biology, given additional emphasis on race and sexuality. While the positive reconstruction of a group identity was strategically essential as a response to degrading and marginalizing cultural practices, the newly created categories of "black female" and "lesbian" risked becoming as monolithic as "woman."

As a result, feminist critics influenced by Marxist analyses of culture stressed attention to historical specificity, to the material conditions influencing the production of women's texts. In *Women's Oppression Today* (1979), Michèle Barrett argued that literary texts must be considered in relation to class structures and to the cultural institutions—including education and publishing—that support both economic and gender inequities. Taking Virginia Woolf as her example, she asked, "what are the consequences for the woman author of historical changes in the position of women in society?" (1). Her reading attended to Woolf's limited access to formal education and her domestic isolation as historical conditions affecting women that revealed themselves in Woolf's novels and criticism. The London-based Marxist-Feminist Literary Collective, whose members included Cora Kaplan and Mary Jacobus as well as Barrett, produced readings of Charlotte Brontë's *Jane Eyre*, *Shirley*, *Villette*, and Elizabeth Barrett Browning's *Aurora Leigh* that identi-

fied the marginal position of women writers in the mid-nineteenth century as part of the general exclusion of women "from the exercise of political power and their separation from production." Ironically, despite their attention to material conditions, such readings continued to privilege the works of a particular class, excluding texts by working-class women and women of color. Many women also argued that in their focus on historical determinism, Marxist feminists overlooked the role of the imagination or the psyche of the individual author in literary creation. These positions attentive to class, sexuality, and race were to reemerge in more complex and convincing forms in the mid-1980s and exert a profound influence on feminist literary studies throughout the 1990s and beyond.

THEORY, LANGUAGE, AND ÉCRITURE FÉMININE: 1980–85

In the early 1980s ("around 1981," according to Jane Gallop) feminist literary criticism underwent a sea change with the introduction of **post-structuralist theory**. Broadly defined, post-structuralist theory is concerned with language in shaping identity and history, and its premises are drawn from philosophy. From **deconstruction** to **psychoanalysis**, post-structuralist theory challenged traditional intellectual categories and practices, calling into question the concept of the individual as a unified **subject**, the stability of meaning, and the "truth" of history.

Feminist critics were initially divided between those suspicious of theory's influence and those who recognized its potential for reinvigorating and enhancing feminist literary criticism. The debate split along lines of gender and nationality, with post-structuralist theory defined by its critics as male and French, "as manly and aggressive as nuclear physics—not intuitive, expressive, and feminine, but strenuous, rigorous, impersonal, and virile," in the words of Showalter ("Feminist Poetics," 140). Others were more open to possibility. In "Dancing through the Minefield: Some Observations on the Theory, Practice, and Politics of Feminist Literary Criticism" (1980), Annette Kolodny argued:

> In my view, our purpose is not and should not be the formulation of any single reading method or potentially Procrustean set of critical procedures nor, even less, the generation of prescriptive categories for some dreamed-of nonsexist literary canon. Instead, as I see it, our task is to initiate nothing less than a playful pluralism, responsive to the possibilities of multiple critical tools and methods, but captive of none, recognizing that the many tools needed for our analysis will necessarily be largely inherited and only partly of our own making. (161)

Early warnings of the dangerous influence of "white, male" theory on feminist projects gave way as post-structuralist theory exerted its influence, enriching and extending feminist critique by drawing attention to another dimension of literature: language.

The first feminist theories influenced by post-structuralist philosophy emerged in France and came to be known collectively as "French feminism" to Anglo-Americans. Contemporary French feminist thought, however, derived from both Anglo-American and French feminist traditions. Virginia Woolf's own position as a literary stylist and experimenter led her to ponder the possibility of a distinctly feminine mode of writing, to question what, if anything, distinguished women's writing from men's. The same impulse can clearly be seen in attempts to define *écriture féminine* (feminine writing). Feminists working in France were also profoundly influenced by Simone de Beauvoir's *The Second Sex* (1949), which applied existential philosophy to the position and condition of women. In her classic text, de Beauvoir argued that woman has been defined as man's "Other," that she has been conceived of as an object with no right to her own **subjectivity**. She notes that this is not a natural condition, but a social and cultural construction: "One is not born a woman; one becomes one." De Beauvoir sought to explain the definition of woman as Other in biology, psychoanalysis, and Marxism, emphasizing that women internalize their objectified status.

The works of the French feminists were first published in France in the 1970s, but most Anglophone readers were introduced to them through Elaine Marks and Isabelle de Courtivron's translations in *New French Feminisms* (1980). As such their influence on feminist criticism and theory in Britain and the United States was felt in the mid- to late 1980s.

The "new" French feminists—most notably Hélène Cixous, Luce Irigaray, and Julia Kristeva—emphasized that woman is constructed as Other through language. In "The Laugh of the Medusa" (1976; "Le Rire de la méduse," 1975), Cixous argued that "nearly the entire history of writing is confounded with the history of reason. . . . It has been one with the **phallocentric** tradition" (249). Consequently, "writing is precisely *the very possibility of change,* that space that can serve as a springboard for subversive thought, the precursory movement of a transformation of social and cultural structures" (249). The identification and practice of *écriture féminine* thus has the potential for undermining woman's position as Other by establishing her as the subject of her own writing, and for transforming her position in culture and politics as well.

In asserting the primacy of language, Cixous borrowed from post-structuralist thought, the deconstructive theory of Jacques Derrida, and the psychoanalytic theory of Jacques Lacan. Derrida, following Martin Heidegger, offered a critique of Western metaphysics, arguing that Western thought is grounded in a series of **binary oppositions**: light/darkness, good/evil, soul/body, life/death, mind/matter, speech/writing, and so on. The terms are not conceived of as equal, but exist in a hierarchical structure (light is privileged over darkness, good over evil, etc.). Fundamentally, Derrida argued, Western thought has privileged unity, identity, and immediacy, or presence, over absence (light is presence; darkness is its absence). In "Sorties" (1980; from *La Jeune née* [*The Newly Born Woman*], 1975), Cixous extended Derrida's argument by focusing on gender, contending that implicit

in each binary opposition is a distinction between man/woman, masculine/feminine. Thus she accounted for woman's position in Western culture as Other: She is defined in opposition to, and in terms of, man. He is present; she is absent. He is associated with being, she is associated with death.

According to Derrida, such meanings are produced in language. The structural linguist Ferdinand de Saussure argued that the process of **signification** was characterized by difference. Meaning was produced not on the basis of the **sign**'s relation to its referent (e.g., the word "cat" meaning the furry little animal). Instead, Saussure argued that the sign (word) was composed of two parts, the spoken or written word (**signifier**) and its mental concept (**signified**). The bond between the signifier and the signified was arbitrary; there is no natural connnection, for instance, between the signifier "light" and idea of light itself. Meaning emerges only through the distinction of one signifier from another. We understand the signifier "light" only in opposition to the signifier "dark." We understand "light" as different not only from "dark" but also from other signifiers ("might," "bright," "tight"). Meaning also unfolds in time, along the chain of signification, the sequence of signifiers that unfolds in time as we speak (or read) words.

Derrida complicated this understanding—hence his theory is *post-structuralist*—by arguing that "within the system of language, there are only differences." The process of making meaning obviates the possibility of a sign bearing a stable, unified meaning. For instance, we understand the word "cat" in part because it is not "dog" or "hat." In the jazz world, "cat" refers not to the furry creature but to a human being, a "cool cat." Signification is not a static process, but a never-ending play of one signifier (that is present in language) against a series of others (that are absent). It is characterized not only by difference, but deferral, for meaning is deferred along the chain of signification, which never ends. Derrida's critique of Western thought focused, then, on how we have tended to stop the play of signification and arbitrarily privilege one meaning over other possible meanings.

In perhaps his most famous example, taken from Plato's *The Phaedrus*, Derrida examined the apparent contradiction between the two meanings of the Greek word "pharmakon" (from which the word "pharmacy" is derived). In Greek, "pharmakon" is an ambiguous term, meaning both poison and remedy. In *The Phaedrus*, Plato refers to writing as a "pharmakon," typically taken to mean that writing is poisonous, open to misinterpretation and misuse. Writing is seen to be dangerous, in the absence of the speaker who can confirm its meaning. Derrida, however, noting that "pharmakon" may also mean remedy, argues that writing may serve a positive role. It can enhance speech, aid memory, and serve as a record of history that lives on beyond the speaker. Writing, can, in fact, not be seen as either poison or remedy but as embodying both elements simultaneously. Deconstructive practice thus undermines or subverts the closure of the binary opposition. Derrida conceived of deconstruction as a two-stage process that first exposes binary thought in language and then demonstrates the continuing play of difference at work.

In "The Laugh of the Medusa," Cixous emphasized that writing has sustained the opposition between male and female. "Woman" has been defined in language, as a signifier defined in opposition to "man." Cixous advocated the deconstruction of this opposition:

> If woman has always functioned "within" the discourse of man, a signifier that has always referred back to the opposite signifier which annihilates its specific energy and diminishes or stifles its very different sounds, it is time for her to dislocate this "within," to explode it, turn it around, and seize it; to make it hers, containing it, taking it in her own mouth, biting that tongue with her very own teeth to invent for herself a language to get inside of. (257)

Defined in opposition to man, woman has been relegated to a subordinate position within language. Cixous proposed an alternative discursive practice—a *new insurgent* writing—as a means of unsettling the opposition that devalues the feminine. Writing, in this sense, means "working (in) the in-between, inspecting the process of the same and of the other without which nothing can live." Cixous capitalized on Derrida's assertion that Western thought is "phallogocentric," that its binary logic privileges the masculine, through the "transcendental signifier" of the phallus. The term "phallus" refers not simply to the male organ but to the power accrued to its possessor in language and in culture.

In her analysis of **phallogocentrism**, Cixous also relied on innovations in psychoanalytic theory. The French psychoanalyst Jacques Lacan traced the origins of patriarchal authority in the process of human maturation, transforming Freud's theory of psychosexual development by focusing on the acquisition and role of language. Lacan distinguished between the **Imaginary** and **Symbolic** orders: the Imaginary refers to the infant's early, preverbal relationship to the mother, the Symbolic to the order of language, an order associated with the father. Prior to acquiring language, the child experiences an imaginary unity with the mother's body and has no sense of itself as an independent being.

According to Lacan, separation of the infant from the mother begins during the **mirror stage**, normally when the child is six to eight months old. During this period, the child encounters its reflection—not necessarily in an actual mirror but even in its mother's eyes or the sight of another child—and thus perceives itself as separate from the mother's body. But what the child perceives is not the self, but an image of the self. It perceives itself as independent entity when, in fact, it is still physically dependent on the mother for its survival. Hence the origin of the self emerges from a misrecognition that the child can stand on its own, move of its own volition, and control physical space. A radical split has been introduced between the projected mirror ideal and the actual self that perceives the image.

The psychological construction of selfhood begun during the mirror stage is only resolved during the **Oedipal crisis**. Following Freud, Lacan argued that the dyadic unity the child perceives between itself and the mother is

broken by a third, the father, through the threat of castration. According to Freudian theory, the boy perceives his difference from his mother in the recognition that he possesses a penis, like the father, and that she does not. Forced, owing to the incest taboo, to repress his desire for the mother, the boy identifies with the father as the figure of authority and the law. In other words, while the physical manifestation of difference is the penis, the psychological manifestation is the power accorded to the father as head of the household. For girls, the Oedipal crisis is far more complicated, as Freud himself noted in his essay "On Femininity" (1932). He posited that the girl recognizes that she, like the mother, is already "castrated," that is, lacking in authority because she lacks a penis: "She makes her judgement and her decision in a flash. She has seen it and knows that she is without it, and wants to have it." She thus turns her desire from the "castrated" mother to the father.

Feminists from Charlotte Perkins Gilman to Kate Millett have mocked Freud's account, noting that by focusing on the presence or absence of the penis it emphasizes **biological determinism**. It institutes, in Gilman's words, "phallic worship" and reduces women to passivity and absence. Others, like Juliet Mitchell in *Psychoanalysis and Feminism* (1974), have noted that psychoanalysis is not a justification but an explanation, a description and not a prescription, for the privileging of masculinity in Western culture. Freudian theory has, in fact, potential value for feminist theory because it demonstrates that sexual definition is not innate or inborn, but constructed and precarious:

> Freud's writing shows that sexual difference is . . . a hesitant and imperfect construction. Men and women take up positions of symbolic and polarised opposition against the grain of a multifarious and bisexual disposition. . . . The lines of that division are fragile in exact proportion to the rigid insistence with which our culture lays them down; they constantly converge and threaten to coalesce. (Rose 226–27)

Boys are taught at an early age not to cry, not to show weakness, not to reveal their emotions, to instead be competitive and independent. Girls learn to acquiese to authority, care for others, display their emotions and sexuality, and repress their independence and self-determination. As we acquire a sense of selfhood we are forced to take up a position on one side of the sexual divide between masculinity and femininity. Identifying the psychosocial processes that privilege masculinity may enable women to challenge and subvert them.

Lacan thus provided feminist theorists with an additional insight and opportunity, for he added to Freud's account that the development of a sense of self coincides with the acquisition of language, with entry into the Symbolic order. As we take up a **subject position** on one side of the sexual divide we also take up a position in language. When we identify ourselves as subjects, as "I," we define ourselves in terms of the **Other**; we are stating,

in effect, that we are not "you" or any other available subject position. When we say "I am" we mean "I am she (or he)." Gender difference is the ground for identity. Lacan contended that the Symbolic realm is governed by the Law of the Father owing not simply to the incest taboo and threat of castration, but to the fact that in the definition of subjectivity, the **phallus** becomes the "transcendental signifier," the basis by which gender is determined and subject position assigned. The subject, however, is constructed through separation and denied imagined wholeness with the mother due to the intrusion of paternal law. As a result, woman is associated with lack and with the "repressed."

Feminists working in the Lacanian psychoanalytic tradition sought to subvert the position accorded woman in the phallogocentric symbolic order. As Cixous argued, "Their 'symbolic' exists, it holds power. . . . But we are in no way obliged to deposit our lives in their bank of lack. . . . We have no womanly reason to pledge allegiance to the negative" (255). Instead, she envisioned a feminine response in language, an *écriture féminine*:

> It is by writing, from and toward women, and by taking up the challenge of speech which has been governed by the phallus, that women will confirm women in a place other than that which is reserved in and by the symbolic, that is, in a place other than silence. Women should break out of the snare of silence. They shouldn't be conned into accepting a domain which is the margin or the harem. (251)

She advocated the paradoxical action of making the silence speak, of giving voice to that which has been marginalized and repressed. The result would be revolutionary: "when the 'repressed' of their culture and their society returns, it's an explosive, *utterly* destructive, staggering return" (256).

Écriture féminine is associated with the pre-Oedipal stage of imagined wholeness with the maternal body:

> Women must write through their bodies, they must invent the impregnable language that will wreck partitions, classes, and rhetorics, regulations and codes, they must submerge, cut through, get beyond the ultimate reserve-discourse, including the one that laughs at the very idea of pronouncing the word "silence." (256)

Associated with the **body**, *écriture féminine* is characterized by its drives and rhythms, its suppleness and fluidity. It would inscribe women's sexuality, "its infinite and mobile complexity." Cixous further envisioned that, repressed within the symbolic, within writing, women's language exists in a "privileged relationship with the voice." An *écriture féminine* would thus capture the patterns of speech.

Cixous's idea of an *écriture féminine* was visionary, an outline of a practice that does not yet exist. She had encountered glimpses of it in the avant-garde practices of modernist texts written by male authors, in James Joyce's

Ulysses when Molly Bloom affirms " . . . And yes," and in Jean Genet's *Pompes funèbres* when "he was led by Jean." If it did exist, it would resist definition:

> It is impossible to *define* a feminine practice of writing, and this is an impossibility that will remain, for this practice can never be theorized, enclosed, coded—which doesn't mean that it doesn't exist. But it will always surpass the discourse that regulates the phallocentric system; it does and will take place in areas other than those subordinated to philosophico-theoretical domination. (253)

Cixous challenges the primacy of philosophical categories and hierarchies, deliberately avoiding "rational" discourse in favor of a poetic style. Thus, Cixous—in an apparent contradiction—did not "define" *écriture féminine* but instead demonstrated its practice in her own writing. Her texts are not organized in a linear narrative, and frequent punning enacts the doubleness or multivalence of language. Cixous's assertion that "she writes in white ink," for instance, embodies the principles she outlines. "She" refers at once to woman, to the maternal, and to Cixous herself. Writing in "white" ink is a contradictory image of the feminine practice of making the silence speak. And white ink is a literary equivalent of mother's milk.

Luce Irigaray similarly defined feminine language in terms of the body, but rejected the association Cixous established with the maternal body as "a privileging of the maternal over the feminine," of accepting a male-derived definition of the "phallic maternal." Instead, Irigaray equated female language with "the multiplicity of female desire." In "This Sex Which Is Not One" (1980; *Ce Sexe qui n'en est pas un*, 1977), she argued that "female sexuality has always been theorized within masculine parameters" (99). Psychoanalytic theory casts her fate as "one of 'lack,' 'atrophy' (of her gentials), and 'penis envy,' since the penis is the only recognized sex organ of any worth" (99). The dominant phallic system privileges sight over touch and mono- (or phallic) sexuality over the multiplicity of female **desire** and defines sexuality according to a binary opposition where the "other sex" is "only the indispensable complement to the only sex" (103). As woman's desire has been repressed, so has her language: "Woman's desire most likely does not speak the same language as man's desire, and it probably has been covered over by the logic that has dominated the West since the Greeks" (101). Like Cixous, Irigaray resisted philosophical thinking and advocated a subversive, revolutionary practice in language, giving voice to woman's desire.

Within the binary logic of patriarchal culture, "she resists all adequate definition" (101). Irigaray argued that Western culture has privileged sight. This dominant economy of **scopophilia** has a double effect: Woman is reduced to an object of the male gaze as the eroticized female body becomes a "beautiful object." But "her sexual organ represents the horror of nothing to see" (101); it is not visible. Instead, Irigaray argued that feminine sexual-

ity escapes scopophilic logic, as woman takes pleasure more from touching than from looking. Her desire evades masculine control for "she touches herself by and within herself directly, without mediation" (100).

To the argument that woman has no visible sex organ, Irigaray countered, "She has at least two of them, but they are not identifiable as ones. . . . Her sexuality, always at least double, is in fact *plural*," for *"woman has sex organs just about everywhere"* (102, 103). Resisting binary logic, Irigarary argued *"She is neither one nor two"* (101). Instead, "her pleasure is far more diversified, more multiple in its differences, more complex, more subtle, than is imagined" (103).

Feminine desire is reflected in language, which echoes its rhythms and pulsations:

> "She" is indefinitely other in herself. That is undoubtedly the reason she is called temperamental, incomprehensible, perturbed, capricious—not to mention her language in which "she" goes off in all directions and in which "he" is unable to discern the coherence of any meaning. Contradictory words seem a little crazy to the logic of reason, and inaudible for him who listens with ready-made grids, a code prepared in advance. In her statements—at least when she dares to speak out—woman retouches herself constantly. She just barely separates from herself some chatter, an exclamation, a half-secret, a sentence left in suspense—when she returns to it, it is only to set out again from another point of pleasure or pain. (103)

Irigaray, like Cixous, envisioned *écriture féminine* as nonlinear, characterized by repetition, incompletion, disruption, and resistance to reason.

Woman's position as subject of language, however, is complicated by her definition within the symbolic order. Defined as lack or absence, she is, in effect, not a subject in her own right but only defined in relation to the male subject. As such, she has two options, according to Irigaray: She can write/speak as a man, mimicking male discourse, or she can be relegated to silence, to the gaps and interstices, and deciphered only between the lines. In her own work, *Speculum of the Other Woman* (1985; *Speculum de l'autre femme*, 1974), Irigaray exhibits both positions. She offers a critique of Freud and Western philosophers from Plato to Hegel, situating her own commentary within their texts, often without distinguishing marks of punctuation. She simultaneously mimics their texts, presenting their words as her own, and disrupts them, insisting deliberately "upon those *blanks* in discourse which recall the places of her exclusion" (142). At various moments, for instance, she writes, "And as I, Freud, say . . . ," while in other places question marks inserted parenthetically or italicized words disrupt the seamless flow of Freud's argument and reveal the disruptive resistances of Irigaray's commentary:

> So you will now hear that "the further you go from the narrow sexual sphere"—constitutable then as a regional activity? compartmentalized? specialized? but in regard to what generality? totality? capital?—"the more obvious will the 'er-

ror of superimposition' become" (p. 115) (an error to which recourse has been and will be made almost continuously, even as an effort is made to dissuade you yourselves from having recourse to it). "For certain women, with whom only men capable of showing themselves passively docile can manage to get along [?], may display, in many domains, tremendous activity." (17)

In this passage, Irigaray intersperses sentences from Freud's essay "On Femininity" with her own questions and comments to disrupt his apparently seamless argument regarding feminine sexuality. The feminine subject—precisely that which Freud's text relegates to passivity—asserts itself to subvert repressive notions of female sexuality. Irigaray thus agrees with Cixous that "a feminine text cannot fail to be more than subversive" (258). Perhaps inevitably, then, Irigaray's unorthodox psychoanalytic critique led to her immediate explusion from Lacan's *Ecole freudienne* because it challenged founding principles of Lacan's theory of gender identification.

Despite their resistance to and critique of binary opposition, Cixous and Irigaray have been criticized for accepting the sexual divide between male and female and simply reversing the hierarchy, privileging the feminine over the masculine. Further, it has been charged that their definitions of a complex, multiple feminine language rest uncritically on a simplistic equation of the feminine with the female, accepting traditional definitions of woman as biological essence, whether the maternal body, in the case of Cixous, or the sexualized female body, in the case of Irigaray. Their references to woman's multiplicity and heterogeneity paradoxically imply a simple, unified "she" that neglects the real differences in the material conditions of women. As Julia Kristeva argued in "Women's Time" (1981; *Le Temps des femmes*, 1979), "the term 'woman' . . . essentially has the negative effect of effacing the differences among the diverse functions or structures which operate beneath this word" (193).

For this reason, Kristeva found "highly problematic" the existence of a "woman's language." She agreed with Irigaray and Cixous that sexual difference is a product of the symbolic order:

> Sexual difference—which is at once biological, physiological, and relative to reproduction—is translated by and translates a difference in the relationship of subjects to the symbolic contract which is the social contract: a difference, then, in the relationship to power, language, and meaning. The sharpest and most subtle point of feminist subversion . . . will henceforth be situated on the terrain of the inseparable conjunction of the sexual and the symbolic, in order to try to discover, first, the specificity of the female, and then, in the end, that of each individual woman. (196)

Kristeva located the point of feminist subversion not in the female body per se but in the "**semiotic,**" her term for the pre-Oedipal system of drives and pulsions that exists between the mother and the child and is "analogous to vocal or kinetic rhythm." Together these drives articulate what Kristeva terms the **chora.**

In *Revolution in Poetic Language* (1984; *La révolution du langage poétique*, 1974), Kristeva described the semiotic as a preverbal signifying system that "precedes and underlies" the symbolic order governed by the Law of the Father. The semiotic is "feminine" only to the extent that is marginalized by the patriarchal symbolic order. It is not a language, for since we are defined as subjects within the symbolic order, we can only speak or write within that order. In fact, according to Kristeva, the speaking subject is split between the semiotic and the symbolic, and language operates a dialectical process, not a monolithic system. Since our entry into the symbolic order results from repressing our unity with and desire for the mother, the semiotic—like the unconscious—can disrupt the symbolic order, revealing itself in language as ruptures, absences, and gaps in the text. As such, semiotic disruption of the symbolic is revolutionary, for it challenges the prescribed order of sexuality and language.

According to Kristeva, this revolutionary energy of the semiotic can best be seen in literature: literature reveals a certain knowledge and sometimes the truth itself about an otherwise repressed, nocturnal, secret, and unconscious universe . . . by exposing the unsaid, the uncanny" (82). She cites as examples avant-garde works by Joyce, Céline, Artaud, Mallarmé, and Lautréamont. Thus, revolutionary language is not identified as the product of female authors but can reveal itself as disruptions of the patriarchal symbolic order in texts written by either sex.

Kristeva's interpretation of literary texts focused on the dialectic between the semiotic and the symbolic to reveal a subversive practice of "intertextuality." In "Psychoanalysis and the Polis" (1982) she examined the novels of Céline, finding semiotic disruption in his segmented sentences and ellipses. Also, like Irigaray and Cixous, she herself exhibited the subversive practices she described and defined. In "Stabat Mater" (1987; *Héréthique de l'amour,* 1977), for example, she placed an analysis of the cult of the Virgin Mary alongside an account of her own pregnancy and experience of the maternal. The two texts, in differing typeface, are separated spatially on the page and further demarcated in terms of style, with fragmented, highly personal reflections on one side and a narrative account of the Christian myths on the other. Her personal reflections literally disrupt the text. Following a critique of contemporary feminist attitudes to motherhood—which tend either to idealize or to reject the maternal function—a journal entry announces, "FLASH—instant of time or of dream without time; inordinately swollen atoms of a bond, a vision, a shiver, a yet formless, unnameable embryo. Epiphanies" (162). Evocations of the specific, material experience of motherhood stand in relation to claims that the Virgin came to become "that ideal totality that no individual woman could possibly embody" and "the fulcrum of the humanization of the West in general and of love in particular" (171). The effect is to undercut or disrupt such totalizing impulses. By essay's end, the two texts have become intertwined and interchangeable, with theoretical argument in the space of personal reflection and elliptical, fragmentary sentences in the place of the analytical.

Kristeva's theory emphasized marginality and subversion and could be described as feminist to the extent that she argues the feminine has been devalued. However, since her account emphasized positionality, not essence—that the feminine is a subject position within language that can be occupied by authors of either sex—some have described her as "anti-feminist." At the same time, despite her emphasis on revolutionary literary practice, she has been accused of giving slight attention to material conditions such as class and race, to the lived differences among women in history and culture, as have Cixous and Irigaray.

FEMINIST LEGACY OF POSTSTRUCTURALISM
AND FRENCH FEMINISM: 1980–90

Many feminist literary critics saw great potential in the post-structuralists' emphasis on language and the position of the speaking subject. Much criticism of the mid-1980s is thus characterized by an attentiveness to language. Following the French example, feminist literary critics engaged in close readings of texts by both male and female authors, locating the workings of the feminine in the gaps, silences, and fissures of the text. Associating the feminine with avant-garde practices meant that many of the most influential texts, such as Alice Jardine's *Gynesis* (1985) and Nancy Miller's *The Poetics of Gender* (1986), focused on women writing during the Modern period. Susan Gubar's " 'The Blank Page' and the Issues of Female Creativity" (1981) interprets a short story by Isak Dinesen as a metaphor for female creativity. Dinesen's story focuses on the defiance of a young princess, whose refusal to consummate her arranged marriage is visible to all in the absence of blood stains on the white sheets, traditionally displayed the following day as a sign of the bride's purity and acquiescence. The blank sheet, to Gubar, tells the tale of either her sexual experience (i.e., that she was not a virgin at marriage) or her refusal to give in to her husband's desires. It speaks in "the subversive voice of silence."

Employing the subversive strategy of deconstruction, Barbara Johnson offered a controversial reading of a poem by Gwendolyn Brooks in "Apostrophe, Animation, and Abortion" (1986). "The Mother" is typically read as an argument against abortion: "I have heard in the voices of the wind the voices of my dim killed children." Attentive to the poet's use of apostrophe (the poetic form of address that animates inanimate objects or forces), Johnson argued that the speaker humanizes the aborted children. Thus the poem can be seen as a more complex expression of a mother's grief. She further notes that, ironically, the speaker herself can only exist in language: she is a mother only by re-animating her dead children in the poem.

The influence of post-structuralist emphases on language and subjectivity was perhaps most evident in feminist investigations of autobiography. Literary critics stressed that female authors emphasized the complexities of subjectivity and self-definition. In their introduction to *Life/Lines* (1988), Bella

Brodzki and Celeste Schenck argue that the masculine autobiographical tradition "had taken as its first premise the mirroring capacity of the autobiographer: *his* universality, *his* representativeness, *his* role as spokesman for the community" (1), and as such relied on a notion of the self as unified and transcendent. Female autobiographers, by contrast, take "as a given that selfhood is mediated" (1). As a result, "Autobiography localizes the very program of much feminist theory—the reclaiming of the female subject—even as it foregrounds the central issue of contemporary critical thought—the problematic status of the self" (1–2).

Feminist critical analyses of autobiography demonstrate that women's subjectivity is framed by definitions of femininity and conceptions of social class, racial identity, and ethnicity. In "Maxine Hong Kingston's *Woman Warrior*: Filiality and Woman's Autobiographical Storytelling" (1987), Sidonie Smith argues that Kingston's memoir challenges "the ideology of individualism and with it the ideology of gender" (150). In her text, Kingston demonstrates that identity emerges within a community. By focusing on the stories of her mother, herself, and other women in the Chinese American community of her past, Kingston demonstrates that her autobiography is shaped by the stories others tell—about her and about themselves. Thus, for Smith, Kingston's text is "an autobiography about women's autobiographical storytelling" (150).

Drawing on psychoanalytic insights into the imperfect and unstable construction of the subject, Shari Benstock argued in "Authorizing the Autobiographical" (1988) that male autobiographical texts tended to "seal up and cover over gaps in memory, dislocations in time and space, insecurities, hesitations, and blind spots" (20), offering instead a unified and coherent self as the "I" of the text. By contrast, women authors of the modern era—Djuna Barnes, Isak Dinesen, H. D., Mina Loy, Anaïs Nin, Jean Rhys, Gertrude Stein, and Virginia Woolf—emphasized the instability of the subject. In analyzing Woolf's *Moments of Being*, Benstock attends to the disparities among Woolf's memories as evidence of the "futility and failure of life writing" (27).

THE POSTMODERN TURN

By the mid-1980s, feminist literary criticism and theory had established itself as a separate area of investigation, conscious of itself as a collective enterprise concerned with sexual difference in literature but equally aware that feminist criticism took a variety of forms and approaches. Collections and anthologies reflected these differences. *The New Feminist Criticism: Essays on Women, Literature, and Theory* (1985), edited by Elaine Showalter, incorporated essays by black feminists, lesbian critics, and feminist literary theorists—the same groups who had so potently challenged mainstream feminist criticism as white, middle class, and monolithic. The "new" feminist criticism was more inclusive and mindful of the differences among women and how such differences shaped both literature and our approaches to it.

By the 1990s, critics self-consciously avoided references to "the" feminist criticism or theory (new or old), insisting instead on the plurality of feminist positions, on *feminisms*.

This self-consciousness emerged as a consequence of the "postmodern turn" in the social sciences. Postmodern theorists argue that the guiding assumptions of Western thought are not universal and unchanging but derive from a particular moment in intellectual history: the Enlightenment. The eighteenth century gave rise to a set of assumptions now considered "modern": the unity of humankind, the individual as the source of creativity, the inherent superiority of the West, the idea that scientific investigation leads to truth, and the belief that history is linear and leads inevitably to social progress. In *The Postmodern Condition* (1984), Jean-François Lyotard identified these theories as "**metanarratives**," explanations that presume an ahistorical, all-knowing, rational subject who has a "God's eye point of view" on history and society. He argued, instead, that the ideals of the Enlightenment emerged out of a particular moment in history and that the authors of key Enlightenment texts (Thomas Hobbes, Montesquieu, Condorcet, David Hume, Adam Smith) were themselves influenced by the historical and social conditions during the period in which they wrote, such as the rise of industrial capitalism, the development of liberal democracy, and the organization of knowledge into separate disciplines. As a result, Lyotard defines the "postmodern" as "incredulity toward metanarratives" (26). Postmodern theoretical practice delegitimizes the so-called foundational theories of modern thought in law, science, medicine, politics, economics, and social theory. Purporting to be privileged narratives capable of evaluating all other discourses, metanarratives are, in fact, historically derived and contingent, as postmodern critics reveal. Thus, the work of poststructuralists can be seen as part of the postmodern turn: We have already seen that Derrida exposed the binarism inherent in Western metaphysics and Lacan revealed the instability of the subject in language. (It is doubtful, however, that Derrida would endorse any notion of "the postmodern" given that the term itself appears totalizing, as Judith Butler points out in "Contingent Foundations: Feminism and the Question of 'Postmodernism' " [1990]).

Philosopher Michel Foucault described such work as evidence of the "local" character of criticism in its resistance to the "global" and totalizing theories that were the product of the Enlightenment. In *Power/Knowledge* (1972), he identified a "return of knowledge," or more forcefully "an insurrection of subjugated knowledges," those blocs of knowledge that were disqualified as illegitimate within the accepted hierarchy of science and knowledge, such as that of the psychiatric patient or even doctor against the word of the established scientist. Foucault called the rediscovery of these "local popular knowledges" a "**genealogy**." In his words, the genealogical project would "entertain the claims to attention of the local, discontinuous, disqualified, illegitimate knowledges against the claims of a unitary body of theory which would filter, hierarchise and order them in the name of some true knowledge and some arbitrary idea of what constitutes a science and its objects"

(83). Such knowledges, Foucault contended, were opposed to the centralizing powers of institutionalized and organized scientific discourse. In works on insanity (*Madness and Civilization*, 1961), medicine (*The Birth of the Clinic*, 1963), the prison system (*Discipline and Punish*, 1975), and sexuality (*The History of Sexuality*, 1976, 1984), Foucault engaged in an "archaeology of knowledge," carefully reading the discourses and documents of the past to track the development of institutionalized knowledge to particular historical contexts and to disclose how competing discourses were silenced and elided.

In short, the thinkers loosely identified as postmodern resist all encompassing statements such as "man is this," "woman is that," or "society is such-and-such." Rather than working at the macro level of philosophy and science (common to the eighteenth century), these thinkers work at the micro level of highly specific investigations of human and social behavior. As Linda Hutcheon notes in *A Poetics of Postmodernism* (1988), "the local and regional are stressed in the face of mass culture and a kind of vast global informational village. . . . Culture (with a capital C and in the singular) has become cultures (uncapitalized and plural)" (12).

The connections between postmodernism and feminism are clear. Hutcheon argues that feminist theories helped to develop the postmodern focus on the "ex-centric," those discourses and aesthetic practices that have been marginalized in Western thought. Feminists have long argued that Enlightenment thought privileges male interests and values, asserting that claims about "humanity" have typically referred to men of a particular culture, class, and race. The project of recovering women's texts and contributions to history and society may also be seen as part of the "insurrection of subjugated knowledges" that Foucault describes. According to Hutcheon, "Feminist theory offers perhaps the clearest example of the importance of an awareness of the diversity of history and culture of women: their differences of race, ethnic group, class, sexual preference." Like the feminist critics of autobiography, Hutcheon takes Kingston's *The Woman Warrior* as a powerful example. She claims that Kingston's text "links the postmodern metafictional concerns of narration and language directly to her race and gender" (70). Kingston identifies the gendered nature of the Chinese language: "There is a Chinese word for the female *I*—which is 'slave' " (70). Yet, at the same time, she constructs her own sense of identity through language.

But as feminist criticism itself became institutionalized it opened itself to the same postmodern critique it practiced. Postmodernism challenged feminist critics to avoid generalizing statements about "women." American feminism, for instance, tended to be grounded in the truth of experience—"the personal is the political"—a statement that ironically denied the diversity of women's experiences by assuming that the personal was the same for all women, despite their real differences in race, class, and sexuality. As Nancy Fraser and Linda J. Nicholson describe, some feminist theories are themselves metanarratives: "They are insufficiently attentive to historical and cultural diversity, and they falsely universalize features of the theorist's own

era, society, culture, class, sexual orientation, and ethnic, or racial group" (27). A postmodern feminist critique would be "attentive to differences and to cultural and historical specificity" (34). It would be (1) explicitly historical, (2) nonuniversalist, (3) comparativist, and (4) plural. According to Jane Flax, "Feminist theories, like other forms of postmodernism, should encourage us to tolerate and interpret ambivalence, ambiguity, and multiplicity as well as to expose the roots of our needs for imposing order and structure no matter how arbitrary and oppressive these needs may be" (56).

In "A Manifesto for Cyborgs" (1985), Donna Haraway offers a radical realization of such a theoretical project. She defines the cyborg as "a cybernetic organism, a hybrid of machine and organism, a creature of social reality as well as a creature of fiction" (191). As an invented creature, the cyborg is free from ties to history and culture. It prods us to think beyond traditional polarities—human/animal, animal/machine, physical/nonphysical, male/female, masculine/feminine, public/private—and thus may "suggest a way out of the maze of dualisms in which we have explained our bodies and our tools to ourselves" (223). As Haraway claims, "the cyborg is a creature in a postgender world; it has no truck with bisexuality, pre-Oedipal symbiosis, unalienated labor, or other seductions to organic wholeness" (192). The cyborg thus incarnates "the permanent partiality of feminist points of view" (192).

For many this represents a disturbing prospect, for it challenges the very foundations of feminism: the category of "woman," the female subject of literary criticism and theory, and the terms "sex" and "gender" themselves. At the end of the twentieth century, feminist criticism and theory was caught up in a significant shift, what Cornel West has termed the "new cultural politics of difference." The distinctive features of this critical turn are "to trash the monolithic and homogeneous in the name of diversity, multiplicity and heterogeneity; to reject the abstract, general and universal in light of the concrete, specific and particular; and to historicize, contextualize and pluralize by highlighting the contingent, provisional, variable, tentative, shifting and changing" (65). We chart a few of these significant changes and their impact on feminist literary criticism in the sections that follow.

Critical Intersections

SEXUALITIES

> In the English language, the word sex is certainly ambiguous. A sign with var-
> ious connotations, sex refers not only to sexual activity (*to have sex*), it also
> marks the distinction between male and female anatomy (*to have a sex*).
>
> —Joseph Bristow, *Sexuality* (1997)

> She is sexuality itself.
>
> —Otto Weininger, *Sex and Character* (1903)

The relationship between **sex** and **gender** remains a vexed question. The earliest feminists were at pains to divorce biological identity from culturally determined definitions of femininity, dismissing attempts to diminish their contributions as products of the weaker or inferior sex. Twentieth-century feminism refined the distinction, arguing that sex, the biological distinction between **male** and **female**, did not determine gender differences, but that instead **femininity** and **masculinity** were socially constructed. In Simone de Beauvoir's famous formulation, "One is not born a woman, but rather becomes one." The cultural construction of woman—particularly its restrictive and debilitating consequences—became the focus of feminism.

Radical feminists of the 1970s, however, noted that in subordinating sex to gender, feminists had erased all attention to sexuality. More significantly, mainstream feminist criticism and theory had elided differences among women, privileging heterosexual experience. Lesbian **separatists** argued that heterosexuality was a means of patriarchal domination, a denial of female pleasure, and the sexual enslavement of women. If feminism meant resistance to patriarchy, then the true feminist—in theory and in practice—was lesbian.

LESBIAN FEMINIST THEORY AND CRITICISM

In *The Dialectic of Sex: The Case for a Feminist Revolution* (1970), Shulamith Firestone argued that women's reproductive capacity was the origin of their oppression; by assuming control of their reproductive functions and pursuing their own sexual pleasures they could end "the tyranny of the biological family" (11). Ti-Grace Atkinson, in *Amazon Odyssey* (1974), argued that

"love" was an institution of heterosexual sex and, along with Charlotte Bunch, contended that lesbianism was the truly feminist revolutionary practice. In "The Woman-Identified Woman" (1973), the Radicalesbians presented **lesbianism** as the logical extension of feminism: "it is the primacy of women relating to women, of women creating a new consciousness of and with each other which is at the heart of women's liberation, and the basis for the cultural revolution" (167). Poet Adrienne Rich, like Atkinson, argued that **heterosexuality** was not natural, but an institution that enforced "women's total emotional, erotic loyalty and subservience to men" (35). Women's natural desire is for other women, and only societal forces "wrench[ed] women's emotional energies away from themselves and other women and from women-identified values" (35). She identified compulsory heterosexuality as a system of male domination, either physically through the chastity belt and child marriage or through "control of consciousness" in the "erasure of lesbian existence (except as exotic and perverse) in art, literature, film" and the "idealization of heterosexual romance and marriage" (39). Not limiting her definition of lesbianism simply to sexual relations among women, Rich outlined a "lesbian continuum," including a range of woman-identified experience, from female friendship to "bonding against male tyranny" (51). As we have seen, the woman-identified woman became a focus of feminist literary criticism, in the works of Bonnie Zimmerman, Lillian Faderman, and others who analyzed images of lesbian women in literature and sought to define a lesbian literary style.

Barabara Smith, for instance, chastised white, heterosexual feminists for ignoring not only black women's writing but also its lesbian themes. In *Toward a Black Feminist Criticism* (1977), she argued that Toni Morrison's *Sula* could be seen as a "lesbian novel not only because of the passionate friendship between Sula and Nel but because of Morrison's consistently critical stance toward the heterosexual institutions of male-female relationships, marriage, and the family" (175).

French feminists Luce Irigaray and Monique Wittig also explore the relationship between female sexuality and male power. In "This Sex Which Is Not One," Irigaray argued that women's sexual pleasure was not monolithic but multiple, and so evaded attempts to contain or control it, and the same could be said for her language. She elaborated on the potential subversiveness of female sexuality in "When the Goods Get Together" (1980; *"Des marchandises entre elles,"* 1977). She, like the radical lesbian feminists, envisioned the institution of sex as a process of exchange, with women as its object. Women's sexuality was exchanged among men through intercourse and marriage: "Woman exists only as the possibility of mediation, transaction, transition, transference—between man and his fellow creatures, indeed between man and himself" (108). If, however, women conceived of themselves not as objects of exchange but instead saw their sexuality as a gift, freely given, they could resist the male sexual economy that degraded their pleasure and person. Then "there would be free enjoyment, well-being without suffering, pleasure without possession" (110).

Monique Wittig similarly argues that lesbianism "has only a distant relation with heterosexuality, since the latter is dominated by its final cause, reproduction, and since the obligatory exercise of heterosexuality, far from having as its goal the sexual expansion of individuals, assures an absolute control of their physical persons" (115). While Wittig, like Irigaray, envisions lesbianism as the free exercise of sexual pleasure, it is not clear that she sees lesbianism as a feminist position. She argues that "it would be incorrect to say that lesbians associate, make love, live with women, for 'women' has meaning only in heterosexual systems of thought and heterosexual economic systems. Lesbians are not women" (118). Unapprehended by the "straight mind," lesbians, in Wittig's view, exist outside and apart from the heterosexual system and male domination.

Both Irigaray and Wittig have been faulted, as were lesbian separatists, for imagining a purely feminine space untouched by the phallocentric order. Annamarie Jagose reminds us in *Lesbian Utopics* (1994) that "there is no outside: there is no original or utopic free space outside culture and discourse, accessible through memory or imagination" (162).

As Diana Fuss has noted, feminists such as Rich and Wittig have also tended to establish lesbianism as monolithic, denying the specificity of lesbian experience. They make contrary claims—Rich contends "all women are lesbians," Wittig "lesbians are not women"—but both definitions overlook the material and historical differences among women: "If Wittig is unable to account for the specificity of women who do not identify as lesbian, Rich (quite paradoxically) is unable to account for the specificity of those women who *are* lesbians. Whereas Wittig's notion of 'lesbian' is too exclusive, too reified, Rich's notion is too inclusive, too vague" ("Essentially," 44). Both fail to imagine that there is not a singular lesbian sexuality, culture, or individual.

PORNOGRAPHY

The limits of this tendency to perceive female sexuality from a singular point of view became readily evident in the rift between feminist theorists over pornography. Andrea Dworkin defined "pornography" as "writing about whores," based on the term's origin in the ancient Greek words *porne* (whore) and *graphos* (writing). She argued that pornography was "objective and real and central to the male sexual system" and by making women into sexual objects it showed that "the valuation of women is widespread and that the sexuality of women is perceived as low and whorish in and of itself" (200). Simply put, "in the male system, women are sex" (202). Pornography does not, as some claimed, "refute the idea that female sexuality is dirty; instead, pornography embodies and exploits this idea; pornography sells and promotes it" (201).

For Dworkin and others, pornography's objectification of women not only is a form of violence against women but also leads directly to sexual harassment, battery, and rape. In Robin Morgan's words, "pornography is the

theory, and rape is the practice" (139). Catherine MacKinnon contends "male dominance is sexual," and "a theory of sexuality becomes feminist methodologically . . . to the extent that it treats sexuality as a social construct of male power: defined by men, forced on women, and constitutive of the meaning of gender" (127–28). For MacKinnon, "sexual arousal . . . is force, power's expression" (136). She rejects lesbian sexuality as transgressive: "women's sexuality remains constructed under conditions of male supremacy; women remain socially defined as women in relation to men; the definition of women as men's inferiors remains sexual even if not heterosexual, whether men are present at the time or not" (141–42). Since male supremacy is "largely universal," all women, regardless of race, culture, or class, "live in sexual objectification the way fish live in water" (149).

Predictably, such universalizing claims came under fire. A 1982 conference called "The Scholar and the Feminist: Toward a Politics of Sexuality" was held at Barnard College, and the proceedings were later published as *Pleasure and Danger: Exploring Female Sexuality* (Vance 1984). So highly pitched were discussions at the conference that they have been described as the "sex wars." Lesbian practitioners of sadomasochism challenged arguments that sexual dominance was inherently male, contending that positions of dominance and submission could be both occupied by women and that dynamics of power contributed to erotic pleasure. Others have argued that images of women in pornography fuel women's, as well as men's, sexual fantasies. For instance, in her study of hard-core pornographic films, Linda Williams emphasized that, in representing sex acts, the films often presented images that were impossible to visualize and thus were dissociated from reality. Instead, she argued such films may even present viewers with innovative alternatives to phallic sexuality. Others have argued that the basic appeals of pornography—seduction, desire, and voyeurism—are the basic components of cinema itself.

Unconvinced by such arguments, Dworkin and MacKinnon introduced the Minneapolis Ordinance in 1984, which enabled women to take civil action against anyone involved in the production, sale, or distribution of pornography. Feminists, including lesbian feminists, desiring *more* sexual freedom not *less*, inevitably rejected the ordinance as censorship. (The Supreme Court agreed, arguing that it violated First Amendment protections of free speech.) The dividing line was never clearer, with anti-pornography critics equating sex with power and their opponents advocating transgressive sexual expression and pleasure. Left unchallenged by both groups was the equation of sexuality with male dominance; female sexuality was conceived of as resisting or evading male domination. Power was male, pleasure female.

Other critics resisted feminist arguments that polarize the masculine and the feminine and that identify women with subjection and subordination, arguing instead that men and women were both influenced by cultural constructions of gender and sexuality. Eve Kosofsky Sedgwick offered a more complicated understanding of gender in *Between Men: English Literature and*

Male Homosocial Desire (1985). She explored the structure of men's relations with other men in novels of the mid-eighteenth to mid-nineteenth century, plotting them on a continuum of same-sex identification called the "**homosocial**," with nonsexual relations such as "male bonding" and friendship at one end and homosexuality at the other. Sedgwick argued that patriarchal structures make heterosexuality obligatory and reveal a fundamental resistance to homosexuality. She further suggested that the consequences for women were clear, citing Gayle Rubin, who contended, "The suppression of the homosexual component of human sexuality, and by corollary, the oppression of homosexuals, is . . . a product of the same system whose rules and relations oppress women" ("Traffic," 180). Power relations between men and among men and women were affected by and dependent upon definitions of sexuality. For this reason, Rubin, who had originally argued in "The Traffic in Women" (1975) that sex "is itself a social product" (166), reversed herself in "Thinking Sex" (1984) and argued that "it is essential to separate gender and sexuality analytically to reflect more accurately their separate social existence" (311).

THE CONSTRUCTION OF SEXUALITY, SEX, AND GENDER

Segwick claimed that "what *counts* as the sexual is . . . variable and itself political" (15). In *The History of Sexuality* (1976–84), Michel Foucault demonstrated that definition and regulation of sexuality were means by which power was organized in Western society. Foucault's original work revised the "repressive hypothesis," the common notion that since the eighteenth century and most notably during the Victorian period, Western culture has repressed sexual expression. Instead, he noted "a steady proliferation of discourses concerned with sex, . . . a discursive ferment that gathered momentum from the eighteenth century onward" (18). Power thus operated differently, not as restriction or suppression but as a means of analyzing, classifying, and regulating sex: "it had to be taken charge of by analytical discourses" (24). The institutions of medicine, psychiatry, economics, education, and law all contributed to the regulation of sex:

> Sex was driven out of hiding and constrained to lead a discursive existence. From the singular imperialism that compels everyone to transform their sexuality into a perpetual discourse, to the manifold mechanisms which, in the areas of economy, pedagogy, medicine, and justice, incite, extract, distribute, and institutionalize the sexual discourse, an immense verbosity is what our civilization has required and organized. (33)

He notes, for example, that the "feminine body was analyzed—qualified and disqualified—as being thoroughly saturated with sexuality" (140). Women's bodies were scrutinized to determine their reproductive fitness and their capacity for motherhood and nurturance.

According to Foucault, the regulation of sex was designed, as the radical feminists had also argued, to sustain heterosexual monogamy as the norm.

But whereas lesbian feminists had conceived of alternative sexuality as pro-
hibited and oppressed, Foucault argued that its regulation took a different
and more insidious form. Rather than being driven underground, homo-
sexuality and other practices deemed "perverse" were made more visible,
given an "analytical, visible and permanent reality." Medical professionals
sought explanations for sexual "deviance" in the body, measuring brain size,
organ shape, and so forth. Psychiatrists and sexologists, from Richard von
Krafft-Ebing to Havelock Ellis, classified "perverts" by naming them
zoophiles, mixoscopophiles, presbyophiles, zooerasts, gynecomasts, and
sexoesthetic inverts.

Particularly in the case of homosexuality, the regulation of sex trans-
formed the practice into a personage. Prior to the eighteenth century, sodomy
categorized as a forbidden act, along with adultery, rape, and incest. "The
nineteenth-century homosexual became," by contrast,

> a type of life, a life form, and a morphology, with an indiscreet anatomy and
> possibly a mysterious physiology. Nothing that went into his total composi-
> tion was unaffected by his sexuality. It was everywhere present in him: at the
> root of all his actions because it was their insidious and indefinitely active prin-
> ciple; written immodestly on his face and body because it was a secret that al-
> ways gave itself away. It was consubstantial with him, less as a habitual sin
> than as a singular nature. (43)

By turning sexuality into the individual, locating it in the body, Western so-
ciety increased and justified its encroachment on the body and its pleasures.

Foucault's influential study made sexuality itself the object of historical
and cultural analysis and complicated feminist understandings of the rela-
tionship between sex and power, challenging simplistic equations with male
dominance. Foucault's work had three important effects:

1. It challenged the division between sex and gender by demonstrating that sex,
traditionally understood as biologically given and unchanging, was itself subject
to historical and cultural transformation. Our knowledge of sex was mediated by
discourse—medical, legal, economic, pedagogic. Western societies have represented
sexuality in historically and culturally specific ways, privileging a normative het-
erosexuality since the eighteenth century.

2. Foucault demonstrated that homosexuality was, like heterosexuality, a con-
struct, that it was, in effect, "invented" in contradistinction to and as a way of rein-
forcing the "norm" of male-female monogamous intercourse perceived as the basis
of the family under capitalism.

3. Foucault's presentation of power as diffused called into question models of
resistance. If oppression has no single, identifiable source, then resistance itself must
be plural.

As a result, feminist theorists began to reevaluate the relationship between
sex and gender and to reexamine homosexuality itself. Judith Butler, for in-
stance, argued that "sex itself is a gendered category." In *Gender Trouble*
(1990) she asked,

> What is "sex" anyway? Is it natural, anatomical, chromosomal, or hormonal, and how is a feminist critic to assess the scientific discourses which purport to establish such facts for us? Does sex have a history? Does each sex have a different history or histories? Is there a history of how the duality of sex was established, a genealogy that might expose the binary options as a variable construction? Are the ostensibly natural facts of sex discursively produced by various scientific discourses in the service of other political and social interests? If the immutable character of sex is contested, perhaps this construct called "sex" is as culturally constructed as gender; indeed, perhaps it was always already gender, with the consequence that the distinction between sex and gender turns out to be no distinction at all. (6–7)

Butler demonstrated that gender distinctions rested on a preexisting distinction between the sexes that was itself a historical and social construct. Thomas Laquer notes that pre-Enlightenment models of sexuality presumed one sex—male—with the female body a reflection of male organs and female sexual energy differing only in degree. By the late eighteenth century, however, sexuality was perceived in terms of a binary opposition between male and female. "Two sexes are not the necessary, natural consequence of corporeal difference" (243), Laquer demonstrates, any more than is one sex. As a result, he concludes that "almost everything one wants to *say* about sex—however sex is understood—already has in it a claim about gender" (11).

For Butler, the binary division between male and female emerged out of a normative heterosexuality. Individuals "only become intelligible through becoming gendered in conformity with recognizable standards of gender intelligibility" (16). These norms of intelligibility rest on binary division between men and women—"one is one's gender to the extent that one is not the other gender"—and assume that desire is heterosexual, that each gender desires its opposite. Butler writes, "The institution of a compulsory and naturalized heterosexuality requires and regulates gender as a binary relation in which the masculine term is differentiated from a feminine term, and this differentiation is accomplished through the practices of heterosexual desire" (22–23). While Butler echoes earlier feminists, such as Rich, in identifying a "compulsory and naturalized heterosexuality," she does so with a difference: Normative heterosexuality is not inherently male but constructed out of a division that configures both genders. Heterosexuality, and not male dominance, becomes the object of theoretical investigation.

This is a significant difference, for Rich and others had insisted on distinguishing between lesbians and gay men: "To equate lesbian existence with male homosexuality because each is stigmatized is to deny and erase female reality once again" (Rich 52). She contended real differences separated the two groups: "women's lack of economic and cultural privilege relative to men; qualitative differences in female and male relationships, for example, the prevalence of anonymous sex and the justification of pederasty among male homosexuals, the pronounced ageism in male homosexual standards of sexual attractiveness" (53). Lesbian experience is "like motherhood, a pro-

foundly *female* experience" (53). Marilyn Frye claimed more forcefully that "gay men generally are, in significant ways, perhaps in all important ways, only more loyal to masculinity and male supremacy than other men" (132). Clearly, such obvious stereotyping (*all* gay men are pederasts? ageists?) and biological **essentialism** rested on precisely the simplistic understanding of sex that Butler and others challenged.

QUEER THEORY

As a result, **queer** theory has focused on the historical and cultural construction of sex and gender. Influenced by post-structuralist theories of discourse and identity, queer theorists emphasized the unstable relations between sex, gender, and desire. In *Queer Theory*, Jagose notes that queer theory "locates and exploits the incoherencies in those three terms which stablise heterosexuality. Demonstrating the impossibility of any 'natural' sexuality, it calls into question even such apparently unproblematic terms as 'man' and 'woman'" (3). Queer theorists agree with Jeffrey Weeks that "what we define as 'sexuality' is an historical construction" (15) and focus attention on practices that destabilize and denaturalize what Butler has called the "heterosexual matrix," including cross-dressing, hermaphroditism, and **bisexuality**.

Studies of homosexuality have been important for revealing the historical and cultural construction of sexuality and gender. Following Foucault, most theorists have identified our contemporary sense of the term— referring to types of sexual person and kinds of erotic attraction—as emerging in the late nineteenth century. (Alan Bray has argued in *Homosexuality in Renaissance England* [1982] for an earlier origin in the "molly houses" that developed in the seventeenth century.) The word itself was introduced by a Swiss doctor, Karoly Maria Benkert, in 1869, but Austrian sexologist Richard von Krafft-Ebing is generally credited with first defining the conditions "homosexuality" and "heterosexuality" in his controversial *Psychopathia Sexualis* (1886, 1892). The term entered the English language with the publication of Havelock Ellis's works in the 1890s, including *Sexual Inversion* (1897), written with poet John Addington Symonds. Before Krafft-Ebing and Ellis, others had constituted same-sex desire as an inversion of heterosexuality. Foucault identifies Carl Westphal's 1870 article on "contrary sexual sensations" as the origin of the idea that the homosexual inverted traditional gender distinctions between masculine and feminine. Joseph Bristow notes that even Karl Heinrich Ulrichs, writing in the 1860s and 1870s to defend "man-manly love" as natural, not deviant as in Westphal and Krafft-Ebing, latched on to the idea of gender inversion as justification. Ulrichs argued that "man-manly" lovers constituted a "third" sex, "not fully men or women" (Bristow 21). More tentatively he posited that there may be a "fourth sex": "a sex of persons built like females having woman-womanly sexual desire, i.e. having the sexual direction of men" (Bristow 22). Significantly, the sexologists had recourse to traditional assumptions about gender divi-

sion. The notion of the homosexual as invert sustains a model of desire as heterosexual opposition: It is either male or female, and simply misdirected. Ulrichs, however, can be credited with complicating the sexologists' scientific model by introducing a split between body and soul or mind: The invert was physiologically congruent with a particular sex (male or female) but his/her sexual desire, while still gendered masculine or feminine, was at odds with the body.

Investigation of the psychic dimension of sexuality became, of course, the object of psychoanalysis. Freud's work in the late 1890s placed primacy on sexuality in psychic development, as the previous section has discussed. For Foucault and his followers, psychoanalysis, like sexology, is a discursive regime regulating a normative sexuality. Despite Freud's recognition that sexuality is originally undifferentiated for female and male children, "polymorphously perverse," and unconfined to any specific bodily zone, he nonetheless argues that as adults we inevitably take up a position on one side of the gender divide and that "normal" development moves away from bisexuality to heterosexuality. We simultaneously achieve gender identity and sexual orientation. As feminists from Millett to Irigaray had already argued, Freud's model of psychosexual development, with the Oedipal and castration complexes as its foundation, privileged the phallus. Foucault takes this emphasis, not as evidence of Freud's misogyny, but of psychoanalysis's complicity in defining and regulating heterosexuality. While psychoanalysis did resist the medical (and religious) tendency to view sexuality as coincident with reproduction, it substituted yet another dimension of prohibition, what Jacques Lacan later called "the law of the Father."

Other critics have noted that sexology and psychoanalysis developed coincident with capitalism and have traced nineteenth-century fixations on sexuality to changing notions of the individual's position in society, particularly the family. In "Capitalism and Gay Identity" (1983), John D'Emilio traces the shift from the family as the locus of production to the family as affective unit, an "institution that provided not goods but emotional satisfaction and happiness" (7). The family was no longer governed by the "imperative" to procreate and produce additional workers to sustain its production. Instead, sexuality became separated from procreation and came to be a way of expressing intimacy and experiencing pleasure. This allowed "some men and women to organize a personal life around their erotic/emotional attraction to their own sex" (8). Lawrence Birken has argued, more generally, that capitalism's emphasis on the individual stresses freedom of choice and the pursuit of pleasure in both the public and private domains. In *Consuming Desire* (1988), he sees the development of sexology as coinciding with emergence of capitalism for the object of both sexuality and consumption is the satisfaction of desire. D'Emilio has noted that this stress on personal satisfaction, combined with the development of cities, freed the individual to pursue his or her desires outside the scrutinizing gaze and social surveillance characteristic of smaller, close-knit agrarian communities. The conditions were thus ripe for the pursuit of alternative sexualities and

for the development of homosexual communities. D'Emilio, like other critics, stresses the paradox inherent in the development of the modern family:

> The relationship between capitalism and the family is fundamentally contradictory. On the one hand, capitalism continually weakens the material foundation of family life, making it possible for individuals to live outside the family, and for a lesbian and gay male identity to develop. On the other, it needs to push men and women into families, at least long enough to reproduce the next generation of workers. The elevation of the family to ideological preeminence guarantees that a capitalist society will reproduce not just children, but **heterosexism** and homophobia. (13)

In these analyses of the emergence of a normative heterosexuality in nineteenth-century medicine, psychology, and economics, feminine sexuality—particularly homosexuality—remains an "enigma" (to borrow Freud's notorious phrase). The term "lesbian" did not enter the English vocabulary until the early twentieth century, first appearing in dictionaries in the 1940s. Critics have noted, for instance, that Radclyffe Hall does not employ the term in her pioneering depiction of same-sex desire in *The Well of Loneliness* (1928). As feminist critics have observed, the silence surrounding female sexuality reveals the persistence of conceiving male sexuality as normative. Late nineteenth-century studies of sexuality partake of the Victorian separation between male aggressivity and female passivity, of making sexual activity itself male and either neglecting female sexual desire entirely or making women the object of male desire, sex itself.

Literary critics attentive to sexuality and gender thus have been faulted for overlooking female same-sex desire. In her essay "When Virginia Looked at Vita, What Did She See; or, Lesbian: Feminist: Woman—What's the Differ(e/a)nce?" (1992), Elizabeth Meese faults both male and female critics of Virginia Woolf's *Orlando* (1928) for ignoring its lesbian focus. In the novel, gender and identity shift, as Woolf traces the biography of a young noble who lives from the Renaissance to the modern era, first as a male and then as a female. Meese claims, "critical interest in androgyny in Woolf's work prepares us for and distracts us from (as it disguises) her lesbian interests—a diversionary tactic she deploys" (103). She argues that heterosexual critics cannot ask the right question or see the text as she, as a lesbian critic, can: "The lesbian critic, 'reading as a lesbian critic' . . . searches for something else and finds it, there in the sometimes silent language of the look between those two women, the space between words, the awesome passion of their engagement, even when they are (only) writing. Asking this improper question marks the lesbian scene or angle of vision, brings it into being" (105–6). Looking as a lesbian, Meese can see that the text is actually about Woolf's relationship with Vita Sackville-West, that "Virginia sees, first and foremost, a lesbian, and invests in Vita, through the character of Orlando, the history of women 'like' her—five hundred years of lesbianism, or four hundred years of English tradition—one of Woolf's most striking realizations, and

the very awareness that produces (itself) in the curious construction of Orlando, larger than life, longer than life, all of life" (111).

As historical investigations, Foucault's work and that of the social constructionists focusing on male homosexuality have faced similar criticism. Teresa de Lauretis claims that in Foucault's work "sexuality is not understood as gendered, as having a male form and a female form, but is taken to be one and the same for all—and consequently male" (*Technologies*, 14). It could be argued, however, that the study of "masculinity" may be valuable for understanding "femininity." If, as Butler has argued, normative definitions of heterosexuality imply that "one is one's gender to the extent that one is not the other gender" (*Gender*, 22), then feminine sexuality is socially constructed against male sexuality and vice versa. Others have seen potential value in applying the Foucauldian approach to specifically female homosexuality, including Fuss and Jagose. Jagose notes, "The lesbian body, then, (like every body) is discursively constructed, a cultural text, on the surface of which the (constantly changing and even contradictory) possible meanings of 'lesbian' are inscribed and resisted" (160–61). The definition of "lesbian" itself can be shown to be coincident with the development and legislation of a normative heterosexuality.

This approach can be seen in John Winkler's essay "Double Consciousness in Sappho's Lyrics" (1990). He notes that lesbian critics have been as hard pressed to offer full accounts of Sappho's works as traditional scholars, and remain between "worship" and "anxiety" of her poetry. Winkler, by contrast, argues that Sappho's poetry must be seen from the perspective of a double consciousness: She is not only a woman writing about desire for other women but also a practitioner of a form of poetry intended for public performance. As he explains, "Women in a male-prominent society are thus like a linguistic minority in a culture whose public actions are all conducted in the majority language. To participate even passively in the public arena the minority must be bilingual. . . . Sappho's consciousness is therefore necessarily a double consciousness, her participation in the public literary tradition always contains an inevitable alienation" (585). Winkler challenges readers to think both "in and out of our time, both in and out of a phallocentric framework" (592). His essay reinforces the contentions of queer theory that sexuality is constructed, defined against cultural norms, and that such strictures shape its expression in literature.

Simultaneously, critics argue that the body itself is discursively constructed, that is, that anatomical sex is in fact configured in language, by medical and psychological discourse. Since gender is inscribed on this uncertain construction, this has profound implications for sexual and gender identity. It follows, as Butler argues, that "gender is not always constituted coherently or consistently in different historical contexts" (*Gender*, 3). The cultural markers denoting masculinity and femininity are arbitrary and subject to change. In *Vested Interests* (1992), Marjorie Garber notes that while we now associate pink with girls and blue with boys, until World War II the associations were reversed: Pink was considered a more active, bold, "mas-

culine" color; blue was more serene and so "feminine." Garber's subject, cross-dressing, demonstrates the discontinuity between sex and gender. Drag, for Butler as well as Garber, "plays upon the distinction between the anatomy of the performer and the gender that is being performed" (*Gender*, 137). A male becomes a drag "queen," for instance, by donning a dress, high heels, and makeup, taken to be signifiers of femininity. A female becomes "butch" by wearing pants, short hair, and no makeup, signifiers of masculinity. None of these markers is in itself inherently masculine or feminine—makeup is worn by actors of either sex, for instance—but accrues this significance in particular cultures and contexts. Garber notes, significantly, that drag is "successful" only when the distinction between sex and gender is most pronounced. Contrary to popular belief, transvestites are primarily heterosexual, not homosexual, males, and many report that their sense of their own masculinity is not diminished, but enhanced, by cross-dressing. Garber concludes that the artifice of femininity supports their belief in the givenness of their maleness, the inner man.

For Butler, however, "drag, cross-dressing and the sexual stylization of butch/femme identities" proves the "performative" nature of gender itself (*Gender*, 137). She writes that "we are actually in the presence of three contingent dimensions of significant corporeality: anatomical sex, gender identity, and gender performance. If the anatomy of the performer is already distinct from the gender of the performer, and both of those are distinct from the gender of the performance, then the performance suggests a dissonance not only between sex and performance, but sex and gender, gender and performance" (*Gender*, 137). Masculinity and femininity themselves are performances. When a woman wears a dress and makeup to feel more feminine, she too is acting, adopting culturally specific signs of femininity that are not in themselves indicative of her sex, her sexuality, or her identity as a woman. Psychoanalyst Joan Rivière described femininity as a "masquerade" in her 1929 article "Womanliness as Masquerade," arguing that womanliness is not real, for it makes no reference to any authentically feminine behavior. In *Female Perversions* (1991), Louise Kaplan used the term "homeovestite" to describe women who dress in stereotypical ways, out of fears of being perceived as masculine. Such arguments suggest that, in Butler's words, "Gender is the repeated stylization of the body, a set of repeated acts within a highly rigid regulatory frame that congeal over time to produce the appearance of sustance, of a natural sort of being" (*Gender*, 140).

In denaturalizing sex and gender distinctions, queer theory has also undermined rigid definitions of "gay" and "lesbian." As David Halperin has claimed, " 'homosexual,' like 'woman,' is not a name that refers to a 'natural kind' of thing" (45). Such a strategy has been particularly effective in resisting the equation of homosexuality with the AIDS epidemic. In its attention to the discursive bases of sexual and gender identity, queer theory has been linked to attempts to denaturalize similarly oppressive definitions of race and ethnicity. According to Eve Kosofsky Sedgwick, "Intellectuals and artists of color whose sexual self-definition includes 'queer' . . . are us-

ing the leverage of 'queer' to do a new kind of justice to the fractal intricacies of language, skin, migration, state" (*Tendencies*, 9).

One of the most potent and persistent arguments against queer theory, however, has been that its account of the performative nature of gender and social construction of sexuality ignores the material reality of women's (and men's) identities, real differences in race, ethnicity, class, and sexual choice. Terry Castle has charged that "it makes it easy to enfold female homosexuality back 'into' male homosexuality and disembody the lesbian once again" (12). Sheila Jeffreys describes queer theory as "feminism-free." Even though she is often credited with first using the term "queer theory" in 1991 as an alternative to what she perceived as a dangerously monolithic lesbian feminism, Teresa de Lauretis dismissed it as "conceptually vacuous" in her 1994 article "Habit Changes." Collections such as *This Bridge Called My Back* (1983), edited by Cherríe Moraga and Gloria Anzaldúa, and *Twice Blessed: On Being Lesbian, Gay and Jewish* (1989) by Christine Balka and Andy Rose stressed the need to take ethnic and racial identity into account along with sexual preference. As we have already discussed, Barbara Smith outlined a black feminist criticism attentive to the lesbian subtext in works by Toni Morrison and others. Such critical projects argue against divorcing the study of sex and gender from other components of identity.

In her essay on Nella Larsen, an important writer of the Harlem Renaissance, Deborah McDowell demonstrates the confluence of race and sexual identity in Larson's fiction. " 'It's Not Safe. Not Safe at All': Sexuality in Nella Larsen's *Passing*" (1986) contends that black women novelists have represented sexuality cautiously in their fiction, or not at all, because "during slavery the white slave master constructed an image of black female sexuality which shifted responsibility for his own sexual passions onto his female slaves" (617). As a result, black women's fiction of the nineteenth and twentieth centuries emphasized chastity. But Larsen, writing during the sexually liberated Jazz Age, explores black women's desire within the strictures imposed on its expression. Her novels "wrestle simultaneously with this dialectic between pleasure and danger. In their reticence about sexuality, they look back to their nineteenth-century predecessors, but in their simultaneous flirtation with female sexual desire, they are solidly grounded in the liberation of the 1920s" (618). McDowell argues that critics of *Passing* who focused on its racial theme—the dangers of passing for white in Harlem—miss the erotic relationship between its female characters, Clare and Irene. "Passing" refers to the act of disguising not only race but also sexuality, and, as McDowell notes, the term aptly captures Larson's narrative technique as well: Her novel passes as a conventional plot about race relations. To fully appreciate Larson's artistry, however, readers must be attentive simultaneously to race *and* sexuality.

At issue are questions of identity. As Steven Epstein has noted, "[P]eople who base their claims to social rights on the basis of a group identity will not appreciate being told that identity is just a social construct" (22). A theoretical impasse exists between those who see shared identity as the foun-

dation for resisting masculinist biases in culture and those who consider such a strategy as naively sustaining acculturated distinctions between sex, gender, race, ethnicity, and class.

SUBJECTIVITIES

Language is our history, personal and political.
—Alice Kaplan, *French Lessons* (1993)

Harkening back to claims that feminist literary criticism and theory of the 1970s and 1980s was the exclusive domain of white, middle-class, heterosexual women, recent studies have highlighted the marginalization of black, Hispanic, and Asian women and asserted the need to consider **race, ethnicity,** and national origin as well as gender. In the intervening years, however, **post-structuralist** theories led to potent criticisms of **essentialist** positions. As a result, just as notions of sex and gender have been profoundly complicated, so too have notions of racial, ethnic, or national identity. Such investigations continue to raise new concerns about what it means to write as or for women.

IDENTITY POLITICS

Some early feminists, such as Kate Millett, adopted the metaphors of colonialism and slavery to describe women's position under patriarchy. African American women were quick to object, arguing that the largely white, middle-class movement could be faulted in its own turn for appropriating such terms and ignoring their historical significance. Black feminists from Barbara Smith to Barbara Christian to Deborah McDowell argued that women of color were doubly oppressed, as women and as racial minorities. Some of the most potent criticisms of mainstream feminism in the 1970s and 1980s came from women who defined themselves as part of a sexual—as well as a racial or ethnic—minority, lesbians including not only black women such as Smith and Audre Lorde but also Chicanas Gloria Anzaldúa and Cherríe Moraga. As critics, they insist that their lived experiences as women, as members of a particular racial or ethnic culture, and/or as lesbians situate them outside mainstream Western culture, a position that provides them with not only an additional impetus for resistance but also a potent means of critique. Their position was influenced by post-structuralist understandings of the constructed nature of subjectivity. If, as theorists contended, subjectivity was culturally derived and defined, then considering class, race, ethnicity, and sexuality, *in addition to* gender, was essential to any critical practice. In "La Conciencia de la Mestiza: Towards a New Consciousness" (1987), Gloria Anzaldúa articulated these complexities as she meditated on

her position as a lesbian of mixed race: "As a *mestiza* I have no country, my homeland cast me out; yet all countries are mine because I am every woman's sister or potential lover. (As a lesbian I have no race, my own people disclaim me; but I am all races because there is the queer of me in all races.)" (80) As we have seen, their literary criticism had dramatic effects, drawing attention to previously overlooked authors as well as defining literary themes and styles distinct from the preoccupations and practices of texts written by white women as well as men. The effect has been particularly pronounced in African American literature. Henry Louis Gates Jr., for instance, has credited feminist investigations of literature by black women as giving new life to African American studies.

Despite their differences, these critics are united in the practice of what has been termed "identity politics," defined, in Diana Fuss's words, as "the tendency to base one's politics on a sense of personal identity—as gay, as Jewish, as Black, as female" (97). Stressing the material differences among women, identity politics challenged unreflective feminist claims about "women" as a group or "woman" as a cultural category. The Combahee River Collective, a black lesbian activist group, issued "A Black Feminist Statement" (1982) that encapsulates this critical position: "This focusing upon our own oppression is embodied in the concept of identity politics. We believe that the most profound and potentially the most radical politics come directly out of our own identity, as opposed to working to end somebody else's oppression" (16).

While a necessary corrective, the practice of identity politics is not without its own difficulties. It has, of course, been dismissed as essentialist, as naively assuming that identity is grounded in one's biological existence as a member of a particular sex or race. In its appeal to the collective experiences of women of a particular minority group it risks making the same kind of universalizing claims it rejects, creating "black women," "Asian women," and "Hispanic women" as monolithic categories. As we have seen in the case of claims about sexual minorities, such a gesture neglects the differences among women identifying themselves as "lesbian" or "homosexual."

Moreover, a monolithic category such as "minority women" or "women of color" may exclude such women from feminist theory itself by reifying their position on the margin. Jane Flax noted that, despite the impact of collections such as *This Bridge Called My Back*, feminist theory in the late 1980s continued to ignore "how our understanding of gender relations, self, and theory are partially constituted in and through experiences of living in a culture in which asymmetric race relations are a central organizing principle of society" (54).

To guard against this tendency, some critics have gone to great lengths to define their own subject position, to clearly define the "I" who speaks in the text. Women of minority groups feared that denial of a unified identity had potentially disastrous political consequences and asserted that one's position as a woman of a specific race or sexual orientation was paramount. In their critical works, the subject is not erased but highlighted, with the

critic speaking self-consciously about her own investment in the subject or text under analysis. Such works are, in effect, memoirs in which the woman strives to create a self in language. Barbara Christian criticized "the race for theory" as "monolithic, monotheistic" and instead asserted "I can only speak for myself. . . . For me literature is a way of knowing that I am not hallucinating, that whatever I feel/know *is*" (77). Amy Ling's "I'm Here: An Asian American Woman's Response" (1987) discussed her difficult position as a Chinese American woman within an English department that marginalizes the texts she studies. She contended that, like black women, Asian American women are "outside the outside," doubly marginalized as women and minorities. Audre Lorde and Barbara Smith have identified their sexuality as a third component of outsider status. In *The Truth That Never Hurts*, Smith explained, "I wanted to illuminate the existence of Black Lesbian writers and to show how homophobia insured [*sic*] that we were even more likely to be ignored or attacked than Black women writers generally" (45). In "Me and My Shadow" (1987), Jane Tompkins expressed frustration at sustaining the dichotomy between her public persona as a critic and her personal feelings: "The dichotomy drawn here is false—and not false. I mean in reality there's no split. It's the same person who feels and discourses about epistemology" (122). bell hooks employed the same directness in *Talking Back: Thinking Feminist, Thinking Black* (1989).

However, as a form of personal criticism stressing the autobiographical, this position has been ridiculed as "moi" criticism in the pages of *Lingua Franca* for reducing the critical enterprise to an exclusive focus on *me*, and in effect closing off discussion: *My* individual response to a text or issue cannot be challenged because you are simply *not me*. A more germane criticism of "positionality"—this idea of positioning oneself on a grid of gender, race, and class—has been identified by John Brenkman:

> It misses the crucial difficult and productive tension within every position, namely, that we are always at one and the same time a member of—(or participant in—) *and* a citizen. Moreover, gender-race-class positionality too easily misses the conflicts that arise *within* every identifiable social group and manifest themselves in *its* political-cultural debates over its identity, its guiding values, its strategies of struggle, its visions of the community's most desired and feared destiny. Stepping into the fray is what criticism is all about. (100)

However, such critiques overlook the fact that the "I" in language is always contingent and that such critical memoirs rest on the assumption that the mode of identity is performative, that one's identity changes in relation to others and in particular situations. For instance, in *French Lessons* (1993), Alice Kaplan recounts her time as a graduate student studying at Yale with the deconstructive theorist Paul de Man, who, it was revealed after his death, had written in defense of fascism. She is not hurt by his betrayal, but regrets that he chose not to teach her about literary fascism and instead "covered his work with the clean veil of disinterestedness" (174). Now a professor herself, she says, "I don't want to fail [my Ph.D. students] the way de Man

failed me. How do I tell them who I am, why I read the way I do? What do students need to know about their teachers?" (174)

Such a critical practice holds the potential for demonstrating the instability of individual and collective identity. Just as the terms "sex" and "gender" have been shown to be historically and culturally defined, attention has shifted likewise to the discursive bases of "race" and "ethnicity."

RACE, ETHNICITY, AND NATIONALITY

Henry Louis Gates Jr. has argued that race is an arbitrary linguistic category that elides differences among ethnic groups. Werner Sollors has similarly claimed "that it makes little sense to define 'ethnicity-as-such,'" since it refers not to a thing-in-itself but to a relationship: ethnicity is typically based on a *contrast*" (288). Black is contrasted to white, for instance. As Stuart Hall has noted, ethnicity is identified as marginal; Americanness or Englishness are never represented as ethnicities. "Ethnic, racial, or national identifications rest on antithesis, on negativity" (288), writes Sollors, and dispossessed groups can only define themselves through resistance. Thus, the very constitution of racial or ethnic identity is itself a construction, defined in opposition to the dominant group or power. The role of the critic, for Sollors, is to reveal "the invented character of modern ethnicity" (303). This involves at least a double gesture: to analyze how imperial powers have defined and subjugated "minority" populations, through literary as well as legal and political discourse, and also how subjected groups have defined themselves in opposition to the dominant culture through the creation of their own culture, including through literature.

Author Toni Morrison has argued that American literature rests on the construction of what she terms "American Africanism." In *Playing in the Dark* (1992), Morrison contends that the American literary tradition emerged in opposition to an "invented Africa," that literary "blackness" caused literary "whiteness." The characteristics championed as "American"—individualism, masculinity, social engagement, moral ambiguity—are in fact "responses to a dark, abiding signing Africanist presence" (5). As examples, she cites the black women who are central to the plots and moral dilemmas of Henry James's *What Maisie Knew*, Gertrude Stein's *Three Lives*, and Willa Cather's *Sapphira and the Slave Girl*.

Morrison and other feminist critics of ethnic literatures have added a triple gesture, examining not only the effects of racial/ethnic oppression but also how such power relations intersect with power relations among women and men. In "Feminist and Ethnic Literary Theories in Asian American Literature" (1993), Shirley Geok-lin Lim argues that the intersection of the two theories complicates our understanding of women's texts. She notes, for instance, that many texts resist the "traditional master plot of ethnic patriarch as villain and ethnic woman as victim":

> One alternative to the representation of woman as a victim to patriarchy is that
> of the disempowering of the central white figure in the Asian kinship nexus
> by a racist and classist white American society. Through the eyes of Asian

American daughters, the father's humiliations, losses, and pathetic struggles against white social authority are both indictments against racism . . . as well as evidence of patriarchal impotence. (579)

Thus the texts are simultaneously examples of ethnic and feminist protest.

POSTCOLONIAL CRITICISM

Postcolonial theory, which examines the literature of cultures affected by imperialism, has obvious applications for feminist theory, as it similarly explores questions of otherness and subjugation. Postcolonial literature, like feminist texts, can be seen as a literature of resistance, of giving voice to historically marginalized groups. The various strands of critical theory defined as "postcolonial" have extended post-structuralist insights about language and subjectivity to analyze imperialism, complicating notions of colonization and subjection. Homi Bhabha argues, like Foucault about sexuality, that culture is discursively constructed and that Western tradition has attempted "to give a hegemonic 'normality' to the uneven development and the differential, often disadvantaged, histories of nations, races, communities, peoples" ("Postcolonial," 437). In *Culture and Imperialism* (1993), Edward Said explains:

> Neither imperialism nor colonialism is a simple act of accumulation and acquisition. Both are supported and perhaps even impelled by impressive ideological formations which include notions that certain territories and people *require* and beseech domination, as well as forms of knowledge affiliated with that domination. (9)

The postcolonial critic is attentive, then, to the discourses of imperialism and colonialism but also to the marginalized discourse of colonized peoples: "Postcolonial criticism bears witness to the unequal and uneven forces of cultural representation involved in the contest for political and social authority within the modern world order" (437). As Bhabha's definition suggests, postcolonial criticism identifies the binarism in Western epistemology that distinguishes colonizer from colonized, civilization from barbarism, developed from developing, progressive from primitive.

Said's earlier work, *Orientalism* (1978), was among the first texts to extend Foucauldian insights about knowledge and power to the study of colonialism, and has, as a result, been claimed as the catalyst for postcolonial criticism. This book, along with subsequent works, *The Question of Palestine* (1979) and *Covering Islam* (1981), examines the history of American and European imperialism in Asia and the Middle East. Said demonstrates that Orientalism, broadly defined as the study of the East, is a system of thought, a discourse of power, and an ideological fiction that defines Eastern culture as inferior in relation to Western culture. The "Orient" is a construct of Western thought, shaped by history, sociology, anthropology, and literature, as in Byron's Oriental tales or E. M. Forster's *A Passage to India*. Such fictions,

however, have shaped Western perceptions of the East as the locus of mysticism, sexual license, and despotism. At the same time, this constructed Orient has "helped to define Europe as its contrasting image, idea, personality, experience." The Orient is the Other against which the West defines itself and is defined negatively as a degraded, primitive culture.

Responses to Said's work have complicated this view by focusing on the discourse of the colonized. Richard Fox has noted the subversive potential of Western stereotypes of the East in the hands of Asians themselves. Gandhi's strategy of resistance, for example, "depended upon an Orientalist image of India as inherently spiritual, consensual, and corporate" (151). Others, such as Dennis Porter and Parminder Kaur Bakshi, have shown that nineteenth-century conceptions of the East as free of repressive sexual morality were used by authors such as Edward Carpenter and E. M. Forster to present positive images of homosexuality in literature. Thus, even *Western* dissidents could exploit the subversive potential inherent in colonial discourse.

As these examples indicate, postcolonial criticism has focused on literature as a weapon of colonial domination but also as evidence of resistance. British imperialists exploited the acculturating power of English literature. British colonialism, in Elleke Boehmer's words, was a "textual takeover" of the non-Western world, an "attempt at both extensive comprehension and comprehensive control" (19). The discipline of English studies, according to Gauri Viswanathan and others, originally introduced to facilitate language acquisition, became instead "an instrument for ensuring industriousness, efficiency, trustworthiness, and compliance in native subjects" (93). The Victorian novel has been cited as the prime instrument of acculturation, given its emphasis on realism and its tendency to reflect the values of the British Empire. As Said has said, "imperialism and the novel fortified each other to such a degree that it is impossible . . . to read one without in some way dealing with the other" (*Culture*, 71). In *Culture and Imperialism* (1993), he supports this claim with persuasive readings of novels by Defoe, Austen, Charlotte Brontë, Dickens, and Conrad. Jane Austen was writing at a time when the British had possessions in the Caribbean and South America, and her novels allude to this colonial experience. In *Mansfield Park*, for instance, Austen's references to Sir Thomas Bertram's possessions in Antigua remind readers that, in Said's words, "the right to colonial possessions helps directly to establish social order and moral priorities at home" (62). According to Said, the economic success of Bertram's overseas properties supports and validates the calm, order, and beauty of Mansfield Park. Domestic and colonial rule support each other. In Brontë's *Jane Eyre*, Rochester's mad wife, Bertha Mason, a West Indian, is confined to an attic, a fact highly suggestive of imperialist tendencies to contain the threat of restless natives, while the Reverend St. John Rivers leaves England to pursue missionary work in India. In both Austen and Brontë's novels, stability reasserts itself by the end, signaling to Said the complicity of the genre, as a "cultural artefact of bourgeois society" (70–71), with imperialism.

Given, then, the particular relation between the nineteenth-century novel and women—as authors and readers—postcolonial literary criticism has enhanced and challenged feminist literary theory. The most influential postcolonial critic from a feminist perspective has been Gayatri Chakravorty Spivak, who has insisted on analyzing sexuality as well as ethnicity. In "French Feminism in an International Frame," she argued that First World feminism demonstrated an "inbuilt colonialism" toward the Third World, either subsuming all writing under the heading of "women's writing," denying its cultural specificity, or categorizing it as "black" or "Indian," terms that obfuscate real differences in nationality and ethnicity. African writers such Amina Mama pointed out the "extension of the term 'Black' to include all those subject to imperialist domination, so that 'Black' sometimes refers to 'white' people" (151). She notes, for instance, that in Britain the term "black" refers to "non-whites," eliding differences among those of African, Afro-Caribbean, and Indian descent, with "diverse cultural, religious and socio-political histories" (153). And each tradition is itself varied: "African women, for example, may come from any part of a continent so diverse that a single nation may have 250 languages reflecting cultural differences which include extremely diverse gender and status relations" (154). While Mama noted the difficulty in trying to "isolate the 'position of women' from any such cultural context" (154), she nonetheless argued that such a strategy was necessary.

Spivak reaches a very different conclusion, one based on a poststructuralist notion of subjectivity. She notes that

> a subject may be part of an immense discontinuous network . . . of strands that may be termed politics, ideology, economics, history, sexuality, language and so on. (Each of these strands, if they are isolated, can also be seen as woven of many strands.) Different knottings and configurations of these strands, determined by heterogeneous determinations which are themselves dependent upon myriad circumstances, produce the effect of an operating subject. (*Other*, 204).

Her focus has been on the "**subaltern**," a term she uses to identify the oppressed subject of colonialism and imperialism. But by emphasizing the various strands that constitute the subaltern subject she has simultaneously complicated postcolonial studies and feminist criticism. Attentiveness to the **heterogeneity** of the subject can be seen as resistance to the **hegemony** of the West, as well as a narrowly defined feminist position. Far from obscuring the question of gender, such complex critical projects raise the stakes of the investigation, demonstrating how inequality between male and female subjects is implicated in and sustained by other imbalances of power and forms of injustice characteristic of late capitalism.

Spivak notes, in "Three Women's Texts and a Critique of Imperialism" (1985), that European and Anglo-American feminist criticism have themselves exhibited a form of colonialism, ignoring the Third World woman as

they define the emergence of the female subject in literature. She takes as exemplary the tendency to focus on nineteenth-century texts—coinciding with the ascendancy of British imperialism—and offers a devastating critique of feminist recuperations of Brontë's *Jane Eyre*. She rejects Gilbert and Gubar's reading of Bertha Mason as Jane's dark double—the "mad woman" of repressed female passion—noting that it emphasizes psychology and Jane's individualism, ignoring the larger context of familial and cultural relations among the characters in the novel. Spivak argues that Bertha, as a white Jamaican creole, is a "figure produced by the axiomatics of imperialism" (899). Jane sees Bertha as subhuman, as groveling "on all fours; it snatched and growled like some strange wild animal." She represents the "not-yet-human" Other in contrast to Jane, Rochester, and others in the family, who represent "civilized" Europe. Her elimination is not then, as Gilbert and Gubar would contend, necessary for Jane to fulfill her own desires, but a metaphor for imperialist violence. Leela Gandhi notes that a similarly attentive postcolonial reading would note that the "civilised real of Austen's *Mansfield Park* is sustained by the distant slave plantation in Antigua" (134).

Rey Chow further notes that postcolonial theory has participated in silencing the subaltern in ceaselessly speaking about marginalism and alterity: "What these intellectuals are doing is robbing the terms of oppression of their critical and oppositional import, and thus depriving the oppressed of even the vocabulary of protest and rightful demand" (13). Even postcolonial criticism attentive to women's position, including Spivak's, has been criticized. In "Under Western Eyes: Feminist Scholarship and Colonial Discourses" (1984), Chandra Talpade Mohanty notes "the production of the 'Third World Woman' as a singular monolithic subject in some recent (Western) feminist texts" (196). She identifies this as a colonial gesture itself that ignores differences among Third World women and that erects the Third World woman as Other to shore up the Western feminist project. Women of the Third World are presented as "ignorant, poor, uneducated, tradition-bound, domesticated, family-oriented, victimised" (200); those of the First World, as "educated, modern, as having control over their own bodies and 'sexualities,' and 'freedom' to make their own decisions" (200). Trinh T. Minh-ha sees the division more simply as between "I-who-have-made it" and "You-who-cannot-make-it" (86).

It is easy to dismiss such claims for offering a monolithic view of Western feminism that repeats the same error of overgeneralization that Chow and Minh-ha point out. Such readings also overlook the fact that Spivak is self-consciously aware of the paradox of speaking for the subaltern, as the question of her influential essay, "Can the Subaltern Speak?" (1988), underscores. In this essay, Spivak notes postcolonial theory's complicity in erasing women: "Between patriarchy and imperialism, subject-constitution and object-formation, the figure of the woman disappears, not into a pristine nothingness, but a violent shuttling which is the displaced figuration of the 'third-world woman' caught between tradition and modernisation" (306). The discourses of colonialism and postcolonial theory have together defined

the Third World woman as Other. She has not been licensed to speak for herself, but has been spoken for, not only in imperialist histories of India but also by insurgents resisting oppression. Colonial powers in India, for instance, supported their practices by appealing to her need for defense. Spivak notes that "white men are saving brown women from brown men" (296), as are women in efforts to rescue rural Indian women from practices such as suttee, the self-immolation of Hindu widows on their husband's funeral pyre. Thus, "if the subaltern has no history and cannot speak, the subaltern female is even more deeply in shadow" (296).

Spivak (1993) has subsequently identified as problematic the First World academy's "construction of a new object of investigation—'the third world,' 'the marginal'—for institutional validation and certification" (56). As translator of Derrida's *Of Grammatology*, Spivak has been influenced by the deconstructive awareness that any text contains within it the potential to be deconstructed in its turn, and so anticipates this possibility in her own work. Such critical self-awareness only confirms, however, the widespread view that the hyperintellectualism of postcolonial criticism means that it is unlikely to find an audience among the dispossessed it claims to assist.

Indeed, some have faulted postcolonial criticism for its own colonialist tendencies. Leela Gandhi claims,

> Postcolonialism continues to render non-Western knowledge and culture as "other" in relation to the normative "self" of Western epistemology and rationality. . . . What postcolonialism fails to recognise is that what counts as "marginal" in relation to the West has often been central and foundational in the non-West. Thus, while it may be revolutionary to teach Gandhi as political theory in the Anglo-American academy, he is, and has always been, canonical in India. (ix)

Postcolonial critics have also failed to attend to the variations in colonialism itself, its differing historical and cultural effects in Africa and India, for instance, and even within each continent. Can the experiences of those in the so-called "settler societies"—Canada, Australia, New Zealand—legitimately be described as congruent with, say, those of the black populations in South Africa? A totalizing view of colonialism elides such significant differences.

As such, many have noted postcolonial theory's tendency to view all colonial texts as repressive, when in fact many reveal the anxieties typical of the period of empire. Boehmer has argued that colonialist writing was "never as invasively confident or as pompously dismissive of indigenous cultures as its oppositional pairing with postcolonial writing might suggest" (4).

Bhabha similarly argues that postcolonial literary texts operate in ways more complicated than in the oppositional model Said and others have advanced. He claims that colonial texts often employ the vocabulary and themes of colonial writing but transformed for anti-colonial purposes. This technique of "colonial mimicry" reflects the ambivalence of the postcolonial condition and the postcolonial subject.

In *The Location of Culture* (1994), Bhabha argues that

> what is theoretically innovative, and politically crucial, is the need to think be-
> yond narratives of originary and initial subjectivities and to focus on those mo-
> ments or processes that are produced in the articulation of cultural differences.
> These "in-between" spaces provide the terrain for elaborating strategies of
> selfhood—singular or communal—that initiate new signs of identity, and in-
> novative sites of collaboration, and contestation, in the act of defining the idea
> of society itself. (1)

Instead, he proposes a model of "cultural hybridity," demonstrating in read-
ings of novels by Toni Morrison and Nadine Gordimer that postcolonial
texts blur the boundaries separating cultures and races, the personal and the
political, and the individual and the communal.

The family in Gordimer's *My Son's Story*, as "colored" South Africans,
live "halfway between" the "real blacks" and the whites who benefit from
the apartheid regime. According to Bhabha, their struggle for liberation is
not a simple opposition movement of black against white but, as disjunc-
tive and displaced, representative of the disaporic origins of colored South
Africans themselves. Gordimer describes the families involved in the anti-
apartheid struggle as "fragmented in the diaspora of exile, code names, un-
derground activity, people for whom a real home and attachments are some-
thing for others who will come after." Bhabha observes that in Gordimer's
and Morrison's novels woman serves as the figure of ambivalence, and the
home as the space where the personal and political merge, as in the case of
My Son's Story, in which Aila's domesticity serves as perfect cover for anti-
apartheid action. Thus, he combines feminist and postcolonial criticism in
his persistent focus on the "in-between."

Bhabha convincingly demonstrates the workings of the "in-between" in
Morrison's *Beloved*. She employs magical realist techniques to merge the past
and present of the slave condition. Beloved is the child murdered by her
own mother, Sethe, to protect her from the horrors of slavery. The child's
ghost haunts the text. Bhabha notes that "the memory of Sethe's act of in-
fanticide emerges through 'the holes—the things the fugitives did not say
the questions they did not ask . . . the unnamed, the unmentioned'" (11). In
the ghost's desire to be named and recognized by Sethe, Beloved represents
not only the personal secret that Sethe has repressed but also the enslaved
minority itself: Her murder is not simply Sethe's crime but is the distorted
consequence of slavery itself in that Sethe can only ensure her child's free-
dom through its death. Morrison fuses personal guilt and public account-
ability, past and present, fantasy and reality. Bhabha's idea of "hybridity"
offers a challenge to postcolonial critics, particularly feminist postcolonial
theorists who have, despite Spivak's warnings to the contrary, remained en-
trenched in oppositional thinking on two levels, perceiving postcolonial texts
by women as resisting colonialism and patriarchy simultaneously.

Nevertheless, many have resisted postcolonial theory's vision of the sub-
ject as discursively constructed. Bhabha has defined "the political subject—

as indeed the subject of politics," as a "discursive event," which means that literature itself has been advanced as a form of political engagement (23). This claim has been rejected as fundamentally naïve—politically and historically. Boehmer contends, for instance, that "the struggle for selfhood is much more than the subject of self-reflexive irony. In a third-world context, self-legitimisation depended, and depends, not on discursive play but on a day to day lived resistance, a struggle for meanings which is in the world as well as on paper" (221–22). Sara Suleri offers "life in Pakistan as an example of such a postcolonial and lived experience" (278), citing laws that undermine women's positions as witnesses to crimes and restrict female sexual expression while licensing male rape. As she explains, "Pakistani laws, in fact, pertain more to the discourse of a petrifying realism than do any of the feminist critics whom I have cited thus far [Mohanty, Trinh, and hooks]" (278). The lived experiences of women, in particular, are overlooked by postcolonial theory.

IDEOLOGY AND CULTURE

It is only in social relations that we are human. . . . To be human, woman must share in the totality of humanity's common life.
—Charlotte Perkins Gilman, *Women and Economics* (1898)

Gender . . . is the product of various social technologies, such as cinema, and of institutionalized discourses, and critical practices as well as of practices of daily life.
—Teresa de Lauretis, *Technologies of Gender* (1987)

In many ways, the preceding debates are each an outgrowth of a renewed insistence on the material, on the lived experiences of women and men and their variations based on race, ethnicity, nationality, and sexuality. **Materialist** critics would note, however, that such theoretical projects still overlook an important variable: economics. Feminist theorists adopting a **Marxist** view are particularly attentive to the reification of gender difference that occurred during the emergence of **capitalism**. They hold that the capitalist system sustains a hierarchy between the sexes that devalues the labor of women, including their literary production. Materialist critics have also drawn attention to **class**, noting that the literary establishment has tended to privilege works written about and by members of the middle and upper classes. They have further challenged the distinction between so-called "high" and "low" culture. Feminist critics have argued that, since women often worked in popular genres, this hierarchy of value has tended to marginalize women's writing. Increased attention to popular **culture** has further eroded bound-

aries between literature and the media. Studies of visual and physical culture—film, television, magazines, fashion, and the body—have enhanced feminist theory and criticism. In their preface to *Feminist Criticism and Social Change: Sex, Class and Race in Literature and Culture* (1985), Judith Newton and Deborah Rosenfelt argue that a materialist-feminist analysis "entails a double work shift: work on the power relations implied by gender and simultaneously on those implied by class, race and sexual identification; an analysis of literature and an analysis of history and society; an analysis of the circumstances of cultural production and an analysis of the complexities with which at a given moment in history they are inscribed in the text" (xix).

MARXISM AND FEMINISM

As liberal movements committed to addressing inequities, socialism and feminism share a common history. Karl Marx and Friedrich Engels published the *Communist Manifesto* in 1848, the same year as the Seneca Falls Declaration, the manifesto of the modern American feminist movement. Marxist theory conceived of history as a series of class struggles, culminating in the conflict between the proletariat (the working class) and the bourgeois (owners of the means of production). Under capitalism, those who controlled the means of production profited from the labor of others; workers, who once directly benefited from the products of their labor, saw their labor exchanged for wages. They were thus alienated from their work and subject to a system of exchange that valued individual gain over the collective good. Marx envisioned the eventual triumph of the proletariat over the bourgeois, once workers reasserted their rights. In the classic Marxist view, the inequities of the capitalist system are at the root of all other social ills, including conflicts between men and women. As a result, the overthrow of the capitalist system would eliminate not only class differences but all social inequities, including patriarchal domination.

Socialists identified an inextricable link between economic and sexual oppression, with monogamous marriage serving as a microcosm of the bourgeois's subjection of the proletariat. In *The Origin of the Family, Private Property, and the State* (1884), Friedrich Engels argued that the oppression of women was "rooted in the twin facts of private ownership of property and the exclusion of women from social production" (189). Engels identified the family as a social organization designed to protect private property, since monogamous marriage ensured the propagation of heirs to the husband's wealth. The family is the site of the first class opposition, between man and woman, and the first class oppression, "that of the female slave by the male" (193). At the same time, the modern patriarchal family effected the economic oppression of women. The division of male and female roles into two spheres excluded women from the public sphere of work, relegating them to private service: "the modern individual family is founded on the open or concealed domestic slavery of the wife" (200), according Engles. Unmarried women's

participation in the public sphere was similarly devalued, as women were assigned to service-oriented occupations reflecting their domestic function (secretary, domestic worker, prostitute) or to the "helping professions" employing their nurturing skills (nurse, teacher, social worker, childcare worker).

As a result, following Engels, the socialists claimed women's condition would be automatically ameliorated with the triumph of the proletariat and distanced themselves from the suffragists. In his popular book, *Woman and Socialism* (1885), August Bebel claimed, "Our goal then is, not only to achieve equality of men and women under the present social order, which constitutes the sole aim of the bourgeois woman's movement, but to go far beyond this, and to remove all barriers that make one human being dependent upon another, which includes the dependence of one sex upon the other. *This* solution of the woman question is identical with the solution of the social question" (211). But for Bebel and others women's equality remained paramount, *"for there can be no liberation of mankind without social independence and equality of the sexes"* (211, emphasis in original).

The socialist view influenced feminist writers such as Charlotte Perkins Gilman, who dedicated herself at the turn of the twentieth century to the same goal of uniting the causes of socialism and women's rights for the benefit of humankind. She reasoned that since "it is only in social relations that we are human . . . to be human, woman must share in the totality of humanity's common life" (233). In her famous *Women and Economics* (1898), she noted that "although not the producers of wealth, women serve in the final processes of preparation and distribution. Their labor in the household has a genuine economic value" (233). Seeking to achieve equality in the household for women, Gilman advocated cooperative arrangements in which domestic labor—cleaning, cooking, childcare—could be shared, freeing women to engage in work. The legacy of such thinking can be seen in modern arguments in favor of daycare, as well as equal pay for equal work. The capitalist emphasis on monogamous marriage combined with the devaluation of women's labor is also responsible, according to socialist feminists such as Emma Goldman, for prostitution. In "The Traffic in Women" (1910), she argued, "Nowhere is woman treated according to the merit of her work, but rather as a sex. It is therefore almost inevitable that she should pay for her right to exist, to keep a position in whatever line, with sex favors. Thus it is merely a question of degree whether she sells herself to one man, in or out of marriage, or to many men. Whether our reformers admit it or not, the economic and social inferiority of woman is responsible for prostitution" (310). Vestiges of this argument can be seen in contemporary views of compulsory heterosexuality as a form of sexual slavery (see the section on "Sexualities"), as the title of Gayle Rubin's "The Traffic in Women: Notes on the 'Political Economy' of Sex" clearly demonstrates.

But Marxist theory and practices, contemporary feminists have argued, have tended to subsume women's concerns under a more general focus on workers. In her influential essay "The Unhappy Marriage of Marxism and

Feminism: Towards a More Progressive Union" (1979), Heidi Hartmann noted "the categories of marxism are sex blind" (1). Marxists believe that women should be considered part of the working class and that the struggle against capitalism should take precedence. Conflicts between men and women will only dilute the strength of a unified proletariat. Hartmann also notes, however, that the reverse position—an analysis focused only on gender—"is inadequate because it has been blind to history and insufficiently materialist" (1). Feminism, as many others have argued, has ignored historical and cultural differences among women and between women and men. Instead, Hartmann urges a "more progressive union": "as feminist socialists, we must organize a practice which addresses both the struggle against patriarchy and the struggle against capitalism" (41).

Michèle Barrett attempted such a combined analysis in *Women's Oppression Today* (1980). Hartmann had warned that "a struggle aimed only at capitalist relations of oppression will fail, since their underlying supports in patriarchal relations of oppression will be overlooked" (40). Barrett similarly contended that the sexual division of labor preceded capitalism, that capitalism reinforced but did not create the division.

Psychoanalysis, which is concerned with how the individual psyche negotiates and sustains its entry into the social order, offered a potent possibility for fusing feminism and Marxism. In *Woman's Estate* (1971), Juliet Mitchell offered a psychoanalytic analysis of preexisting gender division, arguing that women's status and function in society were products of both production and reproduction. She noted that women's role in the family was not simply economic but was also a consequence of biology (her reproductive capacity) and ideology (cultural assumptions about the relationship between men and women). In *Psychoanalysis and Feminism* (1974), Mitchell advocated a combined approach, using Marxism to address economic inequities and psychoanalysis to challenge patriarchal constructions of the family and woman's role.

Adherents of Marxist-feminist approaches to culture have similarly challenged literary interpretation. Barrett provocatively asserted in "Ideology and the Cultural Production of Gender" (1985): "I can find no sustained argument as to *why* feminists should be so interested in literature or what theoretical or political ends such a study might serve" (65). She contended that feminist literary critics have overlooked the fact that literature offers a *mediated* version of social reality and thus cannot be taken as social history. Too much of their work has "concentrated disproportionally on describing *how* gender is represented—'what images of women are portrayed?' is the commonest question—and has not sought to locate this in a broader theoretical framework" (75). Instead, she advocated approaches to literary texts that were more attentive to issues of production, consumption, and representation.

As a member of the Marxist-Feminist Literature Collective, Barrett, along with Cora Kaplan, Mary Jacobus, and others, offered a model for such an approach to literature. In "Women's Writing: *Jane Eyre, Shirley, Villette, Aurora Leigh*," they focused on the "congruence between the marginality of women

writers and the general position of women in society" in the mid-nineteenth century (195). They read key texts by Charlotte Brontë and Elizabeth Barrett Browning as reflections of the general exclusion of women "from the exercise of political power and their separation from production" (195). The collective noted, for instance, that each character has "an extremely marginal and unstable class position" (196), that "none of the heroines have [*sic*] fathers present to give them away in marriage" (196), and that, more generally, a "devised absence of the father" is characteristic (196). As such, the female characters in each text resist the "law of the father." Like Mitchell, the collective saw promise in combining psychoanalytic explanations of gender divisions with Marxist understandings of economic divisions to offer interpretations of literary texts as inscriptions of—or resistances to—patriarchal ideology.

IDEOLOGY

Such readings were influenced by reinterpretations of Marxism undertaken by philosophers Louis Althusser in France and Jürgen Habermas in Germany. Habermas, for instance, extended Marx's view of production. In *The Theory of Communicative Action* (1984, 1987), he contends that societies reproduce themselves not only materially but symbolically, that is, by socializing the young, solidifying communities, and transmitting cultural traditions. He is thus attentive to what Foucault would call the discursive dimension of capitalist societies. Althusser's essay "Ideology and Ideological State Apparatuses" (1971) similarly extended Marx's understanding of literature's role in social construction. Marx believed that capitalist ideology was reinforced and sustained by its representation in art. Thus, Marxist critical practice entailed the "demystification of consciousness" to reveal the illusory nature of our relation to the world. Althusser emphasized that ideology was not simply a set of illusions but a complex system of representations. Just as Lacan argued that we take up positions within the social structure through language, so Althusser reasoned that our position within the capitalist system was configured discursively by a system of representations (discourses, images, myths) through which we experience ourselves in relation to others and to the world. **Ideology** is "that system of beliefs and assumptions—unconscious, unexamined, invisible—which represents the imaginary relationship of individuals to their real conditions of existence" (162). According to Althusser, ideology is not imposed on us from without or above but supported and reproduced by social institutions, including literature. It is a material practice, a mode of perception that emerges "in the behavior of people acting according to their beliefs" (170). As an imaginary construct, ideology offers a false sense of wholeness and naturalness, eliding contradictions to sustain a false coherence. Perceived of as "natural," ideology is in fact an imperfect construction which "obscures the real conditions of existence by presenting partial truths. It is a set of omissions, gaps rather than lies, smoothing over contradictions, appearing

to provide answers to questions which in reality it evades, and masquerading as coherence in the interests of the social relations generated by and necessary to the reproduction of the existing mode of production" (146). Thus, one's relation to the system of production appears "natural" and "universal" rather than as a particular cultural construct. For instance, systems in which one nation or one gender dominates another are presented as the natural order. Once internalized, ideology becomes cultural practice, the way we live. It is supported and reproduced by what Althusser calls "Ideological State Apparatuses": the educational system, the family, the law, the media, and the arts, including literature. It follows, then, that literary criticism could reveal how ideology is inscribed in texts, a process akin to Marx's demystification of consciousness. While Althusser himself did not engage in such criticism, his followers were quick to exploit this possibility.

Materialist critics thus assume, as Cora Kaplan argues, that "author and text speak from a position within ideology—that claims about fictional truth and authenticity are, in themselves, to be understood in relation to a particular view of culture and art" (161). Literature is a site at which ideology is produced and reproduced. In *Desire and Domestic Fiction: A Political History of the Novel* (1987), Nancy Armstrong thus demonstrated that the eighteenth-century novel usurped the function of the conduct book in representing women's domestic role in bourgeois culture. Woman's place as wife and mother in middle-class society was at once produced and sustained by the fictional portraits valorized by novelists. Other critics, such as Terry Lovell in *Consuming Fiction* (1987), shifted the focus from literary production to consumption, to the creation of an audience of women readers as consumers of fictional texts.

Materialist critics also argued that literary analysis can bring ideology to consciousness and expose its contradictions, distortions, and omissions. Pierre Macherey suggested that the text should be read "symptomatically," attentive to its gaps and dislocations as evidence of that which is repressed by the dominant ideology. Critics such as Catherine Belsey, for instance, argued that the object of the critic was then to seek out the moments of incompleteness in the text: "In its absences, and in the collisions between its divergent meanings, the text implicitly criticizes its own ideology; it contains within itself the critique of its own values, in the sense that it is available for a new process of production of meaning by the reader, and in this process it can provide a knowledge of the limits of ideological representation" (57). Through careful readings of Sherlock Holmes stories by Sir Arthur Conan Doyle, Belsey reveals that texts employ classical realist elements to present "a simulated reality which is plausible but *not real*" (63). Despite Holmes's apparent mastery of scientific investigation, he still cannot unlock the mystery of women's sexuality.

Other critics focused more specifically on the ideology of gender. Gayle Greene and Coppèlia Kahn offered a close reading of Isak Dinesen's "The Blank Page" to demonstrate that by attending to the "omissions, gaps, partial truths and contradictions which ideology masks" (22), feminist criticism

can both deconstruct "dominant male patterns of thought and social practice" (6) and reconstruct "female experience previously hidden or overlooked" (6).

Cora Kaplan similarly noted that women writers of the nineteenth century wrote from the position of a particular class (the bourgeoisie) and in the context of a particular audience, an emerging popular middle-class female readership. As a result, gender and class distinctions are persistent preoccupations in texts of the time: "stories about seduction and betrayal, of orphaned, impoverished heroines of uncertain class origin, provided a narrative structure through which the instabilities of class and gender categories were both stabilized and undermined" (168). The impoverished orphan of *Jane Eyre* eventually marries and assumes a position within the bourgeois patriarchal order, but we also see her challenge accepted gender norms. However, as Kaplan notes, such novels reveal their own complicity with nineteenth-century bourgeois ideology, for "novels like *Jane Eyre* tell us almost nothing about the self-defined subjectivity of the poor, male or female. For, although they are both rich sources for the construction of dominant definitions *of* the inner lives of the working classes, they cannot tell us anything about how even these ideological inscriptions were lived *by* them" (169). Representations of lower-class women can be found, according to Kaplan, only in nonliterary texts, in the discourse penned and spoken by working-class women themselves.

CULTURE

Efforts to highlight class divisions and their role in literary production and reception challenged the traditional distinction between high and low culture. Marxist interest in the proletariat or working class transferred itself to literature as interest in the neglected authors of the lower classes and in works dismissed as appealing to a mass audience. In *Culture and Society: 1780–1950* (1958), Raymond Williams argued that the study of culture should be concerned not with part but with the whole of cultural production. Following Williams, cultural critics questioned literature's privileged position in relation to other forms of discourse, including popular genres such as romance novels, science fiction, or detective stories. In the late 1960s and early 1970s, the Centre for Contemporary Cultural Studies at Birmingham, under the leadership of Stuart Hall, gave rise to interdisciplinary studies of the media, dress, dance, and music. One of the most influential works to emerge out of the center was Dick Hebdige's *Subculture: The Meaning of Style* (1979), which examined the subversive potential of punk style in dress and music.

The same subversive practices, feminist literary critics argued, could be found in vilified and marginalized popular fiction, such as romances. Janice Radway, in *Reading the Romance* (1984), and Leslie Rabine, in "Romance in the Age of Electronics: Harlequin Enterprises" (1985), sought to account for the appeal of romance fiction for contemporary women. Much maligned for pandering to women's fantasies, romance novels are typically viewed

by feminist critics as endorsing and sustaining patriarchal definitions of romantic love and marriage, featuring male characters who assume the dominant role in relationships and plots that end, like nineteenth-century domestic fiction, in marriage. Rabine demonstrated, by contrast, that the best-selling Harlequin series sustains its popular audience by conforming to changing roles of women. As women readers entered the workforce, their romance heroines got jobs, too. By focusing on workplace romances, the novels further "suggest that the Harlequin heroines seek an end to the division between the domestic world of love and sentiment and the public world of work and business" (977). Radway contended that romance readers "vicariously fulfill their needs for nurturance by identifying with a heroine, whose principal accomplishment . . . is her success at drawing the hero's attention to herself" (605). The appeal of the romance is its therapeutic value "which is made both possible and necessary by a culture that creates needs in women that it cannot fulfill," and this the source of its "repetitive consumption" (605).

With the triumph of consumer capitalism in the 1990s, the genre offered a "distinctively new script of femininity," according to Rita Felski (129). In "Judith Krantz, Author of the 'The Cultural Logics of Late Capitalism' " (1997), Felski analyzes Krantz's contributions to the "money, sex and power novel" as indicative of the transformation of the early capitalist system's emphasis on production to a late capitalist system focused on consumption and celebrity. Felski's essay, the title of which spoofs Frederic Jameson's subtitle to his influential *Postmodernism* (1990), makes the serious claim that images of gender have changed under late capitalism and that Krantz's novels, and their popularity among women readers, reflect this fact. Krantz's best-selling novels in the 1980s featured glamorous and ambitious heroines who achieve extraordinary corporate success "while engaging in conspicuous consumption of men and designer labels" (130). Felski observes that while Krantz echoes the traditional association of women with consumption under capitalism, "In the postmodern world of the money, sex and power novel, however, such dichotomous, gendered distinctions between work and leisure, production and consumption have lost much of their meaning. Rather, the consumption skills of the Krantzian heroine are the essential preconditions for her entrepreneurial and professional success in the lifestyle, marketing and image industries" (133). In the novels, female power and desire are rewarded, not punished, and in their focus on appearance, image, and style, the novels reflect the "feminization" of contemporary culture.

VISUAL CULTURE

Challenges to the distinction between "high" and "low" culture received added impetus from post-structuralist theory, which had expanded the definition of text to include visual as well as verbal forms, paving the way for studies of other "discursive systems." Loosely gathered under the rubric of

"**cultural studies**," analyses of film, television, advertising, and fashion offered additional possibilities for feminist studies.

Tania Modleski, for instance, made arguments similar to Radway's about the popular appeal of television soap operas for female viewers. In *Loving with a Vengeance* (1982), she claimed that viewers so readily identify with soap opera characters because, as women, they are prone to do so based on their pre-Oedipal attachment to the mother. They find pleasure in the reassuring fantasy of connection. Constance Penley, however, has noted the limitations of this argument in her study of female fandom, "Feminism, Psychoanalysis, and the Study of Popular Culture" (1992). She interviewed female *Star Trek* fans who are obsessed with magazines (fanzines) featuring stories of romance between Captain Kirk and Mr. Spock and examined the erotic, sometimes pornographic, images that illustrated the texts. Penley concluded that the stories and images expressed the women's "desire for a better, sexually liberated and more egalitarian world" (320), a project they believed that they could achieve through fandom, not feminism.

The difference in how women and men look and in the pleasures they take from the visual media has been the focus of feminist film theory. In "Visual Pleasure and Narrative Cinema" (1975), Laura Mulvey argued that mainstream Hollywood cinema presented women as objects of the male spectator, as connoting "to-be-looked-at-ness." While the woman's presence is an indispensable element of the normal narrative film, according to Mulvey her presence generally works against the flow of action, as her visual appearance "freezes the flow of action in moments of erotic contemplation" (62). Influenced by psychoanalytic theories of sexual definition and gender determination that privileged the role of vision, Mulvey argued that mainstream cinema presents women as objects of the male **gaze**. The woman on the screen functions as an erotic object for the characters within the film but also for the spectator within the auditorium. "Cinema," as Mulvey writes, "builds the way she is to be looked at into the spectacle itself" (67).

Feminist film critics of the mid- to late 1980s examined how the gaze configured women's response to film, placing women in a subordinate position both as object and spectator. In *The Desire to Desire* (1987), Mary Ann Doane traced the appeal of the woman's films of the 1940s. She argued that the "woman's film" in some senses attempts to construct itself as the mirror image of the dominant cinema, "obsessively centering and recentering a female protagonist" (13). Presuming a female spectator, woman's film transforms the cinematic structuration of the look, redirecting the masculine desire for the objectified female. Instead, the films highlight the woman's "desire to be desired or desirable" (9). In Alfred Hitchcock's *Rebecca* (1940), for instance, the unnamed character played by Joan Fontaine enters a room dressed in black satin with a string of pearls, precisely the type of dress, Rebecca, the previous Mrs. De Winter, had worn in the hopes of becoming a spectacle for her husband, Maxim. Instead, he relegates her to the position of spectator, directing her attention to images of her that he prefers, those taken on their honeymoon. But, paradoxically, the film also negates female specta-

torship and subjectivity. While *Rebecca* begins with a female **voice-over**, it eventually disappears entirely, just as Rebecca herself is absent from the film.

The problem of female spectatorship is also raised by Annette Kuhn, who argued that "to take pleasure in cinema is to be seduced by [the] operations [of dominant cinema], to be subject to, to submit to, the powers they inscribe" ("Body," 407). She asks, then, whether it's possible for "women/ feminists to take pleasure in visual representation, particularly in cinema?" (407). Subsequent studies advocated the creation of an alternative, feminist cinematic practice. Critics such as E. Ann Kaplan, Teresa de Lauretis, and Kaja Silvermann investigated not only women's portrayal in film but also women's roles as filmmakers to investigate the possibility of resisting the objectification of women in film and to establish a female discourse of film. As Kaplan argued, "we have to think about strategies for changing discourse, since these changes would, in turn, affect the structuring of our lives in society" (34). The essays in *The Female Gaze: Women as Viewers of Popular Culture* (1988), edited by Lorraine Gamman and Margaret Marshment, investigated the possibility of defining female spectatorship, arguing that women could be agents of, not simply objects of, the gaze.

Another approach to the objectification of the female body emerged from the work of Michel Foucault. He argued, as we have seen, that in the nineteenth century the bodies and behavior of individuals became increasing subject to surveillance through a number of disciplinary regimes from medicine to law. In his study of the birth of the modern prison system, *Discipline and Punish* (1977), he writes:

> For a long time the ordinary individuality—the everyday individuality of everybody—remained below the threshold of description. To be looked at, observed described in detail, followed from day to day by an uninterrupted writing was a privilege. . . . The disciplinary methods reversed this relation, lowered the threshold of describable individuality and made of this description a means of control and method of domination. (191)

Griselda Pollack took up Foucault's point, asking, "How do certain people, places, things enter into spaces of representation, which spaces do they enter and why?" (13). In "Feminism/Foucault—Surveillance/Sexuality" (1994), she combines a focus on class and gender to analyze nineteenth-century photographs of working-class women. She argues that women workers transgressed boundaries dividing male and female labor and undercut traditional images of femininity, itself a bourgeois construct:

> Rigidly gendered, the lady is economically excluded from labor, money, and power. The proletarian women's transgression of so complex a formation is, however, there to be seen, in their trousered bodies, with exposed ankles and bared feet, walking to work in public. The bodies of women were required— in bourgeois ideology—to perform and display femininity to signify the bourgeois order of power. Proletarian women's bodies did not confirm their difference and thus their deference. (17)

Analyzing a sequence of pictures taken of British female miners, Pollack is attentive not only to external indicators of femininity—or its denial—such as clothing but also to gestures and postures. In their mining garb, the women stand "legs firmly planted apart, holding studio props such as shovel or riddle" (20). In their Sunday dresses, the women sit "legs erased in the sweep of skirt, hands carefully resting in their laps" (22). The women's ability to break the visual codes of femininity led to anxiety about transgressions of sexual norms as well: "the apparently deregulated sexuality of working women appeared the most vivid and visible expression of the deviance of the working class as a whole from bourgeois norms. It was threatening to the sex-gender system by which the bourgeoisie defined its class identity at its most vulnerable and most urgently defended point" (25), its domestic ideology. Thus, Pollack reveals the photographer's prurient interest in the women he objectifies and exhibits to his middle-class audience.

Foucault's argument about surveillance, however, is not restricted simply to the process of objectification or regulation from without. Instead, he focuses on how regulatory processes are internalized. He explains the process of self-regulation using Jeremy Bentham's model prison, the Panopticon, a circular structure with cells facing onto a central observing station. Each cell has windows in front and in back, enabling the guard in the center to view the prisoners at all times. For Foucault, what is more significant than the guard's ability to see is that each prisoner realizes the possibility of being seen at any time and will alter his or her behavior based on this possibility. The prisoners thus regulate their own behavior. This mechanism of "panopticonism" operates broadly in Western societies, which Foucault describes as "disciplinary societies," where power is not wielded by one individual, one institution, or the state, but is internalized by the society's members and exercised through self-regulatory behaviors and practices.

Feminist critics such as Susan Bordo employed Foucault's model to argue that through exercise and diet women subjected their own bodies to disciplinary practices. In *Unbearable Weight* (1993), Bordo argued that "prevailing forms of selfhood and subjectivity (gender among them) are maintained, not chiefly through physical constraint and coercion . . . but through individual self-surveillance and self-correction to norms" (27). Internalizing the ever-present possibility of being looked at, women seek to transform themselves to meet culturally defined expectations for feminine appearance. Thus, "the body that we experience and conceptualize is always *mediated* by constructs, associations, images of a cultural nature" (35). Such images are homogenizing and normalizing and are "suffused with the dominance of gendered, racial, class, and other cultural iconography" (35).

In a persuasive reading of Toni Morrison's novel *The Bluest Eye*, Kadiatu Kanneh demonstrates how theories of the body and the gaze have been employed in literary criticism and how cultural definitions of feminine beauty disadvantage African American women. Morrison's main character, Pecola Breedlove, wants to look like the icon of American girlhood during her childhood: Shirley Temple. She wants her blond hair and dimples, but particu-

larly her blue eyes. As Kanneh explains, "Living in a world which is run by white domination, which informs the discourses of 'normality' of beauty and worth, Pecola is continually slammed up against an image of herself which is sharply at odds with the white 'norm' " (146). Her black skin, kinky hair, and dark eyes make her the object of the disapproving "white gaze."

Clothing makes the body culturally visible. In *The Fashion System* (1983), Roland Barthes argued that, like language, fashion is a "system of signifiers" that defines and categorizes its wearers. Feminist critics have noted that, as a result, fashion is gendered. As Elizabeth Wilson has argued, "modern fashion *plays* endlessly with the distinction between masculinity and femininity. With it we express our shifting ideas about what masculinity and femininity are" (122). As Joan Rivière has argued, femininity itself is a form of masquerade, in that it is displayed through hair, makeup, and clothing. "Womanliness" is not a given, but is displayed visually. The same, of course, could be said for masculinity. If gendered identity is displayed visually through fashion, such displays can be easily subverted, as in cross-dressing. Critics from Gilbert and Gubar to Garber have analyzed the role that clothing plays in Virginia Woolf's gender-bending novel, *Orlando* (1928). The novel makes fashion central: "Clothes are but a symbol of something hid beneath. It was a change in Orlando herself that dictated her choice of a woman's dress and of a woman's sex." Clothing thus reflects Orlando's shift from male to female, masculine to feminine. While Orlando's sex changes, his/her clothing upholds the construction of masculinity or femininity. The narrator explains, "Different though the sexes are, they intermix. In every human being a vacillation from one sex to the other takes place, and often it is only the clothes that keep the male or female likeness, while underneath the sex is the very opposite of what it is above." This discrepancy between appearance and sexuality is, of course, precisely what transvestism highlights, as Garber demonstrates in *Vested Interests* (1992): "The appeal of cross-dressing is clearly related to its status as a sign of the constructedness of gender categories" (9). Transvestism reveals at once the power and the fluidity of such categories.

Fashion theorists, such as Fred Davis and Ruth Rubenstein, have further noted the coincidence of distinctions between male and female dress with the emergence of capitalism and consumerism. As such, studies of fashion fuse investigations of gender with analyses of power, class, race, and ethnicity. "Fashion *speaks* capitalism," according to Elizabeth Wilson (14). "Capitalism maims, kills, appropriates, lays waste" (14). It is also "global, imperialist and racist" (14), and "at the economic level the fashion industry has been an important instrument of this exploitation" (14).

Under late capitalism, fashion captures all the contradictions of consumerism and celebrity. In "Madonna, Fashion and Identity" (1994), Douglas Kellner argues that Madonna's constantly changing image reflects our postmodern condition, in that her identity is constructed through image and fashion and her self-fashionings "reinforce the norms of the consumer society, which offers the possibilities of a new commodity 'self' through con-

sumption" (159). The identity fashioned through clothing in consumer culture is not necessarily singular, however, as hip-hop style clearly demonstrates. Andrew Ross, in "Tribalism in Effect" (1994), argues that young black males engage in "sartorial terrorism," co-opting the generic sportswear of designers such as Tommy Hilfiger to signal group membership and identity in the outlaw culture of rap. "Popular style, at its most socially articulate, appears at the point where commonality ends and communities begin" (289). As Ross's examples suggest, street style embodies the conflicts of race, ethnicity, and gender at the turn of the century.

Women's clothing and accessories, even shoes, capture the cultural tensions of their times. In an inventive reading of Daphne DuMaurier's mystery-romance novel *Rebecca* (1938), Jaime Hovey argues that anxieties regarding female sexuality are displaced onto the shoes left by the deceased title character, the first Mrs. DeWinter. The unnamed narrator's fascination with her predecessor fixates on her shoes. Hovey argues that shoes are part of the masquerade of femininity, a masquerade donned by Rebecca to appear the perfect wife—feminine and bourgeois—when, in fact, she was sexually adventurous and punished for her transgressions. Thus, Rebecca's shoes "suggest the inauthenticity of Rebecca's sexuality, the insincerity and hollowness of her character, and the falseness of a wealthy, powerful femininity as national ideal. As literal accoutrements of feminine masquerade, Rebecca's shoes elicit the narrator's doubts about femininity in general, because they suggest both the power of Rebecca's seemingly ideal femininity and its 'true' insincerity and lack" (159).

Studies of popular culture have come under fire for displacing the "serious" investigation of literature, with doomsday critics predicting college courses featuring *South Park* and *Titanic* in place of Shakespeare and Tennyson. As even this brief survey has demonstrated, however, studies of visual culture intersect meaningfully with literary studies in that both are concerned with the role of perception in shaping cultural attitudes and social interactions. As contemporary culture is increasingly dominated by the image, critical approaches to film, television, advertising, and consumer culture itself have become crucial, particularly in understanding gender.

CONCLUSION

At the start of the new millennium, feminist literary criticism and theory has been influenced by theoretical investigations of race, ethnicity, nationality, sexuality, capitalism, ideology, and culture. More significantly, considerations of gender have become integral to literary criticism. No longer a separate form of investigation that is marginalized and devalued, feminist literary criticism has become an accepted part of critical analyses of literature by women and men.

GENERAL SOURCES ON WOMEN'S WRITING

Reference Works

Benbow-Pfalzgraf, Taryn, ed. *American Women Writers: A Critical Reference Guide from Colonial Times to the Present*. 2d ed. 4 vols. Detroit, MI: St. James Press, 2000.

Blain, Virginia, Patricia Clements, and Isobel Grundy. *The Feminist Companion to Literature in English: Women Writers from the Middle Ages to the Present*. New Haven, CT: Yale UP, 1990.

Bond, Cynthia D. *The Pen Is Ours: A Listing of Writings by and about African American Women before 1910, with Secondary Bibliography to the Present*. New York: Oxford UP, 1991.

Buck, Claire, ed. *The Bloomsbury Guide to Women's Literature*. London: Bloomsbury, 1992.

Davidson, Cathy N., and Linda Wagner-Martin, eds. *The Oxford Companion to Women's Writing in the United States*. New York: Oxford UP, 1995.

Davis, Cynthia J., and Kathryn West. *Women Writers in the United States: A Timeline of Literary, Cultural, and Social History*. New York: Oxford UP, 1996.

Davis, Gwenn, and Beverley A. Joyce, eds. *Drama by Women to 1900: A Bibliography of American and British Writers*. London: Mansell, 1992.

———. *Personal Writing by Women to 1900: A Bibliography of American and British Writers*. Norman: U of Oklahoma P, 1989.

———. *Poetry by Women to 1900: A Bibliography of American and British Writers*. Toronto: U of Toronto P, 1991.

———. *Short Fiction by Women to 1900: A Bibliography of American and British Writers*. Washington, DC: Mansell, 1998.

James, Joy. *The Black Feminist Reader*. Malden, MA: Blackwell, 2000.

Jordan, Casper LeRoy. *A Bibliographical Guide to African-American Writers*. Westport, CT: Greenwood Press, 1993.

Kemp, Sandra, and Judith Squires. *Feminisms*. New York: Oxford UP, 1998.

Kramarae, Cheris, and Paula Treichler. *A Feminist Dictionary*. Boston: Pandora Press, 1985.

Maniero, Lina. *American Women Writers: A Critical Reference Guide from Colonial Times to the Present*. 5 vols. New York: Ungar, 1979–1994.

Schlueter, Paul, and Jane Schlueter. *An Encyclopedia of British Women Writers*. Rev. ed. New Brunswick, NJ: Rutgers UP, 1998.

Schneir, Miriam, ed. *Feminism: The Essential Historical Writings*. New York: Vintage, 1992.

Shapiro, Ann R. *Jewish American Women Writers: A Bio-bibliographical and Critical Sourcebook*. Westport, CT: Greenwood Press, 1994.

Shattock, Joanne. *The Oxford Guide to British Women Writers*. New York: Oxford UP, 1993.

Todd, Janet. *British Women Writers: A Critical Reference Guide*. New York: Continuum, 1989.

———. *Dictionary of British and American Women Writers, 1660–1800*. New York: Rowman, 1984.

———. *Dictionary of Women Writers*. London: Routledge, 1989.

Trager, James. *The Women's Chronology*. New York: Henry Holt, 1994.

Warhol, Robyn R., and Diane Price Herndl. *Feminisms: An Anthology of Literary Theory and Criticism*. Rev. ed. New Brunswick, NJ: Rutgers UP, 1997.

Women in Literature: A Catalogue of Books by or about Women. London: Maggs Bros. Ltd., 1995.

Anthologies

DeShazer, Mary K., ed. *The Longman Anthology of Women's Literature*. New York: Longman, 2001.

Gilbert, Sandra M., and Susan Gubar, eds. *The Norton Anthology of Literature by Women*. 2nd ed. New York: W.W. Norton.

Smith, Sidonie, and Julia Watson, eds. *Women, Autobiography, Theory: A Reader*. Madison: U of Wisconsin P, 1998.

Stetson, Erlene, ed. *Black Sister: Poetry by Black American Women, 1746–1980*. Bloomington: Indiana UP, 1981.

Todd, Janet, and Dale Spender, eds. *British Women Writers: An Anthology from the Fourteenth Century to the Present*. London: Pandora, 1990.

Internet Sources

The Brown University Women Writers Project, http://www.wwp.brown.edu/wwp_home.html

A Celebration of Women Writers, http://www-cgi.cs.cmu.edu/afs/cs.cmu.edu/user/mmbt/www/women/celebration.html

The Emory Women Writers Project, http://chaucer.library.emory.edu/wwrp/index.html

The Orlando Project: An Integrated History of Women's Writing in the British Isles, http://www.humanities.ualberta.ca/Orlando/

EARLY MODERN TRADITIONS

Primary Sources

Askew, Anne. *The Examinations of Anne Askew*, ed. Elaine V. Beilin. New York: Oxford UP, 1996.

Behn, Aphra. *Oronooko and Other Writings*. Ed. Paul Salzman. New York: Oxford UP, 1994.

Bradstreet, Anne. *The Complete Works*. Ed. Joseph R. McElrath, Jr. and Allan P. Robb. Boston: Twayne Publishers, 1981.

Cavendish, Margaret. *Convent of Pleasure and Other Plays*, ed. Anne Shaver. Baltimore: Johns Hopkins UP, 1999.

Cerasano, S. P., and Marion Wynne-Davies, eds. *Renaissance Drama by Women: Texts and Documents*. London: Routledge, 1996.

Elizabeth I, Queen of England. *The Poems of Queen Elizabeth I*, ed. Leicester Bradner. Providence, RI: Brown UP, 1964.

Fitzmaurice, James, et al., eds. *Major Women Writers of Seventeenth-Century England*. Ann Arbor: U of Michigan P, 1997.

Greer, Germaine, Susan Hastings, Jeslyn Medoff, and Melinda Sansone, eds. *Kissing the Rod: An Anthology of Seventeenth-Century Women's Verse*. New York: Noonday P, 1988.

Haywood, Eliza. *Selections from* The Female Spectator, ed. Patricia Meyer Spacks. New York: Oxford UP, 1999.

Lanyer, Aemilia. *The Poetry of Aemilia Lanyer: Salve Deus Rex Judaeorum*, ed. Susanne Woods. New York: Oxford UP, 1993.

Lock, Anne Vaughan. *The Collected Works of Anne Vaughan Lock*, ed. Susan Felch. Tempe, AZ: Medieval & Renaissance Texts and Studies, 1999.

Pembroke, Mary Sidney Herbert Countess of. *The Collected Works of Mary Sidney Herbert, Countess of Pembroke*. 2 vols, ed. Margaret P. Hannay, Noel J. Kinnamon, and Michael G. Brennan. Oxford: Clarendon P, 1998.

Speght, Rachel. *The Poetry and Polemics of Rachel Speght*, ed. Barbara K. Lewalski. New York: Oxford UP, 1996.

Wroth, Lady Mary. *The Poems of Lady Mary Wroth*, ed. Josephine A. Roberts. Baton Rouge: Lousiana State UP, 1983.

———. *The First Part of the Countess of Montgomery's Urania*, ed. Josephine Roberts. Renaissance English Text Society 140. Binghamton, NY: Medieval & Renaissance Texts & Studies, 1995.

Internet Sources

The Perdita Project (Early Modern Women's Manuscript Collections), http://human.ntu.ac.uk/perdita/PERDITA.HTM

Selected Secondary Sources

Aston, Margaret. *Lollards and Reformers: Images of Literacy in Late Medieval England*. London: Hambledon P, 1984.

Aughterson, Kate, ed. *Renaissance Woman: Constructions of Femininity in England. A Sourcebook*. London: Routledge, 1995.

Beilin, Elaine. *Redeeming Eve: Women Writers of the English Renaissance*. Princeton, NJ: Princeton UP, 1987.

Bridenthal, Renate, Claudia Koonz, and Susan Stuard. *Becoming Visible: Women in European History*. 2d ed. Boston: Houghton Mifflin, 1987.

Brown, Cedric C., ed. *Patronage, Politics, and Literary Traditions in England, 1558–1658*. Detroit: Wayne State UP, 1991.

Clanchy, M. T. *From Memory to Written Record: England 1066–1307*. 2d ed. Oxford: Blackwell, 1993.

Davis, Natalie Zemon, and Arlette Farge, eds. *A History of Women: Renaissance and Enlightenment Paradoxes*. Cambridge, MA: Harvard UP, 1993.

Eisenstein, Elizabeth. *The Printing Press as an Agent for Change*. Cambridge: Cambridge UP, 1979.

Ezell, Margaret J. M. *Writing Women's Literary History*. Baltimore: Johns Hopkins UP, 1993.

Finke, Laurie A. *Women's Writing in English: Medieval England*. London: Longman, 1999.

Fletcher, Anthony. *Gender, Sex and Subordination in England 1500–1800*. New Haven, CT: Yale UP, 1995.

Hannay, Margaret P., ed. *Silent but for the Word: Tudor Women as Patrons, Translators and Writers of Religious Works*. Kent, OH: Kent State UP, 1985.

————. *Philip's Phoenix: Mary Sidney, Countess of Pembroke.* New York: Oxford UP, 1990.

Hobby, Elaine. *Virtue of Necessity: English Women's Writing 1649–88.* Ann Arbor: U of Michigan P, 1989.

Hull, Suzanne W. *Chaste, Silent and Obedient: English Books for Women, 1475–1640.* San Marino, CA: Huntington Library P, 1982.

Klein, Joan Larsen, ed. *Daughters, Wives and Widows: Writings by Men about Women and Marriage in England, 1500–1640.* Urbana: U of Illinois P, 1992.

Kvam, Kristen E., Linda S. Schearing, and Valerie H. Ziegler. *Eve and Adam: Jewish, Christian, and Muslim Readings on Genesis and Gender.* Bloomington: Indiana UP, 1999.

Lewalski, Barbara K. *Writing Women in Jacobean England.* Cambridge, MA: Harvard UP, 1993.

Marrotti, Arthur. *John Donne, Coterie Poet.* Madison: U of Wisconsin P, 1986.

Neale, John E. *Queen Elizabeth I: A Biography.* 1934. Reprint. Garden City, NY: Doubleday. 1967.

Rogers, John. *The Matter of Revolution: Science, Poetry and Politics in the Age of Milton.* Ithaca, NY: Cornell UP, 1996.

Rose, Mary Beth, ed. *Women in the Middle Ages and Renaissance: Literary and Historical Perspectives.* Syracuse, NY: Syracuse UP, 1986.

Scarisbrick, J. J. *Henry VIII.* Berkeley: U of California P, 1968.

Sharpe, J. A. *Early Modern England: A Social History 1550–1750.* 2d ed. London: Arnold, 1997.

Traub, Valerie, M. Lindsey Kaplan, and Dympna Callaghan, eds. *Feminist Readings of Early Modern Culture: Emerging Subjects.* Cambridge: Cambridge UP, 1996.

Trill, Suzanne, Kate Chedgzoy, and Melanie Osborne, eds. *Lay by Your Needles, Ladies, Take the Pen: Women Writing in England 1500–1700.* London: Arnold, 1997.

Wall, Wendy. *The Imprint of Gender: Authorship and Publication in the English Renaissance.* Ithaca, NY: Cornell UP, 1993.

Wilcox, Helen, ed. *Women and Literature in Britain 1500–1700.* Cambridge: Cambridge UP, 1996.

EIGHTEENTH-CENTURY TRIUMPHS

Primary Sources
BIBLIOGRAPHIES

Horwitz, Barbara J., ed. *British Women Writers, 1700–1850: An Annotated Bibliography of Their Works and Works about Them.* Pasadena, CA: Salem Press, 1997.

ANTHOLOGIES

Londsdale, Roger, ed. *Eighteenth Century Women Poets: An Oxford Anthology.* Oxford: Oxford UP, 1989.

Uphaus, Robert W., and Gretchen M. Foster, eds. *The Other Eighteenth Century: English Women of Letters, 1660–1800.* East Lansing, MI: Colleagues, 1991.

Selected Secondary Sources
Bowers, Bege K., and Barbara Brothers, eds. *Reading and Writing Women's Lives: A Study of the Novel of Manners.* Ann Arbor: UMI Research Press, 1990.

Ferguson, Moira. *Eighteenth-Century Women Poets: Nation, Class, and Gender.* Albany: State University of New York P, 1995.

Landry, Donna. *The Muses of Resistance: Laboring-Class Women's Poetry in Britain, 1739–1796*. Cambridge: Cambridge UP, 1990.

Klancher, Jon. *The Making of English Reading Audiences (1790–1832)*. Madison: U of Wisconsin P, 1987.

Myers, Sylvia Haverstock. *The Bluestocking Circle: Women, Friendship, and the Life of the Mind in Eighteenth-Century England*. Oxford: Clarendon P, 1990.

Rogers, Katharine M. *Feminism in Eighteenth-Century England*. Urbana: U of Illinois P, 1982.

Spacks, Patricia Ann Meyer, ed. *Selections from <u>The Female Spectator</u>*. By Eliza Haywood. New York: Oxford UP, 1999.

Spencer, Jane. *The Rise of the Woman Novelist: From Aphra Behn to Jane Austen*. Oxford: Basil Blackwell, 1986.

Turner, Cheryl. *Living by the Pen: Women Writers in the Eighteenth Century*. London: Routledge, 1992.

ROMANTIC REVOLUTIONS

Primary Sources

BIBLIOGRAPHIES

Alston, R. C. *A Checklist of Women Writers 1801–1900: Fiction, Verse, Drama*. London: British Library, 1990.

Boyle, Andrew. *An Index to the Annuals*. Worcester, England: Boyle, 1967.

Faxon, Frederick W. *Literary Annuals and Gift-Books: A Bibliography, 1823–1903*. Middlesex: Private Libraries Association, 1973.

Jackson, J. R. de J. *Romantic Poetry by Women: A Bibliography, 1770–1835*. Oxford: Clarendon P, 1993.

Thompson, Ralph. *American Literary Annuals and Gift-Books, 1825–1865*. New York: H. W. Wilson, 1936.

Wegelin, Oscar. *Early American Poetry, 1650–1799*. New York: P. Smith, 1930.

ANTHOLOGIES

Armstrong, Isobel, and Joseph Bristow, with Cath Sharrock, eds. *Nineteenth-Century Women Poets: An Oxford Anthology*. Oxford: Oxford UP, 1996.

Ashfield, Andrew, ed. *Romantic Women Poets 1770–1838: An Anthology*. Manchester, England: Manchester UP, 1995.

Breen, Jennifer, ed. *Women Romantic Poets, 1785–1832: An Anthology*. London: Everyman, 1992.

Feldman, Paula R., ed. *British Women Poets of the Romantic Era: An Anthology*. Baltimore: The Johns Hopkins UP, 1997.

Fullard, Joyce, ed. *British Women Poets 1660–1800: An Anthology*. Troy, NY: Whitson, 1990.

Jump, Harriet Devine, ed. *Women's Writing of the Romantic Period, 1789–1836: An Anthology*. Edinburgh: Edinburgh UP, 1997.

Lonsdale, Roger, ed. *Eighteenth Century Women Poets: An Oxford Anthology*. New York: Oxford UP, 1989.

Internet Sources

African American Women Writers of the 19th Century (The Schomburg Center, New York Public Library), http://digital.nypl.org/schomburg/writers_aa19/

British Women Romantic Poets: An Electronic Collection from the Shields Library (University of California Davis), http://www.lib.ucdavis.edu/English/BWRP/
Women Romantic-Era Writers, http://orion.it.luc.edu/~acraciu/wrew.htm

Selected Secondary Sources

Colley, Linda. *Britons: Forging the Nation: 1707–1837.* New Haven, CT: Yale UP, 1992.

Curran, Stuart, ed. *The Poems of Charlotte Smith.* New York: Oxford UP, 1993.

Curran, Stuart. *Poetic Form and British Romanticism.* New York: Oxford UP, 1986.

———. "Romantic Poetry: The 'I' Altered." *Romanticism and Feminism.* Ed. Anne K. Mellor. Bloomington: Indiana UP, 1988. 185–207.

———. "Women Readers, Women Writers." *The Cambridge Companion to British Romanticism.* Ed. Stuart Curran. Cambridge: Cambridge UP, 1993. 177–95.

Favret, Mary A. *Romantic Correspondence: Women, Politics, and the Fiction of Letters.* London: Cambridge UP, 1993.

Favret, Mary, and Nicola Watson, eds. *At the Limits of Romanticism: Essays in Cultural, Feminist and Material Criticism.* Bloomington: Indiana UP, 1994.

Feldman, Paula R., and Theresa M. Kelley, eds. *Romantic Women Writers: Voices and Countervoices.* Hanover, NH: UP of New England, 1995. 13–32.

Ferguson, Moira. *Subject to Others: British Women Writers and Colonial Slavery, 1670–1834.* New York: Routledge, 1992.

Kelly, Gary. *Revolutionary Feminism: The Mind and Career of Mary Wollstonecraft.* New York: St. Martin's P, 1996.

Mellor, Anne K., ed. *Romanticism and Feminism.* Ed. Anne K. Mellor. Bloomington: Indiana UP, 1988.

Mellor, Anne K. *Romanticism and Gender.* New York: Routledge, 1993.

Richardson, Alan, and Sonia Hofkosh. *Romanticism, Race, and Imperial Culture, 1780–1834.* Bloomington: Indiana UP, 1995.

Ross, Marlon B. *The Contours of Masculine Desire: Romanticism and the Rise of Women's Poetry.* New York: Oxford UP, 1989.

Schaffer, Julie. "Non-Canonical Women's Novels of the Romantic Era: Romantic Ideologies and the Problematics of Gender and Genre." *Studies in the Novel* 28.4 (1996): 469–92.

Tayler, Irene, and Gina Luria. "Gender and Genre: Women in British Romantic Literature." *What Manner of Woman: Essays on English and American Life and Literature.* Ed. Marlene Springer. New York: New York UP, 1977. 98–123.

Wilson, Carol Shiner, and Joel Haefner, eds. *Re-Visioning Romanticism: British Women Writers, 1776–1837.* Philadelphia: U of Pennsylvania P, 1994.

VICTORIAN CONTRADICTIONS

Primary Sources

BIBLIOGRAPHIES

Knight, Denise D., ed. *Nineteenth-Century American Women Writers: A Bio-bibliographical Source Book.* Westport, CT: Greenwood P, 1997.

ANTHOLOGIES

Armstrong, Isobel, and Joseph Bristow with Cath Sharrock, eds. *Nineteenth-Century Women Poets: An Oxford Anthology.* Oxford: Oxford UP, 1996.

Blain, Virginia. *Victorian Women Poets: A New Annotated Anthology*. Harlow, England: Longman, 2001.

Freibert, Lucy M. and Barbara A. White, eds. *Hidden Hands: An Anthology of American Women Writers, 1790–1870*. New Jersey: Rutgers UP, 1985.

Jump, Harriet Devine. *Women's Writing of the Victorian Period, 1837–1901: An Anthology*. New York: St. Martin's Press, 1999.

Kilcup, Karen L., ed. *Nineteenth-century American Women Writers: An Anthology*. Oxford: Blackwell, 1997.

Leighton, Angela and Margaret Reynolds, eds. *Victorian Women Poets: An Anthology*. Oxford: Blackwell, 1995.

Walker, Cheryl, ed. *American Women Poets of the Nineteenth Century: An Anthology*. New Jersey: Rutgers UP, 1992.

Internet Sources

The Victorian Women Writers Project, http://www.indiana.edu/~letrs/vwwp/

Selected Secondary Sources

Armstrong, Isobel. *Victorian Poetry: Poetry, Poetics, Politics*. New York: Routledge, 1993.

Baym, Nina. *Woman's Fiction: A Guide to Novels by and about Women in America, 1820–70*. 2d ed. Urbana: U of Illinois P, 1993.

Crosby, Christina. *The Ends of History: Victorians and "The Woman Question."* New York: Routledge, 1991.

Douglas, Ann. *The Feminization of American Culture*. 1977. Reprint edition. New York: Anchor Press, 1988.

Hughes, Linda K., and Michael Lund. *The Victorian Serial*. Charlottesville: UP of Virginia, 1991.

Hughes, Winifred. *The Maniac in the Cellar: Sensation Novels of the 1860s*. Princeton, NJ: Princeton UP, 1980.

Ingham, Patricia. *The Language of Gender and Class: Transformation in the Victorian Novel*. London: Routledge, 1996.

Kranidis, Rita S. *Subversive Discourse: The Cultural Production of Late Victorian Feminist Novels*. New York: St. Martin's P, 1995.

Lootens, Tricia. *Lost Saints: Silence, Gender, and Victorian Literary Canonization*. Charlottesville: UP of Virginia, 1996.

McGann, Jerome J., ed. *Victorian Connections*. Charlottesville: UP of Virginia, 1989.

Morgan, Thais E., ed. *Victorian Sages and Cultural Discourse: Renegotiating Gender and Power*. New Brunswick, NJ: Rutgers UP, 1990.

Parker, Christopher, ed. *Gender Roles and Sexuality in Victorian Literature*. Hants, England: Scholar P, 1995.

Poovey, Mary. *Uneven Developments: The Ideological Work of Gender in Mid-Victorian England*. Chicago: U of Chicago P, 1988.

Pykett, Lyn. *The Improper Feminine: The Woman's Sensation Novel to the New Woman Writing*. New York: Routledge, 1992.

———. *The Sensation Novel from* The Woman in White *to* The Moonstone. Plymouth, England: Northcote House, 1994.

Shires, Linda M., ed. *Rewriting the Victorians: Theory, History and the Politics of Gender*. New York: Routledge, 1992.

Tompkins, Jane P. *Sensational Designs: The Cultural Works of American Fiction, 1790–1860.* New York: Oxford UP, 1986.

Tuchman, Gaye, with Nina E. Fortin. *Edging Women Out: Victorian Novelists, Publishers, and Social Change.* New Haven, CT: Yale UP, 1989.

MODERN EXPERIMENTS

Primary Sources

BIBLIOGRAPHIES

Champion, Laurie, ed. *American Women Writers, 1900–1945: A Bio-bibliographical Critical Sourcebook.* Westport, CT: Greenwood P, 2000.

Curley, Dorothy Nyren, and Ruth Z. Temple. *Index Guide to Modern American and Modern British Literature.* New York: Ungar, 1988.

Ouditt, Sharon. *Women Writers of the First World War: An Annotated Bibliography.* London: Routledge, 2000.

ANTHOLOGIES

Dowson, Jane. *Women's Poetry of the 1930s: A Critical Anthology.* London: Routledge, 1996.

Ellmann, Richard, and Robert O'Clair, eds. *The Norton Anthology of Modern Poetry.* 2d ed. New York: W.W. Norton, 1988.

Reilly, Catherine, ed. *Scars upon My Heart: Women's Poetry and Verse of the First World War.* London: Virago P, 1981.

Rose, Phyllis, ed. *Writing of Women: Essays in a Renaissance.* Middletown, CT: Wesleyan UP, 1985.

Scott, Bonnie Kime, ed. *The Gender of Modernism: A Critical Anthology.* Bloomington: Indiana UP, 1990.

Selected Secondary Sources

Benstock, Shari. *Women of the Left Bank: 1900–1940.* Austin: U of Texas P, 1986.

Clark, Suzanne. *Sentimental Modernism: Women Writers and the Revolution of the Word.* Bloomington: Indiana UP, 1991.

Gilbert, Sandra M., and Susan Gubar. *No Man's Land: The Place of the Woman Writer in the Twentieth Century.* 3 vols. New Haven, CT: Yale UP, 1988–1994.

Hutchinson, George. *The Harlem Renaissance in Black and White.* Cambridge, MA: Harvard UP, 1995.

Huyssen, Andreas. *After the Great Divide: Modernism, Mass Culture, Postmodernism.* Bloomington: Indiana UP, 1986.

Nelson, Carolyn Christensen. *British Fiction Writers of the 1890s.* New York: Twayne, 1996.

North, Michael. *The Dialect of Modernism: Race, Language, and Twentieth-Century Literature.* New York: Oxford UP, 1994.

Rado, Lisa, ed. *Rereading Modernism: New Directions for Feminist Criticism.* New York: Garland, 1994.

Raitt, Suzanne, and Trudi Tate. *Women's Fiction and the Great War.* New York: Oxford UP, 1997.

Scott, Bonnie Kime. *Refiguring Modernism: The Women of 1928.* 2 vols. Bloomington: Indiana UP, 1995.

Sulieman, Susan, ed. *The Female Body in Western Culture: Contemporary Perspectives.* Cambridge, MA: Harvard UP, 1986.

Wall, Cheryl A. *Women of the Harlem Renaissance*. Bloomington: Indiana UP, 1995.

Ware, Susan. *Beyond Suffrage: Women of the New Deal*. Cambridge, MA: Harvard UP, 1981.

LATE TWENTIETH-CENTURY DIRECTIONS

Primary Sources

BIBLIOGRAPHIES

Addis, Patricia K. *Through a Woman's Eye: An Annotated Bibliography of American Women's Autobiographical Writings, 1946–1976*. Metuchen, NJ: Scarecrow P, 1983.

Glikin, Ronda. *Black American Women in Literature: A Bibliography, 1976 through 1987*. Jefferson, NC: McFarland & Co., 1989.

Pollack, Sandra, and Denise D. Knight. *Contemporary Lesbian Writers of the United States: A Bio-bibliographical Critical Sourcebook*. Westport, CT: Greenwood P, 1993.

Selected Secondary Sources

Cook, Blanche Wiesen. *Eleanor Roosevelt*. Vol. 2. New York: Viking, 1999.

Evans, Mari. *Black Women Writers*. London: Pluto, 1985.

Henke, Suzette A. *Shattered Subjects: Trauma and Testimony in Women's Life-Writing*. New York: St. Martin's P, 2000.

Lear, Linda. *Rachel Carson: Witness for Nature*. New York: Henry Holt, 1997.

Lionnet, Françoise. *Autobiographical Voices: Race, Gender, Self-Portraiture*. Ithaca, NY: Cornell UP, 1989.

Perreault, Jeanne. *Writing Selves: Contemporary Feminist Autobiography*. Minneapolis: Minnesota UP, 1995.

Rainer, Tristine. *Your Life as Story: Writing the New Autobiography*. New York: G. P. Putnam, 1997.

Feminist Criticism and Theory

Atkinson, Ti-Grace. *Amazon Odyssey*. New York: Links, 1974.

Barrett, Michèle. "Introduction." *Virginia Woolf: Women and Writing*. Ed. Michèle Barrett. New York: Harcourt Brace Jovanovich, 1979. 1–39.

Benstock, Shari. "Authorizing the Autobiographical." *The Private Self: Theory and Practice of Women's Autobiographical Writings*. Ed. Shari Benstock. Chapel Hill: U of North Carolina P, 1988. 10–13.

Brodzki, Bella, and Celeste Schenck, eds. *Life/Lines: Theorizing Women's Autobiography*. Ithaca: NY London: Cornell UP, 1988.

Bunch, Charlotte. "Lesbians in Revolt." *Women and Values*. Ed. Marilyn Pearsall. Belmont, CA: Wadsworth, 1986. 129–131.

Butler, Judith. "Contingent Foundations: Feminism and the Question of 'Postmodernism.' " *The Postmodern Turn: New Perspectives on Social Theory*. Ed. Steven Seidman. Cambridge: Cambridge UP, 1994. 153–70.

Cixous, Helene. "The Laugh of the Medusa." *New French Feminisms*. Ed. Elaine Marks and Isabelle de Courtivron. New York: Schoken Books, 1981. 245–64.

———. "Sorties." *New French Feminisms*. Ed. Elaine Marks and Isabelle de Courtivron. New York: Schocken Books, 1981. 90–8. 179–87.

de Pisan, Christine. "Response to the Treatise on *The Romance of the Rose* by John of Montrevil." *Literary Criticism and Theory: The Greeks to the Present*. Ed. Robert Con Davis and Laurie Fink. New York: Longman, 1989.

Ellmann, Mary. *Thinking about Women*. New York: Harcourt, 1968.

Faderman, Lillian. *Surpassing the Love of Men: Romantic Friendship and Love between Women from the Renaissance to the Present.* New York: William Morrow, 1981.

Fetterley, Judith. "Introduction: On the Politics of Literature." 1978. *Feminisms: An Anthology of Literary Theory and Criticism.* Ed. Robyn R. Warhol and Diane Price Herndl. Rev. ed. New Brunswick, NJ: Rutgers UP, 1997. 564–73.

Firestone, Shulamith. *The Dialectic of Sex: The Case for Feminist Revolution.* New York: Morrow, 1970.

Flax, Jane. "Postmodernism and Gender Relations in Feminist Theory." *Feminism/ Postmodernism.* Ed. Linda J. Nicholson. New York: Routledge, 1990. 39–62. [Originally published in *Signs* 12.4 (Summer 1987), pp. 621–43.]

Folger Collective on Early Women Critics, ed. *Women Critics 1660–1820: An Anthology.* Bloomington: Indiana UP, 1995.

Foster, Jeanette. *Sex Variant Women in Literature: A Historical and Quantitative Survey.* New York: Vantage P, 1956.

Foucault, Michel. *The Birth Of The Clinic: An Archaeology Of Medical Perception.* Trans. A.M. Sheridan Smith. New York: Vintage Books, 1975.

———. *Discipline and Punish: The Birth of the Prison.* Trans. Alan Sheridan. New York: Pantheon Books, 1977.

———. *The History of Sexuality, Volume 1: An Introduction.* Trans. Robert Hurley. New York: Vintage Books, 1978.

———. *Madness and Civilizatiaon: A History of Insanity in the Age of Reason.* Trans. Richard Howard. New York: Vintage Books, 1965.

———. *Power/Knowledge: Selected Interviews and Other Writings, 1972–1977.* Ed. and trans. Colin Gordon. New York: Pantheon Books, 1980.

Fraser, Nancy, and Linda J. Nicholson. "Social Criticism with Philosophy: An Encounter between Feminism and Postmodernism." *Feminism/Postmodernism.* Ed. Linda J. Nicholson. New York: Routledge, 1990. 19–38. [Originally appeared in *Communication* 10.3–4 (1998), pp. 345–66]

Gilbert, Sandra M., and Susan Gubar. *The Madwoman in the Attic: The Woman Writer and the Nineteenth-Century Literary Imagination.* New Haven, CT: Yale UP, 1979.

———. *No Man's Land: The Place of the Woman Writer in the Twentieth Century.* 3 vols. New Haven, CT: Yale UP, 1988–94.

Greer, Germaine. *The Female Eunuch.* London: MacGibbon & Kee, 1970.

Gubar, Susan. " 'The Blank Page' and the Issues of Female Creativity." In Showalter, *New Feminist Criticism*, 292–313. [Originally appeared in *Critical Inquiry* 8 (Winter 1981).]

Haraway, Donna. "A Manifesto for Cyborgs: Science, Technology, and Socialist Feminism in the 1980s." *Feminism/Postmodernism.* Ed. Linda J. Nicholson. New York: Routledge, 1990. 190–233. [Originally appeared in *Socialist Review* 80 (1985).]

Heath, Stephen. *The Sexual Fix.* New York: Schocken Books, 1984.

Hull, Gloria T., Patricia Bell Scott, and Barbara Smith, eds. *All the Women are White, All the Blacks are Men, But Some of Us Are Brave: Black Women's Studies.* Old Westbury, NY: The Feminist P, 1982.

Hutcheon, Linda. *A Poetics of Postmodernism: History, Theory, Fiction.* London: Routledge, 1988.

Irigaray, Luce. *Speculum of the Other Woman.* Trans. Gillian C. Gill. Ithaca, NY: Cornell UP, 1985.

———. "This Sex Which is Not One." *New French Feminisms.* Ed. Elaine Marks and Isabelle de Courtivron. New York: Schocken Books, 1981. 99–106.

Jameson, Fredric. *Postmodernism, or, the Cultural Logic of Late Capitalism.* Durham: Duke UP, 1991.

Jardine, Alice A. *Gynesis: Configurations of Women and Modernity*. Ithaca: Cornell UP, 1985.

Johnson, Barbara. "Apostrophe, Animation, and Abortion." *Diacritics* 16 (Spring 1986): 29–39.

Kolodny, Annette. "Dancing through the Minefield: Some Observations on the Theory, Practice, and Politics of Feminist Literary Criticism." In Showalter, *The New Feminist Criticism*, 144–67. [Originally appeared in *Feminist Studies* 6 (1980).]

Kristeva, Julia. "Psychoanalysis and the Polis." *The Kristeva Reader*. Ed. Toril Moi. New York: Columbia UP, 1986. 302–20.

———. *Revolution in Poetic Language*. Trans. Leon S. Roudiez. New York: Columbia UP, 1984.

———. "Stabat Mater." *Tales of Love*. Trans. Leon S. Roudiez. New York: Columbia UP, 1987. 234–63.

———. "Women's Time." *The Kristeva Reader*. Ed. Toril Moi. New York: Columbia UP, 1986. 187–213. [Originally appeared in *Signs* 7 (1981): 13–55.]

Lyotard, Jean-François. *The Postmodern Condition*. Minneapolis: U of Minnesota P, 1984.

McDowell, Deborah E. "New Directions for Black Feminist Criticism." In Showalter, *The New Feminist Criticism*, 186–99. [Originally appeared in *Black American Literature Forum* 14 (1980).]

Miller, Nancy K., ed. *The Poetics of Gender*. New York: Columbia UP, 1986.

Millett, Kate. *Sexual Politics*. London: Virago, 1977.

Mitchell, Juliet. *Psychoanalysis and Feminism*. New York: Pantheon Books, 1974.

Moers, Ellen. *Literary Women: The Great Writers*. New York: Doubleday, 1976.

Moi, Toril. *Sexual/Textual Politics: Feminist Literary Theory*. London: Methuen, 1985.

Moraga, Cherríe, and Gloria Anzaldúa. *This Bridge Called My Back*. Watertown, MA: Persephone P, 1981.

Rich, Adrienne. "Compulsory Heterosexuality and Lesbian Existence." *Blood, Bread, and Poetry: Selected Prose, 1979–1985*. New York: Norton, 1986. 23–75.

Rose, Jacqueline. *Sexuality in the Field of Vision*. London: Verso, 1986.

Rule, Jane. *Lesbian Images*. Garden City, NY: Doubleday, 1975.

Showalter, Elaine. *A Literature of Their Own*. Princeton, NJ: Princeton UP, 1977.

———, ed. *The New Feminist Criticism: Essays on Women, Literature, and Theory*. New York: Pantheon, 1985.

———. "Toward a Feminist Poetics." In Showalter, *The New Feminist Criticism*, 125–43.

Smith, Barbara. "Toward a Black Feminist Criticism." In Showalter, *The New Feminist Criticism*, 168–85. [Originally appeared in *Conditions: Two* 1.2 (October 1977).]

Smith, Sidonie. "Maxine Hong Kingston's *Woman Warrior*: Filiality and Women's Autobiographical Storytelling." *A Poetics of Women's Autobiography: Marginality and the Fictions of Self-Representation*. Ed. Sidonie Smith. Bloomington: Indiana UP, 1987. 150–73.

Spacks, Patricia Meyer. *The Female Imagination: A Literary and Psychological Investigation of Women's Writing*. London: George Allen & Unwin Ltd., 1976.

Todd, Janet. *Feminist Literary History: A Defence*. Cambridge: Polity P, 1988.

West, Cornel. "The New Cultural Politics of Difference." *The Postmodern Turn: New Perspectives on Social Theory*. Ed. Steven Seidman. Cambridge: Cambridge UP, 1994. 65–81. [Originally appeared in *October* 53 (1990).]

Zimmerman, Bonnie. "What Has Never Been: An Overview of Lesbian Feminist Criticism." In Showalter, *The New Feminist Criticism*, 200–24 [Originally appeared in *Feminist Studies* 7.3 (1981).]

CRITICAL INTERSECTIONS

Sexualities

Abelove, Henry, Michèle Aina Barale, and David M. Halperin, eds. *The Lesbian and Gay Studies Reader*. New York: Routledge, 1993.

Atkinson, Ti-Grace. *Amazon Odyssey*. New York: Links, 1974.

Balka, Christine, and Andy Rose, eds. *Twice Blessed: On Being Lesbian, Gay and Jewish*. Boston: Beacon P, 1989.

Birken, Lawrence. *Consuming Desire: Sexual Science and the Emergence of a Culture of Abundance, 1871–1914*. Ithaca, NY: Cornell UP, 1988.

Bray, Alan. *Homosexuality in Renaissance England*. 1982. New York: Columbia UP, 1995.

Bristow, Joseph. *Sexuality*. New York: Routledge, 1997.

Butler, Judith. *Bodies That Matter: On the Discursive Limits of "Sex."* New York: Routledge, 1993.

———. *Gender Trouble: Feminism and the Subversion of Identity*. New York: Routledge, 1990.

Castle, Terry. *The Apparitional Lesbian: Female Sexuality and Modern Culture*. New York: Columbia UP, 1993.

de Lauretis, Teresa. *Technologies of Gender: Essays on Theory, Film and Fiction*. Bloomington: Indiana UP, 1987.

———. "Queer Theory: Lesbian and Gay Sexualities." *differences: A Journal of Feminist Cultural Studies* 3 (1991): ii–xviii.

———. "Habit Changes." *differences: A Journal of Feminist Cultural Studies* 6 (1994): 296–313.

D'Emilio, John. "Capitalism and Gay Identity." 1983. *Making Trouble: Essays on Gay History, Politics and the University*. New York: Routledge, 1992.

Dworkin, Andrea. *Pornography: Men Possessing Women*. London: Women's P, 1981.

Epstein, Steven. "Gay Politics, Ethnic Identity: The Limits of Social Constructionism." *Socialist Review* 17 (May/August): 9–54.

Firestone, Shulamith. *The Dialectic of Sex: The Case for Feminist Revolution*. New York: Morrow, 1970.

Foucault, Michel. *The History of Sexuality, Volume 1: An Introduction*. Trans. Robert Hurley. New York: Vintage Books, 1978.

Frye, Marilyn. *The Politics of Reality: Essays in Feminist Theory*. New York: The Crossing P, 1983.

Fuss, Diana. *Essentially Speaking: Feminism, Nature and Difference*. New York: Routledge, 1989.

———, ed. *Inside/Out: Lesbian Theories, Gay Theories*. New York: Routledge, 1991.

Garber, Marjorie. *Vested Interests: Cross-Dressing and Cultural Anxiety*. New York: HarperPerennial, 1993.

Halperin, David. *Saint Foucault: Towards a Gay Hagiography*. New York: Oxford UP, 1995.

Irigaray, Luce. "When the Goods Get Together." *New French Feminisms: An Anthology*. Ed. Elaine Marks and Isabelle de Courtivron. New York: Schocken Books, 1981. 107–110.

Jagose, Annamarie. *Lesbian Utopics*. New York: Routledge, 1994.

———. *Queer Theory: An Introduction*. New York: New York UP, 1996.

Jeffreys, Sheila. "The Queer Disappearance of Lesbians: Sexuality in the Academy." *Women's Studies International Forum* 17 (1994): 459–72.

Kaplan, Louise. *Female Perversions: The Temptations of Madame Bovary*. London: Pandora, 1991.

Laquer, Thomas. *Making Sex: Body and Gender from the Greeks to Freud.* Cambridge, MA: Harvard UP, 1990.

MacKinnon, Catherine. *Towards a Feminist Theory of the State.* Cambridge, MA: Harvard UP, 1989.

McDowell, Deborah E. " 'It's Not Safe. Not Safe at All': Sexuality in Nella Larsen's *Passing.*" *The Lesbian and Gay Studies Reader.* Ed. Henry Abelove, Michèle Aina Barale, and David M. Halperin. New York: Routledge, 1993. 616–25. [Originally published in *Nella Larson,* Quicksand *and* Passing, ed. Deborah E. McDowell (New Brunswick, NJ: Rutgers UP, 1986)]

Meese, Elizabeth. "When Virginia Looked at Vita, What Did She See; or, Lesbian: Feminist: Woman—What's the Differ(e/a)nce?" *Feminist Studies* 18 (Spring 1992): 99–117.

Moraga, Cherríe, and Gloria Anzaldúa, eds. *This Bridge Called My Back.* Watertown, MA: Persephone P, 1981.

Morgan, Robin. "Theory and Practice: Pornography and Rape." *Take Back the Night: Women on Pornography.* Ed. Laura Lederer. New York: William Morrow, 1980. 134–40.

Radicalesbians. "The Woman Identified Woman." *Radical Feminism.* Eds. Anne Koedt, Ellen Levine, and Anita Rapone. New York: Quadrangle Books, 1973. 240–45.

Rich, Adrienne. "Compulsory Heterosexuality and Lesbian Existence." *Blood, Bread, and Poetry: Selected Prose, 1979–1985.* New York: Norton, 1986. 23–75.

Rivière, Joan. "Womanliness as Masquerade." (1929) *Formations of Fantasy.* Ed. Victor Burgin, James Donald and Cora Kaplan. London: Methuen, 1986. 33–44.

Rubin, Gayle. "Thinking Sex: Notes for a Radical Theory of the Politics of Sexuality." *Pleasure and Danger: Exploring Female Sexuality.* Ed. Carol S. Vance. Boston: Routledge and Kegan Paul, 1984. 267–319.

———. "The Traffic in Women: Notes on the 'Political Economy' of Sex." *Toward an Anthropology of Women.* Ed. Rayna R. Reiter. New York: Monthly Review P, 1975. 157–210.

Sedgwick, Eve Kosofsky. *Between Men: English Literature and Male Homosocial Desire.* New York: Columbia UP, 1985.

———. *Tendencies.* Durham: Duke UP, 1993.

Smith, Barbara. *Toward a Black Feminist Criticism.* Trumansburg, NY: The Crossing P, 1980.

Vance, Carol S., ed. *Pleasure and Danger: Exploring Female Sexuality.* Boston: Routledge and Kegan Paul, 1984.

Weeks, Jeffrey. *Sexuality.* London: Tavistock, 1986.

Williams, Linda. *Hard Core: Power, Pleasure, and the "Frenzy of the Visible."* Berkeley: U of California P, 1989.

———. "Pornographies On/Scene, or Diff'rent Strokes for Diff'rent Folks." *Sex Exposed: Sexuality and the Pornography Debate.* Ed. Lynne Segal and Mary McIntosh. London: Virago P, 1992.

Winkler, John J. "Double Consciousness in Sappho's Lyrics." *The Lesbian and Gay Studies Reader.* Ed. Henry Abelove, Michèle Aina Barale, and David M. Halperin. New York: Routledge, 1993. 577–94. [Excerpted from *The Constraints of Desire: The Anthropology of Sex and Gender in Ancient Greece* (New York: Routledge, 1990).]

Wittig, Monique. "Paradigm." *Homosexualities and French Literature: Cultural Contexts/Critical Texts.* Ed. George Stambolian and Elaine Marks. Ithaca, NY: Cornell UP, 1979. 114–21.

———. "The Straight Mind." *Feminist Issues* (1980): 103–11.

Subjectivities

Anzaldúa, Gloria. "La Conciencia de la Mestiza: Towards a New Consciousness." *Borderlands/: Frontera: The New Mestiza*. San Francisco: Aunt Lute Books, 1987.

Bakshi, Parminder Kaur. "Homosexuality and Orientalism: Edward Carpenter's Journey to the East." *Edward Carpenter and Late Victorian Radicalism*. Ed. Tony Brown. London: Frank Cass, 1990. 151–77.

Bhabha, Homi K. *The Location of Culture*. London: Routledge, 1994.

———. "Postcolonial Criticism." *Redrawing the Boundaries: The Transformation of English and American Literary Studies*. Ed. Stephen Greenblatt and Giles Gunn. New York: Modern Language Association, 1992. 437–65.

Boehmer, Elleke. *Colonial and Postcolonial Literature*. Oxford: Oxford UP, 1995.

Brenkman, John. "Multiculturalism and Criticism." *English Inside and Out: The Places of Literary Criticism*. Ed. Susan Gubar and Jonathan Kamholtz. New York: Routledge, 1993. 87–101.

Christian, Barbara. "The Race for Theory." *Feminist Studies* 14.1 (1988): 67–79.

Chow, Rey. *Writing Diaspora: Tactics of Intervention in Contemporary Cultural Studies*. Bloomington: Indiana UP, 1993.

Combahee River Collective. "A Black Feminist Statement." *All the Women Are White, All the Blacks Are Men, But Some of Us Are Brave: Black Women's Studies*. Ed. Gloria T. Hull, Patricia Bell Scott, and Barbara Smith. Old Westbury, NY: The Feminist P, 1982. 13–22.

Flax, Jane. "Postmodernism and Gender Relations in Feminist Theory." *Feminism/Postmodernism*. Ed. Linda J. Nicholson. New York: Routledge, 1990. 39–62. [Originally published in *Signs* 12.4 (Summer 1987), pp. 621–643.]

Fox, Richard. "East of Said." *Edward Said: A Critical Reader*. Ed. Michael Sprinker. Oxford: Blackwell, 1992. 144–56.

Fuss, Diana. *Essentially Speaking: Feminism, Nature & Difference*. London: Routledge, 1989.

Gandhi, Leela. *Postcolonial Theory: A Critical Introduction*. New South Wales, Australia: Allen & Unwin, 1998.

Gates, Henry Louis, Jr. "African American Criticism." *Redrawing the Boundaries: The Transformation of English and American Literary Studies*. Ed. Stephen Greenblatt and Giles Gunn. New York: Modern Language Association of America, 1992. 303–19.

Hall, Stuart. "New Ethnicities." *Black Film/British Cinema*. ICA Document 7. London: Institute of Contemporary Arts, 1988.

hooks, bell. *Talking Back: Thinking Feminist, Thinking Black*. Boston, MA: South End Press, 1989.

Kaplan, Alice. *French Lessons: A Memoir*. Chicago: Chicago UP, 1993.

Lim, Shirley Geok-lin. "Feminist and Ethnic Theories in Asian American Literature." *Feminist Studies* 19 (Fall 1993): 571–95.

Ling, Amy. "I'm Here: An American Woman's Response." *New Literary History* 19 (Autumn 1987): 151–60.

Lorde, Audre. *Sister Outsider*. Trumansburg, NY: Crossing P, 1984.

Mama, Amina. "Black Women, the Economic Crisis and the British State." *Modern Feminisms: Political, Literary, Cultural*. Ed. Maggie Humm. New York: Columbia UP, 1992. 151–55.

McDowell, Deborah E. "New Directions for Black Feminist Criticism." *The New Feminist Criticism: Essays on Women, Literature, and Theory*. Ed. Elaine Showalter. New York: Pantheon, 1985. 186–99. [Originally appeared in *Black American Literature Forum* 14 (1980).]

Minh-ha, Trinh T. *Woman, Native, Other*. Bloomington: Indiana UP, 1989.

Morrison, Toni. *Playing In The Dark: Whiteness And The Literary Imagination*. Cambridge, MA: Harvard University Press, 1992.

Porter, Dennis. "Orientalism and Its Problems." *The Politics of Theory*. Ed. Peter Hulme Francis Barker and Margaret Iversen. Colchester, England: U of Essex P, 1983. 179–93.

Said, Edward. *Covering Islam: How the Media and the Experts Determine How We See the Rest of the World*. London: Routledge & Kegan Paul, 1981.

———. *Culture and Imperialism*. New York: Knopf, 1993.

———. *Orientalism*. New York: Pantheon, 1978.

———. *The Question of Palestine*. New York: Time Books, 1979.

Smith, Barbara. *Toward a Black Feminist Criticism*. Trumansburg, NY: The Crossing P, 1980.

———. *The Truth that Never Hurts: Writings on Race, Gender, and Freedom*. New Brunswick, NJ: Rutgers UP, 1998.

Sollors, Werner. "Ethnicity." *Critical Terms for Literary Study*. Eds. Frank Lentricchia and Thomas McLaughlin. Chicago and London: U of Chicago P, 1990. 288–305.

Spivak, Gayatri Chakravorty. "Can the Subaltern Speak?" (1988). *Marxist Interpretations of Culture*. Ed. Cary Nelson and Lawrence Grossberg. London: Macmillan, 1988. 271–313.

———. *In Other Worlds: Essays in Cultural Politics*. New York: Methuen, 1987.

———. *Outside the Teaching Machine*. New York: Routledge, 1993.

———. "Three Women's Texts and a Critique of Imperialism." *Feminisms: An Anthology of Literary Theory and Criticism*. Ed. Robyn R. Warhol and Diane Price Herndl. Rev. ed. New Brunswick, NJ: Rutgers UP, 1997. 896–912. [Originally published in *Critical Inquiry* 12 (1985): 242–61.]

Suleri, Sara. "Woman Skin Deep: Feminism and the Postcolonial Condition." *The Post-Colonial Studies Reader*. Ed. Bill Ashcroft, Gareth Griffiths, and Helen Tiffin. New York: Routledge, 1995. 273–80.

Talpade Mohanty, Chandra. "Under Western Eyes: Feminist Scholarship and Colonial Discourse." (1984). *Colonial Discourse and Postcolonial Theory: A Reader*. Ed. Laura Chrisman and Patrick Williams. New York: Columbia UP, 1994. 196–220.

Tompkins, Jane. "Me and My Shadow." *Gender and Theory: Dialogues on Feminist Criticism*. Ed. Linda Kaufmann. London: Basil Blackwell, 1989. 121–39.

Viswanathan, Gauri. *Masks of Conquest: Literary Studies and British Rule in India*. London: Faber & Faber, 1989.

Ideology and Culture

Althusser, Louis. "Ideology and State Appartuses." *Lenin and Philosophy and Other Essays*. Trans. Ben Brewster. New York: Monthly Review P, 1971.

Armstrong, Nancy. *Desire and Domestic Fiction: A Political History of the Novel*. New York: Oxford UP, 1987.

Barrett, Michèle. "Ideology and the Cultural Production of Gender." *Feminist Criticism and Social Change: Sex, Class and Race in Literature and Culture*. Ed. Judith Newton and Deborah Rosenfelt New York: Methuen, 1985. 65–85.

———. *Women's Oppression Today: Problems in Marxist Feminist Analysis*. New York: Verso, 1980.

Barthes, Roland. *The Fashion System*. Trans. Matthew Ward and Richard Howard. New York: Hill and Wang, 1983.

Bebel, August. *Woman and Socialism*. 1885. *Feminism: The Essential Historical Writings*. Ed. Miriam Schneir. New York: Vintage, 1994. 205–211.

Belsey, Catherine. "Constructing the Subject, Deconstructing the Text." *Feminist Criticism and Social Change: Sex, Class and Race in Literature and Culture.* Ed. Judith Newton and Deborah Rosenfelt. New York: Methuen, 1985. 45–64.

Bordo, Susan. *Unbearable Weight: Feminism, Western Culture, and the Body.* Berkeley: U of California P, 1993.

Davis, Fred. *Fashion, Culture, and Identity.* Chicago: U of Chicago P, 1992.

de Lauretis, Teresa. *Alice Doesn't: Feminism, Semiotics, Cinema.* Bloomington: Indiana UP, 1984.

———. *Technologies of Gender: Essays on Theory, Film and Fiction.* Bloomington: Indiana UP, 1987.

Doane, Mary Ann. *The Desire to Desire.* Bloomington: Indiana UP, 1987.

Engels, Friedrich. *The Origin of the Family, Private Property, and the State.* 1884. *Feminism: The Essential Historical Writings.* Ed. Miriam Schneir. New York: Vintage, 1994. 189–204.

Felski, Rita. "Judith Krantz, Author of 'The Cultural Logics of Late Capitalism.' " *Women: A Cultural Review* 8 (1997): 129–42.

Foucault, Michel. *Discipline and Punish: The Birth of the Prison.* Trans. Alan Sheridan. New York: Vintage Books, 1979.

Fraser, Nancy. "What's Critical about Critical Theory?: The Case of Habermas and Gender." *Feminism as Critique: Essays on the Politics of Gender in Late-Capitalist Societies.* Ed. Seyla Benhabib and Drucilla Cornell. Oxford: Polity P, 1987. 31–56.

Gamman, Lorraine, and M. Marshment, eds. *The Female Gaze: Women as Viewers of Popular Culture.* London: Women's P, 1988.

Garber, Marjorie. *Vested Interests: Cross-Dressing and Cultural Anxiety.* New York: Routledge, 1992.

Gilman, Charlotte Perkins. *Women and Economics.* 1898. 3d ed. Boston: Small, Maynard & Company, 1900.

Goldman, Emma. "The Traffic in Women." 1910. *Feminism: The Essential Historical Writings.* Ed. Miriam Schneir. New York: Vintage, 1994. 308–24.

Greene, Gayle and Coppèlia Kahn. "Feminist Scholarship and the Social Construction of Woman." *Making a Difference: Feminist Literary Criticism.* Ed. Gayle Greene and Coppélia Kahn London and New York: Routledge, 1985. 1–36.

Hartmann, Heidi. "The Unhappy Marriage of Marxism and Feminism: Towards a More Progressive Union." *The Unhappy Marriage of Marxism and Feminism: A Debate on Class and Patriarchy.* Ed. Lydia Sargent. London: Pluto Press, 1981. 1–42.

Hebdige, Dick. *Subculture: The Meaning of Style.* London: Methune, 1979.

Hovey, Jaime. "In Rebecca's Shoes: Lesbian Fetishism in Daphne DuMaurier's *Rebecca.*" *Footnotes: On Shoes.* Ed. Shari Benstock and Suzanne Ferriss. New Brunswick, NJ: Rutgers UP, 2001. 156–76.

Kanneh, Kadiatu. "Love, Mourning and Metaphor: Terms of Identity." *New Feminist Discourses: Critical Essays in Theories and Texts.* Ed. Isobel Armstrong. London: Routledge, 1992. 139–52.

Kaplan, Cora. "Pandora's Box: Subjectivity, Class and Sexuality in Socialist Feminist Criticism." *Making a Difference: Feminist Literary Criticism.* Ed. Gayle Greene and Coppelia Kahn. London: Routledge, 1985. 146–76.

Kaplan, E. Ann. *Women and Film: Both Sides of the Camera.* London: Routledge, 1983.

Kellner, Douglas. "Madonna, Fashion, and Identity." *On Fashion.* Ed. Shari Benstock and Suzanne Ferriss. New Brunswick, NJ: Rutgers UP, 1994. 159–82.

Kuhn, Annette. "The Body and Cinema: Some Problems for Feminism." *Feminisms.* Ed. Sandra Kemp and Judith Squires. New York: Oxford University Press, 1998. 403–409.

———. *The Power of the Image: Essays on Representation and Sexuality.* London: Routledge and Kegan Paul, 1985.

———. *Women's Pictures: Feminism and Cinema.* London: Routledge and Kegan Paul, 1982.

Lovell, Terry. *Consuming Fiction.* London: Verso, 1987.

Macherey, Pierre. *A Theory of Literary Production.* Trans. Geoffrey Wall. London: Routledge & Kegan Paul, 1978.

Marxist-Feminist Literature Collective. "Women's Writing: *Jane Eyre, Shirley, Villette, Aurora Leigh.*" *Feminist Literary Theory: A Reader.* Ed. Mary Eagleton. London: Basil Blackwell, 1986. 194–97.

Mitchell, Juliet. *Psychoanalysis and Feminism.* New York: Pantheon Books, 1974.

———. *Woman's Estate.* Baltimore: Penguin, 1971.

Modleski, Tania. *Loving with a Vengeance: Mass-Produced Fantasies for Women.* Hamden: Archon, 1982.

Morrison, Toni. *Playing in the Dark.* Cambridge, MA: Harvard UP, 1992.

Mulvey, Laura. "Visual Pleasure and Narrative Cinema." *Feminism and Film Theory.* Ed. Constance Penley. New York: Routledge, 1988. 57–68. [Originally appeared in *Screen* 16 (Autumn 1975): 6–18.]

Newton, Judith and Deborah Rosenfelt, eds. *Feminist Criticism and Social Change: Sex, Class and Race in Literature and Culture.* New York: Methuen, 1985.

Penley, Constance. "Feminism, Psychoanalysis, and the Study of Popular Culture." *Visual Culture: Images and Interpretations.* Ed. Norman Bryson, Michael Ann Holly, and Keith Moxey. Hanover, NH: Wesleyan UP, 1994. 302–24.

Pollock, Griselda. "Feminism/Foucault—Surveillance/Sexuality." *Visual Culture: Images and Interpretations.* Ed. Norman Bryson, Michael Ann Holly, and Keith Moxey. Hanover, NH: Wesleyan UP, 1994. 1–41.

Rabine, Leslie. "Romance in the Age of Electronics: Harlequin Enterprises." *Feminisms: An Anthology of Literary Theory and Criticism.* Ed. Robyn R. Warhol and Diane Price Herndl. Rev. ed. New Brunswick, NJ: Rutgers UP, 1997. 976–91.

Radway, Janice. "The Readers and their Romances." *Feminisms: An Anthology of Literary Theory and Criticism.* Ed. Robyn R. Warhol and Diane Price Herndl. Rev. ed. New Brunswick, NJ: Rutgers UP, 1997. 574–608. [Originally published in *Reading the Romance: Women, Patriarchy, and Popular Literature.* Chapel Hill, NC: U of North Carolina P, 1984.]

Rivière, Joan. "Womanliness as Masquerade." 1929. *Formations of Fantasy.* Ed. Victor Burgin, James Donald, and Cora Kaplan. London: Methuen, 1986. 35–44.

Ross, Andrew. "Tribalism in Effect." *On Fashion.* Ed. Shari Benstock and Suzanne Ferriss. New Brunswick, NJ: Rutgers UP, 1994. 284–99.

Rubin, Gayle. "The Traffic in Women: Notes on the 'Political Economy' of Sex." *Toward an Anthropology of Women.* Ed. Rayna R. Reiter. New York: Monthly Review P, 1975. 157–210.

Rubenstein, Ruth P. *Dress Codes: Meanings and Messages in American Culture.* Boulder, CO: Westview P, 1995.

Silvermann, Kaja. *The Acoustic Mirror: The Female Voice in Psychoanalysis and Cinema.* Bloomington: Indiana UP, 1988.

Williams, Raymond. *Culture and Society, 1780–1950.* New York: Columbia UP, 1958.

Wilson, Elizabeth. *Adorned in Dreams: Fashion and Modernity.* Berkeley: U of California P, 1985.

GLOSSARY

Abolition The movement to abolish slavery originating in the eighteenth century. Women were active participants in the emancipation movement, and many found suggestive parallels between the oppression of slaves and the oppression of women.

Aestheticism An attitude or sensibility that promotes beauty as an end in itself and views the creation of beauty as the only proper function for the artist.

Allegory Presentation of an abstract idea through concrete means. Narrative allegory usually has at least two levels of meaning—the first is the story line or plot; the second includes moral, political, philosophical, or religious meanings.

Androcentrism Male-centeredness.

Androgyny A Greek word from *andro* (male) and *gyn* (female) meaning a psychological and psychic mixture of masculine and feminine traits. Considered by some feminists to undercut and erase the binary opposition between masculine and feminine (e.g., Virginia Woolf, Hélène Cixous), offering access to a full range of experience encompassing both masculinity and femininity. Others (e.g., Elaine Showalter) reject androgyny as a feminist position because it erases gender difference and denies the specificity of women's experience and oppression.

Apartheid The policy of racial segregation and political and economic discrimination against non-European groups in South Africa.

Autobiography The story of a person's life written by him or herself. From *auto* (self), *bio* (life), and *graphe* (writing) (see **Memoir**).

Belles lettres Literature regarded for its aesthetic value rather than its didactic or informative content.

Binary opposition Two terms considered to be direct opposites, such as light/dark, good/evil, man/woman. Jacques Derrida contends that Western thought is constructed in terms of such oppositions, hierarchically arranged to privilege one term over the other (see **Deconstruction**). Hélène Cixous claims the fundamental opposition is male/female.

Biological determinism The belief in an innate biological difference between male and female that determines social behavior and cultural differences between men and women (see **Essentialism**).

Bisexuality Having both heterosexual and homosexual desires. According to Freudian theory, sexuality during the pre-Oedipal stage is undifferen-

tiated for female and male children and "polymorphously perverse," both active and passive, and unconfined to any specific bodily zone. Traditional psychoanalysts argue that "normal" development moves away from bisexuality to heterosexuality. Hélène Cixous, by contrast, considers bisexuality a form of resistance to male "monosexuality," which is focused on the phallus to the exclusion of female desire. Gay and lesbian theorists, by contrast, have noted that bisexuality, by fusing heterosexuality and homosexuality, leaves normative (and often oppressive) models of heterosexuality intact. Others, such as Judith Butler, have challenged theories based on claims of a "natural" bisexual predisposition, arguing that sexuality is itself discursively and culturally constructed.

Blacklist A list of persons or organizations to be disapproved, boycotted, or suspect of disloyalty. In the 1950s, suspected Communist sympathizers were denied the right to work, including authors such as Lillian Hellman.

Bloomsbury The area of north London where Virginia Woolf and her siblings lived following the death of their father in the first decades of the twentieth century. Bloomsbury signifies the artistic and intellectual experimentalism of Woolf's circle of friends.

Bluestocking A term referring to members of the bluestocking circle of the late eighteenth century. The term originally referred to male intellectuals who wore blue, not white, stockings to gatherings. (Blue hose were associated with the working class.) Eventually the term came to refer only to female intellectuals, to women taking part in public intellectual life. Often used derogatorily by male intellectuals (e.g., Byron), women of the circle were concerned with setting an example as "respectable" females who could study, write, and publish. Notable members of the circle included Elizabeth Carter, Elizabeth Montague, Catherine Talbot, Hester Chapone, and Hannah More.

Body The female body has figured prominently in feminist studies. It has been identified as the basis for arguments for restricting women's participation, the basis for assumptions that women are inferior in strength, in intellectual capacity (based on smaller brain size), or lacking in that women do not possess the phallus. Feminists have, at various times, tried to recuperate arguments grounded in the body, contending, for instance, that women's reproductive potential makes them more nurturing and caring. Film and cultural studies have focused on the objectification of the female form in mainstream cinema, advertising, and more. The negative consequences of bodily self-regulation—through diet and exercise—have come under scrutiny by Susan Bordo and others.

Canon From the Greek word for ruler or measuring stick. Originally referred to the books of the Old and New Testament approved by church authorities. Adapted to literary criticism to designate those works and authors considered "major." Feminists have argued that the canon has traditionally excluded women and their works. They have criticized the pro-

cess of canon formation, noting that it has not been a disinterested activity but one that is shaped by the literary establishment, predominantly white male critics and academics. One of the significant achievements of literary feminism has been the expansion of the literary canon to include once marginalized works by women, homosexuals, and minorities.

Capitalism An economic system in which the means of production are privately owned. It is distinguished from all other forms of production by its aim: the creation and expansion of capital. Marxist theory emphasizes that such a system alienates workers from their labor and is inherently exploitative. It is thus a system of social relations in which production turns money, things, and people into capital.

Chora Julia Kristeva adopts this term from Plato's *Timaeus* to refer to the receptacle of the drives, rhythms, and pulsions of the **semiotic**.

Class A social grouping whose members share similar economic, political, and cultural characteristics.

Cold War A term coined by Bernard Baruch to describe hostilities between the United States and the Soviet Union, Communist China, Cuba, and governments in Southeast Asia (1948–90).

Colour bar A means of restricting social and political rights of people of color.

Conduct books Achieving their vogue in the eighteenth century, conduct books outlined appropriate behavior for women, and hence contributed to definitions of femininity.

Constructionism Refers to the notion that the individual is socially constructed—mediated by history and culture—not naturally or biologically given.

Counter-Reformation The Catholic response to the Protestant Reformation, symbolized by the Council of Trent (1545–63). It bought reforms into the Catholic church and sent out evangelists, notably the new Society of Jesus, to try to reconvert Protestant populations.

Courtly love A quasifictional system of love behaviors codified in a set of literary conventions developed in southern European poetry from the twelfth through fourteenth centuries. The lover, a faithful knight, pledges himself to his mistress as if she were his feudal lord (in the language of southern France, Provençal, the lady was even referred to as *mi dons*, or "my lord"). A reversal of the traditional power dynamics of the husband-wife relationship, the courtly love relationship was also usually adulterous and therefore dangerous.

Criticism The specific, self-conscious examination of the function and value of literature.

Cult of domesticity The traditional association of women with home and hearth, which reached its apex in the late eighteenth century. Literature, magazines, and conduct books made a virtue of feminine domestic labor and interests.

Cult of true womanhood The Victorian standard for women, defining piety, purity, submissiveness, and domesticity as "feminine" virtues.

Cultural studies An interdisciplinary field encompassing a wide range of critical projects, such as investigations of television and film, youth subcultures, and technology. Much of the work of cultural critics has focused on previously devalued aspects of contemporary culture, including popular culture.

Culture A highly contested term. While in the social sciences, "culture" refers to the material production of a society, in literary and cultural studies the term refers to systems of signification and the production of meaning. In *Culture and Anarchy* (1867), Matthew Arnold defined culture as the "best that has been thought and known." Later thinkers, notably Raymond Williams, have criticized Arnold's notion that the best arbiters of culture would be intellectuals disinterested and disassociated from class interests. Instead, Williams and more recent critics have focused on cultural artifacts and events that do not fit the standards of a dominant or "high" culture and have called into question the seemingly disinterested nature of aesthetic judgment.

Dandy Short for jack-a-dandy; a man who gives exaggerated attention to dress.

Deconstruction A process of critique of Western metaphysics developed by Jacques Derrida.

Desire A term associated with psychoanalytic theory, particularly that of Jacques Lacan, who defined desire as "neither the appetite for satisfaction, nor the demand for love, but the difference that results from the subtraction of the first from the second, the phenomenon of their splitting." He thus distinguishes between *need*, which can be satisfied by the acquisition of a specific object, and *demand*, which is addressed to another and seeks reciprocity. Desire is that which remains and characterizes the subject's inexhaustible longing for its originary unity with the mother, prior to the acquisition of language. For the French feminists, desire is thus associated with the feminine and is contrasted to the phallocentric order of the symbolic.

Difference The distinction between women and men and among women. Feminists have asserted the need to be attentive to difference in resistance to Western cultural traditions that privilege homogeneity and adherence to a singular male-defined norm. More recently, studies of difference have emphasized race, ethnicity, and sexual preference in addition to gender as a means of critiquing dominant cultural traditions.

Dime novel A genre of thriller fiction and, occasionally, fictionalized history popular in the United States in the nineteenth century. They focused on action plots, heroic individualism, and distinctively American settings and situations.

Discourse A term used by Michel Foucault to denote the socially and historically situated use of language. Foucault argued that social institutions construct themselves through their discursive practices by developing shared vocabularies, assumptions, values, and interests that make certain forms of knowledge possible that lead to the accumulation and exercise

of power. Theorists influenced by Foucault have examined the effects of discursive practices in the construction of femininity and a normative heterosexuality that controls social behavior.

Drama A prose or verse composition written for or as if for performance by actors; a play.

Écriture féminine Literally, feminine writing. According to French feminists Hélène Cixous and Luce Irigaray, *écriture féminine* is opposed to the masculine symbolic order and is associated with the pre-Oedipal, the maternal, and the drives and rhythms of the female body.

Epiphany From the Greek ("manifestation," or "showing forth" of divine being), used to describe insight or understanding.

Essentialism The belief in true essence, that is, that which is most irreducible, unchanging, and therefore constitutive of a given person or thing. In feminist theory, essentialism often refers to the belief in a female essence, a pure or original femininity, often conceived of as an extension of female biology (see **Biological determinism** and **Identity politics**).

Ethnicity Used to account for human variation in terms of culture, tradition, language, social patterns, and ancestry rather than racial distinctions that are presumably fixed and genetically determined. Werner Sollors argues, however, "that it makes little sense to define 'ethnicity-as-such,' since it refers not to a thing-in-itself but to a relationship: ethnicity is typically based on a *contrast*," for example, Hispanic from white (see **Race**).

Eurocentrism The belief that European societies are superior to those of other continents, as well as the assumption that the norms and presuppositions of European culture have universal validity.

Female A biological, as opposed to cultural, distinction from the male.

Feminine An adjective referring to qualities culturally ascribed to women, such as nuturance, emotion, softness, passivity, and so forth.

Femininity The quality or condition of being feminine.

Feminism(s) Political positions assuming that women's status in culture has been devalued and misrepresented.

Feminist One who believes in one or more feminist positions.

Fin-de-siècle French for "end of the century," with particular reference to the 1890s, when American and European writers broke from the conventions of realist and Victorian literature to experiment with literary techniques and subjects that would define Modernism.

First wave of feminism The original political movement in defense of women's rights, emerging in the late eighteenth century in the context of democratic revolutions in America and France. It advocated equal rights for women to political participation (i.e., suffrage) and equal access to education.

Free indirect discourse Speech that is reported to the reader rather than directly spoken. French writer Gustave Flaubert pioneered this style in his novel *Madame Bovary* (1857) and was further refined by modernist writers Virgina Woolf , James Joyce, and H. D.

Free verse From *vers libre* (French), poetry that lacks regular meter and rhyme; form preferred by experimental poets of early twentieth century.

French Symbolism Subjective use of symbols to convey private personal and intense emotional experiences.

Gaze Used in film theory to describe how mainstream cinema constructs the vision of the spectator. Feminist film theorists have argued that the gaze constructed by conventional cinema is male because it presents women as spectacles and objects on display, as embodying "to-be-looked-at-ness" (Mulvey).

Genealogy Used by Michel Foucault to describe the process of recovering blocs of knowledge disqualified as illegitimate within the accepted hierarchy of science and knowledge that is a product of the Enlightenment.

Gender The cultural distinction between masculine and feminine, masculinity and femininity. Gender studies are attentive to the system of difference, contending that the terms "woman" and "man" have no meaning independently, but only in relation to each other. While some feminists perceive attention to gender relations as a threat to women's studies, others have argued that such studies sustain the feminist focus on inequities and imbalances of power between men and women.

Genre A distinctive class or category of literary composition (e.g., poetry, novel, drama, memoir). Feminist critics attend to the associations of particular literary forms with women.

Gift books In vogue in the nineteenth century, gift books (also called album books or annuals) were compilations of popular verse exchanged on special occasions such as birthdays or Christmas. Women were often not only contributors to but also editors of such collections and thus shaped the reception and history of popular literature.

Gothic A popular subgenre of the novel featuring a virtuous heroine subjected to danger and dark terror. Conventions include gloomy castles, brooding villains, and secret passageways. Early examples include Clara Reeve's *Old English Baron* (1777), Horace Walpole's *Castle of Otranto* (1765), and Sophia Lee's *Recess* (1783-85). The most famous exemplars of the form were written by Anne Radcliffe.

Gynocriticism A term coined by Elaine Showalter to describe the practice of reading and studying texts written by women.

Haiku Sixteenth-century Japanese verse form that consisted of three unrhymed lines that in total contain 17 syllables; often used by Imagists.

Harlem Renaissance 1920s multiethnic arts movement centered in New York City's Harlem area (Bronx), where poetry, music, theater, and dance flourished.

Hegemony The dominance of one group, nation, or culture over another. The Italian Marxist Antonio Gramsci further refined our understanding of the term in describing the process of the control that the bourgeoisie exerts over the working classes. He argued that hegemonic control is not maintained merely by force or the threat of force, but by the consent of the subordinate class who come to see the dominant class's interests as "natural" (also see **Ideology**).

Heterosexism The unconscious or explicit assumption that heterosexuality is the only "normal" mode of sexual and social relations, attitudes cul-

turally enforced through religion, law, medicine, psychology, and, in some instance, literature.

Heterosexuality Sexual relations between members of the opposite sex. Critics, such as Michel Foucault and Judith Butler, question whether heterosexuality is "natural" or socially produced.

Homophobia Fear of homosexuality.

Homosocial A term used by Eve Kosofky Sedgwick to describe the social bonds between members of the same sex.

Identity politics The tendency to base one's politics on a sense of personal identity.

Ideology Karl Marx and Friedrich Engels originally used the term to describe false consciousness. The term was later defined by Louis Althusser in "Ideology and State Apparatuses" (1971) as that system of beliefs and assumptions—unconscious, unexamined, invisible—that represent "the imaginary relationship of individuals to their real conditions of existence."

Imaginary A term used by psychoanalyst Jacques Lacan to refer to the pre-Oedipal, preverbal phase of infancy when the child experiences an imagined unity with the mother and has no sense of its own difference. The period ends with the Oedipal crisis and the child's entry into the Symbolic Order (see **Symbolic**).

Imagism School of poetry associated with Ezra Pound and Amy Lowell important in United States and Great Britain in the first decades of twentieth century that used concrete images and **free verse** forms.

Impressionistic Writing that tries to capture fleeting impressions of characters, events, and moods.

Law of the Father A phrase used by psychoanalyst Jacques Lacan to describe the phallic order structuring the symbolic, the order of language.

Lesbianism A contested term used to refer not simply to female homosexuality but to woman-centeredness and feminine social relations.

Libraries Circulating or lending libraries significantly altered readership, making texts available to members of the middle and lower classes, including women. The first circulating library, founded in the 1740s in the corner of a London bookstore, enabled middle-class individuals, for whom book prices were still beyond reach, to borrow books for a small fee. The library carried only novels and thus contributed to the genre's popularity, particularly among female readers.

Lyric poetry Words meant to accompany the lyre; song. By extension, short poems that purport to express the feelings of the speaker or singer. Usually distinguished from "narrative poetry," which tells a story, and "dramatic poetry," which imitates multiple voices and is generally meant to be performed.

Magic realism Taken from the German *magischer Realismus*, the term was first used in the 1920s to refer to quasi-**Surrealistic** painting and later applied to fictional prose works that mix realistic and fantasy elements, particularly the texts of Latin American authors such as Jorge Luis Borges, Gabriel Garcia Marquez, and Laura Esquivel.

Male A biological, as opposed to cultural, distinction from the female.

Marxism The theory and practice of revolutionary class politics, derived from the works of Karl Marx. Marxist feminists emphasize the material conditions of women, focusing on class as well as gender distinctions.

Marxist criticism Derived from the work of Karl Marx and Friedrich Engels, Marxist literary criticism assumes that literature and art are the products of historical forces that can be analyzed by focusing on the historical and material conditions in which they are formed. Marxist critics assume that capitalist control of the means of production implies control of intellectual and cultural production as well and analyze the material and social conditions that produce texts. Contemporary Marxist critics further argue that literature does not merely reflect particular class interests, but partakes of and contributes to ideology (see **Ideology**, **Materialism**).

Masculine An adjective referring to culturally defined qualities ascribed to the male sex, including strength, power, aggression, and so on.

Masque A court entertainment in which courtiers and some professionals perform in tribute to royalty or other high-born patrons, all of them usually allegorized to represent court values. Masques included music, spectacle, and poetry and reached their extravagant height in the court of Charles I and his French queen, Henrietta Maria (1625–42).

Materialism In philosophy, the doctrine that all things exist either as physical matter or as dependent upon physical matter. In contemporary theory, Marxist criticism connects all aspects of life and consciousness to the material conditions of existence.

Memoir A term dating from the sixteenth century to denote any personal record of events. Contemporary memoirs emphasize testimony of lived events, often traumatic, in which the writer takes a double position both as witness and as participant. Memoir differs from autobiography in that (1) it does not purport to tell the story whole, (2) it does not normally consider the public lives of famous people, and (3) the first person speaker—"I"—is contingent and self-consciously defined in relation to others and to events (see **Autobiography**).

Metanarratives Used by Jean-François Lyotard to describe the foundational narratives of modern Western thought that presume an ahistorical, all-knowing point of view. **Postmodernism** is "incredulity toward metanarratives." For instance, postmodern critics note that Enlightenment emphasis on the individual presumes a white, male subject.

Mirror stage According to psychoanalyst Jacques Lacan, at six to eighteen months the child begins to experience itself as a self apart from the mother by recognizing itself in its reflected image. Lacan notes that the child accepts this image of an ideal self—whole, separate, independent—when it is, in fact, still dependent on the mother for satisfaction of its needs. Thus, the child originally misperceives itself. The mirror stage ends during the **Oedipal crisis**, when the child enters the **symbolic** order. This is key to understanding Lacan's theory of the **subject** split into subject and object, conscious and unconscious.

Misogyny Hatred and fear of women.

Modernism An international literary and artistic movement of the early twentieth century characterized by experimentation and innovation.

Negrophilia Appreciation of and identification with African American people, customs, and artistic forms.

New Woman A career woman and suffragette of the late nineteenth and early twentieth centuries, often lesbian and an advocate for gay rights, represented in "New Woman" novels.

Novel A fictional prose narrative of considerable length, typically having a plot that is unfolded by the actions, speech, and thoughts of the characters. In the eighteenth century, this form became associated with women, both as writers and readers.

Novella A short novel.

Novel of ideas A novel resisting sentimental appeals and emphasizing intellectual and philosophical ideas.

Novel of manners The dominant form of the novel in the eighteenth and nineteenth centuries that presents social conventions in fictionalized form through the moral, ethical, cultural, and social options exercised by individuals. Early novels of manners presented upper-class life for the instruction and emulation of readers in the lower classes. Following the Enlightenment, novels of manners reflected social critiques of this division and depicted the individual in opposition to an oppressive society dominated by mere manners. Women writers, such as Jane Austen, Frances Burney, Clara Reeve, and Charlotte Smith, exploited this form, presenting images of heroines oppressed by a divisive and hostile social structure. It continued into the twentieth century (see, e.g., Edith Wharton, Barbara Pym, and Anita Brookner.)

Novel of psychological development From the German *Bildüngsroman*; a novel that recounts the development of an individual from childhood to maturity.

Oedipal crisis The Freudian term used to describe the process that produces "normal" masculine and feminine sexuality. In Lacan's rewriting of Freudian theory, the Oedipal crisis marks entry into the symbolic order (see **Symbolic**).

Other According to psychoanalyst Jacques Lacan, an infant, prior to the acquisition of language, experiences an undiffereniated unity with the mother and conceives of no difference between itself and others. Entry into language entails recognizing one's difference from the mother and from others. More simply, the term has been used to describe everything that is not "I." Before Lacan, Simone de Beauvoir argued that woman has been defined as Other in relation to man.

Palimpsest A written document, typically on vellum or parchment, that has been written upon several times, often with remnants of earlier, imperfectly erased writing still visible.

Patriarchy A social and cultural system producing the dominance of men and the subordination of women.

Patronage Until the mid-eighteenth century, most literary texts were published through a system of literary patronage, which privileged male authors of the artistocracy.

Petrarchan Conventions derived from the courtly love tradition and borrowed from the poetry of Francesco Petrarca (1304–74), a founder of Renaissance humanism. Petrarch's sonnets to Laura not only describe her beauty but also focus particularly on the lover's frustrations in a series of "conceits" or ideas and metaphors that emphasized tumult and the siege of contraries (e.g., the lover is a ship in a storm-tossed sea, a hunter fruitlessly chasing a doe, a soldier under the command of a wicked god of love, the lover boths burns and freezes, soars and plummets). Working with sonnets and metaphors from Petrarch was immensely popular throughout throughout sixteenth-century Europe.

Phallocentrism Belief that the male is superior to the female or, more generally, that what is male is a legitimate, universally applicable point of reference for all things human.

Phallogocentrism A term employed by Jacques Derrida and adopted by the French feminists, which combines "phallocentrism" with "logocentrism" to describe the logic of Western thinking that privileges the masculine as the norm.

Phallus While the term can simply mean "penis," it is more commonly used in critical discourse to refer to the authority and power accrued to its possessor in Western culture.

Poetry A literary expression in which language is used in a concentrated blend of sound and imagery to create an emotional response; essentially rhythmic, it is usually metrical and frequently structured in stanzas.

Postcolonialism Colonialism is the direct political control of one country or society by another. Postcolonialism thus refers to the period following World War II that witnessed the demise of many colonial regimes and, in broad terms, describes any culture shaped by imperialism. Postcolonial theorists analyze identity in relation to nationalisms and imperialism, the role of the state, and conflicts between cultures.

Postmodernism In its simplest usage refers to the period of twentieth-century Western culture that immediately followed high modernism (after 1950). Since the 1960s, postmodernism has been associated with the culture of advanced capitalist societies, in which the electronic media bombards individuals with disparate fragmentary images and experiences. Literary works described as postmodern typically a mix of "high" and "low" culture, a pastiche of genres and literary techniques, and a self-consciousness about the arbitrary and fragmentary nature of all texts. As a form of criticism, postmodernism rejects **metanarratives** that purport to present history and culture as a unified whole.

Post-structuralist theory The term refers to the influential work by theorists of the late 1970s and 1980s that arose in reaction to structuralism: Jacques Derrida in philosophy, Jacques Lacan in psychoanalysis, Michel Foucault and Michel de Certeau in history, and Jean-François Lyotard and

Gilles Deleuze in cultural-political critique. Poststructuralists challenge traditional intellectual categories and practices, calling into question the concept of the individual as a unified subject, the stability of meaning, and the "truth" of history. Poststructuralist theories also share an emphasis on the role of language in the construction of identity. Feminists have adapted poststructuralist theories to challenge the binary opposition between male/female and masculine/feminine to analyze the construction of the gendered subject and to define a feminine language.

Prohibition Period in late 1910s and 1920s in the United States when the production and consumption of alcoholic beverages was forbidden by law.

Psychoanalysis Originated by Sigmund Freud in 1895, psychoanalytic theory focuses on the psychosexual development of the infant and creation of the unconscious during the Oedipal crisis. In the 1950s, French psychoanalyst Jacques Lacan reinterpreted Freud's theories to focus on the role of language, contending that the subject comes into being in language, on entry into the order of the symbolic.

Pulp fiction "Pulp" refers to the cheap quality of the paper characteristic of dime novels and serialized works intended for mass consumption.

Queer Originally a term of disparagement applied to homosexuals, the term was recuperated by gay activists in the 1980s, as in the famous slogan "we're here, we're queer, get used to it." When applied to criticism and theory, the term is used to describe analyses of the apparent naturalness of heterosexuality. Queer theory exposes the instability of relations between sex, gender, and desire to demonstrate the constructed nature of sexuality. In its rigorous commitment to poststructuralist notions of identity, it has been distinguished from earlier models of gay and lesbian theories that presumed a preexisting and stable homosexual identity as the basis for politics and criticism.

Race First employed by François Bernier in 1684 to distinguish among humans based on facial features and skin color, it refers to classification of human beings into physically, biologically, and genetically distinct groups. More recently, poststructuralist critics have challenged race as a "natural" category. Henry Louis Gates Jr. has argued that race is an arbitrary linguistic category that elides differences among ethnic groups (see **Ethnicity**).

Radical feminism A movement that emerged in the late 1960s motivated by the failure of the Civil Rights Movement to address the oppression of women. Radical feminists believe that change is impossible within the patriarchal and capitalist social order and argue for the creation of a new social order based on woman-centered values and methods of organization.

Realistic novel A novel that depicts characters, settings, and events in accordance with reality or the reader's perceptions of the real; fictional novels that present a plausible world. Such novels emphasize concrete details and characterization, establishing convincing motivation for the thoughts, emotions, and actions of the character as well as the plot.

Reformation A repudiation of the traditional authority and doctrine of the Roman Catholic church in favor of religion based on the Bible, faith, and individual conscience. "Protestants" sought to protest what they saw as doctrinal and liturgical abuses by the Roman Catholics. Martin Luther is generally credited with starting the Reformation in 1516. Other major reform Protestants of the sixteenth century include the Swiss reformers Calvin and Zwingli, the Scot John Knox, and the English reformers William Tyndale, Thomas Cranmer, and Hugh Latimer.

Regional fiction, regionalism Regional novels represent the domestic realities of life in particular regions, usually rural areas, often employing the local dialect. It has often been a devalued and marginalizing designation.

Romanticism Refers simultaneously to the literary period from approximately 1780 to 1832 in England and the 1830s in America and a revolutionary movement in literature. Traditionally, Romantic literature has been defined as stressing concepts of the self, imaginative transcendence, and nature as a sublime and inspiring force. Some feminist critics have argued that this definition applies only to male writers. "Feminine" Romanticism, by contrast, would appear to accentuate familial relationships in place of radical individualism, quotidian and domestic concerns rather than the supernatural, and nature as nurturing and comforting as opposed to awesome and potentially threatening.

Salon Dating from the seventeenth century, literary salons were places established in the homes of writers and intellectuals where artists, writers, and philosophers debated issues of aesthetic and cultural importance.

Scopophilia Literally, "pleasure in looking." Film theorists have adapted the term from Freudian theory to account for visual pleasure. The experience of viewing a film encourages the spectator's fantasy of observing a private world. Feminist theorists argue that mainstream cinema organizes the pleasure of looking in gendered terms, making women the passive object of the male viewer (see **Gaze**).

Second wave of feminism The post–World War II movement that agitated for equal rights for women and was associated with movements for liberation during the late 1960s. It produced changes in education, including the creation of women's studies programs and feminist literary criticism and theory as a discipline.

Semiotic A term coined by Julia Kristeva to describe the preverbal system of drives and pulsions that connects the infant and mother. After the child's entry into the Symbolic, the order of language, the semiotic may reveal itself as disruptions and subversions of linguistic structure and meaning, producing a revolution in language. While associated with the maternal, this subversive play in language is not the sole province of women but may be seen in the works of men as well (see **Chora**).

Sensation novels Popular during the Victorian era in Britain, sensation novels titillated audiences with lurid stories of bigamy, adultery, incest, illegitimacy, assault, and murder. They are generally considered the precursor of the modern thriller.

Sentiment Eighteenth-century thinkers distinguished between sentiment, the capacity for emotion or feeling, and reason. The distinction had specific gender associations, with sentiment defined as feminine or womanly and reason as masculine. Mary Wollstonecraft rejected this distinction, arguing that women, like men, were "rational creatures." Sentimental literature was popular, however, particularly among female readers, and many female authors, including Sarah Fielding, exploited the vogue for emotional responsiveness and conspicuous displays of intense feeling.

Sentimental novels Novels designed to invoke an emotional response in readers (see **Sentiment**).

Separate spheres Separation between the sexes in social life leading to the segregated worlds of men and women, with men dominating the public sphere of work and politics while women are relegated to the private sphere of the home and domestic chores.

Separatist An advocate of women's separation from male-dominated institutions. Often associated with the radical feminist concept of a woman culture (see **Radical feminism**).

Sex An ambiguous term in English, sex refers both to the anatomical distinction between male and female (to *be* a particular sex) and to sexual activity (to *have* sex). Feminist theorists have tended to distinguish sex from gender, attempting to resist traditional identifications of women with supposedly innate qualities such as emotionalism, physical weakness, and passivity (see **Biological determinism, Essentialism**).

Sign According to French linguist Ferdinand de Saussure, a sign refers to the arbitrary association of a signifier (sound-image) and signfied (concepts). Saussure's insight into the arbitrary relationship between signifier and signified exerted a profound influence on **post-structuralism**.

Signification The process of producing meaning; use of signs.

Signified That object, abstract or concrete, to which a signifier refers. In Saussurean linguistics, it refers to the concept in the linguistic **sign**.

Signifier A sign or sequence of signs that refers to something. In Saussurean linguistics, it refers to the sound image in the linguistic **sign**.

Slave narratives Personal narratives emphasizing the effects of slavery on the slave and slaveholder; among the earliest forms of American literature and the first form to be developed by African Americans. Directed to national and international audiences, slave narratives of the nineteenth century became associated with the abolitionist movement. Women's slave narratives address the contradictions of the female slave's treatment in relation to the ideals of womanhood prevalent during the era.

Social construction, social constructionism See **Constructionism**.

Sonnet A 14-line poem developed in Italy in the twelfth century, made popular by Dante in the thirteenth century and (especially) by Petrarch in the fourteenth century. The Italian version is divided into two groups connected by rhyme, eight lines (the "octave") that present a problem or situation and six lines (the "sestet") that resolve the problem or comment

on the situation. The English sonnet typically is divided into four sections, three groups of four lines ("quatrains") and a concluding two-line rhyme ("couplet"). It was common, however, to experiment with various structures and rhyme schemes within the 14-line limit.

Sonnet sequence A set of sonnets that carry a single voice across different aspects of an experience, usually love but sometimes religion. Popularized by Petrarch's sequence the *Canzoniere*, which were dedicated to his (probably fictitious) hopeless love for Laura. Anne Lock published the first sequence in English (on Psalm 51) in 1560.

Southern Gothic A twentieth-century American variation on the **Gothic** novel, which is typically set in the South and combines dark comedy with an examination of local mores and idiosyncrasies. Women authors Flannery O'Connor and Carson McCullers are considered pioneers in this form.

Stream-of-consciousness A phrase coined by William James in *Principles of Psychology* (1890) to describe the flow of thoughts of the waking mind. The term is now widely used in literary contexts to describe narratives that represent the flux of a character's thoughts or reminiscences without logical sequence or syntax.

Structuralism Structuralism attempts to uncover the internal relationships that give language (or, broadly defined, any system of signs) its form and function.

Subaltern In British military terminology, the term refers to those holding rank below that of captain. The term was adopted by Antonio Gramsci to refer to groups subject to the hegemony of the ruling class, such as peasants and workers, and adapted by postcolonial critics, such as Gayatri Spivak and the members of the **Subaltern Studies** Group, to identify the oppressed subject of imperialism and materialism.

Subaltern studies The analysis of subaltern themes in South Asian history and culture. The Subaltern Studies Group was formed in the early 1980s by a number of intellectuals, including Gayatri Spivak, to examine subordination in South Asian society, whether expressed in terms of class, caste, age, gender, office, or any other way.

Subject Refers to the thinking, acting person. In post-structuralist theory, the term "subject" is to be distinguished from the term "individual," which suggests a degree of autonomy and unity. The subject, by contrast, is a being constituted in and by language.

Subjectivity See **Subject**.

Subject position (1) In literature, refers to the constructed identity from which an author speaks. It may be implicit or explicit, it may extend from an author or speaker's authentic sense of self, or it may be a fiction devised for rhetorical purposes. (2) In post-structuralism, refers to the constructed nature of subjectivity. In *The Archaeology of Knowledge* (1972), Michel Foucault defines the "subject" as "not the speaking consciousness, not the author of the formulation, but a position that may be filled in certain conditions by various individuals." According to post-structuralist

thinkers, we exist as subjects only within language, and, as such, our subject positions are inherently arbitrary, unstable, and fluid.

Subscribers In the subscription system of publication, authors secure subscribers, who pay a fee to underwrite publication. The subscription system undermined the preexisting system of literary **patronage** and paved the way for the modern publishing industry, opening publication to members of the middle class, including women.

Suffrage The political movement in favor of women's right to vote.

Suffragists Radical feminists of the early twentieth century who used violence to force the British government to give women voting rights; as opposed to suffragettes, who used traditional means of rhetorical persuasion to change public opinion.

Surrealism A European literary and artistic technique movement of the 1930s associated with poets Guillaume Apollinaire, who coined the word, and Andre Breton, who founded the movement, which was influenced by the psychoanalytic theories of Sigmund Freud.

Symbolic A term used by psychoanalyst Jacques Lacan to identify the order of language and culture that constructs our sense of identity and reality.

Teleology Philosophical study of the design or purpose in natural processes, with emphasis on the utility of such processes in nature (from the Greek *telos*, meaning complete, final).

Theory, literary A set of principles and assumptions used to explain and/or analyze the structure, language, and forms of literature.

Troubadour Lyric poet of the eleventh to thirteenth centuries in southern France who wrote in provencal language; associated with **courtly love** tradition, later used by early twentieth-century experimental poets.

Unconscious In psychoanalysis, refers to all psychological materials not available to the conscious mind. It contains materials that are repressed during the **Oedipal crisis**, including desires that cannot be expressed or acted upon under the governing social order (e.g., violent urges, sexual impulses, etc.).

Voice-over A narrative method in literature and film in which an unidentified person explains or fills in events that are not directly dramatized.

Woman An abstract term referring to a culturally defined image of women emerging in the late eighteenth century. Mary Wollstonecraft's *Vindication of the Rights of Woman* sought to define "woman" as a rational creature, deserving of equal education.

Womanist A term introduced and defined by Alice Walker, *In Search of Our Mother's Gardens* (1983): "a black feminist or feminist of color. From the black folk expression of mothers to female children, 'You acting womanish,' i.e., like a woman." A womanist "appreciates and prefers women's culture," but need not be a lesbian. She is "committed to survival and wholeness of an entire people, male and female."

Xenophobia Hatred and fear of people and customs from another geographic locality.

Year	Cultural Context	Historical Events
1455		Johannes Gutenberg invents the printing press
1474		William Caxton prints the first book in English, *The Recuyell of the History of Troy*
1501	*Book of Margery Kemp*	
1509		Henry VIII assumes the British throne
1517		Martin Luther's Wittenberg theses; beginning of the Protestant Reformation
1521	Christine de Pisan, *City of Ladies* published in England	
ca. 1524	Margaret More Roper translates Erasmus's *A Devout Treatise upon the Pater Noster*	
1546–47	Anne Askew, *Examinations*	
1558		Elizabeth I begins her reign
1560	Anne Vaughn translates four sermons by John Calvin	
1567	Isabella Whitney, *The Copy of a Letter by a Young Gentlewoman to Her Unconstant Lover*	

1573	Isabella Whitney, *A Sweet Nosegay*	
1576		Building of The Theatre, the first permanent structure in England for dramatic performances
1592	Countess of Pembroke, *Antonius*	
1603		James I becomes king of England
1605		The Gunpowder Plot, a failed effort by Catholic extremists to blow up parliament and the king
1611	Aemilia Lanyer, *Salve Deus Rex Judaeorum*	
1613	Elizabeth Cary, *Mariam, Fair Queen of Jewry*	
1617	Rachel Speght, *A Muzzle for a Melastomous*	
1620		Arrival of the Pilgrims in the New World aboard the Mayflower
1621	Lady Mary Wroth, *Urania* Rachel Speght, *Mortality's Memorandum*	
1625		Charles I assumes the throne of England
1632	Rachel Speght, *The Law's Resolution of Women's Rights*	
1642		Outbreak of civil war in England; theaters closed
1645		Britain hangs witches

1647		Massachusetts and Connecticut colonies execute witches
1649		Execution of Charles I; beginning of Commonwealth and Protectorate (the Interregnum, 1649–60)
1650	Anne Bradstreet's *The Tenth Muse Lately Sprung up in America* printed in London	English and U.S. Puritan laws on adultery
1651	Katherine Philips's poems circulate in manuscript	
1653	Margaret Cavendish, *Poems and Fancies*	
1660		Charles II restored to the English throne (the Restoration)
1662		Royal Society of London for the Improving of Natural Knowledge
1663	Katherine Philips's translation of Corneille's "The Death of Pompey" performed at Dublin's Smock Alley Theater, making her the first woman to have her words performed on a British stage; also first named woman poet to appear in an anthology, *Poems, by Several Persons*	
1667	Katherine Philips, *Poems*	
1668	Margaret Cavendish, *Blazing World* (first science fiction novella in English)	

1670	Aphra Behn's *The Forced Marriage* performed at Duke's Theatre	
1673	Bathsua Makin, *Essay to Revive the Ancient Education of Gentlewomen*	
1676	Margaret Cavendish, *Sociable Letters*	
1678	Anne Bradstreet's *Several Poems Compiled with Great Variety of Wit and Learning* published in America	
1687		Sir Isaac Newton, *Principia Mathematica*
1688	Aphra Behn, *Oroonoko*	The Glorious Revolution: deposition of James II and accession of William of Orange
1692		Salem witch trials begin
1696	Catharine Trotter, *Agnes de Castro* Mary Pix, *Ibrahim, the Thirteenth Emperor of the Turks* Delarivière Manley, *The Lost Lover*	
1697	Mary Astell, *A Serious Proposal to the Ladies*	
1709	Delarivière Manley, *New Atalantis*	
1713	Anne Finch, *Miscellany Poems, On Several Occasions*	

1714		George I becomes King of England
1719	Eliza Haywood, *Love in Excess*	
1744	Sarah Fielding, *The Adventures of David Simple in Search of a Faithful Friend* Eliza Haywood edits the *The Female Spectator* (1744–46)	
1746	Lucy Terry composes "Bars Fight," the first African American poem	
1747	Poems by Lady Mary Wortley Montagu	
1749	Sarah Fielding, *The Governess*	
1751	Eliza Haywood, *Betsy Thoughtless*	
1752	Charlotte Lennox, *The Female Quixote*	
1757	Sarah Fielding, *The Lives of Cleopatra and Octavia*	
1758	Elizabeth Carter, *Epictetus*	
1759	Sarah Fielding, *The History of the Countess of Dellwyn*	
1760	Sarah Fielding, *Ophelia*	
1762	Sarah Scott, *Millennium Hall*	
1763	Frances Brooke, *The History of Julia Mandeville*	
1769	Elizabeth Montagu, *An Essay on the Writings and Genius of Shakespeare*	Invention of the spinning frame, leading to employment of women in cotton mills

1796 **(cont.)**	Frances Brooke, *The History of Emily Montague* (first novel written in and about Canada)	
1770	Phillis Wheatley, "An Elegaic Poem"	
1772	Lady Anne Lindsay, "Auld Robin Gray"	
1773	Hester Mulso Chapone, *Letters on the Improvement of Mind*	
	Phillis Wheatley, *Poems on Various Subjects, Religious and Moral*	
	Anna Laetitia Barbauld, *Poems*	
1775		America's fight for independence from Britain begins
1776		American declaration of independence from Britain
		Abigail Adams advises her husband to "Remember the Ladies" when drafting the new constitution
1777	Frances Brooke, *The Excursion*	
1778	Hester Salusbury Thrale Piozzi, *Thraliana*	
	Frances Burney, *Evelina*	
1780	Anna Seward, *Elegy on Captain Cook*	
1782	Frances Burney, *Cecilia*	

1784	Helen Maria Williams, *Peru, A Poem*	
	Anna Seward, *Monody on the Death of Major Andre*; *Louisa*	
	Charlotte Smith, *Elegaic Sonnets*	
1785	Ann Yearsley, *Poems on Several Occasions*	
1786	Hannah More, "The Bas Bleu, or Conversation"	
1787	Anna Laetitia Barbauld, *Lessons for Children*	American Constitution signed
1788	Hannah More, *Slavery, a Poem*	Prime Minister William Pitt the Younger introduces legislation to regulate the slave trade; the Dolben Act stipulates more humane conditions on slave ships
	Helen Maria Williams, "On the Slave Bill which was Passed in England for Regulating the Slave Trade; a Short Time before its Abolition"	
	Sarah Emma Spenser, *The Memoirs of the Miss Holmsbys*	Australia settled by the British
	Charlotte Smith, *Emmeline*	
1789		The French Revolution begins with the storming of the Bastille on July 14 George Washington becomes first U.S. president
1790	Mary Wollstonecraft, *A Vindication of the Rights of Men*	

1790 **(cont.)**	Helen Maria Williams, *Letters Written in France* *in the Summer of 1790*	
1791	Susanna Rowson, *Charlotte Temple*	William Wilberforce's bill for abolition is defeated 163 to 88
1792	Anna Laetitia Barbauld, "Epistle to William Wilberforce" Mary Wollstonecraft, *A Vindication of the Rights* *of Woman* Helen Maria Williams, *Letters from France*	
1793		Louis XVI and Marie Antoinette executed France declares war on Britain
1795	Helen Maria Williams, *Letters Containing a* *Sketch of the Politics of France* Charlotte Smith, *Rural Walks*	
1796	Frances Burney, *Camilla* Mary Hays, *Memoirs of* *Emma Courtney* Charlotte Smith, *Rambles* *Farther* Mary Wollstonecraft, *Letters Written during a* *Short Residence in Sweden,* *Norway, and Denmark*	War between Spain and Britain
1797	Hannah Webster Foster, *The Coquette*	

1798	Joanna Baillie, *Plays on the Passions*, volume 1	Napoleon Bonaparte's campaigns in Egypt and the Middle East; Britain, Austria, and Russia form an alliance against France
1800	Maria Edgeworth, *Castle Rackrent*	Thomas Jefferson is U.S. president
1801	Maria Edgeworth, *Belinda, Early Lessons*, and *Moral Tales for Young People* Tabitha Tenney, *Female Quixotism*	
1802	Amelia Opie, *Poems*	Treaty of Amiens brings a temporary peace of 14 months during the Napoleonic Wars, making travel and correspondence across the English Channel possible again
1803	Mary Hays, *Female Biography*	
1804		Napoleon crowns himself Emperor of France
1806	Charlotte Smith, *Beachy Head and Other Poems* Mary Robinson, *Poetical Works*	
1807		British parliament passes a general abolition act prohibiting slavery and the importation of slaves from 1808 but does not prohibit colonial slavery
1808	Felicia Hemans, *Poems*	
1810	Anna Seward, *Poetical Works* Anna Laetitia Barbauld edits *The British Novelists*	

1811	Mary Tighe, *Psyche* Jane Austen, *Sense and Sensibility* Elizabeth Inchbald edits *Modern Theatre*	Parliament makes slave trading a felony George, Prince of Wales, acts as a regent for George III, who has been declared incurably insane (the Regency, 1811–20)
1812	Anna Laetitia Barbauld, *1811*	
1813	Jane Austen, *Pride and Prejudice*	
1814	Jane Austen, *Mansfield Park* Frances Burney, *The Wanderer*	Napoleon abdicates and is banished to the island of Elba
1815	Lydia Sigourney, *Moral Pieces in Prose and Verse*	The Hundred Days: Napoleon escapes from Elba and temporarily regains power; defeated at Waterloo and exiled to St. Helena
1816	Jane Austen, *Emma* Jane Taylor, *Essays in Rhyme on Morals and Manners*	
1817	Lady Morgan, *France*	
1818	Jane Austen, *Northanger Abbey*	
1819		Peterloo Massacre United States outlaws the slave trade, but slavery continues until the end of the Civil War (1865)
1820		Accession of George IV Royal Astronomical Society founded
1821	Lady Morgan, *Italy*	Napoleon dies on Saint Helena

1822	Catharine Maria Sedgwick, *New England Tale*	Royal Academy of Music founded
1824	Letitia Elizabeth Landon, *The Improvisatrice*	National Gallery established
1825	Anna Laetitia Barbauld, *Works*	First passenger train in Britain
	Felicia Hemans, *The Forest Sanctuary*	
	Letitia Elizabeth Landon, *The Troubador*	
	Sarah Kemble Knight, *The Private Journal of a Journey from Boston to New York* (published posthumously)	
1826		American Temperance Society founded
1827	Lydia Sigourney, "Death of an Infant"	
1828	Felicia Hemans, *Records of Women*	
	Catharine Maria Sedgwick, *Hope Leslie*	
1829	Letitia Elizabeth Landon, *The Venetian Bracelet*	
1830		Earliest passenger railway line opened between Liverpool and Manchester in England
1831		American William Lloyd Garrison founds the abolitionist magazine *The Liberator*

1832	Frances Trollope, *The Domestic Manners of the Americans*	Reform Bill passed in Britain, extending vote to members of the middle class
	Harriet Martineau, *Manchester Strike*	
1833		British Emancipation Bill prohibits slavery in British colonies
		American Anti-Slavery Society founded in Philadelphia by Lucretia Mott
		Factory Act provides for inspection of machinery, prohibits employment of children under the age of 9
1834		Robert Owen forms the Grand National Consolidated Trades Union in Britain
1837		Queen Victoria assumes the throne of England
		Mary Lyon founds Mount Holyoke Female Seminary to educate young women in New England
1838	Elizabeth Barrett Browning, *Seraphim and Other Poems*	Bill for "Immediate Abolition" enacted
		People's Charter initiates first independent working-class movement
1839	Caroline Kirkland, *A New Home—Who'll Follow?*	Mississippi passes first U.S. married women's property law in America
		Infants' Custody Act passed in Britain

1840	*Dial* magazine founded by Margaret Fuller and Ralph Waldo Emerson	
	Frances Trollope, *Michael Armstrong, the Factory Boy*	
1842		Abolitionist Sojourner Truth preaches in America
1844	Mary Shelley, *Rambles in Germany and Italy in 1840, 1842, and 1843*	
	Elizabeth Barrett Browning, *Poems*	
1845	Margaret Fuller, *Woman in the Nineteenth Century*	
1846		Mexican War (1846–48)
1847	Charlotte Brontë, *Jane Eyre*	British parliament enacts labor law that limits work to 10 hours per day for women and children
	Emily Brontë, *Wuthering Heights*	
1848	Elizabeth Gaskell, *Mary Barton*	European revolutions following publication of Marx and Engel's *Communist Manifesto*
		First Women's Rights Convention opens at Seneca Falls, New York
		First women's college, Queen's College, opened in London
1849	Charlotte Brontë, *Shirley*	
1850	Sojourner Truth, *The Narrative of Sojourner Truth*	Fugitive Slave Law passed in America
	Elizabeth Barrett Browning, *Poems* (including *Sonnets from the Portuguese*)	First national convention on women's suffrage is held in Worcester, Massachusetts

1851	Susan Warner, *The Wide, Wide World*	
1852	Harriet Beecher Stowe, *Uncle Tom's Cabin* Susanna Moodie becomes the first Canadian novelist with the publication of *Roughing It in the Bush* Alice Cary, *Clovernook*	
1853	Charlotte Brontë, *Villette* Elizabeth Gaskell, *Ruth*	
1854	Maria Susanna Cummins, *The Lamplighter* Julia Dorr, *Farmingdale* Frances Harper, *Poems on Miscellaneous Subjects*	Crimean War (1854–56)
1855	Fanny Fern, *Ruth Hall*	
1856	Julia Dorr, *Lanmere* Caroline Chesebro', *Victoria, or the World Overcome*	
1857	Elizabeth Barrett Browning, *Aurora Leigh*	Divorce and Matrimonial Causes Act establishes civil divorce court in London Rebellion begins against the East India Company (ends 1859)
1858	Adelaide Anne Proctor, *Legends and Lyrics*	Elizabeth Blackwell becomes first accredited female physician in Britain and in the United States
1859	George Eliot, *Adam Bede*	Charles Darwin, *Origin of Species*

1859
(cont.)

E. D. E. N. Southworth,
The Hidden Hand

Harriet E. Wilson, *Our Nig*
(first black woman to publish
a novel in English)

1860

George Eliot, *The Mill on the
Floss*

Ann Stephen, *Malaeska:
The Indian Wife of the
White Hunter*

Dora Greenwell, "Our
Single Women"

1861

George Eliot, *Silas Marner* American Civil War (1861–65)

Mrs. Henry Wood,
East Lynne

Harriet Jacobs, *Incidents in
the Life of a Slave Girl*

1862

Mary Braddon, *Lady
Audley's Secret*

Dora Greenwell, "Our
Single Women"

Christina Rossetti, *Goblin
Market and Other Poems*

1863

Margaret Oliphant publishes
the first of her Carlingford
novels (1863–76)

Caroline Chesebro', *Peter
Caradine*

Christina Rossetti, "L.E.L."

Jean Ingelow, "Divided"

1865		Thirteenth Amendment to the Constitution abolishes slavery in the United States
		Vassar college opens
1866	George Eliot, *Felix Holt*	
	Augusta Evans, *St. Elmo*	
1867		Second Reform Bill in Britain extends vote to all male urban householders, effectively doubling the electorate
1868	Louisa May Alcott, *Little Women*	First Trades Union Congress in Britain
		Fourteenth Amendment grants citizenship and "due process" to all persons born or naturalized in the United States
1869		Girton College for Women opens at Cambridge
		Elizabeth Cady Stanton and Susan B. Anthony found the National Women's Suffrage Association
1870	Julia Dorr, *Sibyl Huntington* Augusta Webster, *Portraits*	Women's Property Act passed in Britain; establishes principle that married women should in certain circumstances own and control their own property
		British Education Act of 1870 allows women to take university courses but not degrees
		Fifteenth Amendment protects black American males' right to vote
1871		Trade unions legalized in Britain

1872	George Eliot, *Middlemarch* Frances Harper, *Sketches of Southern Life*	Victoria Woodhull runs for the office of President of the United States as the Candidate of the Equal Rights Party; 16 women are arrested in New York for trying to vote in the election
1875		Smith and Wellesley Colleges founded
1876	Eliza Andrews, *A Family Secret*	British medical schools opened to women
1879		Women's college opens at Oxford Radcliffe founded as the "Harvard Annex"
1881	Helen Hunt Jackson, *A Century of Dishonor*	
1882		Second Married Women's Property Act passed in Britain: married women's separate property protected
1883	Sarah Winnemucca Hopkins, *Life among the Piutes* Ella Wheeler Wilcox, *Poems of Passion*	
1884	Helen Hunt Jackson, *Romana: A Story* Sarah Orne Jewett, *A Country Doctor*	Reform Act extends vote to agricultural workers
1885		Bryn Mawr opens
1886	Sarah Orne Jewett, *A White Heron*	Repeal of the Contagious Diseases Act
1889	Michael Field (Katherine Bradley and Edith Cooper), *Long Ago*	

1891		The word "feminist" is first used in a book review in the *Athenaeum*
1892	Charlotte Perkins Gilman, *The Yellow Wallpaper* Michael Field (Katherine Bradley and Edith Cooper), *Sight and Sound* Anna Julia Cooper, *A Voice from the South by a Black Woman of the South*	
1895	Alice Dunbar-Nelson, *Violets and Other Tales*	Oscar Wilde tried and sentenced
1896	Sarah Orne Jewett, *The Country of the Pointed Firs*	
1897		Havelock Ellis publishes *The Psychology of Sex*
1898		Spanish-American War
1899	Kate Chopin, *The Awakening*	Boer War in South Africa (1899–1902)
1901		Marconi's first transatlantic wireless radio message Death of Queen Victoria
1905		Publication of Freud's *Three Essays on the Theory of Sexuality*
1906		*London Daily Mail* coins the word "suffragette"
1907	Edith Wharton, *The House of Mirth*	
1909	Gertrude Stein, *Three Lives*	First woman suffrage parade held in New York

1909 (cont.)		The White Slave Traffic Act (The Mann Act) passed, outlawing the transportation of women across the state lines for "immoral purposes"
1912		*Poetry Magazine* begins publication in Chicago
1913	Dorothy Richardson, *Pilgrimage* Willa Cather, *O Pioneers!*	
1914	Publication of newly discovered poems by Emily Dickinson First Imagist anthology	Beginning of World War I (August 1)
1915	Charlotte Perkins Gilman, *Herland* Willa Cather, *The Song of the Lark* Edith Wharton, *Flight from France from Dunkerque to Belfort*	
1916		First birth control clinic opens in United States Alice Paul and Lucy Burns establish the National Woman's Party to oppose Woodrow Wilson
1917		Russian Revolution
1918		Representation of the People Act passed in Britain: certain women over the age of 30 given the vote
1919	Willa Cather, *My Antonia*	

1920	Edith Wharton, *The Age of Innocence*	Nineteenth Amendment to the Constitution grants American women suffrage
1922	Willa Cather wins Pulitzer Prize for *One of Ours* Edith Sitwell collaborates with composer William Walton on *Façade*	
1923	Edna St. Vincent Millay wins Pulitzer Prize	
1924	Radclyffe Hall, *The Unlit Lamp* H. D., "Helen"	Act of Congress grants American Indians citizenship
1925	Ellen Glasgow, *Barren Ground* Virginia Woolf, *Mrs. Dalloway* and *The Common Reader* Gertrude Stein, *The Making of the Americans* Anzia Yezierska, *The Bread Givers*	
1926	Staging of Edna St. Vincent Millay's opera, *The King's Henchmen*	
1927	Virginia Woolf, *To the Lighthouse*	Execution of Nicola Sacco and Bartolomeo Vanzetti for murder of two factory officials
1928	Radclyffe Hall, *The Well of Loneliness* Nella Larsen, *Quicksand*	Representation of the People Act passed in Britain: all women over the age of 21 allowed to vote
1929	Virginia Woolf, *A Room of One's Own*	U.S. stock market crashes, launching the Great Depression

1929 **(cont.)**	Jessie Redmon Fauset, *Plum Bum: A Novel without a Moral*	American publishers of Radclyffe Hall's *Well of Loneliness* tried and convicted of obscenity (later overturned)
1930	Katherine Anne Proctor, *Flowering Judas, and Other Stories*	
1931	Kay Boyle, *Plagued by the Nightingale* Virginia Woolf, *The Waves*	
1932	Gertrude Stein writes *Stanzas in Meditation* (published 1956)	
1933	Gertrude Stein, *The Autobiography of Alice B. Toklas* Vera Brittain, *Testament of Youth* Eleanor Roosevelt, *It's Up to the Women*	President Roosevelt introduces "New Deal" measures to ease effects of Great Depression in the United States
1934	Lillian Hellman's *The Children's Hour* runs for 691 performances on Broadway but is banned in Boston, Chicago, and London for references to lesbianism Gertrude Stein's *Four Saints in Three Acts* plays on Broadway	
1935	Elizabeth Bowen, *The House in Paris*	
1936	Djuna Barnes, *Nightwood*	Spanish Civil War (1936–39)

1936 **(cont.)**	Martha Gellhorn, *The Trouble I've Seen*	"My Day," newspaper column by First Lady Eleanor Roosevelt, begins national circulation
1937	Virginia Woolf, *The Years* Gertrude Stein, *Everybody's* *Autobiography* Zora Neale Hurston, *Their* *Eyes Were Watching God*	Pilot Emilia Earhart is lost en route in her attempt to fly around the world
1938	Virginia Woolf, *Three Guineas* Elizabeth Bowen, *The Death* *of the Heart* Anna Wickham, *The League* *for the Protection of the* *Imagination of Women*	
1939	Jean Rhys, *Good Morning* *Midnight*	World War II begins in Europe Name "Rosie the Riveter" coined to refer to women employed in American defense industries
1940	Gertrude Stein, *Paris France* Carson McCullers, *The Heart Is a Lonely Hunter*	Battle of Britain
1941	Lillian Hellman's *Watch* *on the Rhine* wins the New York Drama Critics Circle Award Rachel Carson, *Under the* *Sea-Wind* Virginia Woolf, *Between the* *Acts*	United States enters the war after the bombing of Pearl Harbor
1942	Mary McCarthy, *The Company She Keeps*	

1943	Ayn Rand, *The Fountainhead*	
1944	H. D., *Trilogy* (1944–46)	
1945	Gertrude Stein, *Wars I Have Known*	End of World War II Women lose jobs in industry
1946	Denise Levertov, *The Double Image*	
1947	Kay Boyle, *The Smoking Mountain: Stories of Germany during the Occupation*	Marshall Plan produced to provide massive economic aid to war-torn Europe
1949	Muriel Rukeyser, *The Life of Poetry*	Simone de Beauvoir's *The Second Sex* published in France Alfred Kinsey publishes his study of male sexuality
1950	Gwendolyn Brooks's *Annie Allen* wins the Pulitzer Prize Anzia Yezierska, *Red Ribbon on a White Horse* Anaïs Nin, *The Four Chambered Heart* Tereska Torres, *Women Barracks* Doris Lessing, *The Grass Is Singing* Patricia Highsmith, *Strangers on a Train*	United Nations drafts convention of women's rights Korean War (1950–53)
1951	Hannah Arendt, *The Origins of Totalitarianism*	

1951
(cont.)

Marianne Moore's *Collected Poems* wins the Pulitzer Prize, National Book Award, and the Bollingen Prize

Adrienne Rich wins the Yale Younger Poets Award for *A Change in the World*

Rachel Carson, *The Sea around Us*

Carson McCullers, *The Ballad of the Sad Café*

1952

Edna St. Vincent Millay's *Collected Poems* published posthumously

Gwendolyn Brooks, *Maud Martha*

Mary McCarthy, *The Groves of Academe*

Flannery O'Connor, *Wise Blood*

Dorothy Day, *The Long Loneliness*

Doris Lessing, *Martha Quest*

Elizabeth II of England inherits the throne on the death of her father

Lillian Hellman refuses to testify against colleagues before House Un-American Activities Committee

1953

Jane Bowles, *In the Summer House*

Dorothy Parker, *The Ladies of the Corridor*

Lillian Hellman, *The Autumn Garden*

Ethel and Julius Rosenberg are executed for allegedly passing atomic secrets to the Soviet Union

President Eisenhower issues an executive order prohibiting gays and lesbians from obtaining federal employment

The Kinsey Report, *Sexual Behavior in the Human Female*, is published

1954	Louise Bogan, *Collected Poems, 1923–1953* Alice B. Toklas, *The Alice B. Toklas Cookbook*	U.S. Supreme Court rules that racial segregation is illegal in *Brown vs. Board of Education* End of Korean War
1955	Anne Morrow Lindbergh, *Gift from the Sea* Anaïs Nin, *Diary of Anaïs Nin* (1955–66)	Rosa Parks is arrested after refusing to give up her seat on a bus in Montgomery, Alabama
1956	Gertrude Stein's *Stanzas in Meditation* published (written 1932) Iris Murdoch, *The Flight from the Enchanter*	President Eisenhower calls in federal troops to quell riots during desegregation of Little Rock, Arkansas, school system
1957	Ann Bannon, *Odd Girl Out* Mary McCarthy, *Memories of a Catholic Girlhood* Ayn Rand, *Atlas Shrugged*	
1958	Hannah Arendt, *The Human Condition* Ruth Prawer Jhabvala, *Esmond in India*	
1959	Lorraine Hansberry's *A Raisin in the Sun*, first Broadway play written by a black woman, wins the New York Drama Critics Circle Award Paule Marshall, *Brown Girl, Brownstones*	
1960	Anne Sexton, *To Bedlam and Part Way Back*	Vietnam War (1960–75)

1961	H. D., *Helen in Egypt*	Oral contraceptive ("the pill") approved by U.S. Food and Drug Administration
	Tillie Oslen's *Tell Me a Riddle* receives the O'Henry Award for best short stories	
	Iris Murdoch, *The Severed Head*	
1962	Djuna Barnes's *The Antiphon* premiers in Stockholm	
	Rachel Carson, *The Silent Spring*	
	Ann Bannon, *Beebo Brinker*	
	Doris Lessing, *The Golden Notebook*	
1963	Betty Friedan, *The Feminine Mystique*	Martin Luther King Jr. delivers his "I Have a Dream" speech during a civil rights march on Washington, DC
	Hannah Arendt, *On Revolution*	
	Mary McCarthy, *The Group*	Assassination of President John F. Kennedy
	Hannah Arendt, *Eichmann in Jerusalem*	
	Sylvia Plath, *The Bell Jar*	
1964	Katherine Anne Porter awarded Pulitzer Prize and National Book Award for *Collected Stories*	Civil Rights Act passed by U.S. Congress
	Ayn Rand, *The Virtue of Selfishness*	
1965	Rachel Carson, *A Sense of Wonder*	
	Margaret Drabble, *The Millstone*	

1965 **(cont.)**	Ruth Prawer Jhabvala, *A Backward Place*	
1966	Jean Rhys, *Wide Sargasso Sea* Anne Sexton, *Live or Die* Ayn Rand, *Capitalism:* *The Unknown Ideal*	The National Organization of Women (NOW) founded in the United States
1967	Joyce Carol Oates, *A Garden of Earthly Delights*	
1968	Joyce Carol Oates, *Expensive People*	Assassinations of Martin Luther King Jr. and Robert F. Kennedy
1969	Joyce Carol Oates's *them* receives the National Book Award Margaret Drabble, *The Waterfall* Margaret Atwood, *The Edible Woman*	Stonewall riots in New York City inaugurate the gay rights movement Women's studies degree program established at San Diego State University
1970	Maya Angelou, *I Know* *Why the Caged Bird Sings* Hannah Arendt, *On Violence* Lillian Hellman's *An* *Unfinished Woman* wins the Gold Medal of Drama and the National Book Award Ayn Rand, *Romantic Manifesto* Germaine Greer, *The Female* *Eunuch* Kate Millet, *Sexual Politics* Kay Boyle, *The Long Walk at* *San Francisco State*	

1970 **(cont.)**	Joan Didion, *Play It As It Lays*	
	Anne Tyler, *Slipping Down Life*	
	Ruth Prawer Jhabvala, *An Experience of India*	
	Toni Morrison, *The Bluest Eye*	
1972	Adrienne Rich, *When We Dead Awaken*	*Ms.* magazine appears on newsstands
	Eudora Welty's *The Optimist's Daughter* wins Pulitzer Prize	Education Amendments to U.S. Constitution prohibit sex discrimination
	Doris Lessing, *Briefing for a Descent into Hell*	Equal Rights Amendment passes U.S. Congress but fails to win ratification by 1982 deadline
	Ruth Prawer Jhabvala, *A New Dominion*	
	Margaret Atwood, *Surfacing*	
	Angela Carter, *The Infernal Desire* and *Machines of Dr. Hoffman*	
1973	Lillian Hellman, *Pentimento*	*Roe v. Wade* rejects state laws prohibiting abortion during the first trimester
	Erica Jong, *Fear of Flying*	
	Adrienne Rich's *Diving into the Wreck* awarded the National Book Award for Poetry	
	Rita Mae Brown, *Ruby Fruit Jungle*	
	Toni Morrison, *Sula*	
	Iris Murdoch, *The Black Prince*	
1974	Nadine Gordimer, *The Conservationist*	

1974 **(cont.)**	Gail Godwin, *The Odd Woman*
	Iris Murdoch, *The Sacred and Profane Love Machine* wins the Whitbread Prize
1975	Gwendolyn Brooks, *Capsule Course in Black Poetry Writing*
	Annie Dillard's *Pilgrim at Tinker Creek* wins Pultizer Prize for nonfiction
	Ruth Prawer Jhabvala's *Heat and Dust* wins Booker Prize
	Margaret Atwood, *Lady Oracle*
1976	Maxine Hong Kingston, *The Woman Warrior*
	Ntozake Shange, *for colored girls who have considered suicide/when the rainbow is enuf*
	Adrienne Rich, *Of Woman Born*
	Carol Churchill, *Light Shining in Buckinghampshire* and *Vinegar Tom*
	Virginia Woolf's *Moments of Being: Unpublished Autobiographical Writings* published posthumously
	Anne Tyler, *Searching for Caleb*
1977	Marilyn French, *The Women's Room*

1977 **(cont.)**	Toni Morrison's *Song of Solomon* wins the National Book Award
	Lillian Hellman, *Scoundrel Time*
	Barbara Pym, *Quartet in Autumn*
	Margaret Drabble, *The Ice Age*
	Anita Desai, *Fire on the Mountain*
	Leslie Marmon Silko, *Ceremony*
	Angela Carter, *The Passion of the New Eve*
1978	Hannah Arendt's *The Life of the Mind* published posthumously
	A. S. Byatt, *The Virgin in the Garden*
1979	Nadine Gordimer, *The Burgher's Daughter*
	Angela Carter, *The Sadeian Women*
1980	Lillian Hellman, *Maybe* Audra Lorde, *The Cancer Journals*
	Anita Desai, *Clear Light of Day*
1981	Angela Davis, *Women, Race, and Class*
	Nadine Gordimer, *July's People*

1982	Alice Walker's *The Color Purple* wins the American Book Award and Pulitzer Prize	Equal Rights Amendment to the United States Constitution fails to win ratification by three votes
	Carol Churchill, *Top Girls*	
	Sylvia Plath's *Collected Poems* published posthumously and awarded Pulitzer Prize	
	Audre Lorde, *Zami: A New Spelling of My Name*	
1983	H. D.'s *HERmione* published posthumously	
	Alice Walker, *In Search of Our Mother's Gardens: Womanist Prose*	
1984	Sandra Cisneros, *The House on Mango Street*	
	Louise Erdrich's *Love Medicine* wins National Book Critics Circle Award	
	Germaine Greer, *Sex and Destiny*	
	Nadine Gordimer, *Something Out There*	
	Anita Brookner's *Hotel du Lac* wins Booker Prize	
	Fay Weldon, *Life and Loves of a She-Devil*	
	Angela Carter, *Nights at the Circus*	
1985	Jeannette Winterson's *Oranges Are Not the Only Fruit* wins the Whitbread Prize	

1985 **(cont.)**	Ruth Prawer Jhabvala, *Out of India*	
	Jamaica Kincaid, *Annie John*	
	Margaret Atwood, *The Handmaid's Tale*	
1987	Toni Morrison's *Beloved* wins the Pulitzer Prize	
	Carol Churchill, *Serious Money*	
1989	Amy Tan, *The Joy-Luck Club*	Dismantling of apartheid begins in South Africa
	Angela Davis, *Women, Culture and Politics*	
	Jeannette Winterson's *Sexing the Cherry* wins E. M. Forster Award	
	Fay Weldon, *The Cloning of Joanna May*	
1990	Jamaica Kincaid, *Lucy*	End of the Cold War as the Soviet Union and East Bloc countries end one-party government and legalize private ownership of property
	Eva Hoffman, *Lost in Translation*	
	Anita Brookner, *Brief Lives*	
1991	Nadine Gardiner awarded the Nobel Prize for Literature	
1992	Jane Smiley, *A Thousand Acres*	
	A. S. Byatt, *Possession: A Romance*	
1993	Toni Morrison wins the Nobel Prize for Literature	

1993 **(cont.)**	Susanna Kaysen, *Girl,* *Interrupted*
	Rita Dove named Poet Laureate of the United States
	Margaret Atwood, *The* *Robber Bride*
1994	Edwige Danticat, *Breath, Eyes,* *Memory*
1996	Louise Gluck, *Meadowlands*
	Jamaica Kincaid, *Autobiography of My Mother*
1997	Arundhati Roy's *The God of* *Small Things* wins the Booker Prize
1998	Janice Williamson, *CRYBABY!*
	Mary Karr, *The Liar's Club*
	Toni Morrison, *Paradise*
1999	Arundhati Roy, *Cost of Living*
2001	Amy Tan, *The Bonesetter's* *Daughter*

INDEX